C000259302

MORE THRILLS THAN SKILLS

For more than ten years Paul Harris worked as a freelance journalist and photographer in many of the more difficult, war-torn parts of the world. He reported for newspapers, magazines, radio and TV on a multitude of conflicts from Sarajevo under siege, the anarchy of Albania and the bloodletting in Algeria, to wars in the jungles of Sri Lanka, the bush of southern Sudan and benighted Somalia.

He has an instinct for survival. His 'plane was destroyed by a fighter aircraft on the runway in Ljubljana as the wars in Yugoslavia broke out in 1991. He was close enough to witness the bomb explosion which completely destroyed the centre of the Sri Lankan capital in 1996, from where he was expelled, in 2002, after pressure from the rebel Tamil Tigers.

He almost died in Kosovo after some unsought close contact with dead bodies. He worked in China for *The Shanghai Daily* newspaper and in Colombo for *The Daily Telegraph*, but it was his work, for almost a decade, for *Jane's Intelligence Review*, and the murky world of intelligence gathering, which would ultimately force his early retirement after international terrorists issued a directive for his assassination.

Paul Harris wrote and broadcast for diverse media including the BBC, Sky News, *Jane's Intelligence Review, Scotland on Sunday, The Scotsman* and *The Daily Telegraph*. He was a winner in the British Press Awards in 1993 for his reporting from Bosnia. His previous books include *Somebody Else's War, Cry Bosnia, About Face: Photographs from the Streets of Shanghai* and *Fractured Paradise: Images of Sri Lanka.*

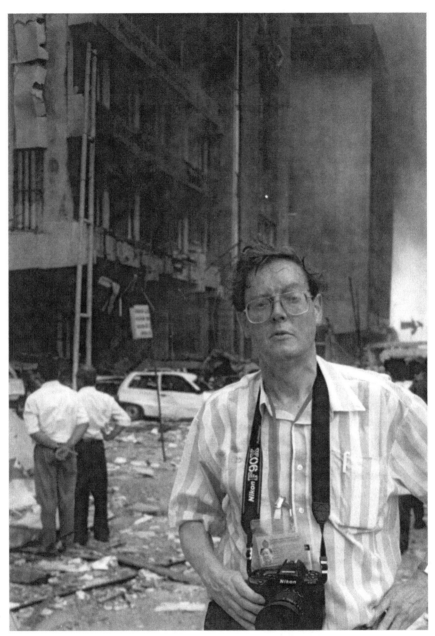

Paul Harris, Colombo, January 31 1996, Central Bank bomb attack

For Jim & Diane

The full story (almost)

More Thrills Than Skills

Dave

Adventures in Journalism, War and Terrorism

Sept 08

Paul Harris

Kennedy & Boyd

Kennedy & Boyd,
An imprint of Zeticula
57 St Vincent Crescent
Glasgow G3 8NQ

www.kennedyandboyd.co.uk
admin@kennedyandboyd.co.uk

First published in 2009

ISBN-10 1-904999-36-0
ISBN-13 978-1904999-36-2

For Lucy

Acknowledgements

This is not a long list of Acknowledgements. This is my own work and I take the credit and the responsibility for it.

I would like to thank Stephanie Wolfe Murray for her useful comments on my publishing reminiscences; Harry Wilken for jogging my memory on our 'interview' with the Rt Hon Ian Smith and other early recollections; Al Campbell for recounting his own vivid memories of life at *The Shanghai Daily*; and Tim Ripley for his input on defence and security issues. And, finally, my thanks to Colonel Bob Stewart. I first met him in war-torn Bosnia in the autumn of 1992. In command of British UN forces in central Bosnia, he was undertaking an incredibly difficult task. I warmed to him very quickly, which was unusual for journalists in their relations with the military. We became friends and he read the text and graciously agreed to write the Foreword.

All photographs are my own, with the exception of the following:

Chapter Two: Edwin Bollier on board the *Mebo 2* radio ship by Theo Dencker, Hamburg; Paul Harris disc jockey by J Geddes Wood, Aberdeen.

Chapter Three & cover: *Paul Harris, Turanj, Croatia, Christmas Day 1991*, by Paul Hackett.

Chapter Eight: Picture of Paul Harris at the Frankfurt Book Fair by Gordon Wright, Edinburgh; Princes Diana and HRH The Prince of Wales by *The Press & Journal*, Aberdeen

Chapter 12: Paul Harris leaving Sri Lanka by *The Sunday Times*, Colombo

Chapter 13: Paul Harris at *The Shanghai Daily* by *Xinmin Evening News*, Shanghai

Chapter Fifteen: Charles Skilton at the London Book Fair, 1972 by Bill Patterson Photography; Paul Harris cutting the Whittingehame House cake by *The East Lothian Courier*, Haddington.

Thanks to the many, unknown helpful people who took photographs of me, using my own camera, in more than 20 countries.

Paul Harris, January 2009

Contents

Foreword

by Colonel Bob Stewart D.S.O.

I first met Paul Harris when he suddenly appeared near my UN force base in Central Bosnia in autumn 1992. My soldiers had warned me that a somewhat bizarre character was wandering around looking like an early European explorer in Africa. When I first met him, he was wearing puttees and a First World War helmet on which he had painted the word 'PRESS' – presumably in the hope that the word might afford him some form of protection if he was in a sticky spot. He looked like he had just come through a time warp from a previous, imperial existence.

Initially, I was bemused. He introduced himself and said he was a freelance photographic and print journalist. It was straightaway clear that he knew Central Bosnia relatively well and he certainly had a good idea of who was who and what was what there. He obviously had a deep interest in what was happening in the Balkans. I revised my initial impression of him. He was not entirely another crazy; lots of them, some posing as war correspondents, lurked around Central Bosnia in those days.

Yes, the guy was strange but I liked him. It was clear to me that this was a decent man who thought deeply about what was happening in Bosnia and who cared about its peoples – all of them, Bosnian Muslim, Bosnian Croat and Bosnian Serb. Like me, he realised that a great evil had been set afoot in the Balkans and he was by no means sure that it could be put back into any bottle.

Paul showed me some of his extraordinary photographs and from them it was clear that he had been to some very dodgy places. I felt he must also be a very brave man because at that time there was very little protection for the freelance journalists who just happened to offend one side or the other, albeit unintentionally. 'PRESS' written roughly on his helmet wouldn't protect him for long. Already a BBC journalist had been cut in half by an armour piercing shell near my base. Journalists had far less protection than my soldiers did.

Paul explained to me that he was not just there as a neutral correspondent who was simply going to witness and report what

he saw without too much personal involvement. This journalist, he told me, was going to try and help the people in the country. The best way he could do that, he thought, was by producing a book of photographs showing the tragedy of Bosnia. In June 1995 he did just that. *Cry Bosnia*, a magnificent photographic record of what was happening, was published with all proceeds being fed back to help the peoples of Bosnia.

I have remained a firm friend of Paul Harris ever since. As I got to know him further I realised that he was truly a 'renaissance man' whose interests, knowledge and international understanding went far beyond the Balkans. He has had an incredibly interesting life: this book shows that clearly.

Although I like and respect him a great deal, every time we meet I am instantly transported back to our first meeting. I suspect there was something of the 'nutter' there then, and there still is. His book will allow you, the reader, to make your own judgement on that.

Bob Stewart
Kingston, Surrey
December 2008

'Nothing was your own except the few cubic centimetres inside your head.'

George Orwell, *1984*

One

The Mouse that Roared

Career Change 1100 hours, June 28 1991

Career changes are generally well thought out and often intricately planned events. Mine happened around eleven in the morning of June 28, 1991 on a warm summer's day in the foothills of the Julian Alps. It was entirely accidental.

Ljubljana was a decidedly dreary place in the 1980s; your archetypal Eastern European city. A city made up of dismal, grey canyons of mouldering buildings, their intrinsic beauty obscured by decades of dirt, decay and neglect. The Titoist monuments to the achievements of the Yugoslav people hardly seemed to inspire the inhabitants in their daily trudge to work. The bars were dark, dismal and smoky places generally full of young soldiers in scruffy uniforms: Yugoslav Army conscripts, far from home and miserable, they formed long, patient lines at public phone boxes waiting to unload their homesickness on relatives in some faraway republic of the Yugoslav federation. By night the city closed down. By eight in the morning, the breakfast room in the city centre Slon Hotel would be full of chain-smoking men in thin, ill-fitting suits drinking *slivovich* or the local pear brandy, *vilyamovka*. they were either putting off that trudge to work, or had already given up the notion for the day.

In the late '80s I must have visited the capital of Slovenia, the smallest of the seven republics making up what used to be Yugoslavia, more than fifty times. Bordered to north, east and west by Austria, Hungary and Italy respectively, the two million Slovenes, even then, saw themselves rather as Europeans; seeking to distance their activities from the rest of the wretched, feuding Balkans. For them there was a pride in their own language; a distinct sense of identity; a general industriousness and a homogeneity uncomplicated by the tedious presence of other ethnic groups. There were virtually no Serbs within Slovenia's borders and little sympathy for the divisive demagoguery emanating from Belgrade.

Slovenia, quite the reverse, had the advantage of a confident, young intelligentsia wary of the forces of nationalism. A certain informed and satirical cynicism was emerging, embodied notably in a radical magazine called *Mladina*.

With less than 9% of the population of Yugoslavia, it was producing more than 30% of the exports. Slovenes became increasingly frustrated with rule from Belgrade and, in 1989, the Slovene assembly amended the republic's constitution to allow a vote on independence. Independence within the confederation turned out to be impossible. In 1990, the Slovene party left the Federal League of Communists and, on December 23 1990, a referendum produced a vote which evidenced more than 90% of the population in favour of independence.

The Slovenes had been tossed into the 1918 Treaty of Versailles concoction that was Yugoslavia - the Kingdom of Croats, Slovenes and Serbs. What is extraordinary is that the opportunistic mish-mash lasted as long as it did. It was not designed as a federation of like-minded peoples desirous of living harmoniously together. Far from it. It was designed by the victorious powers to be a bulwark against a German-Magyar power block in the aftermath of the First World War, itself sparked by the assassination of the Austrian Archduke Franz Ferdinand in Sarajevo by a member of the Young Bosnia movement. The Versailles answer to the problem effectively was to create a Greater Serbia to be known as Yugoslavia.

Things went badly from the start. The Croats boycotted the passage of the 1921 constitution. The Serbs asserted their cultural hegemony by imposing their own version of the Serbo-Croat language, including the use of Cyrillic script, as opposed to the Latin version used in Croatia and Slovenia. Parliamentary rule was abolished in Belgrade in 1929 and Yugoslavia came under the rule of the Serbian King Alexander. Extreme right wing Croats then assassinated him in the south of France in 1934. The Second World War saw bitter and divisive fighting and massacres as the competitive forces of the Croatian fascist *ustase*, the Serbian Royalists and the emergent Communists all locked horns under German domination. But the war did produce one Josip Broz Tito, the strong man that Yugoslavia required. His iron rule held the country together by brute force. It was not as benign as it is

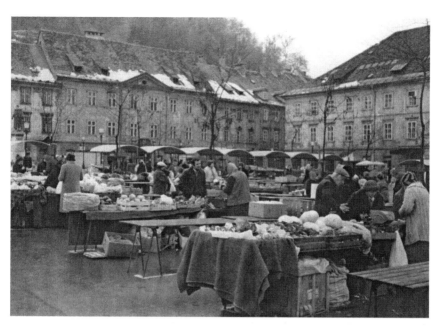

Ljubljana, the fruit and vegetable market, 1986. The Slovenian capital was decidedly drab in those days and the market was just about the most colourful place.

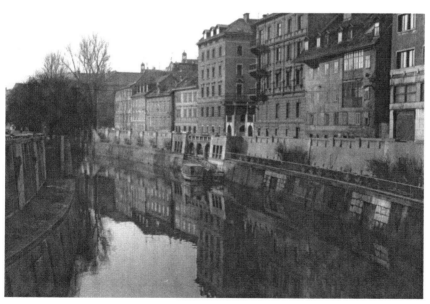

Ljubljana centre 1986

During the 1980s I worked as an export consultant in former Yugoslavia. The principal objective was to promote the printing industry in Slovenia. Slovenia was far and away the most industrious and productive part of the Yugoslav Federation and the World Bank and IMF had invested substantial funds in printing equipment. The problem was nobody in those days knew where Slovenia was. I promoted the business with the slogan On the Sunny Side of the Alps.

Dawn breaks on the morning of June 27 1991. As our bus from Zagreb airport made its way to Ljubljana we ground to a halt as a massive road block was thrown up ahead of us. The object was to impede tank movements and in this the roadblock at Medvedjek was successful until it was bombed from the air the next morning.

often painted. One of the best Yugoslav films of all time remains *Daddy's Gone Away for the Weekend*, a semi-documentary about the thousands of Yugoslavs who served their sentences in labour camps over their weekend holidays.

I remember Janez Fafar, manager of the Vila Bled hotel, once one of Tito's many summer palaces, telling me of how his father presented his bill for laying the exquisite marble floors throughout the building. The wily dictator studied the bill and declared it to be a fraud upon the people and the state. He was never paid. Indeed, the hapless tradesman was incarcerated for years. In such ways, Tito held the whole rickety structure together through a combination of terror and sheer force of personality until he died in 1980. Then the whole thing started to fall apart.

Friends in Slovenia, where at the time I worked *inter alia* as a business consultant, promised me that independence celebrations on the evening of June 26 1991 would be very special. But my flight on the republic's carrier, Adria Airways, kept getting put back that afternoon at Heathrow Airport. Late in the afternoon, Adria's manager, Marilyn, joined me at the bar. "Keep it to yourself but the military have seized Ljubljana airport. There are tanks on the runway."

By midnight, most of the passengers on the flight had drifted away. A group of frail Saga Holidays passengers had been persuaded to leave for home with their zimmers and sticks. Businessmen who had missed their appointments had given up. The lounge at Terminal 2 was almost empty when the flight was called at 1 a.m. By now, in the square before the Parliament Building, Slovenia's President Kucan had declared his tiny republic to be independent. The mouse had roared.

The flight was virtually empty. Apart from myself, there was a Glasgow book dealer called Cooper Hay, who was clutching a portfolio of original Charles Rennie Mackintosh prints, going for reproduction in Slovenia. It was a valuable item, possibly worth as much as £100,000 (almost US$200,000) and we were both a mite concerned about keeping it intact. There was the chief reporter and a photographer from the *Daily Mail*, and just half a dozen or so returning Slovenes. It was 4 a.m. local time when our diverted flight landed at Zagreb in neighboring Croatia.

A misty dawn was just breaking on the Zagreb to Ljubljana highway as the bus slowed to a halt in a long queue of stationary traffic near to the town of Novo Mesto. Unbeknown to us, fifty miles up the road, Yugoslav army tanks were leaving their bases and deploying throughout Slovenia. Together with the photographer from the *Mail*, I strolled about a mile up the road to a checkpoint manned by young men evidently from the Slovene Territorial Defence Force. The first thing I noted were the fresh new Slovenian badges, with the white peak of Triglav, the nascent Alpine republic's highest mountain. There was a certain evidence of haste. They seemed to have been hurriedly sewn onto crisp new camouflage uniforms; some were just pinned on. Eventually, the long line of vehicles moved off but, a few kilometres further on, came to a final halt at a massive roadblock near Medvedjek.

There dozens of lorries had been commandeered by the Slovenian defence force and used to block the road with an impenetrable wall of steel. Then, behind us, soldiers and police started to create further roadblocks. We could neither go forwards nor go back. Something serious was indeed developing.

The roads might have been blocked but the trains were still running. We left the bus, grabbed our luggage and the portfolio of prints and yomped across a field to a tiny, country station. It was one of those picture postcard affairs: an Austro-Hungarian station building complete with stationmaster in a red and blue uniform straight from Gilbert & Sullivan. Slovenes pride themselves on their efficiency and punctiliousness and his flag fell precisely at the appointed hour and train and passengers departed for Ljubljana just as on any normal traveling day.

What I did not yet know was that this was the start of all the wars in Yugoslavia – the great fatal unraveling of the Kingdom of Croats, Slovenes and Serbs. It was taking place all around in the cool, half light of dawn. In the woods and mountains, Slovenian defence forces were being mobilised and issued with brand new uniforms and weapons secretly stored throughout the Republic.

It is truly one of the most extraordinary of experiences to be in a country as it goes to war without warning. I had many times read gripping reports in the newspapers of revolution and coups. But these were usually in tinpot banana republics in South America or

Roadblocks sprang up throughout Slovenia on June 27. This one, on the outskirts of Ljubljana, was made up of commandeered public buses which were filled with gas cylinders and bottles of petrol.

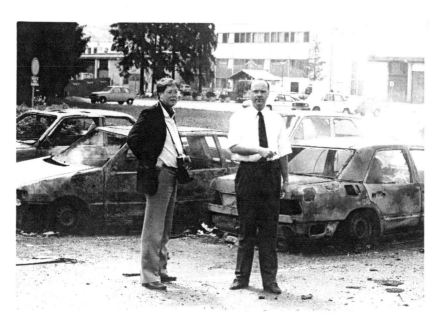

At around eleven in the morning on June 28, my colleague Igor Potocnik and I arrived at a deserted Brnik Airport just after the attack by a Yugoslav air force Super Galeb aircraft. Cars in the airport car park were destroyed in the attack and were still on fire when we arrived.

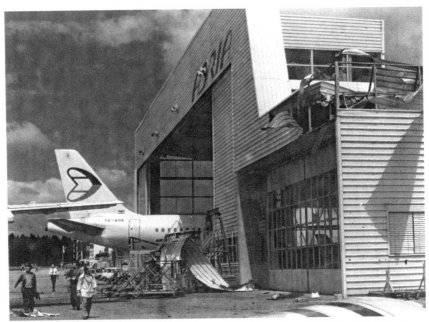

The Airbus A-230 in which I was supposed to fly to London was filled with holes from the Galeb's 23mm. cannon. There was substantial damage to the airport.

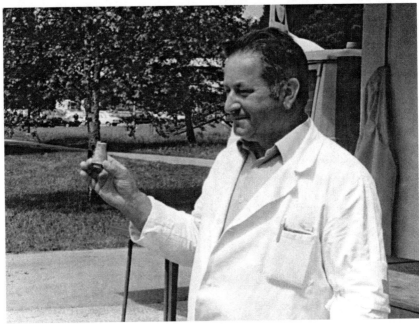

The medical superintendent at the airport clinic held aloft this spent piece of ordinance and declared, "Look at the first bullet fired in the Third World War"!

Africa. This was *Europe*, for goodness sake. Most wars are presaged by months, if not years, of threat, recrimination and civil discontent. But this was all happening quite suddenly. There was no great feeling of being at the epicentre of the world-shattering event it would turn out to be. Only a few weeks previously, drinking the local *Lazko* beer at an outdoor café with workers from Gorenjski Tisk, one of the printing factories in Slovenia, I had asked them if war might break out in Slovenia. Never, they assured me.

By mid-morning, all around the capital Ljubljana, all points of entry to the city were blocked off by barricades using the city's buses, hijacked lorries, earth moving equipment and any other materials which came to hand. There were mines beneath some of these improvised barricades, and many of the buses were full of portable gas cylinders. The buzzword that day on everybody's lips was *blockaade*. This was a war in which everybody could participate; just a tractor and a trailer and you had a *blockaade*.

We checked into the Slon Hotel in the centre of Ljubljana (then the best hotel in a city of grimy offerings) and I switched on the 9 a.m. news in the hotel bedroom. CNN were showing film of Yugoslav army tanks breaking out of the city in the direction of the borders of the country. There were images of the airport at Brnik surrounded by tanks. They were crushing cars and roadblocks before them like *papier mache*. Apparently, there were still many tanks left at the barracks within the city. The objective of the ever growing walls of metal which made up the blockades was to slow down tank movements sufficiently so that the more lightly armed defence forces and civilians might be able to attack the lumbering metal leviathans. The volunteer forces had a devastating weapon which would soon turn the tide: the *armbrust*, a plastic, single use rocket propelled grenade launcher. Devastatingly effective, it would soon restrict tank movements and confine them to their bases. In filling stations around the city, petrol was now being sold in lemonade bottles so as to provide a ready supply of Molotov cocktails.

Waiting for us, at the Slon Hotel, was Igor Potocnik, sales director of Slovenia's largest and most successful printing company, Gorenjski Tisk, with which I have been associated since 1985. When I visited the Frankfurt Book Fair that year I had visited their stand. I found that the World Bank and the IMF had set them

up with sparkling new printing machinery, but there was no work for it. I proposed myself as their agent and it was the beginning of a long relationship which would outlive the Slovenian war of independence. Igor told us that they had a nuclear bomb-proof bunker over at the printing works. That cheered us up enormously: especially Cooper who entered a request that he might deposit his priceless portfolio there. He was now happy enough to speak to the BBC radio programme *Good Morning Scotland* about his first hand experiences of revolution. Military helicopters buzzed over the city and most of the morning a spotter 'plane swept low over the streets dropping a cargo of crudely photocopied leaflets. The leaflets invited us to surrender - I wonder who to? – and sternly advised that resistance was useless.

It was, however, essentially a day of phoney war. The Yugoslav army was making its way to the border crossing points. Meantime, thousands of Slovenes were digging out rusty hunting rifles from the attic and making Molotov cocktails in the back yard. There was a sense of purpose, though, in everyone you met. This was something which had to be done.

At a pavement cafe in the centre of Ljubljana in the evening we heard the sound of firing and - a little later - the rumble of an explosion. A military helicopter which had ventured too near to the parliament building was shot at and hit. It came down in the street near to its base on the outskirts of the city. It was not a great tactical success. It turned out it was carrying supplies of freshly baked bread. I will come to learn that in war large numbers of people seem to die by horrible accident.

My Adria flight from Brnik was due to take off for London at 1030 the next day, Friday. The Adria office in Ljubljana advised that the airport was still closed. I decided to go anyway – my ticket was clearly endorsed, war or no war, 'non endorsable, non refundable' and it seemed like a good idea to go to the airport. I needed that IATA stamp 'Flight Cancelled. Boarding Denied' to get my £110 back! My friend Igor readily agreed to take me in his car – he was as curious as I was to see what was going on.

It was a pretty drive to the airport on twisting country roads. The main *autoput* was closed with piles of sand and mechanical diggers. Ahead of us lay the towering bulk of the Julian Alps; the land to

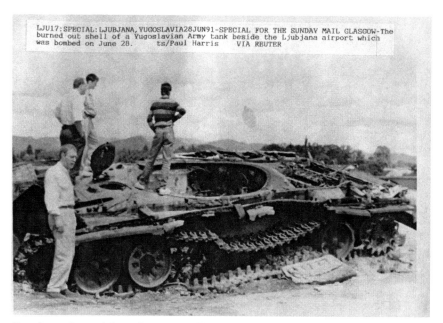

Just down the road from the airport a Yugoslav army tank had been destroyed by enthusiastic locals. On the left of the picture is Glasgow book dealer Cooper Hay, who had brought a £100,000 portfolio of Charles Rennie Mackintosh prints to Slovenia. He was wondering if he had done the right thing . . . This photograph was wired to the Sunday Mail newspaper in Scotland.

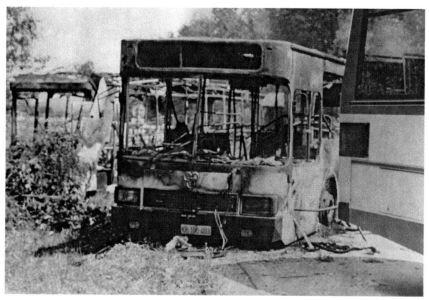

Burned out buses at Brnik Airport. They had been used by locals to block the road and then been destroyed by tank fire. This was one of a series of photographs I sold to the Reuters news agency

11

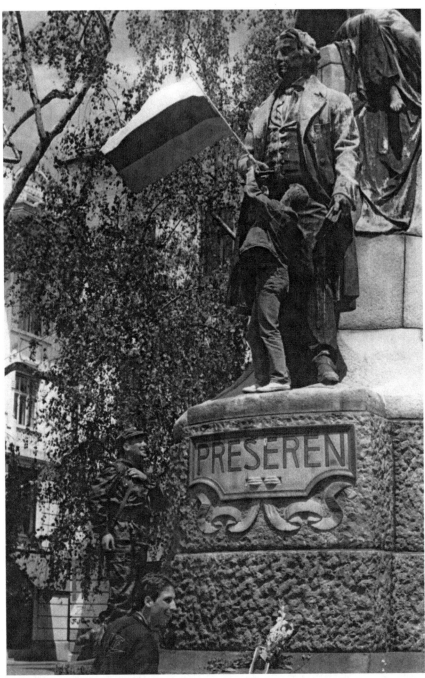

Slovenia is independent. A few days after the unilateral declaration of independence from the Yugoslav federation, on June 30 1991, a youth named Mateusz Korosec scaled the monument of national hero France Preseren and planted a flag in the bronzed hand. I was roaming the deserted streets with my camera and caught the moment.

either side was lush and green, dotted with rustic wooden hayracks and onion-domed churches. At 1015 or so, on the approach to the airport, two ageing Yugoslav air force Super Galeb fighter jets swooped down. The single pass attack was indiscriminate but devastating. They raked hangars, car parks and tarmac with 23mm. machine-cannon and rockets damaging an almost new Airbus A-230, two Dash 7s and a DC-9.

Forced to abandon the car at a rough and ready checkpoint mounted by farmers with pitchforks and blue-overalled workers from some local factory, we marched up a wooded road to the airport buildings. The rustics at the checkpoint were not happy about us going down the road: they averred that a poison gas attack was imminent. I also would soon learn that war sparks incredible rumours which spread like brushfire.

At the airport, all was strangely quiet in the aftermath of the attack: the attack from the air had happened with great speed and was over in seconds leaving behind an eerie vacuum. The airport turned out to be deserted except for a group of firemen who were dousing a line of cars - including a brand new Mercedes and BMW - in the car park.

There was nobody about to impede the curious and we wandered at will around the airport, glass crunching under our feet. It was a strange experience. An airport is normally one of the most intensely policed of places but we were able to poke our noses in anywhere that took our fancy. Police and military jeeps lay where they had evidently been abandoned; doors wide open and keys still in the ignition. Of the occupants there was no sign. It would turn out that most of them had literally taken to the woods.

The steel structure of the hangar building was torn and twisted. In the Adria hangar we climbed aboard a damaged Airbus A-230. This was the aircraft due to fly me to London at 1030. Now its roof is drilled with an extraordinarily neat row of holes through which it is possible to peer out, through the gaping holes in the hangar roof, to the blue sky beyond. I pick up a small piece of the fuselage of the Airbus: ten years later it still sits in my office: a trophy of my first war. The oxygen masks, released automatically in the pall of smoke and dust, dangled down uselessly in the cabin. Airport firemen on the tarmac were busy dousing a fire on the wing of a Dash-7.

At the airport hospital, the medical superintendent held aloft a shell-casing from a 23mm. machine-cannon. At least he seems to know that he is on the cusp of great events. "Here," he announces with a disturbing certainty in his voice, "is the bullet that started the Third World War." Suitably impressed, I take a photograph.

As we left the airport, the world's press was arriving. A customised jeep in army camouflage and with wire grilles over all the windows roared up. I breathed a sense of relief when I saw the Vienna registration. There were two journalists in the front. "Where's all the action?" one excitedly inquired. We directed them to the Adria hangar. We politely declined a proffered lift. Good move as it turned out.

As they roared off a Czech TV crew left at speed in the opposite direction. "They're coming back! They're coming back! Take cover!" We ran for the forest. The Austrians drove out onto the runway.

Leaving the airport, I stopped to hurriedly photograph the wrecks of smoking buses destroyed by Federal tanks. Just at that moment, there was automatic fire from the forest beside us and a missile was fired from somewhere out of the trees at the Austrian jeep now cruising on the runway. The missile found its mark and an enormous shaft of flame shot into the sky.

The two journalists I had just spoken to would be the first of more than 100 to die in the wars in Yugoslavia. They were Austrians and their paramilitary-style jeep was hit by a tank ground-to-ground missile. In this instance, I am afraid to say, Nick Vogel and Norbert Werner must bear much of the responsibility for their own demise. Their camouflaged jeep had all the appearance of a military vehicle: it had fooled us and it certainly misled the Yugoslav army as well. Driving out onto the runway in full view of the JNA forces was at best foolhardy and at worst downright provocative: probably just about as provocative as the time Vogel had exploded firecrackers in a crowd in Northern Ireland. He got great pictures. He also got put in jail and deported. An Austrian Airlines stewardess who was Vogel's girlfriend told me later that he had a death wish: if that was indeed true then his wish was indeed granted in extraordinarily dramatic fashion.

Fleeing the scene, there was a disabled tank at the side road. It appears that locals from the nearby village had most effectively

Slovenes were soon celebrating. Within weeks the independence of the country had been confirmed at an EU-brokered peace conference on the Adriatic island of Brioni.. Here Slovene youths, dressed in their Yugoslav army uniforms, celebrate on the streets of the capital, Ljubljana.

For a while I mixed export consultancy with journalism. I am pictured here (left) with President Milan Kucan of Slovenia (front) and a group of potential investors I brought from London. Far right is Igor Potocnik, then sales director of printers Gorenjski Tisk. We would travel together extensively around the war zones of Yugoslavia.

disposed of it. After a day of phoney war, that Friday saw the start of Slovenia's fight for survival.

At the same time as Brnik was attacked, the vast road block we had encountered at Medvedjek was attacked from the air; traffic on the Hungarian border was under attack at Sentilj and border posts were falling to Federal Special Forces helicoptered in over the barricades of trucks and vehicles.

Cooper Hay left Ljubljana that afternoon, without his priceless prints, on a sealed diplomatic train organised by the Austrian Ambassador. But he would get them back from me by a circuitous route involving more airport closures and tanks a couple of weeks later.

At the Reuters bureau in the Holiday Inn Hotel in Ljubljana I cut a deal. Although they were under pressure, they agreed to transmit my airport pictures, which I sold over the 'phone to my friend Ken Laird, deputy editor of *The Sunday Mail* in Glasgow, if I would give them some images of the burned out buses at the airport.

Sending pictures in those days was tedious in the extreme: a captioned print had to be strapped on to a revolving metal drum which would go round for 20 minutes to send a black and white picture; a full forty minutes for a colour one. Any break in the connection and you started all over again . . . of course, these days you can send a photograph by email in minutes, if not seconds in low resolution. But in 1991 it would still be years before the arrival of email and digital photography. Indeed, mobile phones did not even work in Yugoslavia in those days

There were, as yet, very few journalists in Yugoslavia. The world was really taken unawares by the outbreak of war in Europe. Apart from the chaps from the *Daily Mail* who had come out on the same 'plane, there were no Brits around. So I made some calls. Frank Hurley, news editor at the *Sunday Mail* earnestly counseled me, "We hear it's getting dangerous there. Stay with the other journalists, Paul." Good advice, but there weren't exactly many around at that stage.

Soon I was doing radio reports for BBC Scotland and my account of the airport attack also made the BBC Nine O'Clock TV News. I hadn't counted on that. Back in Edinburgh, my then wife was watching the news and didn't have a notion what I was up to. It came as a bit of a shock, apparently. (When I ultimately

got back to Scotland after unsuccessfully trying to get back via Ljubljana and Zagreb airports she had decided to go her own way. It came as something of a surprise; we were divorced by the end of September).

In the lift coming down from the Reuters Bureau I bumped into Jim Clancy of CNN. They were the only major TV news network who had opted to cover Slovenian independence. A wise decision, as events had proved. CNN had come a long way since I first encountered them at the Cannes Television Festival in 1985. In the lobby of every major hotel there was this television station on all the screens . . . CNN. An all-day news station? Everybody, myself included, opined it would never work. People called it the Chicken Noodle Network. How wrong we were. Jim was convinced that there would be an early peace in Slovenia. "Nobody wants to fight," he averred. He was right but we both underestimated the capacity of the war to spread.

Slovenia's leaders ran a good war. Their strategy was pretty much impeccable, on and off the battlefield. President Milan Kucan came over as the measured, responsible leader: an uncle figure the country – and Europe - could rely upon. The BBC's Misha Glenny waxed lyrical, "Milan Kucan, exhausted from running a war, emerged from his BMW with the complexion of a wraith emerging from his subterranean den." It was difficult to be rude about him. On June 30, Kucan told the world's press at a press conference I attended, "This is David and Goliath – unarmed people against tanks." This made great copy at the time but was not entirely accurate.

Truth to tell, tiny 'defenceless' Slovenia was the only one of the Yugoslav republics to go to war against Belgrade fully prepared. Defence Minister Janez Jansa, a young and personable erstwhile journalist, who had, back in 1988, revealed details in the local student and satirical magazine *Mladina* of the government's plans to crush Slovenia, was in charge. He had been imprisoned for revealing Belgrade's plans but now he was, in a remarkable turnaround, to oversee the defeat of the Federal forces. He had been a martyr at the time, now he was the main man.

He told me later that the details of the attack by Federal troops were revealed to him six weeks before independence. Thousands of

young Slovenes made their way to secret arms dumps and bunkers in the woods and mountains, donned their new camouflage uniforms and took up arms. For many months a recently inaugurated Adria Airways Ljubljana – Singapore service had been flying almost empty of passengers. But the cargo hold out of Singapore was full of weapons, uniforms and munitions.

The most significant weapon in the Slovene arsenal would turn out to be the Singapore-manufactured single-use rocket launcher. The *armbrust*, as it was known locally, literally broke the fibre of the Federal armour. A young soldier, lately a factory worker, explained to me, "An idiot could use this. As you long as you get close enough, you just point it at a tank and it finds the target automatically. Then you throw it away and run off." Within 48 hours the Yugoslav Army's tanks were confined to their bases.

Slovene soldiers surrounded the army's bases and barracks. A stand-off developed. The eyes of the world were on Slovenia and the wily Slovene politicians successfully faced down Belgrade. On the Sunday morning, we were told of an ultimatum to the Slovenes to give up their independence or for the capital to be bombed at 0900 in the morning. The air raid sirens wailed and people went down into the air raid shelters – except the British journalists, of course. They stood in the middle of the road in the main drag, staring hopefully upwards, shielding their eyes from the sun. There was no attack. Indeed, Belgrade never even issued the threat. It was another piece of clever stage management by the Slovenes.

That morning, as I passed through the main square, a young boy climbed the statue of the country's national hero, poet France Preseren. In the shadow of the salmon pink Franciscan church which dominates Preseren Trg he placed the new flag of Slovenia in the hand of Preseren. Not an awful lot of countries have a clerk turned poet as a national hero: he was also reputedly a lecher and a drunkard. He wrote the country's national anthem *Zdravljica*, which translated means 'Cheers'. It's a drinking song, really.

Within a couple of weeks an EU-sponsored peace agreement would be signed on the island of Brioni in the Adriatic. Flags were rarely seen in Slovenia thereafter. I often reflect that display of flags is in inverse proportion to political maturity.

The successful Slovene breakaway engendered some resentment elsewhere in Yugoslavia. In Bosnia, six months later, my driver's

new Slovene money was confiscated by indignant Serb police. In neighbouring Croatia, a schoolteacher friend, Mirjana Dosen, opined, "Well, those Slovenes are very *clever*" She left the rest of the sentence hanging meaningfully in the air. The Slovenes had engineered their exit from the Yugoslav Federation with consummate skill: a ten day war with 66 dead, some of them Turkish lorry drivers or Austrian journalists. Not a bad result. Rather less than the body count on a really bad weekend in the US.

Some people still believe that by forcing the issue of independence the Slovenes made the break-up of Yugoslavia inevitable and that *ergo* they should bear the blame. Rather, Slovenia was the catalyst which prompted the collapse of an already crumbling structure. But soon, nowhere in former Yugoslavia, did anybody care any longer about the Slovenes. Truth to tell, the Slovenes also took remarkably little interest in the successive wars in Croatia, Bosnia and Kosovo. They had better things to do.

Today, Ljubljana is polished, scrubbed, restored and on its best behaviour; prosperous, self confident – arrogant even. If you were trying to be rude you might dub it 'Little Austria'. The pavement cafes fill in the morning and never empty for the rest of the day. A meal in a good restaurant will be impeccably presented and cost you as much as in London or Vienna. The heroic monuments of Tito's time are gone. The Austro-Hungarian baroque, the central European *jugendstil* and the post-modernism of Slovenia's own inspired architect, Joze Plecnik, are all restored and make a clear statement about Ljubljana's view of itself as a significant European capital. Membership of the EU and the Euro zone have arrived. Even Presidency of the EU was achieved in 2008. The Slovenes have successfully accomplished their transformation from Balkan bandits to fully paid-up members of the Europe in which they feel they rightfully belong. The Slovenes are great democrats although, for such a tiny country, it has spawned a mass of political parties, continually dividing and re-forming. But they are tolerant and phlegmatic. They don't even seem to mind the fact that most foreigners don't have a clue where Slovenia is located; that it is all too frequently confused with Slovakia or Slavonia. And my driver from the days of the war now runs a business turning over more than $60 million a year...

Just a very few people dissent from the attainment of this nirvana. A writer for *Mladina* observed shortly before independence. "The only thing that ever made Slovenia interesting was its place in Yugoslavia. Now that is going, this promises to be one of the most boring places in Europe."

Not for me, though. As I stood at the airport that day in the aftermath of the attack by the Super Galeb, I realised that my days as an export consultant in Yugoslavia might be limited. A career change beckoned and had arrived dramatically and unexpectedly. I mused that my monthly cheque, due in three days time, would not arrive. It did not.

A few hours later, Reuters news agency were transmitting my photographs around the world. The world of journalism beckoned.

These days, Slovenia is dynamic and prosperous. The scene at a pavement café on the main square of the capital. Behind is the statue of the national hero France Preseren where I took the picture of the raising of the flag of independence.

Two

An Unsuitable Profession

I've always seemed to live several lives in parallel.

Not quite on the scale of Dr Jekyll and Mr Hyde but there's been a good bit of necessary dodging and weaving. You may not find very much, or anything, in these pages about the Paul Harris you thought you knew: publisher, disc jockey, discotheque proprietor, restaurateur, hotel manager, printing and publishing consultant, art dealer, book collector, writer on art, books, food and drink. This essentially is the tale of something more than a decade in journalism traveling the world, and a few associated activities, some murkier than others.

I'd always wanted to be a journalist. I can remember exactly what inspired this bizarre deep inner-longing. Around the age of ten, I was the yearly recipient every Christmas of *The Daily Mail Boys' Annual*. This quasi-literary offering was eagerly anticipated and voraciously devoured. In one particular issue there was an article about the desperately exciting work of a journalist, illustrated with a drawing of a determined looking fellow in long raincoat and pork pie hat clutching the blower in one of Gilbert Scott's red telephone boxes (I knew all about him as there'd been an article in a previous edition). His breathless prose was clearly breaking news of some great event to waiting millions.

This seemed to me a suitably exciting and stimulating calling, chasing fire engines and police cars, presumably with the licence to break speed limits and other tedious regulations, and with ample opportunity to prise the truth from reluctant mouths.

When I announced this sudden vocational call at breakfast it was clearly not a popular decision. My mother opined that journalists were not really Very Nice People, like us. I wondered by which magical process *The Daily Mail* made its way onto our breakfast table every morning. However, journalists were clearly viewed as seedy reprobates, something not unrelated to drinking habits, apparently. I had no knowledge of that sort of thing at that time; only later would it serve to increase the allure of what was equally clearly not exactly a profession for gentlemen.

There were, however, a couple of early indications of some nascent journalistic talent. At the age of 14, in August 1963, I was strolling the quays of Aberdeen Harbour with my father's 35mm. Kokak Retinette camera ready to hand when there was a promising cry of despair followed by a great splash in the water. The resulting image of an unfortunate crane-man floundering in the waters of the harbour made the front page of the Aberdeen *Press & Journal* newspaper the next morning, under the gratifying headline 'Elgin Lad's Front Page Shot'. A few weeks later, a surprise cheque for 35 shillings appeared in the post, which was even more encouraging.

My sixth year at Elgin Academy, in the northeast of Scotland, provided an opportunity to meddle in the school magazine. Together with a fellow pupil, Harry Wilken, I cooked up a scheme to interview a character who was deeply disapproved of at the time, one Ian Smith, Prime Minister of Rhodesia. Rhodesia had made a Unilateral Declaration of Independence in 1965 and was under sanctions and censure from the entire international community. Of course, there was no way we could get there. So we simply, somewhat optimistically, fired off a list of questions in an Air Mail letter to Salisbury. Rather to our astonishment, an official letter came back a few weeks later answering all our questions.

We were, in local parlance, 'fair scunnered'. We published our 'exclusive interview' in the 1966 *School Magazine*, sandwiched between a poem entitled 'The Meeting of Evils in Macbeth' and a picture of the Senior Girls' Hockey Team. Once the magazine was safely away at the printers and production was virtually complete we repaired to a Gilbert Scott telephone box and made a reverse charge call to *The Daily Telegraph* in London. I announced to the news desk that two schoolboys had got an exclusive interview with the Prime Minister of Rhodesia.

This seemed to occasion some excitement in far-off Fleet Street. It got a page lead in the Torygraph a few days later. We also proudly divulged that we were 'leading members' of the local Young Conservatives. When the article was published in the *Telegraph* it produced an angry riposte from Conservative Party HQ in London's Smith Square asking the local Tory office to ensure that the younger chaps up there toed the party line in future.

One of the gracious Prime Minister's answers caused a furore. 'Like the youth of Scotland, the Rhodesians are fighters,' quoth

ies switch to Goodwood

RACK HUNT
IE WEASEL'

● *A striking picture taken yesterday by fifteen-year-old Paul Harris, 20 Hamilton Drive, Elgin. Paul, who is holidaying in Aberdeen, got this front-page shot when craneman Bert Fraser tumbled into the harbour at Blaikie's Quay. Bert was quickly hauled aboard a trawler.*

ELGIN LAD'S

FRONT-PAGE

SHOT . . .

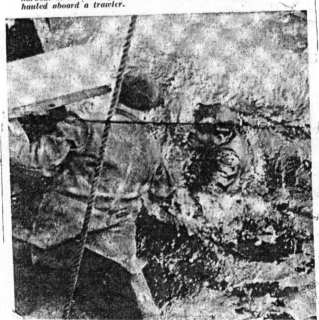

My first published photograph on the front page of the Aberdeen Press & Journal, August 24 1963, was taken of a craneman who had fallen into Aberdeen Harbour. To my surprise, I was paid 37s 6d. (nearly £2) for the picture.

the PM, 'and they will fight for the rights and the basic freedoms of humanity. I am pleased to see that the Rhodesians have won their biggest fight, the fight for independence, but I doubt if the people of Scotland have won their fight yet.' Cue Alex Salmond. This was construed by some, including the solidly left-of-centre teaching staff, as constituting an open invitation to insurrection, in the days when the SNP was still a dangerous revolutionary body on a par with the IRA. We were not popular; except, that is, among the denizens of the press who gathered outside the school gate at 4p.m., notebooks in hand.

A university education in politics and international relations in Aberdeen would serve to lead me seriously astray. Journalism might have been regarded as a safe home in comparison to the lifestyle choice which emerged.

My life has been made up of a series of all-consuming passions. Once an interest developed, it quickly became a passion. It might be replaced several years later by something quite new and different but, for the time being, it would be the focus of all my energies.

An interest in shortwave radio had developed after a cousin gave me a former RAF Bomber Command radio set (type R1224A according to the polished brass plate on the front of the case). Its blue wooden box sported a variety of intriguing dials and knobs on the fascia and mastery of these proved to be the key to a new world waiting to be discovered: commercial radio stations, restricted maritime and military transmissions, and amateur 'ham' radio broadcasts from around the world. In a coved upstairs attic room I spent hours late into the night scanning the airwaves, listening-in and noting wavelengths for future use. This must have seemed a harmless exercise to my parents downstairs but it was, in reality, here that my skills as a journalist, intelligence gatherer and investigator were honed. Radio Moscow, HCJB 'The Voice of the Andes', Radio Free Europe and Radio Tirana might have seemed harmless enough propaganda stations, the sort which flourished on the short wave spectrum in those days before the advent of satellite broadcasting and the internet. But in those days, in the 1960s, virtually all top secret and military communications were passed over the HF short wave bands. I was soon learning how to decode secret military SSB (single-sideband transmissions), the

morse code, and intercepting messages from missionaries in the Congo, UN troops and distress calls from ships at sea.

I even won second prize in a national competition for a new slogan for Roberts radios at the age of fifteen. I came up with 'The World at your Fingertips with a Roberts Radio.' It was derived directly from what I was personally up to.

However, the devious ulterior purpose of some of the international propaganda broadcasters was shockingly revealed to me on the Association of Teachers of Russian school trip to Russia in 1965. Ahead of the trip, I dispatched a letter to Radio Moscow's English department advising them of my imminent arrival. To my astonishment, they wrote back and urged me to come and see them. After a few boring days with my school chums at the Intourist Hotel, I 'phoned the comrades over at Radio Moscow.

The Radio Moscow people were all very charming, Kim Philby types. Far back British accents and quaint political observations drawn directly from Marx and Lenin. Even at 16 years of age I could discern that. They asked me if I would give an interview commenting upon my experiences in Russia. Being a cooperative sort, I gladly agreed. I expounded at length on Russia and the communist experiment and was pretty pleased with the result. It seemed my lengthy contribution was destined to be treated with all due importance. After the broadcast came another pleasant surprise.

"Now please come to the cash room." This was an unexpected turn of events, indeed. It had never occurred to me for a moment that I might be paid for my youthful words of wisdom.

Down at the barred cash room in the deep-most bowels of Radio Moscow I was handed a brown envelope (my first ever) and asked to sign a receipt. When I opened it up, I was stunned to see that it contained the equivalent of £50 sterling: the equivalent of more than a year's pocket money, and almost what I had paid to go on the trip.

Can joy be so unconcealed? Well, I soon discovered that Russian roubles were completely non-negotiable and could not be exported under any circumstances from The People's heaven that was the USSR. What on earth to spend this fortune on? To cut a long story short, vodka seemed to me to be a great investment. It cost virtually nothing and I was more than happy to fund a

stupendous party in our hotel rooms. My last enduring memory was of prostrate bodies everywhere, schoolgirls with their party dresses pulled up, spotty youths honking into the toilets and, the only survivors, our genial bus drivers slugging vodka from the neck of the bottle as they cuddled the prettier members of the party.

Somebody informed on us and we were all paraded at 0700 hours in the yard of the Intourist Hotel for Scottish country dancing. Worse still, when we got back to Scotland the whole matter was paraded before Moray & Nairn District Council Education Committee. Guess who was blamed?

However, I couldn't care less. I was now an international broadcaster. A week later I was glued to Radio Moscow as the short wave signal alternately faded and grew in strength. The introduction was flattering. I was an expert commentator, apparently. The content was not quite what I expected.

I had given what I regarded as a well-balanced view of life in Moscow. Good and bad presented in an even handed manner. Of course, all the negative, or even slightly critical, comment had been left on the cutting room floor. My brilliant interview was one long paeon of praise for Russia and the communist system.

A temporary setback. No matter. A new radio passion had taken over.

I can recall quite clearly first tuning into what was then a truly innovative phenomenon in radio. It was a Sunday morning in the spring of 1964 and *The Observer* newspaper had a story on the front page about test transmissions from a so-called 'pirate' radio ship called Radio Caroline anchored somewhere off the Thames estuary. Portable transistor radios were, in those days, still a relatively new arrival on the consumer goods shelves and they lacked the power and sensitivity to receive such weak signals. True enough, I could not receive Radio Caroline from my home in the north of Scotland on a transistor radio but, being the radio *afficionado* that I was, I connected the RAF communications receiver to a 120 foot-long wire antenna in the garden below. I worked out the length of aerial required to form a full wavelength and switched on . . . I was not altogether sure why at the time, but I felt a very distinct thrill of excitement as I tuned the dial and heard, loud and clear for the very first time, 'Good morning, this is Caroline on 199. Your all day music station'.

A 1964 photograph taken by the Elgin newspaper The Northern Scot. I am sitting in front of a 1940s military communications receiver, type AR88-D. It was then still a state of the art piece of equipment, which cost me £28 secondhand, capable of receiving transmissions from all over the world on most of the wavelengths then known to man. Here I developed early skills in eavesdropping.

An early and successful venture was in the business of mobile discotheques which were all the rage in the Sixties. Eventually, the equipment was all sold off to the pirate radio ship Capital Radio. Some lady friends agreed to pose for this 1968 publicity picture.

At the beginning of the 21st century it's difficult to comprehend what a world virtually without popular music radio was like. At the beginning of the 1960s, most of the time there was no pop music at all to be heard on the airwaves. Indeed, some of the time there was no music of any type at all. In the UK, the airwaves were then the exclusive and unquestioned prerogative of the British Broadcasting Corporation (BBC) which still strictly operated under the Reithian principles imposed by its *eminence grise* in the 1920s and 30s. The rights of musicians and composers were 'protected' by so-called needle time agreements which severely restricted the amount of recorded music played on the radio. The most popular records, or discs, were then 'covered' by live bands playing vaguely ludicrous imitations of the real thing. There was no local radio at all, apart from Manx Radio which operated as a result of the peculiar constitutional status of the Isle of Man. There was no Radio One. There was, of course, the BBC Light Programme.

Of a Sunday afternoon, Light Programme announcer Alan Freeman ("Hi there, pop pickers") presented *Pick of the Pops* which was regarded as the treat of the week with a couple of hours of authentic recorded popular music. A good ten minutes before the programme was broadcast, the family radiogram (1960s terminology for a combined radio and record player) was warmed up and tuned in. Usually, we recorded the programme for later delectation using a bizarre tape recording machine which fitted over the record deck and was driven by the motor of the record player. Apart from the odd disc played on lunchtime shows, that was your lot so far as pop music radio from the UK went.

There was, of course, Radio Luxembourg which broadcast from the Grand Duchy of the same name with its transmitters located far away in a distant foreign land. The signal you might receive reflected this. Luxembourg did not come on the air in English until seven in the evening and although the signal on 208 metres medium wave did improve as darkness fell, it was subject to many variables of weather, sun spot activity in the heavens, and the time of year. Inevitably, as your favourite new disc was played the signal would fade so as to become virtually indistinct. Incredibly, millions of listeners put up with these travails to hear some decent new music.

The pirate radio ships arrived in a radio world bereft of any real choice in broadcasting; virtually bereft of pop music; and which

made no concessions whatsoever to popular culture or mass tastes. I guess that was why I felt so excited as I tuned into that first broadcast from Radio Caroline, the forerunner of a miniature fleet of radio ships which would anchor off the British coast over the period 1964-67. Short-lived in terms of time, nevertheless the pirate radio phenomenon would completely revolutionise broadcasting in Britain, directly leading to the creation of Radio One in 1967 and spawning the creation of BBC local radio, and then commercial radio. Today, when a licence to broadcast on the airwaves is relatively easy to acquire, and the Internet is available to all, it is difficult to recall the assumed all-encompassing rights of government to control all broadcasting.

And it was not just a matter of the pirate stations changing broadcasting for ever. Up until 1964, in the UK, culture and experience was dominated by middle class, middle of the road traditional values. These values were reflected nowhere so forcefully as at the BBC. The BBC endorsed, formalised and disseminated an ethos of subscription to such values in everything it broadcast from news to music. Subscription to alternative values was denied by the BBC's monopoly. The pirates would change that for ever, far beyond changing radio broadcasting. For millions of teenagers and other young people, all of a sudden *there was another way*. The definition of popular culture and access to freedom of expression was no longer the right of a privileged few. Pirate radio may have posed more questions than answers but it successfully challenged a whole series of assumed rights: rights to the airwaves, rights to hear the programmes of ones choice, rights to self-expression, and the right to question things which had never been up for discussion before.

I didn't realise at that moment in time how much pirate radio would influence my own life, as it did those of millions of youngsters in the Sixties. In the wake of offshore pirate radio, came a veritable revolution in music, dress, design, speech, human rights and attitudes. Of course, pirate radio cannot be scientifically linked to all this, and there were other influences at play. However, I do believe it was the catalyst in a much wider series of events.

Like tens of thousands of youngsters (the Free Radio Association, with which I was associated, had more than 100,000 members in 1967), I was passionate about the pirates, their product

and about the issues they had raised. In the 1960s, for the first time, young people were emerging into a new world where they might express themselves, dress themselves and become players in their own right.

My first book, *When Pirates Ruled the Waves*, was painstakingly written in longhand in my school holidays in the summers of 1966 and 1967. The London book publishing industry, reflecting as it did strong traditional values and attitudes, was incredibly snooty about the impeccably and, expensively, typed up manuscript I delivered. I approached no less than 32 publishers over a period of some seven or eight months. All turned the book down. The most common observation was there was 'no market' for such a book. Implicit in this was the feeling that young people would not buy books and that for older people this was a subject of absolutely no interest whatsoever.

With all the optimism and certainty of youth, I was convinced that these views were mistaken and that the publishers were all fools. But I was unsure about how to proceed until the last publisher I approached, Clive Bingley, wrote me a note inviting me to meet him at his office in London's Notting Hill Gate. Clive, now retired, was probably one of the shrewdest and most down to earth publishers in the UK during the 60s and 70s. In the early 70s, together with fellow publisher Lionel Leventhal, who was also enormously encouraging to me, he would start a book fair in London for small and specialist publishers (SPEX) which would, in time, grow into the massive and successful London Book Fair (which they would later sell for a vast sum of money to Reed Exhibitions).

Clive, direct as ever, sat behind his desk in his, to me, impressive book-lined office and told me, "I'm not going to publish your book . . . that's because I publish books on librarianship." I had not done my research properly. But he went on, "However, this is a good book and I believe it will sell. If you can't find a publisher to do it, then I shall help you to publish it yourself." Clive went on to give me a couple of informal seminars on how to publish a book. Within three or four hours, I had it all. Clive was dismissive of the mystique surrounding book publishing and he willingly shared all his knowledge of production, distributors, wholesalers, discounts and booksellers. It took no more time than Clive gave

me. So much for the mystique of publishing In the heady atmosphere of the 1960s, when so much suddenly seemed to be so possible, I never doubted my ability to publish the book and make it the success the traditional publishers sought to deny me.

I was studying politics and international relations at Aberdeen University in the far frozen north east of Scotland: the bit that juts out into the North Sea and catches the wind and spray driving down from Iceland and the Arctic Circle. My more studious endeavours were punctuated by my writing, editing the university newspaper, *Gaudie*, and running mobile discotheques around the campus.

Working on the university newspaper brought me into contact with the owner of the local Scotpix news agency, J Geddes Wood. I soon became Geddes's 'stringer' at the university, feeding stories and pictures to him for onward distribution to the national newspapers. On my first term at university, I was the photographer for the university newspaper. I was immediately recruited during Freshers' Week as soon as word got out that not only was I a keen photographer but that I possessed the necessary skills to develop and print my own photographs: I'd actually been at it since the tender age of eight when I was given my first camera, a Gevabox medium format sporting three exposure and two aperture settings. Chaps who could get it on in the darkroom were in great demand.

I introduced Page One Girls to the paper. Being the university paper's authorised photographer gave me *carte blanche* to stop and proposition the most beautiful girls on campus. I discovered at a relatively early age that apparently prim and proper girls are only too keen to take off their clothes for a photographer who has an apparently good reason for asking them to do so. And so a succession of beautiful women appeared on the front page of the paper attired in increasingly scanty clothing. The circulation of the paper inexplicably soared . . .

One evening I went to the University Union to cover the finals of the annual Beauty Competition, when the most cracking crumpet on campus would line up in bathing costumes and their best togs. Those days saw, as one might say, the last legs of the female beauty competition now regarded as politically incorrect. The winner was a girl called Jenny Hunt, the fragrant English rose type. Jenny happened to be the daughter of a famous father, Sir John Hunt,

conqueror of Everest. The pictures of her were pretty average: she wasn't happy about being photographed and she spent most of her time pulling down the hem of her above-the-knee skirt which was revealing the tops of her stockings and her suspenders.

A couple of days later there was a banging upon my door in the Hall of Residence at the unearthly hour of ten in the morning. This was my second encounter with Geddes Wood: I'd met him a few weeks previously on the site of the collapsed University Zoology building which had blown down in a gale. A police inspector was in the process of ejecting me from the scene and Geddes intervened assuring the law "he's with me."' I was grateful for this.

Geddes summoned me from my slumbers. "Let's get a coffee, we've got things to talk about, Paul."

Jenny Hunt had been the victim the night before of an attempted rape whilst walking home. The progeny of a famous, titled father, this was Big News. And only one person had pictures of her scooping the beauty crown the night before that. I produced the negs and Geddes produced the sales to *The Daily Mail* and *The Daily Express*, after painting out her stocking tops in the darkroom. The world wasn't ready for that sort of thing.

Over the next few years we would share a succession of 'scoops'. One of the biggest was provided by the Fraserburgh Lifeboat disaster at the end of January 1970. The Fraserburgh Lifeboat overturned in heavy seas 36 miles north of its home port: five of the crew died and just one survived, Jackson Buchan, who clung to the upturned hull, against all the odds, and was rescued by a Russian trawler. The story was all the more in the public interest because the previous Fraserburgh Lifeboat had also overturned back in 1953. We went up to cover the story and stayed with a seafaring relative of Geddes' in the coastal village of Findochty. We were by now regularly utilising my skills in scanning the airwaves for information we really shouldn't have had access to and, about 1 a.m., I intercepted a message on the UHF waveband from a Russian rescue boat which had recovered the Fraserburgh Lifeboat, overturned, with the bodies of four of her crew inside. But, over the airwaves, they refused to release it until they were paid salvage. This was an outrageous demand which would surely stir local sensitivities. We knew this was a big story, but it was too late to sell

it to that day's 'dailies' which had already gone to print. So Geddes got on the blower to the London *Evening Standard* and they readily agreed to pay us £500 for the story on an exclusive basis.

Down at Fraserburgh Harbour the next morning the journos were all gathered bemoaning the lack of movement on the story. Then, around 10 a.m., their editors were calling them in the local cafes and hotels asking why the hell they knew nothing about the *Standard's* front page 'splash' by Geddes Wood and Paul Harris . . . we were not popular.

Geddes Wood died suddenly in 2004. He was a great mentor for me in the business of journalism. He had seen it all, done it all and, his many critics in the business would allege, was a bit of a know-it-all. But I learned much from him and admired his freewheeling independent style. Fellow journalists tended to regard him as a bit of a *prima donna*: uncompromising to the point of inflexibility. He was always a man to stand on his rights. I remember him wagging his finger at a Chief Superintendent of police who had brusquely told him to move on from the front gate of the Queen's residence at Balmoral. "I would ask you to address me in a polite tone of voice. Besides, I am not moving on. This is not *your* roadway, it is Her Majesty the Queen's."

He had considerable ingenuity. One of his great coups was to build a miniature camera, when such things did not exist outside the spy movies, fit it into a pair of opera glasses and dispatch a young, unknown photographer, John Palmer, to Elgin Town Hall where 15 year-old Prince Charles was playing in the Gordonstoun School Orchestra. The resulting pictures went all over the world.

It was a full life – academe, discotheques, journalism, *et. al* – which suited me eminently well but I still had this unpublished manuscript on the pirates burning the proverbial hole in my subconscious.

I went to the university printers at the university where I was now in my second year studying politics and international relations, handed over the typescript and politely asked for 2,000 copies, please. I naively assumed that as the Aberdeen University Press it was virtually obliged to print my book for me. To my surprise, they got on with it.

In July 1968, 2,000 copies were duly delivered to the offices of the Free Radio Association (FRA) in Rayleigh, Essex, together

with a bill made out to me for £1,340, net 30 days. At that time, my sole source of income was a university grant of £360 a year so the bill pretty much equated to my total money income for the next four years.

By now, however, my research skills had been honed a little. The FRA, headed up by the immensely committed Geoffrey Pearl and his wife, June, offered the book to its 100,000 members and soon sold several hundred copies, cash in advance.

But it was a quarter-page advertisement on page three of the pop music weekly *Disc & Music Echo* which would really lift the project off the ground. Vast numbers of pirate radio 'nuts' read the paper as it covered developments on the scene in some detail. The journalist who wrote these pieces, David Hughes, told me in The Avenue pub on Shaftesbury Avenue, there were "thousands of pirate nutters out there" and "they'll all want your book". I wanted to believe it but wasn't really sure. How come those genteel folks in book-lined offices in Bloomsbury don't know about this, I wondered?

Of course, they knew nothing about the passionate nutters of Rayleigh, Essex, or Hartlepool, Tees-Side. Just as the simple folks out in the Styx had never heard of Bloomsbury. That was the Britain of the 1960s: vast social chasms, their borders reinforced by an unbreachable social divide.

I stuck the ad into the following Thursday's issue, with an accommodation address in west central London. It was the address of a literary agent friend, who had also professed to be unable to sell the book to a publisher. I didn't dare go into the office on Friday and delayed my visit until Monday lunchtime, not daring to hope I had any orders in response to the £35 advertisement . . . At the top floor offices of the agency in Southampton Row they were very put out. "Where have you been? Please take all this stuff away." The mail was stacked all over their office in bags, bundles and untidy heaps. The Post Office had made special deliveries to get rid of the mail from the sorting office. I opened some up and there, sure enough, were hundreds of orders at 37s 6d a time (just under two pounds in modern parlance). Most people, bewilderingly to me, had just popped cash in the envelopes. I emptied a few envelopes and went out and had a slap-up lunch.

Within a few more days all 2,000 copies had gone to the readers of *Disc & Music Echo*. News of this teenager's *success fou*

reached Fleet Street, with a little help from yours truly, and my success story was all the rage in the Sunday papers, with the lead in Mandrake in *The Sunday Telegraph*. This brought urgent demands from the largest wholesalers in the country, W H Smith (known to *Private Eye* readers as W H Smug) for me to fill their warehouses with books (they had ignored it before publication and declined to stock). I sat for mornings on end in shop windows in London's Charing Cross Road signing copies and escorted by beautiful, nubile girls from some long-forgotten pop group whose publicist, Jonathan Northam, wanted to ride on the back of my glittering success story. At nineteen years old, I was suddenly very rich, dining in the best eateries, escorted by tasty young women and living on the adrenalin of adulatory publicity. The 60s were indeed a spiffing time for some of us.

Of course, it could not last for ever . . . But it would last a good few years. *When Pirates Ruled the Waves* would go through four editions, selling 10,000 copies, between 1968 and 1970. I would soon be driving a Mercedes and owning a couple of discotheques and a publishing business whilst roaming in the groves of academe when the inclination might come to me. This was all very much a 60s success story. Youth was pre-eminent and cash was available in a way never experienced before.

The Beatles were, of course, the ultimate success story of the '60s. In the way one successful man seeks to meet others of like kind, I dropped in on the Apple Company's offices in Baker Street one morning and asked to speak to John Lennon. A secretary bird was about to shoo me away when John's Liverpool tones droned out from behind a half-shut door. "Let the guy in." I marched into John's office. I was impressed. He had two stunningly beautiful mini-skirted girls, one on each knee. One was white skinned and blonde; the other as black as the ace of spades (as we used to say in the '60s before political correctness came in) with long straightened black hair.

"What you got man?" was John's question. I suppose everybody who visited him wanted to sell him something. I already knew, however, what a great supporter he was of pirate radio and I whisked a copy of the first edition out of my bag. Balancing the girls delicately on his knees, he fanned the pages of my book. "Great, man. Great, man." Thus came John's considered verdict. Now to business. "How many you got, man?"

At this stage I made my first and possibly my greatest mistake in business. I assumed John was asking how many I had with me to sell him that day (in fact, he wanted to know how much I had in my entire stock so he could buy the lot). "Twenty, John," I responded. "We'll take them all, man," said John levering the black bird off his knee. "Go and get the petty cash, darling," John instructed her.

This was a bit of a surprise. Everybody else in London was asking for 30 days credit, and actually taking 90 to pay in those days. But Apple did business rather differently (in fact, it went bust shortly afterwards and one Saturday morning they gave everything away from their Baker Street shop). Anyway, my own business dealings with John Lennon were highly satisfactory.

I wasn't so successful handling things with David Bowie. A friend and late 1960s 'mover and shaker' Dick Fox Davies, active in the radio and music scene, introduced me to Bowie in a pub in Beckenham. Bowie was looking for a five hundred pound investment to build himself a recording studio in the basement of his flat nearby. In return I would get 10%, maybe 20%, of the Bowie action. "Look, David," I counselled him earnestly. "Just accept it. You've had your hit, *Space Odyssey*. But that's it. That sort of stuff has had its day." No cash for you mate.

Maybe my second great mistake in business. By now the mistakes are racking up at much the same rate as the successes. Shortly after the publication of *When Pirates Ruled the Waves* I took my new red Mercedes for a European peregrination. I visited Radio Luxembourg to look at a book project with them (non-starter) and then visited a Canadian living in The Netherlands called Timothy Thomasson who ran an outfit called the International Broadcasters Society (IBS). The reality was rather less grand then the name. The IBS was the creation of Thomasson and his wife, Berthe Beydals, run from a small upper-floor flat in the pleasant provincial town of Bussum. Our encounter in Bussum would lead, however, my own *entrée* to the world of pirate radio as a participant.

Out of our meeting, short-lived pirate radio ship Capital Radio would be born. Alas, business-wise this was not destined to be a great success. Within months of launch, the Liechtenstein-registered M V *King David* would be aground on the beach at Noordwijk, right in front of the Grand Hotel, and our hopes, and

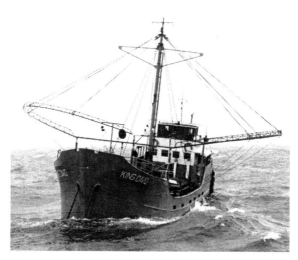

In 1969 we began preparations for the launch of Capital Radio which would be anchored off Ijmuiden, Holland. The radio ship was converted from an old Dutch coaster and started transmissions in June 1970 using a revolutionary ring antenna. This was much cheaper, and offered greater stability, than the tall aerial masts used by most of the 'pirate' ships. It also produced a remarkably good signal over the flat terrain of Holland and East Anglia. The aerial system was designed by the CIA and we copied it from documents found in the files of the BBC in London.

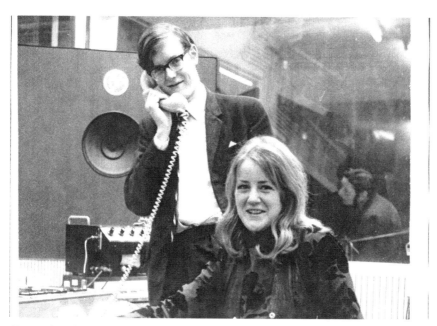

Pictured in the studio on board Capital Radio, August 1970.

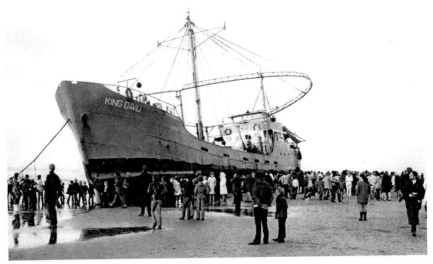

The Capital Radio ship's anchor chain was sawn through in November 1970 and it ended up aground on the Dutch coast at Noordwijk. After protracted salvage operations, the ship was impounded by the salvors and ended up being sold for scrap.

Yours truly pictured alongside Radio North Sea International in 1971. RNI had now become deeply involved in political activities and was associated with the East German Stasi intelligence service, which was building more floating radio stations in the Polish port of Gdansk. Documents which I supplied to MI6 fatally compromised the operation.

cash, were washed up on shore. The saga of Capital Radio, Radio Veronica and Radio North Sea International followed *When Pirates Ruled the Waves* in a separate book entitled *To Be a Pirate King*, which was published in book form in 1971. It was also serialised in the Dutch daily newspaper *De Telegraaf* in 1971.

The text of both books – *When Pirates Ruled the Waves* and *To Be a Pirate King* – were combined and re-published as *Broadcasting from the High Seas* in 1977. It was reprinted twice. *When Pirates Ruled the Waves* would ultimately be republished in 2007: extraordinarily, the 'nutters' would crawl out of the woodwork again and again to buy each new edition. The European pirate radio phenomenon died out, apart from various rebirths of Radio Caroline (reborn aboard the converted trawler *Ross Revenge* in 1983), and other stations like Radio Paradise (arrested by the Dutch authorities in 1981) and Laser 558 which took to the air in 1984 but which came and went amidst financial acrimony and chaos.

During the early 1970s the world of pirate radio ships crossed over dramatically with the world of espionage and Cold War rivalry, and this remains another, rather more curious, legacy of the pirate era. When I published *To Be a Pirate King*, *The Sunday Express* newspaper carried an article referring to my allegations about the activities of Radio North Sea International (RNI) and its owners, the two Swiss businessmen Erwin Meister and Edwin Bollier. A couple of days after the article, in the summer of 1971, a Special Branch officer appeared on my doorstep to make an appointment for me to meet 'someone'. "Who?" I asked, not unreasonably, I thought. "I'm not at liberty to disclose that information," advised Mr Plod.

A few days later, he returned with MI6's 'man in Scotland', retired Detective Chief Superintendent Warren of the Perth police force. Warren made it clear that he knew I had been running and investing in Capital Radio. Ergo, I was liable to prosecution under the Marine Broadcasting Offences Act (1967), which had outlawed all involvement in pirate radio by British citizens. However, these things could be overlooked ... I was invited to reveal what I knew about RNI and worked with MI6 on bringing their game to an end. The security services were specifically concerned with RNI's relations with the East German intelligence services; SIGINT (signals intelligence) equipment aboard the radio ship; and the

station's extraordinary participation in the previous British general election campaign. A patriot to the core, I rallied to the cause.

Bollier was allowed to continue with his espionage activities but would re-emerge dramatically on the international scene in the wake of the Lockerbie bombing of December 21 1988. That night, jumbo jet Pan Am 103 was blown up over the Scottish border town of Lockerbie killing all 259 passengers plus eleven people on the ground.

In 2001, two Libyan intelligence officers went on trial in a specially convened Scottish court at Camp Zeist in The Netherlands, charged with downing the jet. What was most interesting to me, however, was the testimony at the trial of my old 'friend'... Edwin Bollier. I read the reports of the Camp Zeist testimony of the man who admitted to manufacturing the timer of the Lockerbie bomb with a mounting sense of incredulity. The security services knew from my own evidence supplied to them back in 1971 that Bollier was, at that time, working with the East German intelligence services, the *stasi*. We all knew too well – seventeen years before he provided the prime constituent part of the Lockerbie bomb – that he was, in Bond parlance, a thoroughly bad egg. But this was not in the world of James Bond: it was in the harsh reality of the Cold War that unscrupulous businessmen men like Bollier, operating out of neutral Switzerland and with Swiss passports, could operate internationally with virtual impunity.

Edwin Bollier and his partner Erwin Meister were then in their early thirties and termed themselves 'radio engineers'. Their partnership gave birth to the Zurich company Mebo Telecommunications AG, registered on March 24 1971, which operates to this day and which was named in a Lockerbie warrant issued by the Lord Advocate of Scotland in November 1991.

They had first come to public attention at the beginning of 1970 when they launched their pirate radio ship onto international waters off the Dutch coast. How the Zurich radio repairmen who did a line in 'spy bug' transmitters came by the cash was then a mystery. Radio North Sea International was bigger, better and flashier than any other pirate. Aboard a Norwegian coaster converted into the radio ship *Mebo II* in a Hamburg shipyard, it came on the air on January 23 1970. Painted in brilliant psychedelic colours and

topped by a 50 metre high radio mast, it was, for me, a fascinating enigma from the start. Its conventional medium wave transmitter was more powerful than that of any other pirate radio ship, and most European national radio stations, and it also, surprisingly, broadcast on two short wave bands and on VHF. It was difficult to discern any commercial rationale behind the operation.

Controversy dogged the station. Its role in the June 1970 British General Election was extraordinary. It mounted a campaign against the then Labour Government, which lost the election, and was, in turn, jammed by the Post Office, a British naval radio station and the military.

By now I was writing for *Disc & Music Echo* in London on developments in European pirate radio and was also project manager for Capital Radio, anchored just a few miles away from RNI. I was able to infiltrate the Mebo office operation which was located in a suite in the Grand Hotel in Scheveningen on the Dutch coast. From the window of the office we could virtually see the three pirate ships – Caroline, Capital and RNI – impudently at anchor in a row, three miles offshore in international waters outside the jurisdiction of the Dutch authorities. Rather curiously, there was sometimes an out of area US Coastguard vessel to be seen anchored out there as well, and occasionally it actually anchored off our own Capital Radio vessel . . . that may or may not have been because we 'stole' the design for our unique ring broadcasting antenna from an experimental project developed by the CIA . . .

Meister and Bollier did not discuss their business with outsiders and were men of mystery with a well-polished public relations line. Bollier, with his psychedelic kipper ties and expensive Italian suits, was clearly the dominant partner although he left Meister to do most of the talking with people like me. When they talked between themselves they used *Schweizerdeutsch* which I found totally incomprehensible despite a reasonable grasp of 'normal' German. I became aware of shipments of radio transmitter parts to East Germany and discovered in the outgoing mail copies of airfreight waybills addressed to the 'Institut fur Technische Untersuchungen' in East Berlin. This equipment, of US origin, was being shipped by Mebo Telecommunications (then unregistered) of Zurich to East Berlin, via Amsterdam's Schiphol Airport. Such technology

exports were banned under Federal US law. The Institut was a wing of East German intelligence, the *Stasi*.

I spirited away the mail that looked interesting, steamed it open using a technique learned from *The Daily Mail Annual* as a schoolboy, photocopied it, popped it back in the post and laid the copies securely aside for my next trip back to the UK (no email in those days and fax was a relatively new introduction). Back there, usually in Aberdeen, I would be contacted by a Special Branch officer who would set up my meetings with the man from MI6. Hardly surprisingly, I was dealt with on a 'need to know' basis but from the extensive questioning and discussions it became quite clear that 'W' was particularly interested in the East German connection and the interference by the radio ship in the general election.

This was distinctly low grade intelligence work far removed from the glamorous world of Bond. But it was this sort of dull footwork which formed the bedrock of most intelligence operations in those days. I was never paid a penny for my miniscule part in winning the Cold War. Her Majesty's Postmaster General had secretly sworn a warrant for my arrest under the Marine Broadcasting Offences Act 1967 for my part in setting up Capital Radio. I was simply granted immunity from prosecution as was one of my colleagues, Scottish radio engineer aboard Capital, Ewan Macpherson, a friend from university days who had kept our discotheques running. He later learned about the arrest warrants when he applied for a job in defence electronics in California and the CIA produced the skeleton from the closet.

However, evidence soon emerged that the activities of European and American intelligence agencies had borne fruit. On July 8 1971 the Dutch newspaper *De Telegraaf* published a leaked report from the CIA. It revealed that ten pirate radio ships, based on the Radio North Sea operation, were under construction in the Polish port of Gdansk, later to be the birthplace of the Solidarity movement under its leader Lech Walensa, itself to benefit from CIA funding. The programme was under the direction of the Institut fur Technische Untersuchungen. This was believed to be a Cold War riposte to the US-backed operation of the landbased propaganda stations Radio Free Europe and Radio Liberty. It was also likely that such vessels would incorporate a SIGINT (signals

intelligence) capability, which was also a feature of the North Sea operation. Publication of the report effectively compromised the whole operation and work on the ships ceased shortly afterwards.

In May 1971, Radio North Sea had been bombed by frogmen who attached plastic explosives to the hull. Rival Radio Veronica was blamed and owner Bul Verweij went to prison. But in reality it was a botched job by the BVD (Dutch Secret Service) who, doubtless, had carried out the operation on behalf of the CIA, who were already in receipt of the intelligence from Gdansk and my own input shared with them by MI6. Meantime, my own pirate ship, Capital Radio, had been cut adrift on the night of November 5 1970 and had ended up on the beach at Noordwijk – embarrassingly right in front of the Grand Hotel. However, it was at least convenient to be able to sit in the Grand with a drink and observe the long drawn out salvage operations on the ship. The crew and radio operators were rescued by the Noordwijk lifeboat. The Dutch Wijsmuller salvage company spent almost a week salvaging the ship but it turned out to be a somewhat pointless exercise: when the insurance company declined to pay up Wijsmuller arrested the ship and it would eventually be sold for scrap for just two or three thousand pounds, effectively flushing more than £100,000 down the drain.

Radio North Sea International was closed by Dutch government legislation in August 1974. In January 1977 it sailed from Rotterdam for Libya.

As the ship sailed, a photograph of Bollier's new patron, Colonel Ghadaffi, was pasted up in the studio. The ship was sold to Ghadaffi and used to broadcast the Koran. One day, Ghadaffi tired of his plaything, or maybe it had no use for him any longer. A Libyan air force jet fighter strafed the *Mebo II* and sent it to the bottom of the Mediterranean Sea, where it still lies.

But the Bollier saga was far from over. The Swiss business relationship with Ghadaffi was one which would flourish for ten years: right up to the fateful night of December 21 1988 when Flight Pan Am 103 would crash in flames onto the town of Lockerbie. That may not have been predictable. But might it have been preventable? I have always believed so. The world's intelligence community knew all about Edwin Bollier. I knew,

from personal experience, that, at least, MI6, the CIA and the Dutch BVD had actively investigated him more than ten years previously. The enduring question must be why his activities were tolerated over the years.

My own best guess is that following the evidence that he was so closely involved with the East German intelligence services, and the intensive CIA preventative activity around the projected series of radio ships, Bollier was 'turned' by the CIA and became *their* man. It was then a logical act to rein him in during the late 1980s and require him to falsely testify about supplying the timer for the Lockerbie bomb to those persons the US was determined to indict and find guilty of the crime.

Absolutely critical to the successful prosecution of the so-called Libyan 'agent', Abdel Baset al-Megrahi, were two elements: the evidence of Edwin Bollier to the effect that his company supplied the timer for the Lockerbie bomb and the 'discovery' of a fragment of circuit board at the Lockerbie site. This fragment was 'miraculously' discovered several weeks after the disaster, several miles from Lockerbie, by the CIA. It would be more than a year before the same CIA would come forward, allegedly matching the fragment to timers made by Mebo of Zurich and suggesting to the Scottish prosecutors the Mebo-Libya link.

Scottish investigators, guided by the CIA, would then make their way to Malta and gather some highly dubious identification evidence from a Sliema shopkeeper there, linking al-Megrahi to the purchase of clothing, found in the suitcase that had held the bomb and discovered at the crash site. Mr Tony Gauci, the shopkeeper and owner of the Mary's House store, was, significantly, described by chief prosecutor Lord Fraser in several newspaper articles in 2005 as "not the full shilling", the implication being that he was gullible and open to suggestion. Over the years, his accounts of the purchase by an Arab gentleman have varied widely: al-Megrahi was not the only party he identified, wrongly, and his memory could well have been prompted by being shown photographs by investigators.

The Lockerbie investigation was driven, if not run, by the CIA. Twenty years after the Lockerbie bombing, Lord Fraser of Carmyllie, the Scottish Lord Advocate who was in ultimate charge of the investigation into the mass murder, was asked, in

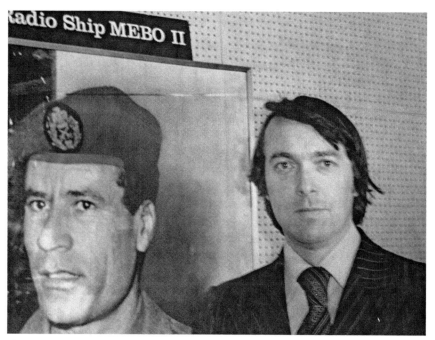

On January 2 1977 the Radio North Sea International ship left Rotterdam harbour with its owner, the Swiss Edwin Bollier, on board. The destination was Libya, where the ship was sold to Colonel Gadaffi. I investigated Bollier for MI6. In 1988, he would supply the timer for the Lockerbie bomb to the Libyans, according to evidence laid before the court in The Netherlands which found a Libyan intelligence officer culpable. In my view, that trial raised more questions than answers.

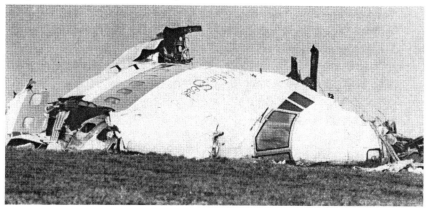

The wrecked cockpit of Pan Am flight 103 which was blown up over the Scottish border town of Lockerbie on the evening of December 21 1988. A total of 270 people died, including 11 in the town. Although the Libyans were fixed upon by British and US intelligence as being responsible, I was not convinced. Britain's MI6 knew years before from my own information about the involvement of the man alleged to have produced the timer.

retrospect, for his views on the case. They were published in *The Times* of London on December 19 2008.

Asked if the CIA could have planted the timer for the bomb, manufactured by Mebo, he observed, "I don't know. No one came to me and said, 'Now we can go for the Libyans', it was never as straightforward as that. *The CIA was extremely subtle.*" But, pressed for his own view, he compared the case to the notorious one against Scottish criminal Paddy Meehan, where the Crown case was 'improved' by the planting of evidence. He added, "If there was one witness I was not happy about, it was Mr Bollier, who was deeply unreliable."

There is little doubt in my mind that the Libyans did *not* carry out the Lockerbie bombing but, rather, that it was carried out by the Palestinian terror group PFLP-GC, based in Damascus, acting upon Iranian instructions in response to the 1988 downing of an Iranian airliner by the USS *Vincennes*. It was a simple matter of revenge. There are adequate open sources to support this contention and, for the first 18 months of the investigation, this was the view of Scottish detectives working on the case. Amongst other evidence, just a couple of weeks before the Pan Am explosion, German police had captured a Palestinian group after a bomb attack in Berlin: it was in possession of Toshiba cassettes adapted as bombs, identical to those, the fragments of which, were also found on the ground after the Lockerbie bombing, immediately subsequent to the event This was far more convincing evidence than that later produced by Bollier and the CIA.

In the climate of 1990, as these developments in the investigation were taking place, it was politically inconvenient to lay the blame for the Lockerbie bombing at the door of either Iran or Syria. They were vital allies around the time of the first Gulf War. However, it was politically very convenient to have the Libyans own up to the crime, to bring them back into the international fold so that their vast oil resources might be developed. This is what happened. The Libyans got their investment in their oil infrastructure, much of it coming from the US, and the Syrian/Iranian conspiracy was let off the hook. The deal would later go sour, at least as far as the Libyans were concerned, when Washington failed to come up with its side of the bargain. Specifically, it failed to open a US Embassy

in Tripoli and to complete full recognition of the Ghadaffi regime. But the matter was now closed from the US point of view.

Bollier's use, so far as the intelligence services are concerned, has been exhausted for ever and he has retired into obscurity. He will never be used again and is simply an intriguing footnote in history. But I will always think of him as an unsatisfactory footnote with insufficient attribution.

In the context of pirate radio, I suppose RNI was as an indicator of what could have developed on the high seas if the development of pirate ships had remained untrammelled and unscrupulous operators and intelligence agencies had been allowed to move in.

Romance, adventurism and drama always seemed inextricably linked with the saga of the pirate radio ships. You might say these elements went with the territory – and the people who made it their own. Whether it derived from the romance of the rusty old ships themselves, the nascent power of broadcasting over its listeners, the emotive power of music, or simply the notion of boldly going where others fear to go, the story of the pirate radio ships around European coasts remains a compelling and fascinating tale. Although made illegal by virtually every government in Europe, the pirates did relatively little harm whilst bringing enjoyment to vast numbers of people, and more than a little fulfillment to those intrepid modern buccaneers who were involved.

Radio Moscow and the 'pirates' had introduced me to the world of radio and, in a modest way, to that of journalism. During the 70s I continued writing and some publishing. Although you don't realize it at the time, youth presents the best opportunities. You tend not to recognize your own real talents. One day in July 1977 a bright young journalist from *The Scotsman* came to do an interview. Julie Davidson wrote a polished and, I assume, incisive, feature which described me in almost lyrical terms, 'the silhouette of a fashion model . . . a side-burned Botticelli cherub: complexion lucid as the Flower Honesty, eyes wide as a gasp of innocence. He looks like the lamb rather than the lion . . .' One of my neighbours observed, "Have you been giving her one, or what?"

It would, however, be a long time before full time journalism would present itself as a real career option, and that's what this book is really about.

There are plenty of excellent and worthy tomes dealing with the serious business of reporting other people's wars and disasters. The moral dilemma of the journalist cast adrift on tides of outrageous fortune have been dealt with more than competently elsewhere - from Phillip Knightley's *The First Casualty* through John Pilger's *Heroes* to Martin Bell's *In Harm's Way*.

The armchair adventurer of bloodthirsty mien might be directed towards Michael Herr's *Dispatches*, the more literary-inclined reader to veteran writer Martha Gellhorn or the brilliant Ryzsard Kapucsinski. These are actually my personal favourites. I am not seeking to compete with them.

These days I often find myself speaking to a roomful of people about my experiences. The locations in the last few years are about as varied as might be imagined: a ladies' social circle in a Scottish village; a Rotary Club at dusk on the east coast of Sri Lanka in a town controlled after dark by terrorists; a gathering of senior NATO intelligence officers; a Washington convention with 3,000 lunchers clanking their cutlery, coffee cups and jewellery; a Cunard liner on the high seas packed to the gunnels with multi-millionaires. All these very different audiences - batty old dears, beleagured businessmen, politicos and the not so idle rich - are essentially interested in the same things.

They ask questions which are, let us say, rather personal. *Do you earn a lot of money for what you do?* Most audiences clearly think I do and evidence utter disbelief when I deny it vehemently. *What do you eat in a war zone and where do you stay?* One from the ladies who clearly think I need feeding up. *Don't you get frightened?* Of course I do, but I don't admit it. *Where do you buy photographic film/ aspirins/ plasters/beer/spark plugs in a war zone?* These are not such daft questions as they might appear. And there is always a bolder chap who will eagerly ask the one that would really have got the audience on the edge of its seat. Except he always asks it at the bar afterwards. *I suppose you pull a lot of women in your business?*

There is an awful lot of minutiae in these pages: the day to day stuff about working as a journalist which doesn't tend to make it into more worthy accounts. A friend was a mite disparaging about the title of this book, *More Thrills than Skills*. He suggested that it was unnecessarily self-deprecating. Maybe so. I'm not the one to

judge. But the successful journalist in the unfriendly environment of a war zone requires, first and foremost, a very real taste for excitement. Then, as a colleague once observed, a capacity for rat-like cunning will serve him well. As for the rest, you'll learn the skills on the job.

I did. This is how.

Three

Baptism of Fire

Croatia 1991

I used to congratulate myself that I wasn't naive enough to expect war to be like a John Wayne movie. In reality, I discovered it was.

At least in the beginning it was. For a few brief days in September 1991 I found myself in a supporting role, if not exactly a major player, in a bizarre black farce enacted in eastern Croatia in those early days of the Yugoslav wars. That same sort of mixture of tragedy and humour must have been in mind for Mark Twain when he observed, "The secret source of humour itself is not joy but sorrow."

The Press Centre for the war in Croatia in those days was in the plush and rather incongruous surroundings of the capital Zagreb's modern, 4-star Intercontinental Hotel. On a good day, it was but a short and convenient drive from the front. At the end of September '91 you could drive to the frontline near the village of Pokupsko in less than thirty minutes, do your story, and be back for a beer in the bar by lunchtime.

Of a morning, journalists milled about questioning the bright and earnest young men and women; most were émigré Croatians who had come back from places like Australia, Canada and America and were making their English language skills and enthusiastic commitment available to their nascent independent homeland. Croatia, a land of some three and a half million now warring souls, had, of course, been lumped into the Yugoslav federation imposed by the Treaty of Versailles in 1919. Slovenes, Croats, Serbs, Bosnians, Kosovars and Macedonians all found themselves thrown into the same melting pot; a pot which would turn into a cauldron in the early 1990s. One man had held it all together since the end of the Second World War – Marshall Tito: a man of perception, commitment and utter ruthlessness. He succeeded in imposing his will on his fractious peoples, fully recognising

their propensity to divisiveness. Ten years after his death, though, the whole fragile body politic would fall apart. In June 1991, the Slovenes in the very north of Yugoslavia waved goodbye to the federation. After a brief 10-day war, the EU brokered a peace and by implication recognised the secession. The writing was on the wall for the rest of the federation. Within fifteen years there would be an agglomeration of pocket states where Belgrade once ruled supreme: Slovenia, Croatia, Bosnia Herzegovina, Republika Srpska, Serbia, Montenegro, Kosovo and Macedonia.

Unlike Slovenia, Croatia was cursed with two warring ethnic groups: Christian Orthodox Serbs who looked to Belgrade for inspiration and leadership and the larger Catholic Croat population which relished the prospect of independence. In the spring of 1991, ominous unpleasantness had started in areas where there were significant Serb minorities: particularly in the area known as Krajina, to the south of Zagreb, and in the east of the country along the border with Serbia. This 'unpleasantness' would, in short order, lead to what would become known as 'ethnic cleansing' as Serbs and Croats staked their claims to areas in which they were in the ethnic majority. All war is unpleasant, of course, but one in which neighbour turns on neighbour, virtually overnight, exhibits a particularly uncompromising and vicious mentality.

War had come suddenly and largely unexpectedly to this part of the Balkans. Few of us were experts at that time, but journalists, who may be obliged to travel in any one year to half a dozen or more war zones, learn fast. There is a certain familiarisation pattern based around press centres, accreditation, bars, hotels and restaurants. The first journalists to appear in a new war zone generally set the pace, or the standards, depending on how you look at it, and identify the most amenable places to gather. In Zagreb, an up and coming European capital, there was a good deal of choice in the matter but the Intercontinental Hotel, by virtue of its hosting the International Press Centre, was very much the centre of events in those early days. The pressmen planned their days at the front or, for those with possibly more sense, at the twice daily press conferences and in the bar. There tended to be a bizarre holiday atmosphere as guides and interpreters were arranged. "Hey, Miroslav, it's your lucky day - you've drawn CNN today!" Miroslav doesn't look over

the moon about his assignment. Possibly because the CNN crews were soon known as the highest risk takers in a war which, just in the first ten weeks, had claimed the lives of twelve journalists, with two more missing without trace.

There's no interpreter for me today. This is bad news. Although I was prepared to take the odd risk or two, one personal rule I then had was not to travel without a native speaking Croatian. So it looked like a day with the scavengers of the press pack at the conferences and watering holes. But, lo, Sherry sweeps in.

Now some American lady journalists really do look like movie stars and Sherry from remote Iowa was no exception. She might have been from the backwoods but you'd never have guessed it. Manicured, designer-dressed, dripping with jewels, painstakingly made up (warpainted?) and bubblingly effervescent, she cut a dazzling swathe through the scruffy, jean-clad film crew girls. I always talk to Americans. Lacking all that tedious European reserve, the rapport tends to get going quickly and you know where you are rather more rapidly.

And, guess what? Sherry actually speaks Croatian by some fortuitous accident of birth. We two were obviously made for each other and I'm really looking forward to a cosy day out. Then the bad news. She's actually travelling with someone else and, with a degree of trepidation, I agree to a threesome.

Fortunately, Judy is not the incredible hulk I feared. Rather, a mixture of Marilyn Monroe and Barbie Doll. She's a complete flake. Which is not what you would exactly expect from your actual Professor of Journalism at the University of Texas here to write an intellectual analysis of journalists under fire. As she goes off to spend half an hour in the "bathroom" to engage the mascara I do wonder if she is going to be a bit of a liability, but dismiss the uncharitable thought from my mind.

I knew from Croatian TV there'd been a lot of fighting at the town of Pakrac, normally just a couple of hours drive from Zagreb, and it sounded a reasonable destination for a day out with a picnic. As *Rolling Stone* writer and foreign correspondent P J O'Rourke put it so eloquently in *Holidays in Hell*, "I just figured what with guns going off and things blowing up, there'd be plenty of deep truths and penetrating insights."

Your local 'friendly' Chetnik. A picture of the archetypal Serbian soldier which I took on Christmas Day, 1992, in the village of Turbe, on the frontline between Serb and Muslim forces in Central Bosnia. I went up there with the British army's Cheshire Regiment, commanded by Col. Bob Stewart.

Christmas Eve 1991. I snapped this picture in a smart bar in Zagreb, the Croatian capital.

Driving into the besieged town of Pakrac, September 1991. The defending Croats were surrounded by Serbs. We are being waved through by a local fighter called Daniel. Note the bullet hole in the car windscreen.

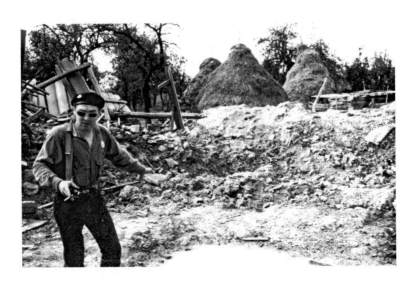

Daniel points out the crater where once his house stood in Pakrac.

So, we're roaring down the completely deserted Zagreb to Belgrade motorway in Mr Hertz's Rentacar when we hit the first major crisis.

"Paul, I need to visit the bathroom!" comes the plaintive cry from Judy in the back. Sherry observes drily, "How does it feel to be out for the day with your two older sisters?" I desist from comment. I don't have any sisters. And, anyway, I'm older than the girls. But I'm altogether too gallant to brag about my youthful exterior.

A few kilometres down the road in the town of Kutina, where you could already hear the dull crump of distant, heavy shelling, the bathroom brigade decamp into a bemused stranger's house and I visit the local police headquarters. Now, I'm getting quite good at this.

"Offizeer," you shout imperiously. The British are very good at that sort of thing. It's very important in war situations to speak to organ grinders and not the monkeys. When he appears you produce every bit of paper you have: passport, press card, driving licence, National Library of Scotland reading room ticket, and so on. He can't read any of this stuff, most likely. There are two words, though, I have found every soldier in every war zone understands and which invariably wreaths the most cheerless military face with smiles.

"BBC, Lonndon" I announce in the manner formerly used when reading the News in Slow English for Foreigners. Now, I don't know what the BBC in London might actually think about my taking their name in vain throughout the battle zones but, believe you me, it's the best way to actually achieve anything.

The commandant produces his battle map of the area when I ask about the way to Pakrac. Disturbingly large areas are marked 'Chetnik' – reputedly they're not exactly friendly, have big beards and carry knives in their teeth - but he starts to draw a somewhat complicated route. Now I'm the chap who can't cope with a railway timetable, never mind wend my way through this lot. However, I do have a tried and tested softly, softly strategy which has worked for me without fail. Village by village, I work my way to the front line stopping at every bar. That way, you will always find out *exactly* what is going on.

As we leave, Sherry asks some sort of question in Croatian which I don't understand. Just in case she's asking for the local bathroom map, I don't pursue things. Just down the road we pass

- going the other way - the Worldwide Television News (WTN) film crew. I wave them down. Somewhat disconcertingly, they simply urge us, "Go back, go back. You can't get to Pakrac". Now, that sort of defeatist talk is not the way to cover a war . . .

So we press on to the next - shell-shattered - village of Gaj. Unpromising stuff. All the houses are either boarded up or there are gaping holes in walls and roof, The windows of the local shop are blown out and you can simply walk in where the plate glass once was and help yourself. The shelves are fully stocked. Enquiries at a small but well patronised bar reveal there is allegedly one route open to Pakrac and we press on - after finding the obligatory bathroom.

An hour later and we are driving round this forest on dirt roads which would be fine for tractors - even tanks. We are, of course, completely lost. There are a lot of tree trunks laid deliberately across roads and so there's a good bit of reversing and enough ten point turns on the narrow tracks to get me through the advanced driving test. I casually ask Sherry about her query to the commandant back in Kutina.

"I just asked him what were our chances of getting through to Pakrac."

"What did he say?"

"Fifty, fifty," she cheerily reports.

Retracing our steps, we come face to face with a convoy of half a dozen cars: spray-painted for camouflage and with their windows shot out, weaponry protrudes from every orifice. I recognise a guy from the bar and he makes the sort of offer you can't refuse.

"All around in these woods are Chetniks. If they catch you, kill you and play with the women. You come with us to Pakrac."

And so we commenced a bizarre progress to relieve embattled Pakrac. Our gleaming white VW Golf car in the middle of the convoy - I declined a kind offer on behalf of the Hertz Corporation to spray paint same in green camouflage colours - we set out on an odyssey from village to village, collecting men, guns and cars as we went. At every village the form was reassuringly the same: a sort of party by motorcade. There is much backslapping, laughing and joking, uncertain camaraderie and mutual demonstration of weaponry, which looked as if it had been hurriedly dug out from

attics and barns. Some of this hardware might have passed as the latest thing in Chicago in the 1930s but it doesn't look to me to be up to the task in hand.

Invariably, there were beers and then a bottle of home made *slivovich* would be handed around from mouth to mouth by way of a fraternal rite. It would have been churlish to refuse.

The girls were obviously making a big hit with the guys and everything was getting rather macho. I recall, a trifle disturbingly, the words of the aforementioned Mr O'Rourke, who was a great, if misleading, influence upon me at that time, "It will always be more fun to carry a gun around in the hills and sleep with ideology-addled college girls than to spend life behind a water buffalo or rotting in a slum." I am a bit alarmed about Judy's tendency to observe in English how young these guys are and then address them as "Bambino". This they don't seem to appreciate and in view of their assorted weaponry, I find it somewhat tactless. But it's becoming increasingly clear that the girls are my *laissez passer* and I keep my mouth shut and my opinions to myself.

At one bar, a grinning, moustachioed character asks me to hold out my hand. Thinking it might be another beer, I stretch it out to find a grenade clamped in my palm. I just hold on, pushing the pin in, grinning furiously, until the beer is finished. Much amusement all round.

Meantime, Judy discovers she has run out of film. She asks if I will lend her some. This was always my least favourite request in a war zone. The film you lent was invariably what you will need later in the day. When I declined, she looked distinctly put out and asks where the shops are. I tell her, somewhat brusquely, and in an evidently unappreciated attempt at humour, that it's Sunday and the shops are, of course, closed. Heavy artillery explodes resonantly in the background.

By the time we reached a small village - Prekopakrac - on the outskirts of our destination, let's say I was really feeling quite brave about things. That was rather fortunate because it was under constant bombardment. I abandoned the girls when they went to the bathroom and was taken in a fast, bullet-scarred car down into the town. I tried not to think too hard about the bullet hole in the windscreen, directly in my line of vision, the shattered glass spreading out in great tentacles over the field of view.

Down in Pakrac there was an awful lot of the grim reality of war around. Nothing had prepared me for the scene of senseless and utter devastation in a town which had then been under attack from the Yugoslav army and Chetnik irregulars for twenty days. Some buildings had totally disappeared into enormous craters caused by heavy artillery; others were pockmarked and holed by machine cannon or rocket attack from the air. All the time there was the sharp 'crack' of sniper attack. Not only was the town surrounded by the Yugoslav federal army who were shelling it, but the Serb guerrillas were actually inside it; an invisible enemy holed up in flats and shell-shattered buildings and literally shooting at anything that moved.

More disturbing even was the information gleefully imparted to me by my guide that many of the snipers were Yugoslav Federal Army special forces: crack shots with high power rifles. He handed me a vicious-looking bullet of Czech manufacture. Narrow and very pointed, it thickened out disturbingly at the back end - or whatever you call it. This agent of destruction doesn't just enter the body at one point and pass cleanly through on the other side, leaving a nice neat hole. The hole may be neat enough at the front, but as it spins its way through flesh and bone it tears away a great chunk of the body as it emerges on the other side.

I stuck this nasty little agent of unpleasant death into a hidden pocket of the fisherman's jacket I was wearing. This I would regret later. It was not received well at London's Heathrow airport the following week when the X-ray scanner picked it up. I've still got the receipt from Special Branch somewhere.

There were few defensive positions remaining for the Croat defenders. We went to one in a modern flat block on the outskirts of the town. Surrounding blocks were, unpromisingly, shattered by what appeared to be aerial attack. We ran from the car into the block where several flats were still occupied. Not by the normal quota of domestic residents but, almost exclusively, by what appeared to be a mixture of soldiers in a hotch-potch of imaginatively created uniforms, and civilian enthusiasts, all bearing an extraordinary range of weaponry. I was shown the technique of moving about the rooms and stairs: close to walls, at the backs of rooms and at the double past windows and through open areas. There was a

distinct air of unreality. Like we were preparing for a movie shoot rather than a shoot out.

We sat down in a curtained room for the usual beer with brandy chaser. A body lay behind the sofa a few yards from where we drank. It was very still. I wasn't sure whether it was dead or dead drunk and didn't feel inclined to find out. The talk was all of when the EEC or the UN would come in to relieve the siege. I found it impossible to disillusion these embattled and dedicated men trying desperately to defend their homes. I was embarrassed by their touching faith in the toothless lion of the EEC.

Another hair-raising drive then followed to the centre of military operations at the police station. Whilst I was at the police headquarters a deafening barrage started. I had never been under that sort of sustained attack before. It was the coping with the noise which seemed to take over all the senses. Not just the noise of exploding shells all around but, as the Croatians returned fire from the basement with automatic weapons, the deafening confusion of sound was like an anaesthetic which denied all senses. I couldn't actually see the enemy but I assumed - at the time - that the frenzied defenders could as they unloaded their magazines. In retrospect, I realised they couldn't . . .

In a lull in the fighting we ran a zigzag course back to the car punctuated by a mortar round which, thankfully, only showered us with no more than dust and debris but quite did for the borrowed BBC tape recorder I was carrying. We left Pakrac at speed. Despite the rain of bullets, mortars and general unpleasantness, incredibly it seemed to me, we were still alive. All the fire - the snipers excepted - seemed to be totally indiscriminate and I mused that most people were probably killed 'accidentally'. I ruminated on the statistical chances of death in this war. Were you more likely to be killed by accident in this disorganised multi-fronted war than in one of the more regimented variety? Without doubt, I did, that day, take risks that later I would never have taken.

Back in Prekopakrac, the girls had been having a whale of a time. They had been fed, watered and generally entertained royally by the local soldiery. Empty bottles and pitchers of wine littered a table in a barn. An inquiry from Judy about the nearest shop selling photographic film - I wouldn't have had the nerve - had,

Black humour in the border town of Turanj, just outside Karlovac, Croatia.

Christmas Day 1991 in Turanj, Croatia, and I am captured off guard, slugging a quick whisky by Scottish photographer, Paul Hackett. He joked at the time that he had just taken 'the classic' war correspondent picture. It's still my favourite.

incredibly, produced within a matter of minutes a whole box of films salvaged from the ruins of some local emporium. One of the fighters simply took Judy down to a local shop, kicked in the window and wandered around sweeping the goods from the shelves until he found a stock of celluloid. I wasn't really too sure about associating with looters.

My travelling companions seemed to have taken a shine to the notion of staying overnight. The local head Rambo has announced we could stay at his aunt's house. I was none too keen. Even less keen when we arrived at a farmhouse in the middle of nowhere with no welcoming old auntie in evidence. The girls seemed captivated by the rural solitude. Captives they certainly would be, I reckoned. After all, a chap fighting in the frontline, laying his life on the line, is likely to think it pretty unreasonable of a woman who fails to lay herself down by way of thanks for a spot of hospitality and a drop of *slivovich*. The girls were utterly appalled at my cynicism about the motives of the "bambinos".

The journey back to Zagreb was largely uneventful. Except, ten kilometres up the road, Judy discovered she'd left her mascara in the "bathroom" at Prekopakrac. I declined to go back. Then it really did get unpleasant.

Three weeks later I was doing my couch potato thing back home in Scotland. As I flicked idly from channel to channel, I caught the News at Ten on ITV and some immortal words to the effect that there now followed an exclusive report from the Croatian town of Pakrac. "Besieged for two months, an ITN crew was the first to reach Pakrac as it was relieved by Croatian National Guard . . ." Now, I could have sworn that those were some of the same guys we passed going in the opposite direction.

Croatia, and specifically the town of Pakrac, provided my introduction to the shooting war. Slovenia had really only been a warm-up. Six months after the conflict in Yugoslavia started, I would find myself in Slavonia, on the eastern front, and then in Karlovac for Christmas. It was my first 'festive season' at war, in Croatia on the border with the breakaway Serb region of Krajina, which first brought home the savage realities of conflict. Christmas in a war zone is always particularly poignant and I had never before experienced the unique sensation of observing life and death at close

quarters at the time of Christian celebration. For me, Christmas in Croatia brought the challenge to try and convey to people at home back in Scotland what was being endured in former Yugoslavia. I was personally moved by what I saw and the real challenge was to find an adequate form of words. My writing on the bitterness of Christmas in Croatia was published in *Scotland on Sunday* and *The Scotsman*. It had a freshness and an honesty, a sense of revelation and personal discovery that I would be unable to retain for much longer. Everything was so new and terrible. This was what I wrote in December of 1991 in my article 'Christmas in Croatia'.

It is the season of goodwill to all men and a small Christmas tree illuminates the bleak corridor outside the mortuary at Djakovo Hospital, just a few kilometres from Croatia's eastern front. The bodies of the three Croatian National Guardsmen were brought in around midday on stretchers and laid out in the white-tiled room for postmortem. Still dressed in their dark green camouflage uniforms, their features were frozen at the moment of death. The yellowed pallor and the staring expressions - of seeming disbelief at their fate - lent them the appearance of skilfully executed waxworks. But waxworks they were not. Brutal execution was what had cut short their lives but a few hours previously.

Their features aged in death, these three young men were just 23, 25 and 28 years old. They had all lived in the same village of Sodolovci; they had all been friends and they had all joined up together three months ago to protect their village from the Serbian irregulars, the Chetniks who had started to infiltrate the area. With the fall of Vukovar last month, the front line gradually edged nearer and nearer to their village and now the front line fighting is all around: reaching the beleagured towns of nearby Vinkovci and Osijek.

Last night the three had set off from their village on a night patrol. When they had not returned by dawn, search parties were sent out. Villagers combing the woods discovered their bodies in a shallow grave. It was evident they had been shot but the full horror of their death was only to become apparent with the postmortem.

Their commanding officer arrived. Solidly built, self assured, you could sense he was a leader of men. No time was wasted, he had done this before. Deftly, he emptied the pockets; useful items of equipment were retrieved for future use; documents and papers laid aside. Then the bodies were stripped. This was heavy work.

A quick restorative beer in a Croatian café on the frontline

Rigor mortis had set in and the bodies had to be cumbersomely manhandled by the officer and two young female doctors.

Soon the manner of their death became apparent. All had been shot: many times in both arms but these wounds were not the cause of death. Their bodies had been cut with knives and then two had been finished off with knife wounds to the heart. The third had died when his head was battered and crushed, possibly with a rifle butt.

Dr Shelko Milic, head of surgery at Djakovo Hospital, was in no doubt about the sequence of the night's events. "These men were taken prisoner. Some of the wounds may have come in the fight but they were shot in the arms later, tortured and then killed."

The door to the mortuary was opened to let in the cold fresh air and to dispel the rising stench. Every so often, the young girls would go out into the fresh air in their bloodied white overalls, wipe their brows, gulp down the clean air, and then return to their bloody work.

The soldiers and doctors standing around the door are transfixed by the horror. Nobody notices a little old man making his way to the open door. He looks old - very old. Old enough to have seen three of these wars. His face is deeply wrinkled and weatherbeaten - the face of a man who worked his life on the land. His jacket - probably his best - is a couple of sizes too big and flaps around. Too late the soldiers see him but he is too quick for them. Lowering his head, he weaves between them like a hare in flight and then is at the mortuary door peering in at a vision of hell. There is silence for a brief moment as he takes in the scene and then a desperate, piercing wail. "*Mou sin. Mou sin.*" My son, my son.

Led gently from the mortuary, he breaks free from the soldiers and, clutching his head in his hands, he runs to and fro, hither and thither, wailing piteously. Tears are now running in rivulets down those aged wrinkles on his face. He is inconsolable. All attempts at comfort are shrugged away.

Other relatives arrive. One young wife collapses at the door of the mortuary and is carried away by two soldiers. The doctors carry on with their gruesome work. And, all the while, the old man continues his anguished dash around the mortuary building.

Half an hour or so later, I prepare to leave. The doctors are wiping the blood from the walls of the mortuary. Dr Milic sucks pensively on a gold cigarette holder. "Yes, I am a professional

and I have seen this before. But it is still very difficult for me." There are tears in the eyes of a soldier standing at the door. The commanding officer makes unrepeatable observations about the Chetniks. And the old man continues his anguished progress in a frenzy of personal despair, repeating over and over again, in frenzied disbelief those same two words. *"Mou sin. Mou sin."*

. . . In the silences between the singing and the prayers you could hear outside the impatient chatter of machine gun fire, the explosion of mortars and the dull crump of heavy artillery. The singing was loud and passionate, as if in direct defiance of the incessant reminder of the horrors being enacted outside the Franciscan Church of the Holy Trinity in the town of Karlovac. This was the reality of a mist-laden, drizzly Christmas Day in Croatia.

The assembled worshippers must, superficially at least, have resembled any congregation elsewhere in Europe that Christmas morning. Sprucely turned out children, their cheeks made red in the sub-zero temperatures outside; peasant women and widows in black; townswomen in their furs and hats; old men in their best suits. But, as you looked around that packed church a few minutes before morning mass was due to begin, there were no young men, few fathers and certainly no men of military age. Then, just as the service was about to begin, men in uniform filtered in through the congregation. They came in twos and threes until the church was packed. There they stood crowded into the nave in their green camouflage uniforms, heads bowed and hands crossed respectfully. Here and there were the German-made dark brown uniforms of the 110th Brigade which included the foreigners who have come to fight here and Serbs who have elected to stay and fight with the Croatians. And, in stark contrast, conspicuous in its pristine white, was the uniform of a solitary EC monitor.

At the end of the nave, where you would normally have been able to see the ornamental stained glass in all its glory, sandbags were piled to the roof. The frontline is only a couple of kilometres from this 17th century church with its painted frescoes, finely wrought pews and its prized black Madonna. The 80,000 inhabitants of Karlovac have been under daily bombardment since September 15. Whether or not by Divine intervention, this beautiful church has thus far been spared but all those gathered there must have been aware of its fragility, its awful vulnerability in the face of devastating modern weapons of war.

Even for an outsider, essentially uninvolved in the day to day

traumas of this war torn community, the service was a deeply moving experience. Prayers for Croatia, prayers for their own community, prayers for the soldiers, prayers for the bereaved and prayers for the dead. Even a prayer for the journalists killed in the war. And for the EC monitors.

Some of the women cried. But, as I looked around, it was clear that most of the soft, gentle sobbing was coming from the soldiers. From the men in uniform, none of whom could have been soldiers for any more than six months, and who had seen so much in such a short time. I had only once before seen the faces of men like that before - two days previously at that mortuary in Djkakovo. And I knew why these men were crying.

Christmas lunch had not been on the menu when we set out that morning but it rather unexpectedly appeared when we pitched up at military headquarters in Karlovac to collect our escort to the frontline. In the mess, soup, chicken and vegetables, salad and cake, were all washed down with an excellent Dalmatian wine.

A couple of kilometres up the road in the village of Turanj, just across the river from Karlovac, they were also lunching - and fighting - when we arrived in the afternoon. A couple of tank crews, clearly expecting not to do any business that day, were singing noisily in the kitchen of a farmhouse, an empty bottle of Kentucky whisky on the table. In a stone barn across the road a hot Christmas meal was being delivered to the couple of dozen or so soldiers billeted there.

I had last been in Turanj in the middle of September and had sat outside on the terrace of a neat cafe in the warm autumn sunshine. That same cafe - like all the buildings around - was now totally devastated: its roof blown in, its interior gutted by fire, the outside pockmarked by bullets and the striped awnings hanging down in shreds. It now boasted a rough and ready sign. 'Hotel California'. This village was now the killing ground with just two or three hundred metres dividing the protagonists. Nobody now lived in this once prosperous village which had once been full of people who went to work in the textile factories and engineering works of Karlovac. Within sight of Turanj - on a better day than that of Christmas Day 1991 - is the Jugoturbina works. In June it employed 10,000 people. That day, after three months of wilful damage, there were just 200 workers.

There is a heavy, damp mist. This we are glad of. It cuts down the sniper activity and observers can't call in the mortars. The mud lies thick and glutinous and we pick our way gingerly through

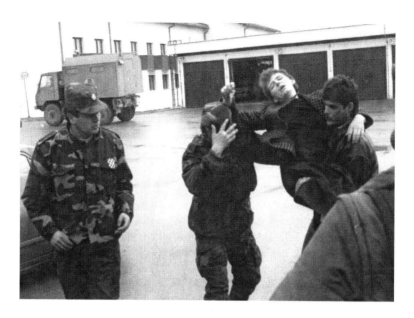

Christmas Eve 1991 outside the mortuary in Djakovo. This young woman has just seen the body of her husband who was tortured and executed by the Serbs.

The church in Karlovac, Christmas 1991. Sandbags have been piled up in front of the stained glass windows and Christmas tree lights twinkle merrily amidst a background of shellfire.

mud, shrapnel, shell casings and the assorted detritus of war. A shell lands noisily a couple of hundred yards or so up the road, setting light to a once neat, whitewashed house. We take cover in the barn where Christmas dinner is being devoured. The soldiers sleep here in shifts before moving up the road to do battle. In the corner is a Christmas tree complete with decoration and lights - the only light in the room - next to a radio operator intercepting morse messages in the gloom.

One of their number has been killed a few hours previously in the yard outside by a mortar bomb and they have just finished burying him. Nevertheless, morale seems remarkably good. Or, at least, there is much bravado about. A young soldier approaches and touches my arm.

As I look into his eyes I know that I am looking into the face of a deeply troubled man. Jadranko is 21. He speaks perfect English - and he desperately wants to talk. Conscripted into the army just a few weeks previously, he had finished three years of a five year course in shipbuilding engineering. "I know I must fight for Croatia. But really I want to learn. To live." I recognise that he is looking for some reassurance from me; that he instinctively feels I will understand his unhappiness and fear. But our talk is interrupted by the guffaws of his fellows who are, I realise, poking fun at him. The commanding officer waves me away from him, lest I become contaminated. Jadranko slinks away into the darkness of a corner, retreating into his own misery: the weakest animal in the pack.

Christmas Day brings Turanj its own footnote in the history books. The very last convoy of Federal troops to retreat from Croatian territory under the supervision of EC monitors leaves here mid-afternoon to cross over into Bosnia, just three kilometres down the road. This rearguard is made of the mine disposal team and their equipment from Pleso barracks, near Zagreb. They remained behind to try and clear the mines from around the barracks. The problem was they laid the mines without charting them and so three of their number had died trying to locate them in the frosty ground of winter.

Passing the convoy through the lines turns out to be a tricky operation. Although only a few hundred metres separate the two sides, communication is currently only being conducted through the barrel of a gun. My respect for the EC efforts improves dramatically when the white jeep with its blue insignia simply drives up the road into the mist, its klaxon hooting noisily. It

comes under fire and after a couple of minutes turns back. One of the monitors points out to the Croatians that they have failed to remove all the mines - there are still deadly Saracen anti-personnel mines on the road. The Croatians give the distinct impression they aren't that bothered.

The French leader of the EC team - Eric Gautier - rounds on them and addresses them like so many naughty children. "Right, I tell you what I am going to do. I am going back up that road and I will stand beside those mines and wave the convoy around."

And that is precisely what he did. He had guts that Frenchman. That was the only truly Christian act I witnessed in Karlovac that Christmas Day. But why did he do it? Not for Croatia, not for the retreating Serbs. Certainly not for Europe. I think I know why.

He was that EC man bowed in prayer in the Church of the Holy Trinity on Christmas morning.'

Four

Underneath the Volcano

Montserrat

The remaining expats on the Caribbean island of Montserrat were referring to the Kleebs as The Cliffhangers. This reflected a mixture of irreverence and awe. Robert Kleeb and his wife Beverley had retired to their sunshine tropical paradise from Detroit just three years previously and built their luxury home on the headland above Isles Bay. Things had not gone quite according to plan.

First of all, the cliff fell away beneath their house right in front of them. Unnerving. Then, in July 1995, the apparently extinct Mount Soufrière volcano started to blow its stack behind them. Two years later, the couple seemed remarkably unfazed by either event: they - alone - had stayed on to live literally in the shadow of the volcano in the so-called Forbidden Zone, in defiance of government, police, governor and all the apparatus of officialdom. With water, electricity and telephone cut off they were isolated and under siege from both natural forces and fellow humans.

But Robert Kleeb was not a man to give up. I drove to his home across the abandoned golf course. Access was guarded by two large dogs: a Doberman and a Great Dane. "They keep the police away," observed Kleeb laconically as he unbolted his ash-stained front door.

He had his strategy worked out. "I've got 3,000 flushes of the john in there. I've worked out we can last a year here," he said, waving at the waters of his swimming pool. Instead of being turquoise blue, they were grey with pollution from the ash that was everywhere: every surface - from the pool deck to the statue of Winston Churchill in the hall - was layered in the volcanic ash which fell all day, every day. Much of the time it was fine and invisible. But when the volcano was in full flow it floated down like autumn leaves, or came down like grey sludge with the rain.

Montserrat was not the first time I had observed this type of head-in-the-sand reaction to imminent danger. It is, of course, a fact of life - and, more often than not, of death - that people never

believe that disaster will come knocking on *their* door. From the Bosnian peasant who locked his door, and somehow believed the horrors of ethnic cleansing would pass his family by, to the man who lived underneath the volcano, there are, at any one time, I suppose, hundreds of thousands of people in the world who firmly believe that *they* enjoy a special immunity; that they can survive the most unpleasant extremes of this planet.

I didn't usually do volcanoes. Most of my reporting from danger zones has been from civil, and uncivil, wars. But, in August 1997, scanning the news agency reports I spotted a brief two sentence item about the volcano in Montserrat. Apparently, it showed signs of renewed activity. No big deal, no big story. But it knawed at me that morning. I had a strange premonition and I went to the telephone and called my travel agent.

Yes, there was a single seat left on a charter aircraft leaving Gatwick the next day for neighbouring Antigua and, the cruncher, at a bargain £200 for a 14-day return ticket.

A quick search on the Internet revealed the possibility of staying in a rather beautiful house, in a private flat at the pool level, formerly the home of Paul McCartney and Stevie Wonder. I was clearly meant to go!

I called around the people I usually wrote for but Montserrat was not on the news agendas. They were not encouraging. However, I left some contact numbers and packed an overnight bag, the cameras and the satellite telephone. I reckoned it might a bit of a break and I could maybe do a couple of background features ...

I flew across the Atlantic quite oblivious to some totally unexpected developments on the floor of the British House of Commons. As I flew into Antigua and scoured the harbour for a small boat to ferry me across to Montserrat, the British Commonwealth Minister was addressing the House on a matter of great urgency. According to information received by his department, the island of Montserrat faced the imminent likelihood of "a catastrophic explosion".

I awoke the next morning to sun and blue seas clearly visible through my bedroom window and, yes, there was the reassuring grey bulk of a British warship offshore. Although I did not know it at the time, this was HMS *Liverpool* dispatched by the British government

to organise the evacuation of the island. Behind me there was a promising plume of grey smoke emitting from Mount Soufrière.

I set up the satellite telephone next to the pool and tucked into a satisfying breakfast of fresh fruit. Then the satphone started to ring. "Hello, Paul. Are you there in Montserrat? Are you OK?" Of course, I appreciated the unexpected concern of the news desk at Sky which came as something of a surprise, until, that is, they told me I was on a breaking news story.

Over the next couple of hours the satphone rang red hot with orders for 'pieces' for radio, TV and the next day's papers. There were no other journalists from the UK anywhere to be seen. I rubbed my hands with glee. Sky were sending over their No. 1 reporter, Jeremy Thompson but, splendid news, their broadcast kit was too heavy to get onto the small local ferryboat. They would await the arrival of a chartered tug in Antigua. With any luck, it would be a long time coming.

The next evening I was observing a small political demonstration seeking more assistance for survivors of the volcano when I noticed a couple of journalistic types freshly arrived from the UK. There was David Sapsted, from *The Daily Telegraph's* New York bureau, and a rather snooty chap from *The Times* of London, whose name I have failed to commit to memory. David was friendly enough but the chap from *The Times* clearly thought that a roving freelance filling in for Sky until the big names arrived, and covering events for the 'regional' daily *The Scotsman*, was a particular form of low life.

"Look here," quoth the man from *The Times*. "We have to have a meeting to discuss how we cover this story." I looked blankly at him, genuinely bemused. "How do you mean, how we cover this story?" And I added, none too diplomatically. "I've been covering it fine until you chaps arrived."

The representative of The Thunderer looked at me stonily as if I was a Neanderthal idiot. "We have to agree on the stories we send and when we send them." He looks around for support from David and tells me the facts of life. "We're eight hours behind London. So, no stories after midday. The subs don't like to change the story after the first edition goes. Agreed?"

I pipe up, the apparently naïve voice of dissent. "Look I'm a freelance journalist and I have clients who want my copy any time of day."

The Thunderer shrugs his shoulders and turns on his heel. And I am left to my own resources. Which I am quite happy about. I am delighted to be told by David that they couldn't get a decent room anywhere on the island and are staying in a roadside shack vacated by a refugee in exchange for several hundred dollars. When I tell them I am staying in Paul McCartney's 'gaff' with a 75 foot pool all to myself, the evident pain on their faces almost breaks my heart.

Of course, in the nature of the business, as soon as Sky arrives I will be out of a job for the broadcaster. But, for the moment, I'm doing three foreign news slots a day, live by satphone.

Two evenings later, the local equivalent of a revolution took place. Locals demonstrated in the streets of the capital, Salem, which had replaced Plymouth after it was buried in ash; they burned tyres and then battled the Montserrat police riot squad. *The Times* and *The Telegraph* were nowhere to be seen. Of course, it's 4.30 p.m. and they wouldn't want to be bothering the subs. I throw open the back of the rented car, put up the dish and broadcast live as the riot is put down a few yards away.

Naturally, amongst the most avid Sky viewers back in London, who are treated to my breathless live account, are the news desks of *The Daily Telegraph* and *The Times*. I can imagine the scene. The editor growling, "Where the bloody hell are our chaps?"

That night I do several updates and, later that night, the government of Montserrat resigns. All grist to my mill. The next morning, I have a front page 'splash' in *The Scotsman* and the other nationals are quoting my stuff from Sky. Altogether a rather satisfactory result. As I recline by the pool the next morning, two very irate journalists knock on the door. I am obliged to recline on my lounger with a cold beer and listen to their litany of complaint. I gather that all diplomatic relations have been withdrawn. They won't ever speak to me again . . . at least not for three days, as it will turn out.

On the Thursday, the island loses all telephone links with the outside world. Horror of horrors, there is no way to send copy to London . . . and I am the only one who has come armed with a satellite telephone, totally independent of any terrestrial links.

"Could we possibly sit by your pool and use your satphone," is the cap-in-hand request. *The Times* man couldn't bring himself to ask me

but deputes the hapless David for the job. Being a reasonable fellow, I naturally make my satphone available to colleagues in all too evident distress. "That'll be US $10 a minute, cash, of course." Satphones are, indeed, expensive bits of kit to use. But not that expensive, of course. By the end of the day, I've got $800 in cash in my pocket and am congratulating myself on a very satisfactory day's business. And the users of the improvised Montserrat telecoms service have receipts for US$1500, so everybody is deliriously happy.

Soon Jeremy Thompson arrives and I am, of course, a back number in the glamorous world of broadcasting. He is generous in his thanks for what I've done for Sky but that's it. There is a full crew on the scene, a star broadcaster and no room left for yours truly and his breathless style of reporting. I'm not really bothered. The best of the story has now been and gone in my view.

But I can afford to be generous. I take Sky and WTN (Worldwide Television News) up to meet the Kleebs. They put on their usual star performance. Robert Kleeb has a great way with words from his isolated villa with the volcano spewing ash behind him. He refuses to believe the prophets of doom. He says the scientists at the Volcano Observatory are "academic whores". He dismisses the credentials of the earnest vulcanologist and Head Scientist at the Montserrat Volcano Obervatory. Professor Stephen Sparks is here from the University of Bristol – "hardly the Athens of the West" as Kleeb puts it - and goes on to angrily suggest the volcano is "a cash cow" as the scientists "dance to the tune" of the British Governor and the government.

The Kleebs are, of course, distinctly nouveau. They are amongst the rather more recent of immigrants. In 1490 something, Columbus sighted this lush, tropical island and called it Montserrat because it reminded him of the landscape surrounding the monastery of Montserrat in his native land of Spain. Today they call this the Emerald Isle of the Caribbean after the settlers who came later. In 1632, the English governor Sir Thomas Warner ordered the tiresome dissident Irish living on nearby St Kitts to colonise Montserrat for England and the island soon became renowned as a refuge for persecuted Irish Catholics from other English colonies.

The evidence of this Irish diaspora is everywhere. Irish shamrocks adorn Government House and the cannons on the

foreshore of the now abandoned capital of Plymouth. The flag and crest bear a lady - Erin - with a cross and a harp. St Patrick's Day is celebrated with an open air fête. The names of the estates, villages and heights are pure Irish: St Patrick's, Fergus Mountain, Kinsale, Galway's, Cork Hill, Sweeney's, O'Garro's and Galloway. The irony is that this remains to this day an English colony and despite the loyalty of the inhabitants to the Crown, there is virtually nothing English about the culture and traditions of Montserrat.

Montserrat enjoys an extraordinary and unique Afro-Irish culture; a curiously integrated mixture of the cultures of the Caribbean slave and the Irish settler. The story, doubtless apocryphal, is told of the Connaught man arriving on Montserrat around the turn of the century. He was astonished to be hailed in his native Connaught brogue by a negro at the shore. Thunderstruck to find what he assumes to be a fellow countryman, he turned promptly around and returned to the Emerald Isle, grateful to have retained his white skin intact. And it is still seems curious, and intriguing, to hear a black Monserratian ending a sentence, "at all at all".

The original settlers chose to take their chances on Montserrat, even though the Soufrière Mountain - literally 'sulphur pot' - had erupted less than a hundred years previously. Both the Irish and the black slaves imported from Africa lived a straitjacketed life as second class citizens under the autocratic rule of the English governor: slaves denied their liberty and Irish Catholics denied their religion. The official church was the Church of England and in those early days Catholic priests were smuggled in disguised as fishermen or merchants. But the volcano brought dividends to the settlers. The sugar cane industry was nourished by the rich and fertile volcanic soil in the 17th and 18th centuries. Things worked out well.

Then, in July 1995, the volcano, generally thought to be extinct, awoke after almost four centuries of inactivity. Apparently, the geologists term this a 'sub-duction zone'. It is here that the North and South American tectonic plates meet, pushing against each other beneath the weaker Caribbean plate. In pre-history this threw up the islands of the Lesser Antilles, of which Montserrat is just one 39 square mile product. Where the plates meet the rock melts into magma and is expelled to the surface. As it rises, it forms a dome against which the magma continues its relentless

pressure. What happens then seems to be anyone's guess. Already, two thirds of this island had been abandoned, including the capital, Plymouth, the airport and the best of the agricultural land.

Ivan was the pool man in Old Towne, a graceful residential area. It was a place of elegant villas in well tended gardens full of dazzling flamboyant trees, neatly manicured lawns and generous swimming pools. There should have been a lot of work here for Ivan. The pools were grey with volcano ash and the bottoms silted up with pumice gravel thrown out by the towering Soufrière Volcano which growled away, clearly visible.

But Old Towne was deserted. It was a ghost town of lavish but abandoned homes. In August 1997, the scientists retracted their earlier view that Salem and its neighbouring residential areas were safe from the volcano. The government of Montserrat promptly ordered all the residents out - wealthy local businessmen and expatriates alike.

But on a steep tarmacadamed road, next to a villa called *Connemara*, with a shamrock sign on the gate testifying to the Irish antecedents of its erstwhile owner, there was still a rambling bungalow in use. It was the home of the Montserrat Volcano Observatory, or MVO. Here were gathered scientists from all over the world in a bid to second guess the natural, uncontrollable powers of a force which, in reality, they did not understand at all. The then Head Scientist in charge was Professor Stephen Sparks, an intense, bright and enthusiastic 48-year-old. One of Mr Kleeb's "academic whores".

You got the impression he was every bit as much in his element as the grumbling volcano which could be seen from the terrace of the villa spewing ash in great sculpted clouds. "Well, you see, all volcanoes are individuals," he explains, in the manner a cat lover might speak of a treasured moggy.

Journalists nodded, purporting to understand his evident fascination.

Yeah, well, when's this baby gonna blow, the man from *The Boston Globe* wanted to know. "Ah well, the volcano is now in a pattern of highly predictable behaviour. Every day there are hundreds of hybrid swarms, pyroclastic flows and emissions of ash." To you and me, that means earthquakes, clouds of steam and chemicals

superheated to more than 1000 degrees centigrade travelling at up to 120 m.p.h., and choking ash with particles of deadly silica which, after a few months exposure to a human being, will likely lead to silicosis.

Great, does that mean it's not in danger of exploding any longer? "The problem is that this pattern of behaviour could stop at any time and then we move into a new cycle. We can't *actually* predict when that might happen . . ." In fact, the new cycle *would* start within a couple of weeks.

None of the scientists would venture an opinion as to what form that next cycle might take but there seemed to be several possibilities. The volcano could carry on its present cycle for up to two years. It could "go to sleep", as the scientists put it. Then there could be an explosion of a force of up to ten times any previous explosion. This could blow out the side of the volcano producing an unfriendly rain of hot rocks the size of tennis balls over the entire area of the island. It would likely mean the complete destruction of the present capital Salem and its plush residences. Apparently, there was a ten to one chance of that: the professor regarded it as "highly unlikely" Phew!

I asked with all due temerity about 'the doomsday scenario'. Reassuringly, that was a thousand to one against according to the Professor. Which is rather a good job, as it would not only wipe Montserrat off the map, but the tidal wave would also likely take out the tourist paradise of Antigua thirty-five miles away.

The holy of holies lay behind a door labelled ASH FREE ZONE. We're not talking here about a ban on smoking. In an air conditioned cool unique on the island, was the technical nerve centre furnished with equipment provided by the British Geological Survey in Edinburgh, Scotland. Seismographs hummed contentedly away until, quite suddenly, one went into whine mode. This clearly excited the Professor, "Earthquakes, earthquakes," he mumbled urgently. Behind a constantly moving computer screen recording seismogram readings sat a uniformed officer of the Montserrat Defence Force. The government regarded any information relating to the volcano as a matter of extreme sensitivity. Reasonable really. The volcano had already occasioned the fall of one government in the previous week.

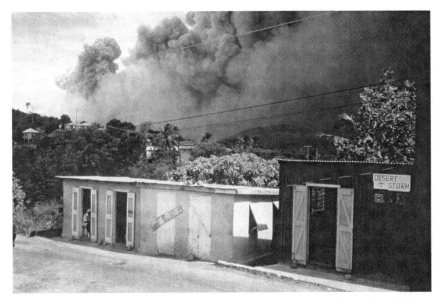

The volcano on Mt Soufriere, Montserrat, gives off clouds of smoke and steam in this view from Salem, which became the capital after the inundation of Plymouth..

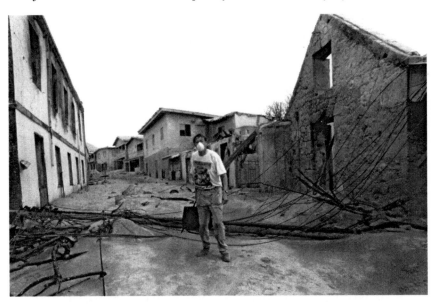

I visited the abandoned capital, Plymouth, with a WTN film crew and we were obliged to don face masks to keep the fine volcanic dust out of our lungs

All this on site activity was backed up daily helicopter inspections carried out by local daredevil pilot Jim MacMahon, and a constant real time Internet conference whereby the latest readings were analysed by eager vulcanologists all over the world.

One thing about Professor Sparks. He wasn't one of those scientific know-it-alls. "Volcanoes are complicated things - we don't understand everything about them . . . this is a very unusual volcano in that the explosive activity is normally at the start, then it goes quiet. This one is just the opposite . . . this makes it difficult to predict." He sounded - and looked - genuinely puzzled.

This was not reassuring. Then came a decidedly unscientific bit of analysis. "The magma dome is growing at the rate of seven hundred thousand domestic fridges a day, and increasing." Sorry? Apparently, this was the vulcanologist's quantitative terminology for the build-up of the lava dome. And all that stuff will likely blow off one day, as it did at the end of June taking 300 foot off the top and bringing a 1000 degree avalanche down on fertile farming land, and farmers.

However, at least Mr Sparks had got the politicians sized up, which was a decidedly endearing quality. "The interaction between scientists and politicians in London is nil." And what about British Government Minister George Foulkes' doomsday analysis of the risk, which prompted such a panic about the island? "I would say Mr Foulkes got it hopelessly wrong." So there, George.

Down the road, this is all beyond Ivan Hickson the pool man. He's just registered to evacuate to Britain and take the British government's package for evacuees. "Ah need a rest from all this, man. Ah's taking da two thousand pounds."

Soufrière had emitted steam, ash, red hot rocks and a mixture of superheated chemicals and liquefied rock. This was not a lava volcano. This deadly mixture was known as a 'pyroclastic flow'. At first, it was difficult to get your brain and elocution around 'pyroclastic' but T-shirts bearing the message were everywhere ($10 US) and even the smallest of local children talked with authority about its awesome danger when it swept down the mountain at speeds of up to 120 mph at over 1,000 degrees centigrade.

When the mountain became angry these flows poured down its steep slopes filling the valleys, or *ghauts* as they are known locally,

and swept away everything in their path. A fifty foot high water tower - full of water - was swept downhill hundreds of yards by such a flow. Whole villages and urban areas, including the capital Plymouth, had to be abandoned in the face of the onslaught and are now eerie, deserted ghost towns like some long abandoned film set.

Despite the extreme dangers, people went back to the unsafe, Forbidden Zone, or Restricted Areas, as the government termed them. Despite steel gates secured with padlocks on all the roads and sweeps by police helicopters, large numbers of people made the trek back to their homes risking arrest or, worse, the angry and unpredictable attentions of the Soufrière Volcano. Whilst I was there, they found three fresh bodies in Plymouth.

Many of the reasons for return might seem mundane. Some people simply wanted to see their homes again, to be reassured that they still existed. Most did, although they may be mummified in layers of grey ash several feet deep. Farmers went back to animals and crops they have been forced to abandon and salvaged what they could to bring to market.

But others returned for a more basic reason. They went back to make love in the shells of their abandoned homes. The aptly-named Donaldson Romeo, an eloquent and outspoken 35 year-old, who has been championing the rights of native Montserratians, explained. "We're talking about people who have been evacuated to live in communal shelters - some have been there for as long as 15 months. They live in mixed dormitories, as many as fifty sharing a single toilet. They have no privacy, no possibility of close physical contact. So, at the weekends, they creep back to the home they once knew and make love there."

Despite such indignities, the incontrovertible fact was that most of the remaining 4,500 or so native Montserratians wanted to stay on their little island - even though the habitable portion had been reduced to just 12 of the original 39 square miles. The airport was gone, the capital with its shops, port and modern hospital was gone. The insurance companies and Barclays Bank had pulled out and the local Building Society had put up a bald notice at its gate: "Sorry we are closed" leaving depositors high and dry.

Most of the expatriates, the seekers of a quiet retirement in the sun and the fabulously wealthy who had flocked to the island

in better times, had packed their bags and gone. The Kleebs were the exception rather than the rule. Robert Kleeb didn't have much choice, and he explained why. "I invested $800,000 in this place. That's my capital locked up. There's only one way I leave here. In a body bag . . .".

He smiles reassuringly at his wife, Beverley. She seems to understand. She should do. She's the part-time prison psychiatrist. Except the prison's just closed: most of the convicts have been moved to other islands in the Caribbean and they say they're putting the rest in the army. The Montserrat Defence Force could be looking at a significant increase in its 80-man establishment.

Most other expats have packed it in. George Martin's Air Studios, where the likes of Paul McCartney, Stevie Wonder, Sting and Elton John recorded, are abandoned in the forbidden zone, the pool black with ash, the dust building on the diving board and on the comfortable furniture in the sitting room.

Americans Jim and Beverley Harris retired a few years ago to the Providence Estate House in the north of the island - still thought to be 'safe'. Providence must be - by anybody's standards - a dream house. It certainly was for Paul McCartney who stayed here through the 1970s. By the side of the generously-sized pool, in which I am now swimming, he sat with Stevie Wonder and wrote *Ebony & Ivory*. But for Jim and Bev the dream has gone sour. "We came here for golf, tennis and a relaxing retirement. Not for the excitement." A helicopter chartered by the Volcano Observatory flew low overhead to land a couple of hundred yards away drowning out Bev's words. "Look at it, it's like Saigon these days."

White expats and native Montserratians only mixed at a superficial level. It was hardly surprising. Whilst the music of Handel floats over the pool deck at Providence, up the road in St John's people dance in the main street to reggae from a ghetto blaster. You sense that the reggae stimulates and satisfies those in St John's rather more.

Ernestine M Y Cassell, director of Montserrat Tourist Board, was a real trooper. 'The show must go on' seemed to be her motto: in the midst of all this, she announced a rather extraordinary and forward looking tourism initiative for the beleagured island. As the volcano threatened to blow its top, she announced a campaign to attract "adventure tourists".

"Montserrat is currently the focus of world interest and now is the time to market the island," she resolutely declared. "I can't sit here until the volcano subsides." She thought there was a niche market for people looking for thrills and for serious vulcanologists: people in anoraks - to you and me - who get seriously excited by pyroclastic folows, magna domes and mega-eruptions.

She admitted to me she was breaking new ground, so to speak. "My university course in marketing never told me how to market a volcano." Ernestine, who had been running the island's tourist industry for more than 10 years, was a graduate of the International Institute of Tourism Studies at George Washington University, in Washington D C.

However, she had looked at the market in other places.

"After all, three million people a year visit Hawaii to look at their volcanoes." Here came the cruncher. "And our volcano is much more spectacular!"

The problem on Montserrat was that every single hotel had either been destroyed by all those unpleasant and explosive gases, or were in danger zones which the scientists predicted could be due for early incineration. So the resourceful Ernestine was in talks with "several" American-Caribbean cruise lines to charter a small cruise ship to anchor offshore as a floating hotel. From such a ship they would then either ferry or helicopter the punters ashore, dependent upon their pocket books.

Before Soufrière blew in 1995, Montserrat was, she says, "a relaxing get away from it all place", a reputation which endeared the island to the famous and mega wealthy. They've now hotfooted it, so to speak, well away.

I was staying in the one time Beatle's residence but I'm now moved on by pre-booked visitor pressure to millionaire Mrs Frink's place. Mrs Frink was not in residence so I moved in with her six cats, two dogs and maid and gardener, while she was presumably following what's going down on CNN. However, every cloud has a silver lining and her maid is turning a few bucks by renting out Mrs Frink's elegantly appointed chintzy bedroom, complete with four-poster.

Tourism used to provide almost 20% of the GDP and before the volcano was *the* major foreign exchange earner. A few itinerant journos don't quite make up the looming deficit.

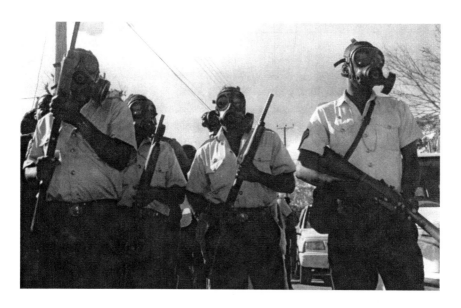

The Montserrat riot police take on demonstrators in the town of Salem. I covered it live for Sky TV.

The key to covering the Montserrat story effectively was my satellite telephone. Normal communications were poor on the island and on a number of occasions broke down completely. Here I am using the then newly-developed Mini-M satphone in Algiers.

In 1994 tourism receipts were US$25.1 m.; down to $21.6 in 1995; slumping to $8m in 1996 and, in 1996, languished at $3m. Mini-industries like sailing, fishing and tour guiding virtually disappeared to be replaced by micro industries like printing T-shirts with that great marketing message of all time, PYROCLASTIC FLOW.

Doom and gloom apart, Ernestine claimed that a major US resort developer was mustard keen to get into the safer northern part of the island with a major development. Further south they could have got in rather cheaper. The Sky News team - typically British stiff upper lip - rented a magnificent villa with ash-filled swimming pool in The Very Dangerous Forbidden Zone (with superb view of the volcano as a background for what newsmen term 'stand ups'). Within ten minutes the letting agent was offering to sell them the million dollar pad for just $100,000 . . . Just for fun, they got her down to $50,000. There were some great - albeit speculative - investments around.

As I wrote all this, nobody knew what would happen in the future. Everybody was suffering from some sort of stress. Not so much post traumatic stress syndrome as a continuing stress; the stress of not knowing how long the nightmare would go on. The scientists originally said the volcano would probably be active for two years. Then they said it could go on for another four years . . . In fact, the passage of the months and years would see Mount Soufrière go safely back to sleep again, for the moment.

Every native Montserratian seemed to have the sort of problems which would terminally fracture any British family: businesses gone, homes and possessions destroyed, people were uninsured and usually still paying mortgages on property they most likely would never see again, paying rent on top of the old mortgage or, worse, living in a communal shelter. For the older and the frail, the deadly silica already was clogging their lungs as silicosis set in.

You couldn't help thinking most societies would have collapsed long ago under this type of pressure. But here the mutual support mechanism ran strong and deep. If you were driving along the road and somebody else was walking, you would stop and give them a lift. That simple. If a friend was driving in the opposite direction, you stopped and talked. The traffic behind stopped and waited patiently. The horn was hardly ever used. The ties of family, friendship or simple acquaintance seemed to endure notwithstanding recent

unsettling events: the volcano, fall of government, riots, political demonstrations and an unsuccessful attempt at mass evacuation by a bemused British government.

Down the road from the shelter at St Peter's, children learned Caribbean steel band music in the shade of the wooden church. An announcement from ZJB Radio Montserrat, 'The Voice of the Emerald Isle in the Caribbean - a Special place for Special People', usefully advised that "the set of keys lost on the road to St John's can be collected from Mr Sweeney's shop." Veronica, a middle aged woman living in a bus shelter with all her worldly possessions packed in cardboard boxes, is sustained by the unquestioning optimism which stems from deep religious faith. "Every day I thank the Lord for my salvation."

Everywhere was that resilience, warmth, resourcefulness and feeling of community. The Montserratians may be dismissed as 'simple people'. By some, as idle and laid back. As an English sailor from HMS *Liverpool*, who has just finished putting up a tent for evacuees, complained, "Here we are sweating our guts out for these buggers and all they want to do is lie in the sun and swig beer." All around him, lying on the lush green grass were indeed the natives, swilling beer and pop. If he'd troubled to ask them they would have observed that why should they lend a hand with all these mustard-keen British sailors around . . . In the Caribbean you don't put yourself out for anybody or anything without good reason. Especially when you know what's going down, man.

In the next few days, the British government's proposed emergency mass evacuation would bring less than forty people to this tent, rather than the anticipated 4,000. And most of them would be seizing the chance of a couple of months and a Merry Christmas with relatives in Birmingham, or wherever.

Yet, despite all that had happened, you heard nothing in the way of self pity on this island. Princess Diana was dead in a road accident in faraway Paris but a few hours as I made my way to the ferryboat to leave the island at 6 a.m. All along the road, beside the pathetic wooden shanty dwellings, the Montserratian flags were already out and flying at half mast.

Where the flags had appeared from was a mystery and goodness knows these poor people had surely enough problems of their own than to care about the death of some distant, remote Princess.

But that's not the Montserratian way.

Five

In Europe's Wild West

Albania

This is the Wild West, I am thinking. A few days ago I was sitting in the air-conditioned cool of the office of the Minister of Tourism in Tirana and being told persuasively of the warm welcome awaiting tourists. Now I am sitting in the baking 38 degree heat in the remote mountains of southern Albania. Outside the car, two policemen in extravagantly peaked caps and dark glasses are giving my driver the local lesson in driving etiquette. One is screwing up the bunched flesh of his cheek between thumb and forefinger while the other has hold of his chin which he jerks up and down as the other screws. I have travelled in most of the Balkans and do not regard myself as a nervous traveller. But I'd never seen anything like this before - not even in Bosnia or Serbia at war.

Eventually, the poor chap was reduced to tears and, at this point, his pockets were emptied and the money - $20 in local *leks* - provided by me that morning for petrol was carefully counted out. This would evidently do to account for some imagined driving infraction and the lot was confiscated, a ticket given and then promptly torn up. Then we were on our way again.

Not quite, though. As the policemen stopped another car and set about the next unfortunate, local people working at the side of the road in this mountain village approached with sympathy, drinks - and a fistful of *leks* which they energetically and noisily urged the driver to accept in compensation.

On the one hand, in 1993 Albania was Europe's poorest and most backward country with surprises - not all pleasant - around every corner. On the other, it was a breathtakingly beautiful country of rugged grandeur and simple, generous people. Unfortunately, this incident - in an event-filled day - was not altogether untypical.

The tourist industry had hardly arrived yet. It was, after all, just two years since the country was released from the yoke of possibly the most brutal Communist regime in the world - almost one

million of the country's three million inhabitants were imprisoned at one time or another, Albania moved into total isolation from the rest of the world and its leader Enver Hoxha devoted himself to building no less than 700,000 concrete bunkers all over the country in defence against imagined enemies. As he was totally paranoid, some of the bunkers faced north and east, when he feared the enemy might come from Russia, China or Europe, while others faced west when he feared attack from the US. Now with a democratically elected government, Albania was opening its doors to the world but there was still much to be done - and undone - before it would become an entirely suitable tourist destination.

Minister of Tourism Edmond Spaho explained to me that there was a ten year plan for tourism, devised in association with the European Bank for Reconstruction and Development. "We shall avoid mass tourism and the pollution, destruction of the environment and unsympathetic building which comes with it. Instead, we shall build tourist villages with low hotels and promote the natural assets." These natural assets included what were termed the "museum cities" of Berat and Gjirokaster. Berat was a remarkably well preserved example of an Ottoman city with winding alleyways, mosques and semi-fortified houses, the whole dominated by the imposing mediaeval citadel. In Gjirokaster, citadel, mosques, the old bazaar quarter and fortified 19th century merchants' houses all clung spectacularly to the hillside above the Drinos Valley. It came as no surprise that Gjirokaster caught the imagination of travellers like Byron, Hobhouse and Edward Lear. Sometimes it was difficult to remember that you were, in fact, in southern Europe such was the distinctive flavour of the Orient.

The coastal plain was ringed to north, east and south by dramatic mountain ranges rising to 2,700 m. and harbouring vast blue lakes. The Ministry of Tourism identified so-called 'Priority Tourism Zones' for early development: principally around Pogradec on the indisputably beautiful Lake Ohrid, and on the coast near to Saranda and Durres. Here, according to the Minister, "all other economic activities shall be subordinated to tourism." There were six designated National parks where flora and fauna, including brown bears, wolves, lynx and wild boar, were to be protected. Hotels and winter sports facilities were to be constructed in the

mountains. Dance, music and local handicrafts would be developed as attractions in themselves.

Back in 1993, foreign investors were already being encouraged to participate in the ten year plan with tax-free breaks, tax relief and low land rentals. These were all noble and ambitious ideals. The problem with Albania was that the country was still firmly locked in its own troubled past.

Spaho did admit that the development of the tourist industry would be dependent on development of infrastructure like the airport and the country's dilapidated and skeletal road system. Under the Hoxha regime, private cars had been banned and the roads were now crumbling under an explosion of traffic.

I visited Albania throughout the 1990s and have returned every year between 2005 and 2008 to accompany American tourists to Durres, Tirana and the Roman ruins at Butrint, near to Sarande. With the exception of a vastly improved road between Durres and Tirana, there is little to see in the way of infrastructure development, apart from mushrooming petrol stations. To visitors from the US, the country remains incredibly primitive.

Then, as now, driving was a seriously dangerous undertaking. It was bad enough and crazy enough on the potholed roads during the day, but at night it became a veritable nightmare as unlit horse-drawn carts, bolting cattle, wandering goats and donkeys and pedestrians, all with no apparent road sense, seemingly came from every direction. Horn and accelerator appeared to be the only controls in serious use and large numbers of cars were unlit at night due to a chronic shortage of spare bulbs, and all those over-zealous policemen unaccountably disappeared; probably to the nearest bar with the day's takings. Every few hundred yards there seemed to be a car or truck broken down at the side of the road. Preventive maintenance was an unknown concept and spares were virtually impossible to maintain except at makeshift roadside stalls.

Outside the capital, hotel accommodation was dire. In the fascinating southern city of Gjirokaster, not far from the Greek border, the hotel, optimistically described in the 1993 *Blue Guide to Albania* by James Pettifer as 'an acceptable place to stay', was indubitably the worst hotel I had stayed in anywhere in the world.

Large parts of the floor in the room were mysteriously missing (I wondered if they had resorted to burning the floorboards), and

around midnight the local wildlife emerged to disport itself. In the early hours they were joined by the most enormous crickets I had ever seen who lined themselves up on our bed-head chirping merrily and loudly. I gave up the unequal struggle and retired to the balcony with my girlfriend, Megan, for the rest of the night, watching the beauty of the dawn as it came up over the narrow, steep streets which climb up to the Turkish-built Citadel.

The whole hotel stank evilly. The contents of the wastepaper basket could not possibly be described. All the toilet accommodation was unaccountably locked - although this may have been *in lieu* of cleaning the facilities judging from the smell which wafted out when I ill-advisedly tried to peer through the keyhole. It was necessary to climb down three floors to visit indescribably filthy facilities shared without privacy by both sexes.

Our driver wisely opted to sleep in the car, after removing the wheel trims, wing mirrors and anything else that moved. Armed with a can of Mace gas he went to sleep, only to be awoken by the local police demanding $5 for the right to sleep in the car.

We were rather luckier. A policeman armed with a Chinese-made AK-47 Kalashnikov assault rifle - which he engaged in noisily stripping down and reassembling - spent the night on the landing outside our room. I was thunderstruck not to be charged for this service in the morning. Which went to show just how quickly I had adapted to Albania.

But things were not to get any better and, alas, Spaho's optimism would prove ill-placed. Four years later and the dawning of 1997 brought riots, civil collapse and, eventually, international intervention in the wake of a great rage sparked by the collapse of pyramid schemes. A large part of the population was impoverished. The south of the country descended into chaos and things weren't much better in the capital, Tirana. Just south of the central town of Fier you passed into the lawless south. I inadvisedly decided to explore it.

The muddy green waters of the River Vjoses came to mark the border between north and south Albania. To the north was the territory held - more or less - by President Sali Berisha's government forces. The Albanian army seemed to have evaporated around here: the only visible security a few miles up the road near to

Fier was provided by a group of scruffy policemen with automatic rifles clustered around a solitary tank, its barrel pointed defiantly down the road. An ancient Russian-built T-34, at least forty years old, it would, anywhere else, long ago have been consigned to the scrapyard. But come 1997 in Albania, the ownership of weapons was truly democratised by the distribution of more than two million of them throughout the population, and the denuded apparatus of the state had to make do with that which is either too bulky, aged or useless to carry off.

To the south of the river was rebel-held territory. The principal towns of Vlore, Gjirokaster and Sarande were run by self-styled Salvation Committees, who were utterly powerless political players. The claim to fame of the 26 year-old leader in Vlore - Albert Shyti - seemed to be based solely on his status as an Elvis Presley look-alike. He appeared every morning at an approving public rally, his shirt split open to the waist, medallions swinging wildly.

But the real power in Vlore - once the Albanian navy's principal base and a bustling port - lay with the competing criminal gangs jockeying for supremacy. Vlore has always had the reputation of being a centre of criminality operating with only minimal challenge from the authorities. It became a centre of anarchy: a place where you could do anything, any time . . . provided your weaponry exceeded the firepower of the chap you were doing it to.

Things went pear shaped for me in Vlore within an hour of arriving. That morning, just south of Fier, still outside rebel territory, Italian General Giglio had told journalists it was far too dangerous to go into Vlore. He had special forces to hand - in the form of men of the crack Col Moschin paras - but he was not prepared to approach by road until a sea landing could be simultaneously mounted. He was waiting for the local equivalent of D-Day.

The Red Cross decided to go in anyway with a three vehicle convoy to unload badly needed flour, pasta and cooking oil at the main hospital, the psychiatric hospital and the orphanage. I piled into a Mercedes loaded with news agency journos.

We made the hospital drop OK. Guys with AK47s glowered menacingly from the walls above and somebody fired an RPG into a wall a couple of hundred yards away. It gave the local yobs a great laugh as we jumped out of our skins.

My Albanian girlfriend, Megan. Without her help it would have been extremely difficult to work in Albania, a wild and lawless country.

My hosts, the Shehu family, on the balcony of their home in downtown Tirana

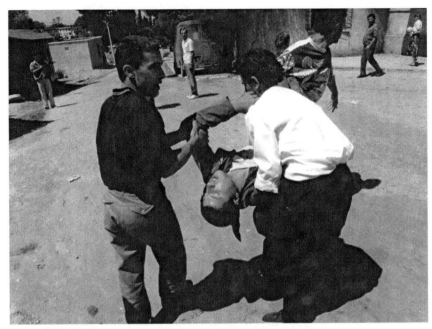

This soldier had fallen out of the back of a military truck we were following. It didn't stop to pick him up so we did.

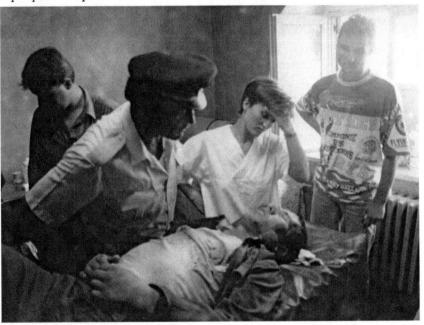

We took the injured, unconscious soldier to the nearest hospital. It had no medicines and no resuscitation equipment. The nurse revived him by slapping his face repeatedly.

The Mercedes was uncomfortably crowded and I joined an Italian photographer, Luca, in his luxury, rented Italian four wheel drive. The psychiatric hospital drop was achieved and then the convoy moved on ... But, as we turned onto a main road, a couple of black Mitsubishi Intercooler Turbos cut into the convoy behind the ICRC lead Range Rover and cut us right out. Gunmen armed with AK47s leapt from their vehicles and signalled us to the side of the road.

Luca, as the driver, made the decision to comply with their instructions. I knew it was a tough decision to make. Did you carry on and risk a hail of fire or comply? Personally, I have always carried on in this sort of situation but, Luca, drafted in from his usual beat doing pics of businessmen in Milan pulled over. Then he asked if he could take their photographs. Oh, Christ. Thus, we found ourselves standing at the side of the road in front of a ditch with AK 47s pointed at us. And these guys were really unfriendly, unshaven louts, spitting venom. Even worse we couldn't understand what they were accusing us of; and they couldn't understand us. Difficult to build a relationship. Best case scenario, I decided, was that we would be robbed and the car taken; worst case, we would be beaten and killed.

A flash Merc was driving past and diverted their attention. I decided I wasn't waiting around and legged it as fast as my pins would carry me down the road - half expecting a burst of fire at any moment.

I was really congratulating myself on my successful exit as I flagged down another Merc (everyone seemed to have one around here) and a grinning, smart-suited and moustachioed chap picked me up. He said he was "special policeman from Tirana". Really? I asked him to follow in the direction of the Red Cross convoy. But instead he pulled off the road onto an unmade track and we were climbing, so far as I can see, to nowhere. He's looking at my bag, swigging a bottle of beer and, as he stops the car, pulls a 9mm. automatic pistol from his belt. I grin foolishly, playing the idiot, pull a handful of deutschmark notes out of my pocket and give them to him.

He looked pleased enough and drove me back down to the main road. I asked for the hotel, where I knew the other journalists

stay, and we drove on. Frankly, I was getting a bit panicky now . . . but when he flagged down some gun waving mates in a car approaching and then went over to speak to them, I decided it was time to leg it again.

I dashed across the road, using a truck as cover. There were several cars approaching, so I used the universally successful trick. I pulled out a DM 100 note (almost forty quid or sixty bucks in real money) and waved it about. The effect was magical and another Merc slewed to a halt, I jumped in and, five minutes later - and DM 100 the lighter - arrived at the Hotel Bologna.

The modern Hotel Bologna was on the seafront near to the harbour and was enclosed by brick walls and iron fencing. I climbed gratefully over the fence as the security guards emerged from the entrance. It was reckoned to be as safe as safe could be around here, although I knew that a few nights previously a three hour gun battle raged around the hotel as a gang tried to seize control. The owner called in his own rival gang who beat off the putative intruders. Italian journos staying in the hotel had written extensively about the criminal battles in Vlore and they were now none too popular.

The menu was limited. It was fish . . . or fish. I gave my order. At least it was going to be fresh. A man got into a small boat moored in front of the hotel, rowed out a hundred metres or so, peered over the side and promptly dropped a hand grenade into the sea. Quite a lot of fish floated up to the surface and my lunch was as good as on the table.

As I scoffed the delicious fish and downed some Nastro Azzuro specially ferried in from Italy, the owner's gang pitched up for their scoff. Nasty moment. *They are the same guys who held me up at the side of the road.* They are pointing at me and jabbering menacingly. Fortunately, the hotel proprietor sorted out a potentially nasty situation and sternly ordered them to find the missing Luca, who they'd got stashed somewhere or other. It turned out this mob are controlled by one 'Partizan' Caushi, a local criminal who provided the protection for the hotel.

You could hazard a guess as to where the owner's clout came from. Moored in the harbour below was his gleaming white luxury speedboat. He boasted to me he could get across the Adriatic to

Italy in less than forty minutes. This was not weekend pleasure cruising. This, I guessed, was drug trafficking, the real economic underpinning of Vlore. In the prevailing state of anarchy, drugs from the east were coming into Vlore by ship in very large consignments, quite unchallenged. It was then relatively easy for small, fast craft like this to then to ferry them across the Adriatic to lucrative markets in Italy.

After lunch, some guys from Associated Press were pulling out of town and I decided I definitely wanted the first ride back to Tirana. Unfortunately, the bridge at the unofficial border at Novosele turned out to be controlled by . . . guess who? This was just not my day.

This was no normal border crossing. At the bridge, on the pot-holed main road, such as it was, between the port of Vlore and the Albanian capital Tirana, travellers were being pulled from their cars by our familiar band of desperadoes posing as the forces of law and order. A duo of policemen in uniform looked on powerlessly at this motley crew - there were maybe ten or a dozen of them - variously dressed in black and white winter camouflage trousers, green fatigues, balaclavas and baseball caps; some, including their aggressive six foot four inch leader, the aforementioned 'Partizan' Caushi, wore bullet-proof flak jackets padded with ceramic plates over their 'battledress'. They all carried the ubiquitous AK-47 machine gun with their wicked twin curved magazines bound together by brown parcel packing tape: the practice adopted by hooligan paramilitaries the world over.

A young boy of maybe eighteen years was pulled from the wheel of a black Mercedes at the point where traffic was funnelled into single file by a barricade of broken concrete and burned out cars. The thugs beat him with the butts of their weapons, one fired his weapon into the air and Caushi took a bayonet from his belt and gleefully and randomly punctured the youth's body as he screamed piteously. Our car approached the barrier and we were signalled to pull over to one side by an unshaven lout.

The driver tried to explain that we were journalists. A vicious snarl creased the gunman's face. "Italian ! Italian !" he shouted excitedly, raised his AK-47 and fired in our direction. He fired six, maybe eight rounds. They passed harmlessly over the roof of the car.

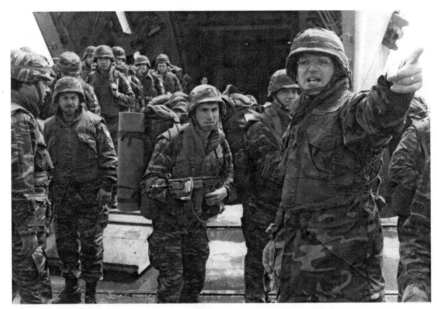

Several European countries, including Greece and Italy, launched Operation Alba in the aftermath of the collapse of the pyramid schemes as complete anarchy enveloped Albania. Here, Greek troops come ashore from a landing craft at Durres.

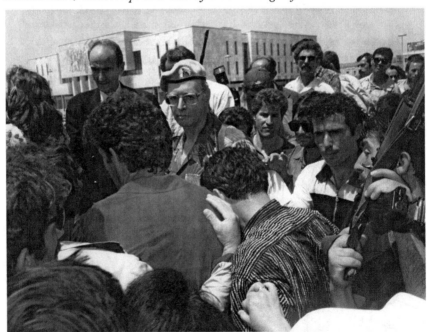

As Albania made tentative steps towards representative democracy in 1997, putative King Leka arrived in the country in a bid to re-install the monarchy. He was the son of the legendary King Zog who had been deposed by the Italians in 1939.

The driver, Dieter, a German news agency reporter, kept his head, thank God.

"No, not Italian, German," he explained calmly in a sort of Eurolingo. You could almost see the idiot gunman's brainbox slowly clicking into gear. It was evident he was either drunk or high on drugs - probably both. He quite suddenly altered his view of the situation and clapped the driver playfully on the shoulder. "Germany, OK. Germany, OK."

Other gunmen pressed in on the other side and we desperately sought their approval. Everything seemed to be playing in slow motion. We were now the centre of their undivided attention: the young boy lay whimpering in the gutter at the side of the road. I tried to follow the track of all of these waving, menacing guns wondering what the hell to do if one started up on us: little chance, the thin metal of the Mitsubishi would be no barrier to them. Contrary to popular myth, fostered by Hollywood gangster movies, cars do not stop bullets.

After a few minutes which seemed like an eternity, the Chief Hooligan signalled his approval and we were allowed through to the other side of the river. In truth, never, even in four years in Bosnia, had I been so frightened as I was that day in Vlore. In Bosnia, as journalists we cursed the continual checkpoints, the demands for papers and the restrictions on movement, but these in themselves ensured some degree of control in the midst of a vicious war.

Here, in southern Albania, there were simply no rules. Just irrational, unpredictable and implacable thugs. The prisons were empty and the lowest criminals had been given access to unlimited weaponry and ammunition and some hotchpotch uniforms, and were now suddenly free to carve out their own piece of territory in which they could rule supreme, unchallenged, robbing, beating and, if the whim took them, shooting the less powerful.

I had planned to spend three days in Vlore, the centre of resistance to the government in Tirana, but I returned, terrified, after just eight hours.

I returned to Vlore in 2008 aboard a small cruise ship, the *Clipper Adventurer*. I am glad to be able to report that some things had changed. Partizan Caushi was, I was told by our guide, residing behind bars. The Hotel Bologna had had a makeover and the local

police seemed to be in control of the city. The poverty was still all too apparent but there were those signs of an emerging economy: coffee bars, Coca Cola signs and fast food outlets.

Tirana was always better. Although not much. I soon decided that I didn't like the neighbours in Rruga Barrikada (the stirringly named Street of the Barricades). That was no big deal for me – I was just passing through the capital of benighted Albania as the pampered guest of my girlfriend's family. But their noisy neighbours really were the end . . .

The chap next door couldn't decide whether he was coming or going. It was usually the early hours of the morning - well into the so-called curfew - when he threw open the boot of his Mercedes. It was either already full of - or about to be filled with - AK47 machine guns. Some nights the Kalashnikovs were being noisily decanted into the house, others they disappeared with a great clatter into the boot and were sped off - doubtless to some eager waiting customer with a bit of personal vengeance to look after. In case of any sudden problems, my purposeful neighbour always had a loaded machine gun on the passenger seat.

We'd just had two days without electricity. That was because the chap at the corner who had a bar-restaurant - actually a particularly dingy joint with a few formica-topped tables - got a bit over-excited after he'd had a few beers. He went out and shot through the overhead electricity supply cable. That was no problem for him - commercial and domestic supplies were on different lines around there - so he disappeared back into his brightly lit bar while the rest of us poor sods sat huddled around the stubs of impossible-to-get candles.

My generous hosts were the Shehus - mother, two daughters, two cats and one dog. The elder daughter, Megan, was a particular friend of mine over a period of many years. We met on an Adria flight out of Ljubljana and were firm friends by the end of the flight to London. She and her family were incredibly phlegmatic and resourceful in the face of the difficulties of everyday life in the Albanian capital. In the morning, Mrs Shehu would boil me two mugs of hot water on a picnic stove for washing and then lit a candle to relieve the gloom of the bathroom. The problem in the washing department was that the city authorities only let water into the pipes between the hours of three and four in the morning.

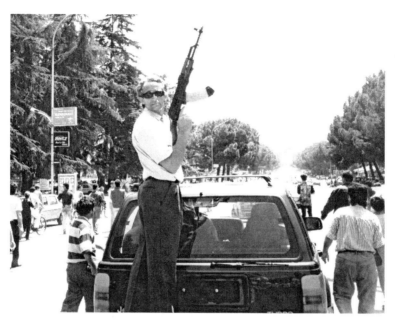

Armed men with a ferocious array of weaponry were a regular sight on the streets of Albania during the 1990s. This man was a bodyguard of King Leka.

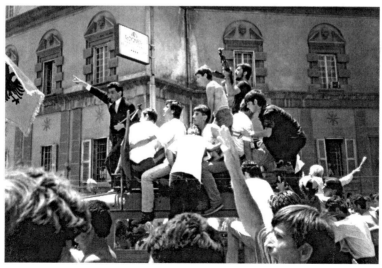

King Leka's attempted coup in July 1997. Leka and his supporters marched on the premises of the electoral commission which was counting the votes. A gun battle erupted shortly after this picture was taken in Tirana's main square.

So far as I could tell, all the women of Tirana got up at three, washed their hair, filled all available containers with water and went back to bed. I'm insufficiently motivated to get up for my ablutions at 3 a.m. so I had to make do with mugs, buckets and balers at eight.

But breakfast was unmarked by compromise. Coffee was made on the picnic stove and bread was toasted by perching it on the bars of the portable gas fire, and then turning the gas up to full.

As the electricity company hadn't pitched up to repair the damage somebody produced a ladder and some passer-by with extraordinary faith in his own immortality went up and joined the lines together again amidst a great shower of sparks and local applause. Then everybody repaired to the bar for an entirely justified celebration. Just another scene from everyday life in broken-down Tirana.

It was 5.10 a.m. when I momentarily thought the world had come to an end. An enormous explosion awoke me from my slumbers and drove the early morning songsters from the trees. The trouble was when you heard an explosion in the middle of Tirana it was either bad news, or very bad news. Somebody had, at best, had their property destroyed. At worst they'd gone up with it. Or, even worse, it might presage another bout of unrestrained anarchy like the beginning of '97.

They reckoned that more than two million guns, grenades, mortars and rocket launchers had been 'liberated' from armouries abandoned by the military. These were now in private hands awaiting some suitable opportunity for future use. Tinderbox was a quite inadequate word to describe the atmosphere in Albania.

But this particular explosion was a little different from the usual random stuff. Most come into the categories of, either, kids throwing a hand grenade to see if it actually explodes and, if so, how much damage it will do to the neighbour's dog, or, the liberation of any luxury goods which happen to have been left in the closed-up shops. A couple of weeks previously, in my least favourite town of Vlore, a crowd of particularly energetic young chaps had hauled the safe out of the local bank in broad daylight and chucked hand grenades at it until it sprang open, showering them with local worthless *lek*, for all the world like in some Clint Eastwood movie.

This time the target was the parked Mercedes of Tirana's police chief (*everybody* seems to have a Merc in Europe's poorest country). Couldn't happen to a nicer chap you might well think. However, it wasn't parked outside his own house at 5.10 a.m. What exactly he was doing is best left to the imagination but it does graphically demonstrate what an angry husband could achieve with just a few pounds of dynamite in a city where law and order has disappeared from the streets.

After drugs, the really big criminal business was in cars. It was Daly-Dreamland. Dodgy motors might not have been quite ten a penny but Europe's most de-luxe cars - virtually straight off the production line – were generally available for just a few grand.

Albania was a unique case study in the extreme results of economic collapse. Not only did the failure of pyramid investment schemes lead to the virtual impoverishment of an entire nation, but it caused the government to be replaced and the very apparatus of the state to collapse. Without the intervention of a military multi-national force, the so-called Alba Force, there can be little doubt that Albania would have terminally imploded. By 1997, most of the economic activity was controlled by criminals and even legitimate businesses were subject to widespread extortion.

Often said to be Europe's poorest country, it was initially puzzling for the visitor who would see vast numbers of luxury foreign cars on the streets - especially the ubiquitous Mercedes which was, and still is, particularly prized. Especially since, just six years previously, private car ownership was banned by the communist dictatorship and there were just 5,000 cars in the whole country to service the requirements of government officials and public service. By the beginning of 1997, it was estimated there were more than 500,000 vehicles in Albania - 60% of them Mercedes.

How the Albanians could afford these extravagant German status symbols - the average monthly wage was just $70 - became rather clearer when you learned that a staggering 80% of the cars on the road were stolen in Western Europe and imported, arriving by road either through Bulgaria and Macedonia, or by ferry from Italy or Croatia.

I researched this story for *The Daily Telegraph* in Albania and Frankfurt. A criminal told me how he would identify and steal a luxury car overnight in Munich or Frankfurt. By the time dawn

came, and the theft was discovered, he would have cleared the Austrian border with the last available computer tracking facility and be into former Yugoslavia at the Slovenian border. By early afternoon he would be on a ferry at the Croatian port of Rijeka bound for Albania.

Sold without papers, a Mercedes less than a year old could be bought in Albania for dollars for just $6,000 - less than £4,500. In the UK, the same car would cost between £20,000 and £30,000 . . . Of course, the stolen car could only be used within Albania where the authorities chose to turn a blind eye to the origins of most of the cars on the road and effectively connived by issuing new documentation.

My girlfriend Megan used to drive a brilliant red Ford Orion (rather dangerously - she bought her driving licence for US$100 from the relevant official) which seemed to be of German origin (it still had its international 'D' sticker on the back). The real giveaway, though, was when she opened the doors, with their bored out locks, and started the car with a bulky metal object resembling a Magimix cake mixer.

Older Merc models were even cheaper - and insurance write-offs and EU test failures were available for just a few hundred dollars. But, in Albania, no self-respecting driver *really* wanted a beat up old Merc.

An Interpol team went to Albania in 1992 in a bid to enlist the support of the local police. One of the team, a senior Italian customs officer, told me the following year, "They have been pretending to cooperate but really have just given us the run around." In fact, many of the underpaid police were actively involved with the criminals.

At an election rally in 1996, President Sali Berisha claimed Albanians' dreams of prosperity were being fulfilled by his government, "You dreamed of having villas instead of bunkers . . . you dreamed of owning a car and now Albanians have the highest number of Mercedes per capita in the whole world." He conveniently ignored the source of this manna from heaven - as he did with the pyramid schemes.

Despite the economic collapse, the car market still seemed to remain buoyant (although I noted in 1997 that a brand new Ferrari was on sale in the gangster town of Vlore at half price).

The Tirana daily *Dita Informacion* reported that "an Opel in good shape is exchanged for 60 Kalashnikovs in the southern town of Gramsch." Even some of the highest in the land seem quite unconcerned about the dubious origins of their de-luxe transport. Former Central Bank governor Ilir Hoti inherited a Mercedes from his predecessor but, when he took it to Italy, Italian police checked their computers and told him it was stolen. He got it back but most new owners of stolen vehicles would not be so lucky when customs officials routinely computer-checked the chassis numbers of vehicles at national borders.

One disadvantage of an economy where such a high number of cars are stolen is that a dealership network has never had a decent chance to get established. And without legitimate dealers there were no spares available . . . Spares were sold from the side of the road, typically on the outskirts of town, and these had been obtained - you've guessed it - by being stolen from the stolen cars. A major failure, or the need for something like a new engine, meant you really had to steal another car to get the parts.

On one of my trips to Albania, my driver pulled into a petrol station and was not quite quick enough off the mark. By the time he got out of the car, four urchins had moved in, whipped off the hubcaps and were away like greased lightning. Ten minutes later they would be on sale a few hundred yards down the road. "Pssst, want to buy four hubcaps stolen from a stolen car?"

Absolutely nobody parked their car on the street at night which made the streets look rather tidy come darkness. Vehicles were in locked and guarded compounds, behind high walls or in garages. Otherwise, they quite simply wouldn't be around in the morning.

Mrs Shehu was philosophical about all this mayhem around her as she went about her work carrying and boiling water and lighting the candles. "Albania !" she shrugged her shoulders. "The new Sarajevo."

Fifty years of repression under the regime of Hoxha, wartime occupation by the Germans and the Italians, and the ensuing chaos had failed to produce any viable working model for the people of Albania, so close to the West geographically but so far away culturally and politically.

Large areas of rural Albania are to this day still run according to

the mediaeval Law of Lek, known in its full form as the *Kanun of Lek Dukagjin*. The Dukagjin were the leading tribal chiefs in northern Albania. This primitive legal code is effectively a compendium of tribal and clan customs passed down since ancient times. Among other things, it lays down the conditions under which it is permissible to kill an enemy. In this, the preservation of personal honour and that of the clan, or *fis*, is paramount and it is, accordingly, responsible for the tradition of the blood feud. Blood feuds in Albania can span centuries: they only involve the men, not the women, thus explaining why the fields in some parts are full of women toiling away while their men folk drink and play cards at home, the excuse being it is simply too dangerous for them to go out! Killing is not punishable under the Kanun where the killer takes revenge the same day as the offence is committed. After the fall of communism, the Law of Lek, which had been discouraged by Hoxha, re-emerged, especially in the north. Probably the most spectacular example of this occurred in Tirana in February 1992 when a man was beheaded with an axe in a hotel lobby in revenge for a killing by his father forty years earlier in a village in northern Albania.

The device of assassination as a political tool also survives to this day. During the late '20s and the '30s King Zog is said to have survived more than fifty attempted assassinations, including one on the steps of the parliament building. With two bullets inside his body, he strode into the chamber and delivered a two hour-long speech which brought the chamber to its feet in a standing ovation. Then he took himself off to hospital and had the bullets removed.

In 1997, there was an attempted assassination of a Democratic Party leader within the chamber. He survived . . . but was gunned down the following September as he left party headquarters.

The parliament building featured in another colourful Zogist tale (of which there are many). The morning after his wedding night in 1938, he despatched the bloodstained nightdress of his wife, Queen Geraldina, an American-Hungarian beauty, to the parliament. This evidence of his prowess, and the virginity of his new found wife, is also said to have brought the deputies to their feet. Far removed from the experience of our own dear Queen.

To his credit, Zog did bring a degree of entirely temporary peace and stability to his country. At the suggestion of the British government, he engaged three retired Scotland Yard police officers

to train his own police and advise on internal security. They came up with a spiffing idea. Whenever the local hooligans got out of control in a particular town or region they went in with the local police and oversaw the summary and random execution of half a dozen or so local males. It worked. Peace descended on fractious rural Albania.

The royal family swallowed up a significant percentage of the national budget during the 1930s. They built a summer palace on a hill above Durres which was said at the time to resemble a casino in one of the poorer Belgian resorts. It was looted in 1997 and is now the home for a forest of cellphone antennas. A loan from the Italian national bank was used for the supply of extravagant white uniforms for Zog, black SS-style uniforms for his sisters, known as 'The Zoglets', and a consignment of damp and useless ammunition.

The Zogs were obliged to flee in 1939 as the Italians invaded. At least they were able to do so in some style in a brilliant, scarlet-coloured, white leather-seated open Mercedes sent by Hitler as a wedding gift (the English king sent a telegram). This was the beginning of a spectacular peregrination around Europe courtesy of the Merc and the Orient Express: the British Foreign Office referred to it as 'King Zog's Circus'. As Paris fell, they were motoring to Bordeaux amidst dreary lines of refugees. Dive-bombed by German planes, King Zog refused to exit his motor, apparently declaring, "The pilot is not yet born who would fire on the Fuehrer's car."

During the war, Albania was regarded as a posting too far, worse than Stalingrad, by officers of the Wehrmacht. They found the locals impossible to deal with. The Germans tried to raise an SS division in Albania (they had more successfully achieved this with the Kosovo Albanians who provided the 20,000 strong Skanderberg Division), but this provoked fearful rivalry amongst Albanian army officers and the proposed promotion of a mere Captain to SS Colonel led to his assassination as he left German headquarters dressed in the full uniform of an SS Colonel. The Germans were furious at the execution of their man and demanded suitable punishment.

The General who had instructed the assassination was summoned to the office of the ruling Regent Mehti Bey who

admonished the fellow before the German commanding officer. "I require you to apologise to our dear German friend for the terrible mess you have occasioned on his doorstep. Next time you have to shoot one of their officers, make sure it is done in the barracks and not on the street." The Germans were furious.

Then there were Hoxha and his Communists in the hills, the Zogists looking to the Ritz Hotel in London for inspiration and the rebels of Balli Kombetar. The Italians surrendered in 1944 and soldiers who got detached from their compatriots were sold in the markets at one gold napoleon each as beasts of burden. The more unfortunate ones were eaten by starving Albanians. The British secret agent Colonel David Smiley unwittingly had a particularly tasty meal of Italian soldier stew from his Albanian hosts but, being a polite English gentleman, forebore to complain.

Queen Geraldina duly provided the newly established and newly dispossessed Zog dynasty with a male heir in the form of Crown Prince Leka. It is worth noting that Zog was, until 1928, a mere tribal chieftain who became president and then rather promptly declared himself king. In the wake of the disintegration of Albania during the pyramid scheme collapse at the beginning of 1997, King Leka returned to claim his throne.

You might have expected that Albania's king-in-waiting, King Leka 1 might be one - maybe the last - of Albania's gentlemen. After all, he almost became an English gentleman after living at the Ritz, private education and military training at Sandhurst Royal Military Academy. Leka declared that he was newly arrived to unite his people. This was a noble concept in a country where everything seemed to be terminally fragmented. They said he was the tallest man in Albania, at six foot seven inches - in a land where rather a lot of men resemble stunted garden gnomes. He certainly stood head and shoulders above his potential subjects. That also made him an ideal target for snipers - which meant he was constantly surrounded by trigger happy thugs who didn't exactly serve to promote the kingly image.

In the first week of June 1997, the descent of Leka from regal persona to illegitimate hooligan was mirrored by a certain sartorial decline. On the Sunday - as all good Albanians turned out to vote under the barrels of the guns of NATO troops supplied by Operation Alba - King Leka-to-be was voting in a sober suit. By

Tuesday, a powder-blue safari-suited Leka was claiming 'trickery' was about to deprive him of his throne. A press conference at the lavish, Austrian-owned Rogner Hotel was monopolised by his own thugs who had packed the hall in advance of the world's press who, disconcertingly, could not actually get in there for a large band of chanting and screaming royal enthusiasts.

On the Wednesday, he failed to show as his supporters massed in town. When police attempted to break up the demonstration an interesting confrontation developed. A white van screeched to a halt and decanted members of the ruling President's Presidential Guard. One brandished a loaded rocket-propelled grenade launcher: a fearsome weapon in a crowded city centre square. Exit forces of the police.

By Thursday, Leka was on show again, surrounded by dozens of the now familiar thugs. He had three principal bodyguards: a long-haired lout with more magazines taped to his AK-47 machine gun than any self-respecting soldier might expect to use in 24 hours; an enormous gorilla-like figure with grenades hanging from his belt and which clanked together like the old joke about the orang utang swinging through the jungle; and a character in full paramilitary police uniform and dark glasses. These unprepossessing chaps were directed in their general levelling of weapons and darting about by a glamorous girl: tall, lithe and with long black hair, she told me her name was Loretta. Unfortunately, and most disappointingly, she was a complete loony - obsessed with the regal persona and his indisputable right to the throne, blah., blah.. Yawn, yawn.

Leka himself was by now cutting a rather ludicrous figure. He was sporting combat fatigues, a grey beret and had two pistols stuck into his belt. His so-called 'court minister', a nervous besuited fellow much given to waving his arms about, seemed to resent suggestions that this it was unreasonable for the king to be tooled up. It was, apparently, perfectly natural for a king, who had lived virtually all his life in exile in Britain and South Africa, to carry pistols and wear a uniform. "When he was born, King Zog put a revolver under his pillow." So there. Another story goes that his English nanny asked what he was playing at with his rows of lead toy soldiers. "Firing squads," it is said he replied.

King Leka addressed his supporters in the main square and then led them down the Boulevard to the offices of the election

commission allegedly denying him his rightful throne. This was a strategic miscalculation.

A cursory study of history would have revealed that the main Boulevard of Tirana was constructed by dictator Enver Hoxha not just with the objective of providing a generous thoroughfare for the enthusiastic plaudits of the workers, but it was also designed, in case anything ever should go wrong, to facilitate a clear field of fire.

Almost as soon as the protesting royalists reached their objective they were scurrying like rabbits for their burrows as police machine guns raked the boulevard with fire. One of his supporters died and another was seriously wounded as fire was exchanged. Leka himself was now seen sporting an Uzi machine gun. I took cover in the Rogner Hotel, which turned out to be an excellent decision. It was stoutly defended by Austrian special forces who had been installed to evacuate, if need be, the election monitors.

By then it was a case of My Kingdom for a Landrover as Leka was borne away to safety. Just a few days later he was on the plane back to South Africa and the peace and quiet of his successful arms dealership.

The story was not yet over. At the beginning of 1999, he was arrested by South African police on a charge of illegal possession of arms and later, in November 1999, he was sentenced to three years jail *in absentia* by a Tirana court for his part in that rally. The state prosecutor had, in fact, asked for a life term on a charge of organising an armed insurrection.

Then, in the autumn of 2002, he miraculously reappeared in Tirana. Truly a second coming, all forgiven, apparently. Faraway in Sri Lanka, I observed his return courtesy of BBC World. Around him, I recognised the same dark glasses, the same unruly mop of hair. He was doubtless relieved to be met at Tirana'a airport by the same loyal thugs as had protected him last time around.

Albania does not boast a king these days. But it does boast a faltering, nascent democracy. My girlfriend Megan had the right idea. She ultimately married an EU citizen and now she and her family are all Dutch citizens living happily in peace and safety.

Albania still has more than a little way to go.

Six

Travelling in Style

Bosnia, Eritrea, Somalia

Hermann Goering had a special convertible model built to take him to war. The Skodas which took me me around the battlefields of Bosnia were two production line, three-year-old Rapid Coupés: they ran there for more than four years, suffered the most appalling abuse and covered almost 100,000 kilometres - much of it over unsurfaced roads - throughout Slovenia, Bosnia, Serbia, Kosovo, Croatia and Macedonia.

In the early days of the wars in former Yugoslavia most journalists simply pitched up at the car rental desks at the airport and disappeared into the distance in a freshly valeted saloon. A considerable number of these hire cars, hardly surprisingly, never returned to base. In Slovenia's brief ten-day war the combined hire car fleets of the newly independent state were decimated by an estimated 50%, largely thanks to the efforts of journalists. At best, cars were returned in a rather different condition from that they went out in . . . During the Croatian war of 1991, local fighters around Pakrac were most insistent on the necessity of spraying my gleaming white Hertz car with camouflage paint. Hardly surprisingly, the hire companies started inserting war zone exclusion clauses in their contracts. This had appalling implications - especially for freelance journalists like myself. A TV cameraman of my acquaintance overturned his rented Lada Niva in central Bosnia, cheerfully reported the loss and was considerably put out to find a $15,000 debit on his company American Express card the following month. The company accountants were even more upset. *The Independent's* defence correspondent, Chris Bellamy, was following me along the rather difficult Route Triangle in central Bosnia when I saw, behind me, his rented car running inexplicably off the road. It was not a good time for him to be searching under the dashboard for his notebook. However, a nice man from the SAS helped recover his car which was, alas, a non-runner by that time.

The Daily Telegraph
MOTORING

SATURDAY, JUNE 10, 1986

MOTORING

How my Skoda went marching on in Bosnia

Vehicles are constant casualties of war, especially those used by the press. Here, **Paul Harris** tells how his car won the day

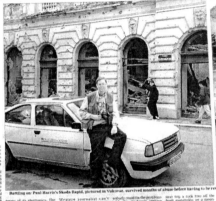

Rattling on: Paul Harris's Skoda Rapid, pictured in Vukovar, survived months of abuse before having to be rescued by friendly Danes, right, when the electrics failed

The Skoda achieved a great deal of notoriety in the war zones of Yugoslavia and The Daily Telegraph caught up on the story. Skoda were delighted and offered me a free car. I didn't take up the offer: they had done away with the rear engine and twin carburettors and the more modern models just didn't cut the rug for me.

Driving could be hazardous in Bosnia. Defence correspondent Chris Bellamy, who worked for The Independent, ran his hire car off the road on Route Triangle, the supply route created by the British army. As we contemplated the wreckage a British SAS man appeared on the scene and gave him a hand. He was a bit shy about being photographed, though.

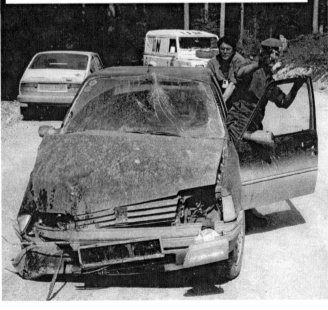

110

As rental ceased to be realistic - and the risks increased - the larger newspapers and broadcasters moved into customised and armoured vehicles. At anything up to £150,000 a time, this was hardly an option for your truly but with three cars sitting outside my house in Scotland I decided to export one to the frontline. The Rover seemed too good to condemn to what seemed like almost certain death in Bosnia, and my 1948 Sunbeam Talbot 80 would have been a mite tricky on spares. So it was call-up time for the three year old Skoda Rapid Coupé.

I'd been attracted to it by the *Autocar* review in 1988 which surprisingly compared the handling to the Porsche 911, " . . . handles like a Porsche . . . more fun than a GTI." It was, indeed, an extraordinarily nippy little fun car and if it hadn't been for the social approbrium I would have been a truly enthusiastic owner. And it had been decisively refused an MOT by a local garage which then offered me a derisory hundred quid for it, saying "really we shouldn't let you even drive it home." I was offered £600 as a trade-in against a new car. About the same as a two week car rental, in fact. So it was Bosnia for what was regarded as a write-off in the UK motor trade.

Effective 'write-off' value was an important consideration. It was, of course, quite impossible to insure a car at all in Bosnia during the war and there was only a limited form of third party border insurance available for Croatia and Serbia. But the good news was that no MOT was required and so it was possible to simply drive a car into the ground. Most journalists have tales of their cars being stolen in the war zone but here the Skoda scored: nobody wanted to steal a highly conspicuous right hand drive vehicle - and a Skoda at that. The car soon became well known to the police and military on all sides, all over Bosnia.

Skodas, generally, are also well known to mechanics throughout the Balkans, although my model proved a little advanced for some in terms of its electronics. The car's performance over the unsurfaced, dirt track and mountain roads of Bosnia was quite extraordinary. The combination of rear-engine and rear wheel drive with semi-trailing arm rear suspension - designed by Skoda in cooperation with Porsche - gave excellent traction. As a precaution against both bad roads and mines, I had steel plates welded underneath the car

in Slovenia, to protect the brake and fluid lines and to afford some minimal protection against mine damage, in case the worst should happen. It was virtually impossible to push the 1289c.c. engine too far but, together with the petrol injection, there always seemed to be enough power. In Christmas 1994, after four feet of snow had fallen on the mountain passes, an officer in the Royal Highland Fusiliers told me there was absolutely no way I could get out of central Bosnia without 4-wheel drive. And I hadn't dared to admit that my snow chains had disappeared. In the event, the tiny Skoda sailed past heavier 4-wheel drives and army trucks hopelessly bogged down in the fresh snow.

The sleek, rather un-Skoda-like lines of the Coupé driven on British plates and sporting the St. Andrews Cross of Scotland tended to occasion curiosity wherever it went. Police and military checkpoints were a universal feature on virtually all the roads. Skoda jokes also seem to be universal. Serb policemen cheekily enquired why a supposedly rich western journalist couldn't afford a proper car.

The car was a great icebreaker at normally tough checkpoints. There was usually guaranteed to be an officious chap who wanted to look everywhere. Inside, under the seats and in the boot: sometimes he insisted on the 'boot' being opened up. Making sure the others were in on the joke, I made a great show of refusing. "Nothing in there." Then I would shrug my shoulders and open up the 'boot' - to reveal the engine. Everybody got a good laugh - and then the inevitable drinks and cigarettes were handed round.

It got me places an ordinary car wouldn't reach. In the second year of the Bosnian war, I travelled the notorious northern corridor - the Serb 'lifeline' through northern Bosnia - without any of the many necessary permissions. It was partly down to the ostentatiously bizarre nature of the car and partly due to the strategy of giving lifts to the drunken and licentious soldiery.

"Take us to kill Croatian *ustase* in Brcko !" Camouflage-clad young Rade gestured insistently with his Kalashnikov and breathed his beery breath on my driver Igor and I through a set of spectacularly broken teeth. Waylaid outside a smoke-filled bar packed with soldiers in Prnjavor in northern Bosnia, we could hardly fail to be impressed by his zeal for killing Croatian 'fascists'.

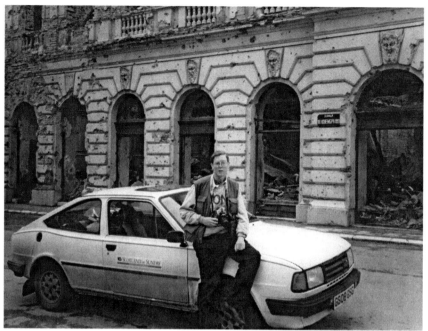

The faithful Skoda which, denied an MOT in Britain, did more than 100,000 miles around the war zones of Yugoslavia. This picture was taken in battle scarred Vukovar, Croatia.

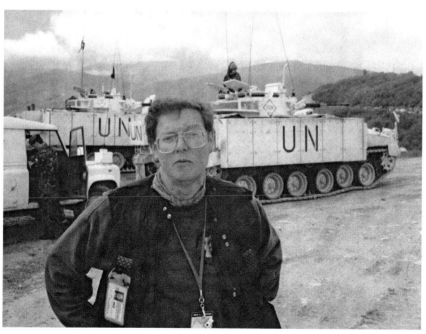

In central Bosnia, 1995. In the background is a Warrior armoured fighting vehicle

But it was much against our better judgement that we reluctantly agreed to take him and his fellow fighter, Goran, to the front. We were in the so-called 300 kilometre long 'northern corridor' and only too well aware that to have two uniformed and armed Serbs with us could indeed be something of a mixed blessing: on the one hand, a distinct advantage at the Serb checkpoints for two journalists travelling without permission in a sensitive zone but, on the other hand, a tempting target for the Croatian snipers and mortar positions just two or three kilometres to the north and south of the road.

The 'northern corridor' snaked its tortuous way through northern and eastern Bosnia, connecting Serbia proper to the Serb strongholds in Bosnia and Krajina. It was the only supply link: as such it was then the indispensable key to the creation of a Greater Serbia.

Until August 1992, parts of the northern corridor were held by Croat and Muslim forces making the passage of Serb supplies and war materials virtually impossible. So, that summer, Serb forces drove a 10 kilometre wide corridor through their enemies' positions. Although this strategic corridor was heavily defended, it remained under constant pressure.

The evidence of the fighting was to be seen on both sides of the improvised route. Not just in the shattered buildings or, indeed, the shell and mortar holes in the road itself, but in the Bosnian Serb military presence: aged T55 and T72 tanks, a few of the more sophisticated M84s; military trucks and buses packed with soldiers continually on the move; and tense groups of soldiers or white-belted military police in control of every junction and crossroads. Now it was a tarmacadamed road, then little more than a cart track, now a newly-built stretch of wide dirt track. We alternately sped and lurched past towns and villages which had seen some of the most appalling massacres and cleansing of the bloody Bosnian war. We drove through the rolling countryside and fertile soil of the Sava valley to Derventa - the deserted apartment blocks on its northern outskirts presenting their blackened, shell-shattered facades to a wasteland of destruction, the smaller dwellings once standing in their shadow now reduced to piles of rubble.

Then, along the banks of the River Bosna to Modrica - riven by siege. When I had stood above the city the previous May, I had

observed its gradual destruction as both sides poured shells into the other's sector. Now I could observe the incontrovertible evidence of its pointless destruction. As we rumbled over an improvised Bailley-type bridge, I passed under the hill where I stood less than a year ago and witnessed those early throes of death.

And on to Brcko where, a year previously, I had watched maybe 15,000 people flee in one single weekend. Now the the ruins of a once thriving industrial city and port on the River Sava were eerily deserted. The northern and eastern suburbs of the city were still being fought over. The area around Brcko was one of the few parts of Bosnia where the Muslim-Croat military alliance still survived against a common Serb enemy, whilst Muslim and Croat fought it out in central Bosnia.

Meantime, from the back seat, we were treated to a relentless diatribe from young Rade. Three years in the army and he had absorbed some curious ideas. He was convinced that Germany and the US would attack the Serbs of former Yugoslavia. "We are ready for them. We will destroy them." Now an afterthought. "Will you English also attack us?" I neatly side-step this one in my usual way. "I am from Scotland. You should understand Scotland is a separate nation from England. We are different." He seemed to be well satisfied by this nationalist explanation.

Now came a mildly sensational piece of news to which we had not been privy. "Already we have shot down one US AWACS plane." This was announced with evident pride as his finger insistently jabbed my shoulder. "Be sure you write this truth in your newspaper." His friend, Goran, unnervingly prepared his Kalashnikov for firing. Weapons handling was not a strongpoint with these chaps. They tended to treat their guns like movie props. NATO no-fly-zone or not, two Gazelle helicopters flew low overhead barely above tree-height in the direction of military headquarters in Banja Luka.

As we reached the checkpoint at Modrica, the bombastic Rade had a sudden change of mind. He was not going to kill *ustase* in Brcko after all. We were glad of this, if only to rid ourselves of our increasingly tiresome passenger. Instead, he now planned to meet up with military drinking buddies in Modrica Lug. We were mightily relieved as he lurched off and I was gratified to note that

he was stopped by the military police and appeared to be getting a hard time of it over the state of his travel papers.

Near to Brcko, Goran left us for his unit and we were now on our own to deal with the military checkpoints. It was mid-afternoon and our progress came to a halt at the checkpoint outside the eastern Bosnian town of Bijeljina. Passports and press cards were this time insufficient to get us through a rather more thorough check. We lacked the necessary permission from military headquarters in Banja Luka. Of this I was, of course, only too well aware. I also knew we would never have been granted permission to travel this road so I hadn't even bothered rolling up in Banja Luka to be kept waiting in order to to learn this rather obvious piece of information.

We were detained at the side of the road by a not unfriendly group of military police and their less compromising commander. They were all fascinated by the Skoda. Part wonderment at how it managed to get to the war zones of former Yugoslavia, part the usual amazement that a western journalist apparently couldn't afford more opulent transport. The hours passed and darkness fell as telephone calls were made. Around 8 p.m. we were instructed to proceed to the nearest police station and from there were taken to the local HQ of the Office of National Security where our passports were confiscated. We were lodged overnight in the local hotel. Or at least that is what it was in better times. It was now a hostel for soldiers and showed signs of widespread military abuse: the wardrobe in my room appeared to have been opened with a Kalashnikov. Bullet holes were splayed across the doors, both of which now flapped uselessly open.

Questioning started at 8 a.m. prompt. It was something of a parody of interrogation techniques; second rate B-movie stuff. A plainclothes officer did it from the textbook. "It is no use to deny things. We know that your passports are forgeries. You must confess what you are doing here." My driver, Igor, got the treatment first.

Waiting in the corridor outside I was earnestly engaged in conversation in halting German by a burly bull-headed, but altogether genial, denizen of Serbian Security. He tells me he must learn German for his job. He clutches a thick, well-thumbed dictionary in his hand. I ask him in a simple sentence of German

if Bijelina is his home town. He refers to the dictionary looking up the word town, the word home, and so on. Communication is slow and ponderous. His job is apparently very important.

"When the Germans come and attack us it will be my job to interrogate the prisoners." This could be a long war. Meantime, he is conscientiously taking every opportunity to spruce up his command of the language. Our conversation comes to an end as I am summoned for interview by a gap-toothed, leather-jacketed operative of state security.

My questioners have a basic problem. As they do not speak English - and I am not prepared to admit to any knowledge of Serbian - they are obliged to use Igor for translation. The interview accordingly is leisurely in its progress and working out acceptable answers is not that difficult.

Igor: "These chaps say your passport is forged. That's not true is it?" "Now they say you're a spy. That's nonsense isn't it?" Establishment of my own identity beyond the shadow of a doubt is not too difficult either: press cards from the UN, Republic of Krajina and Tanjug in Belgrade; letters from the editor of *Scotland on Sunday* and the BBC; driving licence, credit cards, National Library of Scotland reading room ticket and Amnesty International membership card - this last, curiously, impressing them the most. I shower them with pieces of paper, all of which are religiously photocopied.

My questioner is fast building up a thick file. This is clearly Very Important. I am asked how many times I have visited the war zones of Yugoslavia. When I reply "twenty-eight" my questioner looks mildly shellshocked. I bombard him with quite useless and irrelevant bits of information: a description of the long journey by car from Scotland, my work and holidays in Yugoslavia before the war, and so on, and so on.

Eventually, he barks out a command to a colleague outside the door. Nothing as final or quite as exciting as instructions to form up a firing squad. The door opens and a tray laden with glasses, coffee and real Napoleon brandy appear as if by magic (apparently stolen from an impounded lorry parked outside which is being industriously emptied onto the pavement). Now, the business apparently over, all is, quite suddenly, smiles and *bonhomie*. We

are obliged to remain another hour to drain the bottle with our erstwhile captors after which, amidst much back slapping and handshaking, we are waved merrily on our way. Control over drinking and driving is clearly not a priority around here.

On another notable peregrination, I treated the reporter for the US military paper *Stars & Stripes* to a Skoda-ride through the war zones. Bill Sammon was an affable type, if something of a greenhorn. I met him at a press conference given by the French military and he revealed that just six weeks previously he had been working as a reporter on *The Plain Dealer* in Cleveland, Ohio. Not an ideal training for Bosnia but I offered to take him under my wing.

We drove up to Tuzla in a three car convoy accompanied by Jon Swain of *The Sunday Times* and Erich Rathfelder of *Tageszeitung*. It was just as the news of the fall of Srebrenica broke.

The drive was marked by the usual litany of front line experiences. At one point, Bill disappeared off to relieve himself. He must have been well hidden because we all resumed our journey, believing him to be in one of the other cars. Fortunately, we were halted at a Bosnian checkpoint just a mile or so ahead when an out of breath Sammon caught up with us. At another stop, he left his notebook on the roof of the car. He remembered it a few minutes later and I reluctantly turned back.

We espied two local youths dragging the day's trophy along the road, an old tin bath. As we passed, Bill let out an anguished yell. His notebook was lying, safely retrieved, in the bath. He had to part with a few Deutschmarks, but at least he got his notebook back.

My driving seemed to impress him. He wrote about it in *Stars & Stripes*. 'Harris plows [sic.] forward like a man on a mission. Skidding near the edges of sheer cliffs without guardrails, veering past pedestrians at the last possible moment, nudging the bumper against the rumps of stubborn sheep – these are simply the things one does if one wants to make Tuzla on time, Harris seems to believe.'

The drive to Tuzla was, though, well worthwhile. Not only did we witness the arrival of thousands of very young, aged and female refugees with their harrowing tales of the mass murder of their menfolk, in the worst single instance of genocide in Europe since 1945, but Bill discovered a US Ranger called Guy Sands (Major) in charge of Tuzla airport. He was wearing the uniform of the US

Rangers. Sands opened up to Bill due to his being from an official US War Department publication. It was a great story, finding US Special Forces, operating in darkest Bosnia and we both did well out of it. I wrote it up for Jane's, did a couple of BBC broadcasts and a report for the *Washington Post*. Sands turned out to to be an interesting character. He wasn't in the US Rangers at all but was a sort of military spook. General Sir Michael Rose had him thrown out of his headquarters after he found him rummaging through the drawers. He has more recently rolled up in Afghanistan on a civilian-military cooperation programme. Believe that one and you'll believe anything.

On rather better roads, there were all the speeding tickets gunning the fastest Skoda in the West through Croatia and Slovenia on the way home. I particularly remember one unpleasant situation just over the Slovenian border.

I had driven six or seven hundred kilometres out of Bosnia and then Croatia after several weeks on the frontline. Reaching Slovenia was an enormous relief: at last, a country at peace with itself, a degree of safety and decent roads. Through the border control, I gunned the twin carburettors that lurked under the bonnet of the Skoda. Three or four hundred metres ahead, two policemen emerged from the bushes onto the road and flagged me down. It soon became clear they intended to throw the book at me: speeding, dangerous driving, driving without seat belt, driving with a car in a dangerous condition (multiple bullet holes), etc. etc. It was getting expensive so I decided to play my trump card.

A few months previously I had enjoyed morning coffee with Slovene President Milan Kucan, a most amiable and, in Slovenia, universally respected man. I had jokingly observed that I sometimes had problems with the authorities as a journalist. He took out one of his splendid embossed business cards and wrote in his own handwriting a brief endorsement: 'For Paul Harris, a true supporter of Slovenia in its fight for independence. With respect, Milan Kucan, President'.

I presented the card to the officious guardians of law and order. I swear their mouths fell open. They were rendered momentarily speechless. Then, simultaneously, both sprang firmly to attention, saluted smartly and waved me on . . .

Twenty months of abuse eventually proved too much for the first faithful Skoda. It packed up in Tuzla, in the very north of government-held territory within sight of the front line, and, of course, nobody could fix the problems with the electronic ignition and electric petrol pump. That would have been the end - if some obliging Danish UN chaps hadn't promptly loaded it into a truck and driven it three hundred miles down to the Croatian coast at Split. Alas, all fixed up, on the next trip a rock tore off the front suspension on a mountain road, reverse gear disappeared, and the shock absorbers gave up the unequal struggle. Incredibly, it still ran and limped back to base.

Back in Britain, I got hold of a five year old 136 Rapid Coupé. Lacking the demanding electronics of the 135 it could be fixed more easily. Nevertheless, it almost failed to survive its first trip. Just outside the British base in central Bosnia somebody chucked a hand grenade. I'm not absolutely sure whether the grenade actually bounced off the passenger window breaking it in the process, or the glass was just blown in by the blast. But the British army, in the form of good old REME, came to the rescue with some beautifully fashioned fibre glass and I was on my way again. The only problem was that I could no longer wind the Plexiglass windows down.

The 136 seemed a trifle sluggish. Indeed, its performance over successive peregrinations around the battlefield saw it get slower and slower. Eventually, after one trip, the mechanic solemnly announced that I'd actually got it back running on just one cylinder. Fortuitously the old 135 still lay in his yard, abandoned but not entirely forgotten. So, we popped the engine from the 135 into the 136. Two years later, it was still running like a bird with a couple of hundred thousand kilometres notched up. Then I gave it to a Scottish charity of which I was a trustee and Connect successfully ran the car for another couple of years. Alas, it met a sad fate. Having survived the war zones of the Balkans, a beautiful but slightly dippy Iranian actress friend parked it on the steet in Sarajevo. Once the real war was over, the Bosnian police became curiously energetic about trifling matters like parking and all of a sudden they seemed to have an inexhaustible supply of trucks undamaged by war to lift away illegally parked cars.

The Skoda was duly lifted away, meeting an untimely and undignified end in the crusher of Sarajevo town council, a victim

of the unpaid parking fine. I have to say I was very sad and felt it was a rather unfitting end for a vehicle which had given such sterling service to Bosnia.

Nothing beats having your own vehicle and driving yourself in a war zone. Local drivers can work out to be splendid chaps of the highest moral fibre, incisive intelligence and developed instincts. But, usually, they turn out be seriously flawed in at least one of those departments.

In eastern Sri Lanka a spot of midnight shelling over the roof of the hotel in Batticaloa led the driver to vacate his room and spend the night on the beach. In the morning, he blithely announced over breakfast that he was off, back to the capital Colombo and that I should either accompany him or make my own way in the world. I told him to clear off and come back on Saturday (which he didn't do) and was not altogether sorry to see the back of him. I had only discovered at our first pit stop that he had a prodigious appetite for alcohol, which he expected me to finance.

Travelling in India I developed the technique of open auditions for drivers. I would go to the busiest local taxi rank and announce that I required a driver. They would gather around like flies but a few sentences of interrogation in the Queen's English would soon establish who had a reasonable command of the lingo: there's absolutely no point in taking on a driver who can't understand a word you say. Having disposed of most of the applicants you could quickly sort out who to engage. Following the Sri Lanka experience, my preference has always been for good Muslim drivers who don't drink and, ergo, tend to be much more reliable. Except in Baghdad, I suppose.

The most dangerous place to hire a car and driver, or a taxi is at an airport. This applies virtually anywhere in the world. Fresh off the plane, even if not exactly an innocent abroad, you are still, jetlagged, disorientated and disorganised, easy meat for predators. The best you will get off with is being ripped off. The worst is ending up deceased. Some airports are worse than others.

Algiers is one of the worst: taking a cab at random there during the 1990s was almost certain to be the last thing you would do such was the control that militant fundamentalists exerted around the capital. The Algerian government, give them their due, didn't

want to lose you either. It's very bad publicity having journalists knocked off. When I went to cover the election there in 1997, the minibus on which I travelled in from the airport had police cars front and back, motorcycle outriders and half a dozen Interior Ministry close protection agents aboard.

In hazardous locations like Algiers, Moscow, Karachi or Tirana, it's pretty well essential to arrange to be met: by friends, other journalists or, hang the cost, the hotel limo. Of course that's all assuming you get there in the first place. Airline services in the remoter, strife torn parts of the world can be, er, interesting. They'll never get voted the World's Most Favourite Airline in some posh magazine, but Djibouti-based Daallo Airlines was an outstanding outfit that certainly reached the parts other operators couldn't reach.

In the Horn of Africa - where everybody sometimes seems to be fighting someone - Daallo soared high in the sky where others feared to fly. Tiny Eritrea was locked in an on-off war with neighbour Ethiopia in the summer of 1998. Ethiopia uncharitably threatened to shoot down civil aircraft using the airport serving the capital, Asmara. To prove the point, they both bombed airports on each other's territory and Messrs. Lufthansa, Egyptair, Yemeni Airways and Saudia all chickened out. Even the locals, Eritrean Airways, packed it in. Something to do with the tedious business of insurance cover which, apparently, didn't bother Daallo too much.

So Daallo was flying in and out three times a week. Who, you might ask? So did my travel agent. When I eventually got a number from the Eritrean Embassy in London I called Daallo in Dubai. A jolly-sounding fellow said they would certainly get me to Asmara if I met him behind the potted palm in the Transit Lounge at Dubai airport. Sorry, say that again? Well, we don't take credit cards, so please have US$500.00 ready in the proverbial brown envelope. Well, you see we're not actually supposed to sell tickets in the Transit Lounge.

Somewhat to my surprise, the transaction worked splendidly. My seat was already efficently reserved against my telephonic order and a boarding pass was duly passed over beside the potted palm. At the gate, the departure indicator suggested a mini-tour of the hellholes of north east Africa: Djibouti (arid desert state of French Foreign Legion fame), war zone Asmara and, then, on to Mogadishu, capital of blighted Somalia.

At Djibouti, Beau Geste's favourite airport, there wasn't much parked on the tarmac. A lot of French Foreign Legion helicopters in freshly painted camouflage taking off and landing . . . and an interesting looking biplane. It was a long time since I'd seen one of these at a commercial airport. I confess to more than a twinge of disappointment when it transpired we were not travelling in the biplane. Instead we clambered aboard an ancient Tupolev which had just one word painted in capital latters on the fuselage: TAJIKISTAN. Apparently, the sometime personal transport of the president of that benighted country.

As it happened, my $500 had secured me a seat in so-called business class next to the managing director of Daallo on the flight into Asmara. "This is the first daytime flight so I though I should be on it." As an afterthought he added, "The Ethiopians have been threatening to shoot us down so we've always gone in at night before." Thank you very much for making that clear. Apparently Daallo took a certain pride in serving the more difficult destinations. They were then serving six locations in Somalia, as well as Somaliland, the newly self-declared republic unrecognised by anybody. The only time I'd ever flown out of Somalia in the past, gunmen fired at the aircraft just for fun.

The aircraft which comprised the Daallo fleet were straight out of *The Old Curiosity Shop*. Today it's a Tupolev 154; it was early sixties vintage. Interestingly, the seats raked both backwards and forwards so some passengers faced one direction, the others the opposite. Some of the seats just collapsed when people sat in them and passengers prostrated themselves on the sedentary debris. I was very lucky. It was just the seatbelt which didn't work.

The crew, though, were very unobtrusive. The pilot and co-pilot sported T-shirt and Y-fronts. There was none of this boring emergency exit stuff. Out of Dubai, most of the passengers appeared to have brought their suitcases into the cabin with them. They just piled them in the places where there was most room . . . the emergency exits. Mr Daallo went on to tell me that he hired all his aircraft, complete with crews, from Tajikistan. He said the pilots were very good.

"The pilot today used to be Mr Gorbachev's personal pilot - as well as a test pilot in the Soviet air force. He's got 15,000 hours but

can't get a job back home." Apparently, we are in good hands. It did seem, however, that the creaking old crate would never get off the ground from Djibouti.

Actually, the landing was one of the smoothest I can recall in a rather long and varied aeronautical career. All that was left was a taxi-in through a row of neatly parked fighter aircraft. Very reassuring. The $500 flight even seemed rather good value compared with the $3,000 a head paid by the 25 journalists who had flown in on a private charter from Nairobi.

The last word might go to the barman at Dubai Airport who had politely asked which airline I was flying with.

"Daallo," he raised his eyes beseechingly to the sky. "Inshallah Airlines, as we call it around here."

Well, God *was* willing and I *did* get there.

All flying is essentially a hazardous undertaking. But some war zone airmen are indeed magnificent men in their flying machines. I met Hugh Pryor over Christmas of 1998. Christmas never really came for the crew of UN flight Tango One. Neither was there much time for new year celebration for the air crews flying emergency relief into flood-hit Somalia. Seven days a week working up to eleven hours a day, Captain Hugh Pryor and his co-pilot were flying their small Twin Otter prop aircraft out of its base in northeast Kenya and into the wild fastnesses of Somalia, bringing emergency food, blankets and medical supplies to remote villages cut off by floodwaters.

Famine, war, flood and disease. There seems to be an almost Biblical inevitability about events in benighted Somalia. It seems impossible to halt the cycle. Weather, land, climate and people all seem intractable, implacable.

The airlift was run by the UN's World Food Programme (WFP) from a single runway by the town of Garissa in the far north of Kenya. As the River Juba — normally just 50 metres wide — overflowed its banks and spread over an area up to 35 km. wide, WFP chartered aircraft and brought supplies into neighbouring Kenya.

Of a morning, the small apron was packed with the aircraft: three Russian MIL-8 load-carrying helicopters, a couple of large Buffalo transporters, a Cessna Caravan and the Twin Otter.

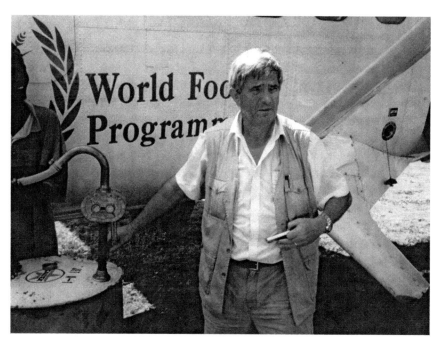

Hugh Pryor was a remarkable daredevil pilot who flew desperately needed aid into war-torn Somalia. Here he fills the tank of his Twin Otter.

We flew low over the wreckage of a Twin Otter downed the previous week in Somalia. If the locals had been eating the narcotic leaf known as kat then they tended to fire at the World Food Programme aircraft after they had deposited the aid supplies.

Overnight, they had been refuelled, repaired and loaded. By 6 a.m. they were lifting off in the early light and would not return until dusk, refuelling and resupplying at improvised dirt landing strips and narrow ribbons of road in Somalia.

The aircraft could not operate out of war-torn Somalia. The underwriters at Lloyds and the charter operators preferred the safety of a Kenyan base. Just six weeks of aid was reckoned to have kept 25,000 families alive in the lawless land which was, and still is, Somalia, where civil administration has collapsed and a network of competing local warlords and their armed militias have long ago taken over.

I found there was more than a dash of *Boys Own Paper* derring-do about the motley band of men who flew those unpredictable missions. The MIL helicopters were flown by Russians and Bulgarians who were there to earn hard currency. The fixed wing aircraft, chartered in South Africa, were crewed by a mix of locals, Brits, South Africans and Americans.

The Otter was flown by 53 year-old Hugh Pryor. As we cruised at 11,000 feet over the flooded landscape, from which a few roofs and the taller trees peeked their way through the muddy green waters, he flipped open his logbook. That week he had completed an impressive total of 5,280 hours in Otters. He learned to fly as a farmer in Tanzania and had come to this sort of charter work via commercial and military work: service in the Omani Air Wing and commercial airlines. He had flown for the Red Cross in the war zones of Angola, Mozambique, Zaire and Sudan. Not for him, the world of highly paid airline work which he condemned as "the most boring, soul destroying." Not for him the long haul flights to exotic destinations, the sterile hotel rooms and a job where "you never get to know your passengers."

Instead, he slept in a tent in a guarded compound in Kenya by night eating rice and potatoes and, by day, flew into remote makeshift airstrips which you suspected no completely sane pilot would tackle.

He made an early start every day. By 7.30 a.m. we were approaching a dirt strip at Bualle in southern Somalia. After heavy overnight rain, Hugh was uncertain about the state of the strip and puts the nose down for a "touch and go" landing: if the nose should

start to sink into the soft ground then we would overshoot and be off. But, safely on the ground, we were met by a group of gunmen armed with the ubiquitous AK-47 machine gun. Apparently, this group is on side: they are a militia hired to protect the WFP's local implementing partner, World Vision. The emergency supplies left here will be ferried on to their ultimate destination by boat. Refuelled from metal drums at the side of the strip, we were soon off to our next stop, Kismayo.

Within minutes of our intended landing the radio crackled with a message from the UN's man on the ground, a Scots former SAS officer who has been spying out the territory. "Do not attempt to land. Situation on the ground totally unpredictable. A lot of shooting."

Kismayo is not a dirt strip: it is a full blown airport facility constructed originally by the Italian army. As such, it is regarded as a prize of war, held then by the most powerful 'clan' in the area: that of General Mohammed Morgan. For every truck they loaded for the UN they got US$ 9.00. Around here that was big money and their monopoly was deeply resented by the half dozen or so other clans in the area. And so, they periodically disrupted flights by firing in the air as aircraft came in to land.

This was the hazard most feared by Hugh Pryor in what was already a hostile environment for flyers. "Somalia has ceased to exist in aviation terms," explained Hugh. "That's actually unique in my experience. There is no air traffic control - Mogadishu control is now in Nairobi but we can't get Nairobi on the radio up here . . .". Air traffic control, such as it was, was achieved by all aircraft over Somalia sharing the same frequency and telling each other where they were. Landing and local weather conditions were reported by aid workers on the ground using walkie-talkies. Often there was no information from the ground. Then the pilot was simply on his own.

We circled for a half hour and were then advised that Morgan's men had things under control on the ground with their heavily-armed 'technicals': open trucks with heavy machine guns mounted on the back. We got down but we were lucky. Landings were often aborted - for a variety of reasons.

As we flew into Jamaame in Somalia, Hugh coolly announced, "Donkey cart on the road. Let's overshoot." There was no landing

strip here: just a narrow ribbon of road with just inches on either side of the wheels. And Jamaame was an island in an ocean of muddy, green floodwater.

Although we were safely landed, local aid workers were not there to meet us as expected and the gunmen who emerged from the bush at the side of the road were not the intended recipients of the UN's largesse. However, there was no realistic option but to unload and, as operations rather frantically proceeded, a pickup full of armed men from the neighbouring village arrived. Hugh observes casually that this is a recipe for disaster and works on defusing the rising tension with smiles and jokes as he chucks the bags of maize out of the body of the aircraft.

A gunman known to Hugh came up and whispered urgently. "You go now. You go now. They're going to shoot you . . .". Pre-flight checks were brief and Hugh took the Otter off flying low, just above the ground and the water "to make as small a target as possible" as the firefight broke out below us. "That fight," said Hugh, "will decide who gets the food." Some shots were fired upwards in our direction but Hugh kept the aircraft down very low – low enough, indeed, for me to be able to photograph the wreckage of another Twin Otter downed recently after depositing its shipment of aid . . .

Eventually the waters of the Juba receded. But the receding waters brought new and terrible perils. Disease comes in the wake of the floods. The mosquitoes bring virulent, chloroquine-resistant malaria and haemhorragic fever; the washing of the soil spreads cholera and anthrax. Animals - goats, cattle and camels – which lie dead in the fields and at the side of the roads will themselves become a lethal source of infection.

As the New Year drew in the pilots at Garissa were living on rice and potatoes. Anthrax had entered the food chain. Hugh and his colleagues were brave enough to fly the planes . . . but not to eat the meat.

Seven

The Compleat War Correspondent

Bosnia

The veteran war correspondent Martha Gellhorn once said that a correspondent could only ever really fall in love with one war. I think she was right. All journalists have their favourite war. Mine was Bosnia although I was not quite as enamoured of the conflict as *The Times* journalist Anthony Loyd. He lodged next to me at the Vitez frontline rooming house known as Victoria's (named after the phlegmatic lady who ran it). Loyd, a retired army officer with an inordinate love of 'bang bang', would write a distinctly peculiar book about his experiences in the Bosnian war entitled *My war gone by, I miss it so*. Nevertheless, there was something intangibly special about the war in Bosnia. Maybe it was because it was my first, more likely because I knew the territory before the war

The Bosnian war had the dubious distinction of three separate warring parties: Serbs, Muslims and Croats. Many journalists would also classify the UN as a fourth warring party, as we so often seemed to be in conflict. The presence of so many warring parties in close proximity to each other produced a fund of bizarre stories. If you couldn't find a story with one side, you just crossed over to one of the other sides.

There was Postman Pat who delivered the mail without fail every day in Vitez during the war. He'd be finished by late morning and would then go home for some restorative *slivovich* and a few beers. This would, so to speak, fire him up and he would then dust off his personal mortar in the garden and start lobbing shells over onto his Muslim neighbours. After they got around to opening the mail, presumably.

Inspector Slavko was a well known TV detective around Vitez. His exploits were described as legendary - if not miraculous - in certain circles. He believed in old fashioned, no-nonsense methods and was also something of a specialist in a particularly unpleasant and socially threatening crime wave which touched the lives of

media stars and their retinue. Don't be misled, you wouldn't have been able to follow his adventures on your local TV station - but he did his bit to ensure you actually *received* your TV news.

Slavko's 'patch' was in the small, once peaceful town of Vitez, in central Bosnia, where back in 1994 there was a surge of crime centring around the TV crews encamped there. As if the poor chaps didn't have enough problems - what with snipers, three warring sides and distressingly little in the way of hard liquor - the local yobbledehoy took to relieving them of their expensive hi-tech gear.

Within two or three months there were half a dozen of these heinous crimes. All were ultimately solved by the determined efforts of a young, camouflage-clad military police Inspector called Slavko. Reuters lost literally everything from their lockup premises: TV gear, satellite dish, wire machines, flak jackets and helmets - even their invaluable stocks of beer. A cool quarter of a million dollars-worth. Technical equipment, not beer, that is. Then Sky TV lost their gear as well.

Slavko set his trap. He kept watch on the TV houses and when local children clambered on the balconies to steal the thirsty TV mens' beer (they kept such vast stocks of the lifesaving stuff they could not accommodate it inside), he swooped. "I arrested all the children and made them talk." Rumour has it they were stood on wet linoleum for extended periods of time. Gradually, older brothers were pulled in, then their fathers. The missing beer was recovered first, then the flak jackets, then the TV equipment. "At one stage we were holding 100 people," he recalls proudly.

Eventually, the ringleader was exposed. Somewhat unfortunately for the police department, he turned out to be a policeman. "So we gave him three years inside, instead of the normal one year," he announces grimly. You somehow got the impression that court formalities were dispensed with.

He thought he had finally cracked the media crime wave until the day ITN cameraman Nigel Thompson put down his camera in the BBC's garden on Vitez's 'TV alley', as he prepared to do a live piece to camera with defence correspondent Geoffrey Archer. There was about two minutes to go before Geoffrey's broadcast. They nipped inside for a coffee, or something similar. Alas, when he went to retrieve his camera from the ground to beam Geoffrey

War photographers under fire, Turanj, Croatia, December 24 1991.

In the Bosnian war there were dangerous extremists on all sides. This jeep carries Croatian ustase, extreme right wing fighters, many of whom were involved in ethnic cleansing of Muslims. The photograph was taken on Route Triangle into central Bosnia; a British army checkpoint has been set up on the road ahead.

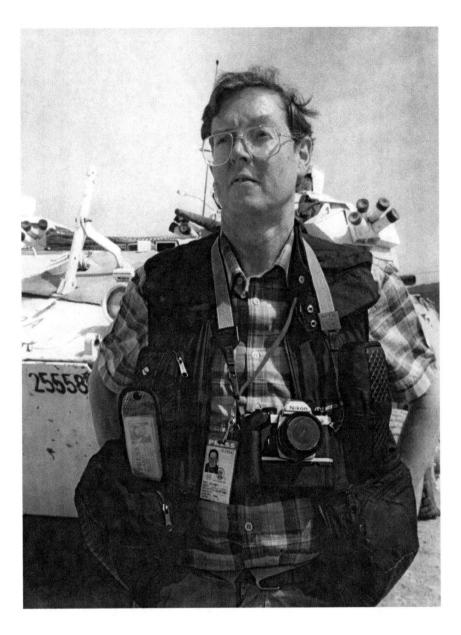

This photograph was taken in spring of 1995 in central Bosnia

to the world . . . no camera. Quite apart from the longer term problem of recovering $50,000 worth of camera, there was the more immediate one of the link to London *sans* camera. Fortunately, the nice chaps from the BBC obliged and Geoffrey was beamed to the world on time by his rivals.

'TV Alley' was a long, winding road next to the British base, so-called because of its population by the great names of broadcasting who rented virtually all the houses there. The firmly secured satellite dishes pointed skywards to all corners of the globe: to the headquarters of RTL, ABC, CBS, BBC and Reuters in faraway New York, Washington, London and Luxembourg.

Sitting one Sunday morning in the BBC house in TV Alley, the Inspector was asked by yours truly who he suspected of the latest crime, "To me, everyone is a suspect," he declared and his icy gaze swept the roomful of heavily hungover TV persons. "Perhaps it is an 'inside job'," he mused Poirot-like and disappeared into the garden to examine some mysterious footprints.

Meantime, ITN put up a reward of DM 1000 (about $600) in an attempt to flush out the miscreant. That might not sound an awful lot for a $50,000 camera. But it *was* the equivalent of about 20 years' salary around central Bosnia at that time.

You would hear some very odd stuff on local radio around Vitez. The British army kept up its urgent appeals for farmers not to till their fields in mined No Man's Land. The news advised that the Mayor of Busovaca had relinquished his position - to become the head of the Bureau of Tourism and Forestry in central Bosnia. The rumour among the journos was that he was to launch woodland adventure holidays. And now Inspector Slavko was harnessing the power of radio. He was advertising, under an assumed name of course, "Enthusiast seeks TV camera".

The main base for British troops in Bosnia was established in Vitez in the autumn of 1992 by Lt Col Bob Stewart and the officers and men of The Cheshire Regiment. The Bosnian conflict had broken out earlier in the year. The first widespread violence had started on February 28 around Bosanski Brod and by mid-April ethnic cleansing of Muslims by Serb paramilitaries was well under way all along the banks of the Sava River. Bob came into Vitez in the late summer of that year with an untried mandate - to get the

aid through to those most in need in an ethnically divided region - and very little in the way of guidance as to how to achieve it. He set about it with dogged determination and those of us who met him in the field could not fail to be impressed by his sense of fairness in an impossibly complex quagmire. What he made particularly clear was his spontaneous and heartfelt outrage as a professional soldier seeing attacks on helpless, innocent civilians.

He was remarkably frank about this with the journalists reporting the war. We all felt much the same as him and he got extensive coverage in the UK media. We respected him as a commander but his cordial relations with press and television did not endear him to the Ministry of Defence at home. This would be turned against him later when officialdom got the chance to get the knife into him.

In the aftermath of the appalling tragedy of Ahmici - an entire Muslim village was wiped out overnight by Croatian paramilitary thugs - the BBC perversely captured on film one of the few satisfying images of the Bosnian war.

The news film, fronted by Martin Bell, showed Col Stewart and his men on the outskirts of the torched village where they had just witnessed scenes of unimaginable horror. The local HVO (Croatian) commander pitches up in a battered saloon car (doubtless stolen) and demands of Bob his permission from the HVO to be there. For a moment, Bob appears speechless at the fellow's temerity but then lets the thug have it with both metaphorical barrels, "I don't need the permission of the bloody HVO. I am the United Nations! What has happened here today is a disgrace …". It was unscripted and technically incorrect but it was from the heart. And I know people in front of their TVs, wherever they were, applauded Bob's knee-jerk reaction to the brutality - especially at a time when the UN's official efforts were looking increasingly feeble.

Bob later gave evidence at the Hague War Crimes Tribunal where senior HVO officers were prosecuted over the Ahmici massacre. One, Mario Cerkez, who I interviewed at length in his headquarters in nearby Vitez, was sent to prison for a very long time, although his conviction was later rescinded. Neither Bob nor I were convinced that a satisfactory case had been made against him.

The British army made itself as comfortable as possible in the grounds of the school at Vitez. All the national elements in

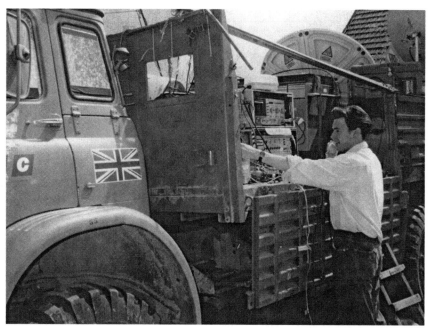

TV Alley, Vitez, central Bosnia, 1993. This BBC truck carried all the equipment necessary for an outside live broadcast. Today, you could pack everything that was needed in a small suitcase.

This photograph of me was taken near Vitez, central Bosnia, over Christmas 1992. The World War I tin hat came from a jumble sale in Edinburgh where I paid less than £1 for it. I painted it UN blue and it served me faithfully until a British army officer took objection.

Under Wraps invite some audience participation.

The girls of Under Wraps sign videos and books for the squaddies in the REME workshops at Vitez. The evening produced a series of successful photographs I sold to The Sun and to Mayfair, the men's magazine. Lynne the Lynx (right) was very proud of her breast enlargement operation.

the UN force had their own acronyms. The Dutch were known as CLOGBAT and BRITBAT soon became known as MUDBAT as the squaddies settled into what seemed to be a permanent sea of mud as playing fields disappeared under the rain and snow of Bosnia. Soldiers are quite good at making the best of things. "Any bugger can be uncomfortable," is an oft expressed piece of army wisdom. The secret is how to *make* yourself comfortable.

I remember a rare occasion when the British Ministry of Defence did its best to make the troops happy. On an already warm August evening in 1995 five hundred British soldiers packed the improvised 'theatre' in the garage of the REME workshops at the Vitez base. Lynn 'The Lynx' from Manchester, her sister Christina and dancing girls *Under Wraps* (Tamsin, Megan and Ruth from Glasgow) strutted their stuff and stripped for the British squaddies of the Devon & Dorset regiment the night before they were sent to the front lines above Sarajevo. The atmosphere was already hot and steamy even before the girls hit the stage and after their sexy hour-long routine there was bags of, er, excitement in the air.

The show was put on by CSE - Combined Services Entertainment - the modern day replacement for ENSA ('Every Night Something Awful'). But, I could authoritatively report, things had moved on in leaps and bounds since the days of Dame Vera Lynn. Buxom Lynn was about as far removed from Vera Lynn as Vera Duckworth is from Marlene Dietrich. Lynn leant over me - and a hundred squaddies fair to say - with her hot breath and ginormous mammaries. She told me she had a breast enlargement operation in Sweden and I believed her as I stared down the panorama of Silicon Valley. The girls were real troopers. They stripped to the bare essentials for fire eating routines, magic acts and pictures with the boys. But the really big hit of the show was when the girls stripped out of UN uniforms and did interesting things with those blue berets . . . I've truly never seen any audience more enthusiastic about anything.

Sixties pop group The Searchers appeared in the second half of the show not looking too much the worse for wear thirty years on and pepped up the boys with *Love Potion Number 9* and *Sweets for my Sweet*. Then it was all over and the 'boys' and girls left the stage to *Land of Hope and Glory*. Probably the most memorable night at the theatre I've ever had.

Col. Bob Stewart (left), his RSM and BBC journalist John Simpson pictured Christmas 1992, Turbe, Bosnia.

The charming and personable Luigi Caligaris (left) talks with a journalist from the Scottish Daily Record in Bosnia. Luigi came to Bosnia as a journalist but he was, in fact, sent there to gather information for the Italian military. We became firm friends. He later became defence minister of Italy under Berlusconi.

138

In the Bosnian war all sides had their own way of winding up their troops. The Croats tended to use LSD tablets, the Muslims smoked dope which they grew around Mostar and our boys had Lynn and company. At 6 a.m. the next morning they clambered into their transport to the front above Sarajevo fired up by the power of the girls of CSE. As one squaddie put it, "They probably don't know what they did to me - after all it's three months since I saw my wife." Some of us were fortunate enough to prolong the encounter in the relatively cloistered calm of the officers' mess.

War and romance have ever been inextricably linked. Or so it might seem to generations raised on Hollywood and paperback fiction. But sometimes those liaisons passionately forged in The Winds of War come back to haunt the participants in a rather more sterile ambience - like Norwich Crown Court where one Squadron Leader Nicholas Tucker, it was determined, did away with his wife after a passionate affair with his 21 year-old Bosnian interpreter.

Extraordinary allegations emerged in the courtroom in 1997 - of missions and patrols abandoned in central Bosnia "at the whim" of the Squadron Leader's interpreter. These may seem to imply a certain recklessness - if not exactly in the face of the enemy then at least prejudicial to good order and security. Yet, truth to tell, passionate - usually transient - relations of this kind were far from exceptional.

In a war zone like Bosnia there were generally three types of expatriates on the ground, so to speak. There were the military men, the aid workers and the journalists. The fact is that as the dangers increase, so people move, let's say, closer together.

One of the well publicised relationships was that of Lt Col Bob Stewart, commanding officer of the Cheshire Regiment. The tabloid press unkindly dubbed him 'Bonking Bob' after the news broke of his relationship in Bosnia with a representative of the Red Cross and the failure of his own marriage. The winter of 1992-3 was particularly hellish in central Bosnia and Bob was, effectively, the captain alone on the bridge as violence erupted all around his isolated peacekeeping mission.

At the time, journalists working regularly around the base in Vitez knew full well what was going on and all were agreed this was not a fit matter for the public print. Besides, many of them

were themselves married men trying to bury the trauma caused by what they were seeing and experiencing every day by way of intense, short-lived affairs with their own local interpreters or 'fixers'. Or, indeed, with their own colleagues. It was only when a tabloid hack parachuted in on an 'in and out' operation that the story broke. The 'leak' was a woman writing for *The Mail on Sunday* who got the drift of Bob's relationship and splashed it all over the tabloid. After that, of course, it was open season and poor Bob was comprehensively pilloried. Although he inevitably left Bosnia under a bit of a cloud, he is still well remembered there and the success of his mission notably ensured the survival of his regiment at a time of swingeing military cuts in the UK.

I am glad to be able to place it on the record that, after Bosnia, Bob and his *amour*, Clare, married and they now are contently ensconced with a large and very happy family.

Indeed, quite often the affairs forged in war stood the test of time rather well. A Dutch photographer I knew went along to cover one of those events in besieged Sarajevo which the Bosnians mounted from time to time as a two-fingered salute to the Serbs on the hills above raining down fire on them. This particular act of defiance was the Miss Sarajevo contest. A couple of dozen girls, involuntarily slimmed down on European Union hard rations, paraded in the Holiday Inn Hotel. The winner got . . . the photographer from Holland where they were last heard of happily married. The BBC reporter Malcolm Brabant consummated his liaison with his Nordic girlfriend on Sniper Alley as the firefight raged above their heads. I last saw them, still hand in hand, in the shadow of the volcano on Montserrat.

In Vitez, all the hacks hung out at P/INFO: the army press centre in central Bosnia, irreverently known as The Schoolhouse, located in what used to be a private house near to the entrance of the British army camp. The British army rented it at a phenomenal rate from an absentee landlord. Bosnians were very amenable to that sort of situation. A hundred metres down the road, a whole family of five locals were quite happily living in the hen hutch at the bottom of the garden to facilitate the accommodation of Tony Birtley and the American film crew for ABC Television – at two thousand Deutschmarks a month.

June 1993 and refugees fleeing from a bus bombing near to the British base in Vitez are refused entry to the camp, despite the presence of snipers all around. Here this woman was begging for refuge.

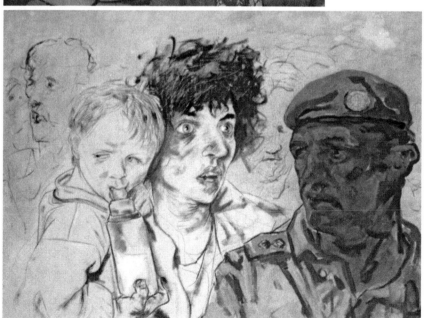

Peter Howson, the war artist, was staying at the base in Vitez during this incident. He later painted this picture which he based upon my photograph.

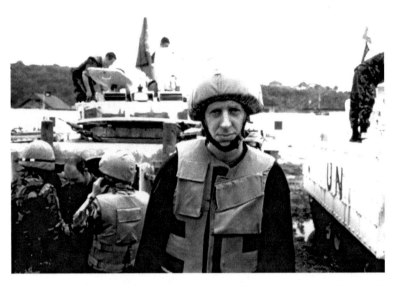

Peter Howson, the official war artist, pictured at the British base in Vitez, June 1993.

Scotland on Sunday splashed my story of the treatment of the war artist, Peter Howson, across the front page and two pages inside the paper.

During the spring and summer of 1994, the warcos milled about under the supervision of the 'Housemaster', Major James Myles, who was in charge of P/Info. We were a truly shambolic lot and he did his best to exercise some sort of discipline over the motley international collection of writers, photographers, TV and radio people.

Twice a day we gathered for briefings, seated obediently on school benches. The British Army computer at Split Airport recorded that they had issued 14,000 press accreditations since the previous October. Fortunately for the Major, we didn't all turn up on his patch at the same time and they'd started to weed out an awful lot of impostors in the Harry Lime mould: black marketeers, drug pushers, arms dealers and the like.

A crowd of Italians with press accreditation turned up on a flight into Sarajevo, blithely asked the way into town and strolled off down deadly Snipers' Alley. When the French UN commander sent out an APC to retrieve them it turned out they were tourists on a 'war holiday'.

The warcos divided into three main species. There were 'The Regulars' who were dug in for the duration: the BBC (known irreverently as The Broken Biscuit Company), ITN, Sky, Reuters and a sprinkling of chaps from Very Important Organs like *The Times* and *Daily Telegraph*. They were terribly well equipped with satellite dishes, computers and assorted technological wizardry. The BBC even had a complete range of Marks & Spencer pre-packed meals. We much envied them for that although John Simpson was kind enough to share one with me on Christmas Day in 1992.

The Regulars were awfully matey with the army and a mite snobbish. At barbecues held in the whoosh and glow of the free nightly fireworks displays of tracers and rockets, they jawed on all the time about their televisual derring-do in Beirut and the Gulf.

Then there were 'The Freelances'. They were really a bit of a nuisance. As we were independent, both by nature and the requirement to make a living, we didn't stick around long enough to develop the same cosy relationships. The army tended to think of us as jolly unreliable; we didn't realise everything that was said was "strictly off the record". Sometimes we didn't join the pool (that is to say we didn't share our stories with the other warcos) and actually went off on our own rather than on the cosy army-escorted field trips.

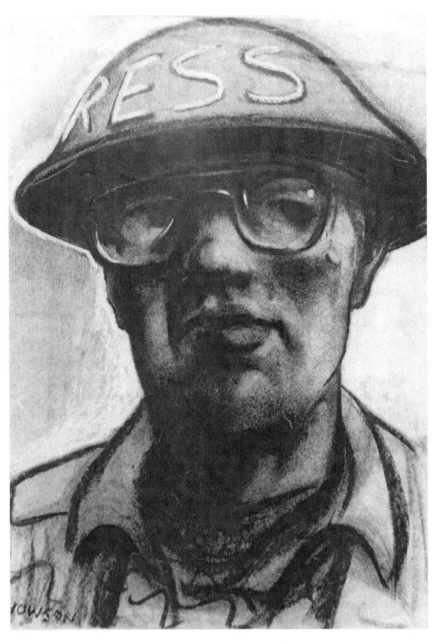

Peter Howson executed this not altogether flattering charcoal drawing of me during his stay in Vitez.

In May 1994 the Reuters man, who ran the pool in Vitez, asked me if I would sign up for the pool. Winding him up, I asked, "What does that mean, John?"

"It means you only go out one day a week. You share your copy with everybody else and you can relax the rest of the time."

Winding him up somewhat further, I explained, "But I'm a freelance and I'm here to get exclusive stories for my papers."

"Well fuck off then," quoth the man from mighty Reuters.

Off course, the pool was a system devised by the army in a bid to keep journalists in line. If you could make sure only one was out and about then you could control the story much more easily. For its part, the army would argue that it could only adequately protect one journalist, one photographer and, maybe, one TV crew at a time. It could not protect a rabble.

Finally, there were 'The Spooks'. These were, typically, journos who were somewhat vague about their employers. They tend to claim they work for *Machine Guns and Howitzers Monthly* or some obscure and quite untraceable evening paper in the US Midwest. They asked all sorts of tedious questions about the impact resistance of Chobham armour. More often than not, they were reporting back directly, or indirectly, to the CIA/MI6/GS9, or combination of them all.

There was a young guy from Finland who was always hanging around the Holiday Inn Hotel in Sarajevo. We called him Finnbar. We knew he represented some unpronounceable organ of the Finnish press. He was clearly on a tight budget because he slept in the laundry cupboard. It ultimately turned out, to everyone's embarrassment, not least the UN's, that he was an enterprising 16 year-old schoolboy who had submitted a letter for UN accreditation on the notepaper of the school magazine.

The Major was looking particularly crestfallen one day, a typical sort of day at The Schoolhouse. An Italian journalist, Luigi Caligaris, who has just left, hadn't exactly been given the red carpet treatment. As he bade farewell to the hard pressed P/Info supremo he blithely announced. "I would like to be able to thank you for all your cooperation. But I cannot find it in my heart to do so. I think you should know I am brigadier in Italian army and special advisor to Minister of Defence." Collapse of stout party.

Luigi became a good friend of mine and my photograph of him would appear on the back cover of his book *Paura di Vincere* the following year. He would then be appointed Defence Minister of Italy by PM Silvio Berlusconi.

One day, Allan Little, the radio reporter for the BBC World Service, was seen to be a Very Bad Boy indeed by spreading the word abroad about the British Army's refusal to admit inconveniently bleeding and mortared refugees into the camp. It was the first item at the top of the news after *Lilliburlero* (the stirring march which presages the BBC World Service news).

A disgusted young P/INFO Captain with his ear pressed to the crackly 5 p.m. World Service News wailed, "And they're supposed to be on our fucking side." In the middle of a war you can't trust anybody - least of all The Bloody Press.

My own personal fallout with the chaps from P/Info occurred over the tortured issue of The Official War Artist. In its wisdom, the British government decided to send out an official war artist to record the horrors and suffering of the war in Bosnia. He was a young chap called Peter Howson who emanated from one of the posher parts of Glasgow but who was a dab hand at portraying gang life, street violence and general criminality. Eminently suitable for a 'posting' to Bosnia, where he should have been very much at home. Like most artists, however, Peter was, at heart, a very sensitive chap and when I met him in Glasgow ahead of the assignment, he was clearly nervous about it. I flew to Croatia ahead of him and met him at Split airport as he stepped off a military transport 'plane.

It was arranged that I should accompany him on his mission. He was also trailed by a BBC film crew. He was in the hands of the military: they barely tolerated my presence, which had been officially cleared and would 'dump' me as soon as possible, but, from the outset, they resented the presence on the battlefield of "the bloody war artist."

I could understand this but when they started making life thoroughly miserable for the poor chap, I started to take detailed notes. Once we got to Vitez, they separated me off from him and tried to prevent him from seeing me, or any other journalists apart from the TV crew with which they got incredibly friendly.

One evening, a young Captain with a far back English accent announced triumphantly to all and sundry in the P/Info office,

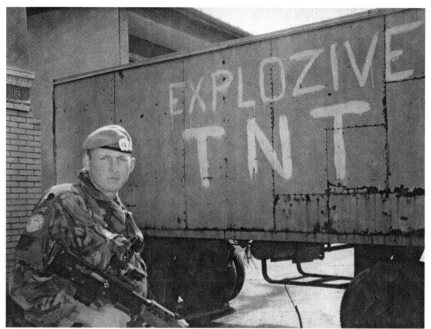

The town of Vitez was divided between warring Croats and Muslims. The Muslim section was divided off by this truckload of explosives.

The Polish agency reporter Ryszard Kapucinski, one of the greatest war correspondents of the 20th century. I interviewed him at the Frankfurt Book Fair.

A refugee boy sleeps in the street, Belgrade, June 1992. I took this picture as I went out to dinner one evening. I never rated it particularly but it was enormously popular and received many publications.

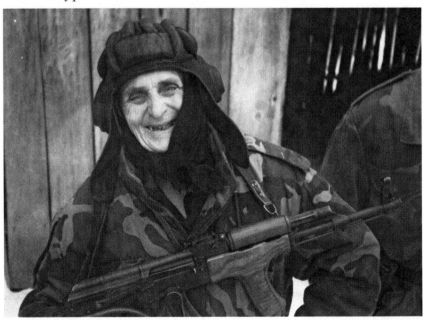

My first really successful picture was in January 1992 and featured a lady called Rozika Militic. The battling, toothless granny had captured a Serbian tank along with her three sons. It was a great story and the picture editors loved the photograph.

"We got the war artist shit-scared this afternoon." They had taken him to the scene of some really 'hot' action in nearby Travnik, the scene of particularly ferocious inter-community fighting. Peter was shown somebody's brains on the pavement and, understandably, didn't feel well and was promptly sick. The military found this rather amusing.

The next morning, Peter sought me out and asked to speak to me. We went behind a container in the army base where he promptly collapsed in tears. He was frightened, deeply unhappy and felt isolated. He wanted to leave immediately. In my view, his 'hosts' were deliberately treating him badly and I felt it was extremely unfair and gratuitously unpleasant.

I took him to the office of the Regimental Sergeant Major, introduced him and left him to make his own pitch. The RSM made it clear he blamed me for 'interfering' although I was just the messenger in the matter. However, my having 'interfered' was also assumed by P/Info and things got a trifle uncomfortable for me as well. I stayed around long enough to ascertain that Howson would be removed from the theatre of war, and I flew home. By now the story was out in all the press that he was a coward leaving the battlefield, a view promulgated in off the record briefings by the army.

I thought this was scandalous and I went to the editor of *Scotland on Sunday* in Edinburgh, Andrew Jaspan. Andrew didn't take so much a moral view. As a seasoned editor he knew it was a bloody good story and the Saturday the paper was to go to press, he sat me down in the office, asked for a front page story and a two page spread for the inside of the paper. I wrote 6,000 words in a few hours using my detailed notes from central Bosnia.

The article was deeply critical of the army, and particularly the P/ Info people. It did not reflect well on the British regiment holding the fort in central Bosnia, the Prince of Wales' Own Regiment of Yorkshire. I was, frankly, pleased to get the opportunity to tell the truth as I had seen it. It was the only time in my journalistic career that I was openly critical of the British army for which I have and have always had the greatest respect. On this occasion, I felt obliged to set the record straight for Peter.

A few days later, Andrew called me to his office. "There's been a lot of flak from the MOD (Ministry of Defence). I told them to

get lost." He didn't use that phrase. "This is rather more important, I think." He handed me a neatly typewritten letter. It was from Peter's father.

It was an extraordinarily simple and moving epistle. It talked of his despair at his son's suffering in Bosnia and his deep distress at the allegations of cowardice published in the press. It talked in very personal terms of his son and their relationship and his own sense of isolation at the hurtful press reports. 'I know my own son.' But then he went on to aver that my story had unexpectedly come along and corrected the balance: alone, *Scotland on Sunday* had told the real story, and he was grateful for that.

"I think another press award is in order," commented Andrew. I didn't get one for that story but I had, in fact, just picked up a British Press Award at a glittering ceremony in London's Grosvenor House Hotel for my reporting from the Bosnia-Croatia border in the spring of 1992.

In the Second War they put the warcos into a military uniform bearing the large letter 'C'. The original intention had been the letters 'WC'. This ignominy was escaped only at the last minute. In the Gulf War correspondents were put into uniform and either adopted studied sloppiness or went 'army barmy'. John Fullerton, the Reuters man, who I was to encounter in central Bosnia, was, according to my friend and foreign editor, Trevor Royle, the best turned out chap in uniform in the whole war, military or civilian.

Anything went in the Yugo war zones. Enterprising *Guardian* Journalist of the Year Maggie O'Kane got some of her best stories dressed as a refugee travelling on buses. I got a rocket from The Housemaster on account of my own gear. "I say this is an awfully bad show. You were seen crossing the lines this morning in a blue helmet. Are you trying to pass yourself off as a member of the UN or what?" Got it in one, James. Shorts, jeans and sweatshirts tended to be favoured by most of The Regulars but then they only ventured out in their heavily armoured vehicles.

My problems with the army in the summer of 1994 led to the suggestion at the P/Info office in Vitez that they were going to have my UN press accreditation withdrawn. This would have been a disaster because it would have not only meant that I would not have access to UN personnel or facilities, but other bodies, like the

Bosnian and Croatian authorities, tended to accredit on the basis of the 'pre-screening' afforded by one having got a UN pass. When this threat was announced I pre-empted it rather quickly.

What they didn't known in Vitez, because I chose not to tell them, was that I was a member of the Strategic and Combat Studies Institute in Surrey, England, and that I went down to Camberley regularly where I advised and lectured senior officers of the British army on public information strategy. A quick call to the right people and Vitez was effectively isolated on the issue.

Whatever was worn underneath, everyone wore a flak jacket in those days. This was no optional extra, it was obligatory. The better off had their jackets individually tailored with high collars and fold-down crown jewel protectors. The BBC's Martin Bell got a groin injury from shrapnel while he was on camera in Sarajevo. AP photographer David Brauchli carelessly lost a testicle in Sarajevo. Logically, he was known as 'one ball Brauchli'. So the protector flap (all one standard size with no concession to individual vanity) was not such a bad idea. These jackets are, however, far from bullet-proof. You will survive a high power round if it happens to hit a ceramic tile front or back - if you have the tiled version - but it will tunnel its way right through the Kevlar, which makes up most of the structure of the jacket.

As the squaddie who fitted Peter Howson into his jacket cheerfully observed, "It won't stop the bloody bullet but this here jacket'll hold your guts in, Sir, after the bullet's gone through you." The humour was a bit misplaced on poor old Peter.

When to don flak jacket and helmet was always a thorny matter of etiquette. It was regarded as prattish to wear it inside the P/INFO centre but it was acceptable to don it once outside. Of course, the building was actually under fire several times and modern weaponry penetrates walls, windows and roofs like the proverbial knife through butter.

French 'snapper' Antoine Gyori was the only chap to survive when a mortar popped through the window of a cafe in Karlovac in Croatia. I noticed Chris Morris of *Time* actually wearing his helmet at the airport on the way home. There again, he's seen wars in every continent and he knows only too well what just one tiny sliver of shrapnel can do to the human brain.

An interview in the snow on the streets of Sarajevo, February 1995

The best dressed and outfitted warco would, in theory, be turned out carrying around 15 kgs. of gear. The complete war rig-out would set him back more than $50,000 without taking into consideration an armoured Landrover: former Northern Ireland police units were favoured. The armoured ABC News Chrysler model used in central Bosnia reportedly cost $200,000 when it was built for the Gulf War. But then it did have a couple of enviable facilities. If pursued you had two options: you could either spray oil on the road behind, or shoot flame out from twin cylinders at the back, James Bond-style.

The warco probably has the best range of toys anywhere right at his fingertips. Come to think of it, he is sometimes better equipped on the battlefield than the combatants.

When I first went to war in Slovenia and Croatia in the summer of 1991, I have to admit that I was fairly oblivious to the danger and the threat of personal injury. That was a sort of glorious innocence; a honeymoon period when it all seemed like some sort of movie in which other people got injured and killed. After you've survived a few scrapes, you subconsciously assume you're immortal, untouchable. You're also buoyed up by the incredible adrenalin surge of simple survival.

In those early days, I suppose I spent too much time with 'bar room' fighters: young men in camouflage uniforms, generally festooned with grenades, knives and guns, who, for the price of a few beers or 'shorts', would regale you with their tales of 'derring do' at the front. In retrospect, some were doubtless pure invention, most were the stuff of generously elaborated fantasy. They were supplemented by extravagant affirmations of patriotism and nationalism which inevitably seem to accompany the intake of copious amounts of alcohol wherever you might travel in putative or newly independent countries. Nevertheless, such situations delivered up much in the way of useful anecdote and just occasionally led to a decent story.

Stories about women always sold well back home. My story about Yugoslava of Yugoslavia went all over the world. Her Dad didn't exactly do her any favours when, twenty-four years previously, he christened his bouncing baby daughter Yugoslava. But, then, that was in the days when naming your offspring after the Yugoslav

The Fully Equipped War Correspondent

Clothing

Kevlar helmet $500 or WW2 tin hat $10 at yard sales

Boots from Army surplus store, insoles and steel toe caps

Money belt to carry at least $5,000 in appropriate currency

Action trousers with zipped pockets

Belt: Dr Brown's Expedition First Aid Kit belt (incl. syringes, anaesthetics, water purification tabs, antiobiotic, dressings)

Photographer's waistcoat Multi-pocketed and can hold up to 8kgs. of vital kit

Flak jacket Not bullet proof as supposed Kevlar best with ceramic plates

Professional Equipment

Satphone. Connect to computer to send words and pictures

Videophone, for broadcasters. One Person operation so cheap to operate

Computer smaller the better

Camera Nikon the choice of the pros but there are enthusiasts for Canon

Short wave radio Sony used to make excellent pocket model Out of fashion since arrival of Internet

Walkie talkie Potentially useful

Swiss Army knife Essential

Torch and spare batteries

Compass & maps Surprising how often these items are forgotten

Notebooks, pencils

Films (memory cards today)

Tampons, for both sexes. Make excellent highly absorbent wound dressings

Less likely assets

Ample supply of passport pix, for next item

Accreditations to all parties in conflict plus UN, EU. Etc

Sealed laminated card with blood group, insurer, next of kin and air ambulance numbers

Two or three fake Rolexes Can extricate from trouble at checkpoints

Condoms Less obvious uses include carrying water, mending tyres, orificial concealment

Food 4-5 days supply in form of high energy cereal bars – abjure chocolate, messy, causes headaches

Cigarettes: whether you smoke or not, these are currency in most war zones

Hip flask Ensure full

Dentanurse Kit Do-it-your-self fillings

federation was a fashionable expression of patriotism. Who was to know, back in the early 1970s, that the dream would fall apart so catastrophically? In the 1990s it was a difficult handle to live with.

But if *pater* failed in the nomenclature department, he certainly made up for things elsewhere. For Yugoslava Siljak grew up into a tall, striking and statuesque blonde. Then she applied for the plum job as an announcer on Pale TV, the personal fiefdom of Serb leader Radovan Karadzic. War brought her a not inconsiderable degree of fame with the Bosnian Serbs. Bosnian Serb TV was one of the first goals of the nascent Serb republic. It was regarded as pivotal in the establishment of the breakaway state and it was established very soon after the fighting started. As BBC TV reporter Martin Bell put it, "I know, they pilfered most of my equipment."

Whilst I was lurking in newly relieved Sarajevo, the locally-based political magazine *Slobodna Bosna* (tr. *Free Bosnia*) published a caricature on its front cover. The image depicted so-called High Representative Carl Bildt - the enigmatic Swede in charge of implementing the civil aspects of the Dayton Agreement - playing the new Bosnian lottery. On the magazine cover, perched provocatively next to Bildt, with her back to the reader, is the voluptuous figure of a long-haired blonde, cigarette holder in hand, a suggestion of extravagant eye glasses, ample buttocks spreading over the green baize of the gaming table. The suggestion is clear. Although Bildt, by his own admission, spent his youth reading military magazines, playing war games and making model aircraft, it seems his interest in blondes came later.

What I wanted to know (purely on behalf of my readers in the UK, of course) was who is this blonde and just what is her influence over the lanky, bespectacled and boyish former Swedish PM turned EU supremo in Bosnia ?

I learned that an article to be published in the next issue of *Slobodna Bosna* would link the beautiful Yugoslava, er, romantically with Bildt. I tracked down the magazine's editor Marko Vjesovic at his downtown Sarajevo office. Yes, indeed, there were revelations to come. The duo had been seen hand in hand a few weeks ago in the newly 'liberated' Serb suburb of Vogosca. "My source is absolutely reliable," asserted Vjesovic. Bildt's people were tight-lipped at his headquarters just down the road. But, as Mandy Rice Davies so aptly put it, they would be, wouldn't they?

I liked this April 1992 image of a boy fleeing from Bosnia across the Croatian border at Gunja because it had a timeless quality. It reminded me of images of the Second World War.

The key to the enigma was clearly the lady herself. However, staking out and door-stepping a Bosnian Serb media star in the so-called 'capital' of Pale might have tested the toughest *Sun* reporter. No journalist could operate amidst the chalets, ski slopes and bell-touting mountain goats of Pale without the personal permission of Sonja Karadzic, daughter of the Great Man and Renowned War Criminal. It was Sonja who completed the clan's total control over all media activity, national or international from Pale's so-called International Press Centre.

The Great and Large Lady - known to irreverent journos as The Zeppelin - did not deign to emerge from her ski chalet office but a hapless go-between took my questions, one by one, to her office and duly re-emerged with an answer. No, you cannot stay in Pale. The hotels are closed to journalists today. No, you cannot work in Pale. No, you cannot interview anyone here. Yes, you may drink a beer, Yes, you may have lunch here. Of course, you can speak with the waiter to order lunch . . .

"Now you are making fun of us. You will find that is not advisable." Press centre denizen Mr Marko Marchetich was deadly serious. I had a curious sense of *deja vu* about this forty-something with his unruly mop of hair. I complemented him on his command of the English language. He looks black affronted. "I *am* English. Educated at Edinburgh University." Another returnee for the cause.

And, as if to bolster his credentials, "I voted for Robin Cook in his Rectorial Election." That might well have compromised the then Foreign Secretary. Marko further claimed to be a friend of Gordon Brown. I smelt a scandal coming on but I really had enough on my plate for the moment with Yugoslava . . .

This clearly had to be a quick in and out operation. A half-day stake-out of Pale TV proved to be disappointingly uneventful despite the fact that it, and its employees, were controlled by the Interior Ministry Office of National Security. I successively accosted two bemused blondes before hitting the target on the third attempt. She didn't exactly seem keen to talk. So I promised the lovely Yugoslava a spread in *Hello* magazine. This really did the trick. Some of us hacks truly have no shame.

The lady was nervous. "Yes, we were close. I saw a lot of him when I was working as the translator for Prime Minister Kasagic and Mr

I shot this December 1991 image in black and white, which seemed to lend it added power. It was taken at a reception centre near Zagreb where Croatian prisoners of war were brought after release by the Serbs. Most were old and this woman searched fruitlessly for her young husband, who bore an uncanny resemblance to Paul Newman.

Bildt . . . former Prime Minister Kasagic, that is." Kasagic had been dismissed by Karadzic two weeks previously. And the lovely Yugoslava was recalled by her masters to Pale - the relationship unconsumated. But she would say that, wouldn't she? With a sigh, Mata Hari turned, brushed back the blonde tresses and headed back to the studio as a policeman called the press centre. I took the road out of town.

As journalists in a war zone, we were, of course, supposed to be hard-bitten, fully objective and to remain unmoved by the entreaties of the underdog. I detected a change in that traditional view during the course of the war in Bosnia.

The veteran BBC newsman Martin Bell coined a phrase around the end of the Bosnian war: 'the journalism of attachment'. Going very much against decades of firmly established BBC tradition, Bell suggested that journalists should not stand back but, instead, actually take sides with those patently oppressed in a conflict like the Bosnian war. After years in Bosnia – and much time spent in towns and cities like Sarajevo held in the vice-like grip of siege – he came to see this as a moral duty. Once the end of the Bosnian war came he was rather put out to grass by the BBC before, as his erstwhile boss John Simpson strangely puts it in his book *Strange Places, Questionable People*, 'the poor man forsook it all and went off to be a politician.'

On the occasions I met Martin Bell in Slovenia and, later, Bosnia, I rather took to him. He had a permanently troubled air – which, at the time, I put down to the shrapnel injury he dramatically acquired in his groin on camera in Sarajevo – and seemed buried in his own perplexing thoughts. I found him infinitely preferable to the loudmouthed crowd of louts and misfits who generally populated the press hangouts. In fact, I think he was genuinely struggling with his own conscience and seeking to rationalise his own thoughts on what we all were doing in Bosnia.

I never got around to asking him if he had taken his cue from the veteran Polish war correspondent Ryszard Kapuscinski, to my mind one of the greatest of all time. I met him one year at the Frankfurt Book Fair where he told me, "You cannot be impartial. I have always taken sides. It is inevitable and lends emotion to your work."

Eight

A Roof Over Your Head

From Algeria to Sri Lanka

When a promising little war breaks out in the far flung Republic of Ishmaelia, or wherever, there will always be certain types of hotel guest for the establishment that keeps open its doors. With the package tourists and businessmen gone, there are now four quite distinct types of guest. There are journalists, aid workers, spooks and 'war tourists'.

That the journos and the aid workers should be there goes without saying although not all journos are as dedicated to their craft as they might be. Writing of the Commodore Hotel in Beirut during the 1980s, correspondent Robert Fisk referred to "a breed of journalistic lounge lizard, reporters who rarely left the building - or the downstairs bar." The Commodore is probably best remembered for the resident parrot, Coco, whose convincing imitations of gunfire and incoming shells would more often than not cause guests to dive for cover. It was rebuilt after its 1987 trashing by Druze and Palestinian gunmen. But Coco fled and was never found despite a British journalist's generous offer of a $500 reward.

Hotels in Beirut have had a hard time of it. The fabled St Georges Hotel was blown up in the bomb attack that killed Rafik Hariri and sixteen of his entourage in February 2005, and remains an empty shell. Other hotels like the Holiday Inn have never been repaired.

During the Croatian war of 1991 the Intercontinental in Zagreb, far from the frontline, was packed with the breed Fisk talked of. A photographer friend discovered he could sell an unprocessed roll of film in the bar for a hundred bucks. He sold a lot of blank rolls before he was obliged to escape an army of armchair pundits.

Down in Dubrovnik, during the Serbian siege of the picturesque ancient walled city, the best hotel was indubitably, despite its unlikely name, the Argentina. It was renowned for the quality

of the home-grown cabaret. Here journos and TV crews amused themselves at the piano with choruses of *Always Look on the Bright Side of Life* as the Serbs poured shells into the city. *The Independent's* man Phil Davison was picked off by a sniper at the front door. The fragments in his leg were left there by the doctors to excite airport x-ray machines.

The social life tended to attract journalists to Le Pnomh, the main hotel in the Cambodian capital. It enjoyed "an irresistible atmosphere of hot sex and ice-cold drinks . . . long legged French girls grace the pool" according to *The Sunday Times'* Jon Swain. Alas, standards were not maintained by the Khmer Rouge.

I never stayed there, but friends told me the place to stay in Baghdad in days of yore was the Hotel al-Rashid with its marble, chandeliers, garden promenades, a lot of pictures of Saddam Hussein and window glass three inches thick. It enjoyed excellent views: it was from here in 1991 that CNN's Peter Arnett famously observed the smart bombs weaving their way through the streets and around corners right past his window. In those days it was the safest place to stay. The bunkers beneath the hotel reputedly held 1,000 people.

One of my personal favourites was on the Kenya/Sudan border. Trackmark Camp in Lokichokkio was really handy for those aid flights into Sudan which, as journalists, we were often able to piggy-back our way onto. Just over the border from famine, pestilence and war why not enjoy cold beers and a swim in the pool? Accommodation was either in traditional thatched *turkals* or in tents. My advice was always to go for the tents. It was easier to get rid of the mosquitoes. But you had to keep a sharp eye out for the odd cobra in the grounds.

Even in the most dangerous places of the world there is almost always one hotelier who stubbornly stays open to receive a mix of war guests. There is a certain category of hotel which will never appear in the handbook of *The World's Leading Hotels*. When war and civil breakdown comes to a country most hoteliers simply pack up and go. They are slaves bound to the credit card economy and the type of demanding guest who will complain about building work next door, never mind the odd bit of shelling or snipers routinely picking off the patrons. Nevertheless, all over the world - in places

The St Georges Hotel in Beirut was destroyed in the 2005 bomb explosion which killed former President Rafiq Hariri.

The Hotel El Aurassi, Algiers, also known as Fortress Aurassi. It was heavily defended by the security forces during the 1990s although journalists were unsure as to whether that was to keep out terrorists, or keep them inside.

like bloody Bosnia, anarchic Albania and battered Beirut - at least one hotel usually survives to resist the tide of more disagreeable human events. These hoteliers are really the ones who should pick up the awards for customer service, endurance and determination.

The war tourists are a curious breed. They are a curious mix of intending 'do gooders', hopelessly-out-of-their-depth academics and thrill-seekers with battered copies of *Combat & Survival* stuffed in their flak jacket pocket. In Croatia I once encountered a mercenary who confessed to arriving just with his passport and a copy of *Combat & Survival*. That was a stroke of luck for me as I wrote for the magazine at the time and it provided some excellent copy which much excited Bob Morrison, the editor.

During the mid-1990s Algiers was one of the most dangerous places in the world. A former SAS man of my acquaintance, then working in the oil industry protection business, told me in 1997 that my survival time on the streets, without protection, would be around 12 minutes. However, notwithstanding the constant noise of police sirens, fire engine klaxons and the bomb explosions, Algiers is a beautiful city more redolent of Marseilles than Baghdad. At least it seemed so to me, writing on my balcony at the vast, modern Hotel El-Aurassi, known to its residents as Fort Aurassi.

We were a mixed bunch - international journalists and election monitors there to watch Algeria vote after a six year-long democratic hiatus. You could tell the hacks apart from the monitors: the journalists were a scruffy lot in those securely zipped, multi-pocketed waistcoats, and the election monitors, usually retired intelligence officers and military men playing James Bond in their dotage, either wore dark suits or had gone quite native. There was a Swedish one in a crisp, tailored safari suit straight off the set of *Out of Africa*.

There was nothing wrong with the hotel. It was international five-star luxury: three restaurants, a vast swimming pool, a tennis court complex and de-luxe rooms with bathrooms the size of your average four-star hotel bedroom.

All that having been said, this was a prison, albeit a luxury one. The hotel complex was surrounded by high walls, barbed wire and metal railings: every fifty yards or so, machine gun-toting police special forces warily watched for an attack from outside . . . and

those of us on the inside trying to get out. On the roofs of buildings all around were police marksmen. If you went for a swim in the pool you would be outnumbered by the upholders of peace and democracy. One night they were returning fire off the high diving board. Hardly anybody swam in the pool.

Leaving the hotel was a major operation and you were obliged to precisely follow the correct procedures: fifty-eight journalists had been murdered in Algeria in 1996.

First of all, you went to the press desk and asked for official permission to go out. Vague, general requests would be turned down. You didn't get to go out without a specific destination. Then the hotel ordered a taxi from the guarded park below the building. Then you were assigned a close protection squad of no less than three plainclothes Interior Ministry security police by their chief who guarded the door. His guys stuck to you like glue . . .

At first it made you feel kind of privileged - like the President of the United States. If your taxi slowed down or stopped in the traffic, they were out of the following car like greased lightning and running alongside your taxi, eyes everywhere, hands inside their jackets ready to draw the heavy, shoulder-holstered Berettas. If you emerged from your taxi anywhere in the town of Algiers to admire the view, two were instantly at your side, whilst the other acted as the 'perimeter man' a distance away taking in all the angles of possible attack; the protection system known as *cercle de rapprochement*. If you met anyone downtown, the cars waited for you at the door with engines running. When you left you waited just inside the door for the sign to leave and then you made for the taxi at the double as your protection covered your hurried exit.

Departure from the pre-arranged schedule was not an option: you had to go back to the hotel and start the whole procedure over again. On the third day in Algiers en route to some political rally, a plume of smoke rose from the area around the *casbah* as a bomb blew aboard a public bus. An official in our car waved his hand airily. "Take no notice, today is the day we burn the rubbish." Two hours later, journalists were allowed on the scene as the fire brigade finished flushing away the blood and body parts

Trips out of town were another thing. A notice in the lobby advised journalists they had to give 36 hours notice. You requested your destination and presented yourself two days later. The security

The Hotel de L'Angleterre in downtown Algiers was destroyed by a bomb.

The legendary Galle Face Hotel has been described as 'a colonial time machine'

for this trip was even more impressive. You joined a convoy of at least three fully armoured Toyota Landcruisers each carrying four green-uniformed men of the crack *Gendarmerie Nationale* - a sort of Algerian answer to the SAS. I asked one of them what his work entailed. "We work like social workers with the people," he told me. Really?

The vital thing was that you must give the impression of playing the game with your minders. Try and give them the slip - or escape from the hotel - and it was a bit like Patrick McGoohan trying to get out of The Village in *The Prisoner*. Waste of time. I lasted about two minutes on the streets of Algiers before pistol-packing minders jabbering into walkie-talkies tracked me down innocently photographing a couple of pretty girls. "Girls do not like to be photographed here." That was a new one on me. Apparently, they were as forbidden as a photo subject as were all policemen, soldiers, police cars, government buildings, jails and, even, the ubiquitous AK-47 rifle (around since 1947).

I know only one journalist who successfully bucked the system in those ultra-dangerous days. I travelled out on the plane with James Miller of Frontline Television, the highly respected TV news agency. Miller was vastly experienced and he told me it was his intention to breakaway at the first opportunity. This he did successfully and got exclusive footage. Alas, he would be shot dead in 2003 by an Israeli soldier in Gaza.

Usually, if you turned out to be a nuisance then you were on your bike. They had a singularly effective way of dealing with offenders. No unseemly deportations with struggling journos manhandled to the plane. The management of the Hotel El-Aurassi, the only secure pad in town, sent you up a letter requiring you to vacate your room in favour of some other client. Having been ejected from your room, you had two choices: airport, or check in at one of the more picturesque joints downtown. This was not an attractive option. A journalist loose on the streets had, on average, 12 minutes to live. That's the time the Islamic terrorists took to spot you and organise a hit .. . The hits were 100% effective. They didn't waste bullets. They liked to get up real close and cut your throat from ear to sternum in imitation of an ancient Muslim religious ritual.

Funny thing, as I looked down from the sun-baked balcony of my room on the sweeping deep blue expanse of the bay of Algiers, the

comings and goings at the busy port, and on the streets of the Algerian capital, gin and tonic in hand life didn't really seem that bad.

And the bit I *really* loved was the drive back to the hotel from those trips to the country as the guest of the *Gendarmerie Nationale*. We drove back in a convoy of 24-valve Landcruisers, sirens wailing and lights flashing, at speeds of up to 150 k.p.h. flanked by police motorcycle escorts, as local drivers pulled off the road in terror onto verges and pavements. Gosh, it's fun around here . . .

But my favourite hotel was in the Sri Lankan capital, Colombo. The Galle Face, built in 1867 in the heyday of British rule, was still, in the mid-1990s, a magnificent, crumbling colonial-style hotel with mighty entrance halls and extravagantly uniformed waiters and doormen in gold braided sarongs and tunics. There you could still sit on the terrace looking over the Indian Ocean, watching the sun set over palm trees and fondly imagine that the world had never moved on from the days when much of it was coloured red on the map.

I remember when the establishment was under the personal direction of its owner, Cyril Gardiner, a renowned local eccentric: he asked guests not to use the lifts – "it's good for your health to walk up the stairs" – and deeply disapproved of smoking. You got a $5 a night discount on your room rate if you were found not to have smoked while staying. He was definitely more Basil Fawlty than Conrad Hilton in style.

I enjoyed a love-hate relationship with the Galle Face Hotel The promise of a warm welcome was communicated in advance by the letterhead confirming your reservation: 'Established 1864. Dedicated to Yesterday's Charm and Tomorrow's Comfort.' Known to its fans simply as 'the GFH', and pronounced as in ancient 'Gaul', 'the writer Simon Winchester aptly referred to it as 'a colonial time machine.'

It still survives as a bit of an anachronism although there is now a 'boutique' wing with jacuzzis, sunken baths and other modern paraphernalia. Make sure you stay in the old part of the hotel. It must be difficult to find a hotel anywhere in the world so redolent of the charms of yesteryear. More of a colonial-style palace than a hotel, aged retainers in pristine white military style uniforms, replete with red epaulettes and gold braid, cheerily salute your

Khutan, the doorman of the Galle Face Hotel, photographed in 2002. He had just celebrated sixty years working in the hotel.

progress through the magnificent, airy halls and over the creaking teak floors and fraying red carpets. During the late '90s, many of them had worked in the hotel for more than half a century. The ratio of staff to guests was a generous four to one. No employee had ever been sacked, apparently, until dynamic new management was drafted-in in February 2002. Then things started to change somewhat.

Your bedroom in the old wing, furnished with genuine, highly polished antiques, would likely be the size of half a dozen modern chain hotel rooms put together: the average size seemed to be around 30 foot by 20 foot. And all for less than $50 a night in those days. The King Emperor Suite, which has oft housed members of the British Royal family, is said to have the largest lounge in any hotel anywhere in the world.

It is a real seaside hotel: the waves break onto the beach just a few yards from your window beyond the neatly manicured lawns. It was immortalised in 1997 in the novel *Facing Out to Sea* which told the unlikely story of a high powered female executive coming to unwind in its hallowed halls and falling in love with a member of staff.

To my mind, the best thing about the Galle Face is still sitting on the terrace of an early evening with a cold beer watching the fiery red sun setting slowly into the Indian Ocean beyond the gently stirring coconut palms.

You could then, if you wish, happily absorb the rest of the evening reading and chuckling over the self-congratulatory stone plaques and wooden notice boards seemingly scattered at random through the extensive and grand public rooms and corridors. A letter of commendation from the Aga Khan is quoted, "Happiness is the Galle Face Hotel". One plaque records the various great and the good who have stayed including the Duke of Edinburgh, Noel Coward, Laurence Olivier, Lord Mountbatten, Cole Porter, George Bernard Shaw, Trevor Howard, Bo Derek, Pandit Nehru and Tigger Stack Ramsay-Brown M C (who he?).

It seems there was a time when anybody who was anybody would stay at the GFH when in Ceylon. Alec Guinness relaxed there after filming *Bridge over the River Kwai* up country. Gardiner gave up his own luxury suite to Arthur C Clarke so that he could finish work on *3001: The Final Odyssey*. The book was finished in the suite

used by H M Queen Elizabeth and Prince Philip, Richard Nixon and Lord Mountbatten. Clarke was able to complete the work in complete secrecy in the decaying seediness of the Galle Face. A bust of Sir Arthur C Clarke is a feature in the main hall. Beside the bust stands a stone water trough topped with frangipani petals. Under the Gardiner regime, birds freely nested in the rafters above and could swoop down to drink.

Film makers often come to the hotel to shoot movies. One Italian director told me, "Everything is here, untouched. We save all the money on the set budget."

The plaques and notices are effectively memorials to the hotel's eccentric owner, deceased in 1996, Major Cyril Gardiner. Often charming, frequently uncompromising, if not totally intransigent, Gardiner was a true autocrat within his own four walls. Gardiner gave a lunch in the hotel for the Queen of Denmark - after whom he named a suite - and after the meal she noted the No Smoking sign. Though reportedly "craving" a cigarette she forbore to smoke such was Gardiner's forbidding presence.

I once had cause to call Gardiner the Basil Fawlty of South Asia. Back in April 1996, the Galle Face was going through, let's just say, a difficult patch. In the course of one week's stay, you couldn't help but notice that the aged roof was leaking copiously on the stairs. The staff of a lunchtime grabbed placards and demonstrated at the main entrance over Gardiner's conservative view of staff remuneration, before returning to work in the afternoon. The terrace dining area resembled a shower cubicle in heavy rain and as I tucked into my damp curry and rice I could not help but observe a trio of half drowned rats emerge from a drain cover. The water ran brown from the taps. The electricity regularly failed several times a day as the aged generators vainly attempted to cope with the vagaries of the Sri Lankan national grid. And, in the heat of the night, the insects came out to play.

About 1.30 one morning my *sang froid* snapped as the flying cockroaches, having knocked themselves out by flying into the walls at high speed, tumbled around me on the bed. As a phalanx of room boys attacked the incursors with their shoes, beating them to death on the carpet, I summoned Cyril to the telephone.

He appeared to listen patiently to my complaint. Nobody had warned me, however, that he was particularly protective of

his cockroach population. "Mr Harris, you must understand," he began with an ominously wearisome tone to his voice, "that these cockroaches have been here since before man was on this planet. They tell me that they will be here even after a nuclear war. What can you really expect me to do about them? If you don't like my cockroaches then I suggest you move to the Hilton Hotel."

I did. After all, this was hardly the mollifying response of the remorseful hotelier. At least, when I checked out, the cashier told me, "Mr Gardiner says there is no bill for you, Mr Harris". The next several trips I stayed in the Hilton. There were no cockroaches. Everything worked perfectly. But it was charmless and boring. And then the Tamil Tiger terrorists blew in the windows anyway. So, I found myself back at the Galle Face with all its elegant, fading grandeur. Although I tried my very best to resist the feeling, I really felt I was coming home.

Cyril has passed on to the great hotel in the sky after a heart attack on the dance floor but his spirit remained for many years. The telephones were unpredictable. The fax went down for two or three days at a time. A uniformed servant smilingly presented you with a telephone message written in beautiful script. As you tipped him 50 rupees you discerned the message was three days old. There was no dining room as such - all meals were taken in the open air out on the pillared and stuccoed terrace. The coffee was legendary. Quite undrinkable. Your beer could easily take thirty minutes to reach you courtesy of a waiter in a starched sarong, but most of the time you simply didn't mind, such was the charm of the ambience.

Cyril once summed it up. "This hotel is not perfect but I think it is delightfully imperfect." It was a wonderfully prescient observation which provided me with the perfect title for my book on the hotel, *Delightfully Imperfect*, which would appear in 2006 after I actually lived in the place for a year when I was *The Daily Telegraph* correspondent in Colombo. A previous correspondent who lived there, John Rettie, moved out after he found his telephone to be tapped. My experience would be disturbingly similar . . .

I would let his son, Sanjeev, see an advance copy but he forebore to comment. Somehow, I don't think he quite approved of my spilling the beans on the hallowed halls.

Arthur C Clarke came to the launch of my book of photographs of Sri Lanka, Fractured Paradise. The launch was held at the Galle Face Hotel in 2001. At the end of 2001, I would return to live in the hotel for almost a year.

All this would not last for ever. The Raffles Hotel group had their beady eyes on the GFH. The deal fell through. Cyril's son, Sanjeev, then took charge and determined to bring the 19th century kicking and screaming into the 21st. There were now things called televisions in all the rooms, a buffet at breakfast and the sound of hammering and sawing reverberated around the halls and corridors. The so-called boutique extension called the The Regency has been opened, but, for all its luxury, it lacks the true rundown charm of the older part of the hotel.

Get yourself to the GFH for the experience whilst it survives as an anachronism. The actress Carrie Fisher wrote to Gardiner summing up the appeal of his establishment, "You could be alone here without ever feeling lonely." Indeed.

The Mount Lavinia Hotel is half an hour's drive south from the GFH. It was originally the residence of the British Governor, Edward Barnes. The Mount Lavinia is also one of the great colonial relics of old Ceylon. Formerly, merely the weekend residence of the Governor – the present building dates from 1877 – it is said that he was obliged by the British government to sell the magnificent retreat once they found out about it. In London, apparently, they failed to appreciate the luxury and expense of this remarkable piece of colonial architecture with its palatial rooms and labyrinthine corridors. Today, it is full modernised and represents the apogee of luxury.

It is particularly agreeable to sit on the terrace at the side of the pool of a Sunday lunchtime as the bathers splash, a band plays and waiters in black tie serve cold beers. The hotel stands on a promontory surrounded by the Indian Ocean on three sides and the overall impression, as a clarinettist plays *As Time Goes By*, is one of being on a luxury liner at sea.

The New Oriental Hotel in Galle, another two hours drive to the south of the island, was not quite in the same league until it was recently refurbished. Once it was *the* hotel in a fortified, walled town successively occupied by the Portuguese, the Dutch and the Brits. The NOH is the former British barracks. The rooms were cavernous. In my room in 2001 there were two four poster beds, a three piece art deco suite with 1960s coverings and a ceiling fan with blades the size of an aircraft propellor. There was no

air conditioning and the colonial heritage was abundantly clear from the pictures on the wall. There were two framed pictures: of wrinkled old Dutch pipe-smoking fishermen on a beach in the Low Countries and matching pictures of our own Dear Queen and Prince Philip: colour pictures from the era of the coronation now turning a sickly green in the tropical sunlight.

Years ago, the guidebooks noted the Dutch colonial furniture, the grand piano which guests were encouraged to play, and the Old Masters on the wall. The grand piano was still in evidence but nobody played it while I was staying. Apart from myself, there was a retired English couple who returned year after year and an English film actor, one Oliver Tobias, on his honeymoon. He was a sort of Oliver Reed character who was there with his exceedingly beautiful young bride. The only film I could recall seeing him in, appropriately enough, was *The Stud*. I was glad to be able to report that he still seemed to be lasting the pace. "I made a film here twenty years ago," he recalled over a local Lion beer. "The army lent us five thousand men and an elephant-borne regiment of cavalry." Those days are long gone – as are the Old Masters and the best of the antique furniture. However, the NOH has now joined the boutique hotel league, although it almost perished in the terrible tsunami which wrought such havoc upon the city of Galle.

But the place to stay for the visitor to Sri Lanka with a penchant for the delightfully archaic is the 122 year-old Hill Club at Nuwara Eliya, in the centre of the island's tea growing area. High in the hills, it is cool and the weather frequently dismal. A bit like Scotland, really. The building itself is a cross between a Tudor castle and a Cotswold manor. Here, for around £30, or $50, a night, you could wander through a forgotten world of billiard tables, book-lined rooms, Men Only bars, and a withdrawing room with a wedding picture of Charles and Di still occupying pride of place as late as 1996.

Reassuringly, over the stone fireplace in my bedroom was a reproduction of Sir David Wilkie's *The Reading of the Will*. Jacket and tie was *de rigueur* at dinner until very recently and a member of staff would lead you to a wardrobe off the butler's pantry where you could select from a range of old school ties and butlers' jackets which would be duly handed back at the end of the evening. Now

The route to my suite overlooking the Indian Ocean followed this magnificent open balcony.

The view from the balcony of my suite at the Galle Face Hotel.

you can get away without a tie: a disappointing emergence into the 21st century. That notwithstanding, as soon as you reach your room, your own butler will arrive with a hot water bottle.

In the morning I was chuffed to leave with a monogrammed ashtray, a wonderfully stylish egg cup, the teapot and a candle holder stashed in my suitcase. Sign of the times, old boy. They were flogging the china off at reception.

There used to be another peaceful, fascinating and beautiful place to put your head down on the eastern coast of Sri Lanka. It was called the Nilaveli Beach Hotel. I often reflected this must surely be the nearest thing to paradise - if such a thing might exist on this earth. The turqouise blue waters of the Indian Ocean crashed gently onto pure white, palm-fringed sands which seemingly stretched away into infinity. My cool, airconditioned hotel room opened directly onto the beach and, of a morning, it was an effortless 100 metre sprint into the clear, warm waters of the ocean. For the snorkeler, just beyond the gentle surf there were stunning, white coral reefs and shoals of exotic tropical fish. A couple of miles offshore over the clear water was Pigeon Island, breeding ground for the Blue Rock Pigeon. It is said Admiral Lord Nelson used the island for gunnery practice.

Over a breakfast of fresh pineapple it is already time to consider dinner. Yes, lobster, would be fine and a boatman is engaged to catch your dinner. Here, there's no pollution, no sewage. No hawkers on the beach - well, there is one inoffensive chap on a bicycle selling spectacular conches at a couple of quid a go. No deafening disco. No drunken louts. No noise of jet skis. No film of suntan oil on the clear, still waters of the swimming pool. As the sun sets over the Indian Ocean and the blue sea turns a reddish grey you tuck into perfectly prepared lobster, sweeter and fleshier than it seemed possible to imagine.

Members of staff busy themselves catering for your every need. This all sounds so perfect that you might rightly wonder why when I tell you that most of the time I was the only guest in the Nilaveli Beach Hotel. That, indeed, there were frequently no guests at all despite the derisory $15 a night price tag.. That paradise remained beyond the reach of all but a very few. Rightly, it should have been at the top of the list of Asia's dream hotels. But Nilaveli (pronounced Nee-laa - vely) was the last remaining, functioning luxury hotel on

The GFH, as it was known, was always being visited by interesting, and often famous, people. One day, I photographed the doyenne of war photographers, Tim Page, outside the hotel.

The Nilaveli Beach Hotel was one of my favourite hotels. What was particularly nice about it during the conflict in Sri Lanka was that it was usually deserted. I was quite often the only guest and had the beach and ocean all to myself.

the whole of the east coast of troubled Sri Lanka in the 1990s. It was firmly in No Man's Land.

A few years ago, manager Mr V Prem Kumar sat, most of the time, in the hotel alone with 20 members of staff. For the 23 year-old, Nilaveli Beach Hotel was on the very front line in Sri Lanka's long running war in paradise: it effectively existed as an oasis of luxury and safety in the no man's land of a bitter war. It was a strange, bizarre haven and its continued existence was something of a mystery, even to those who were in on the secret.

In the early 1980s, tourist hotels mushroomed along the north east coast of Sri Lanka in the area north of the port of Trincomalee, or 'Trinco' as it is known, dubbed 'the best natural harbour in the world' by Nelson. The vast white beaches and the warm, blue waters combined with mean temperatures around 28 degrees made it perfect for tourist development. The science fiction writer Arthur C Clarke, from his base in the Sri Lankan capital of Colombo, bought land for a deep sea diving school and investors poured into the area.

But a bloody attack on the Sri Lankan army in July 1983 announced the emergence in the north of the country of radical, uncompromising leader, Vellupillai Prabhakaran. A ruthless ideologue, he sought to lead the minority Tamil population, concentrated in the north and east of Sri Lanka, into an independent state of Tamil Eelam. Soon Sri Lanka was plunged into ethnic conflict as majority Sinhalese fought Tamils in the streets of the cities, including Trinco. Up until the summer of 1985 the hotels on the east coast were full with western tourists but that year the tentacles of war spread inexorably and the tourists stayed away.

Most of the Colombo-based owners abandoned their hotels to looting and decay: just next door the Blue Lagoon Hotel lies deserted and ruined. Others that attempted to stay in business were destroyed. That summer the Moonlight Hotel, just a couple of hundred metres the other side of the Nilaveli Beach Hotel was blown up the Tamil fighters: the LTTE, or Liberation Tigers of Tamil Eelam. Its eerie, collapsed ruins and its stagnant, sludge filled swimming pool stand in silent testimony to what happens to a tourist industry when war arrives.

Somehow Nilaveli stubbornly remained in business - with virtually no business to speak of - as the war has ranged around

it. The barman reminisced to me about the summer of 1985 when there were almost three hundred guests packed into the 90 rooms laid out in whitewashed, terraced bungalows. Empty it became, but it was not operated as some sort of cheap, gimcrack joint: towels were changed twice a day, there were fresh sheets on the bed daily. However, a photograph of a throng of extravagantly uniformed and sarong-clad staff at the opening in 1974 hanging in the office shows that things are not quite as they were. Nevertheless, whenever I visited, as the tropical dawn broke at 7 a.m., a dozen or so workers were already busying themselves scooping overnight fallen leaves from the pool, brushing the tennis court, polishing the tiled floor of the open-sided restaurant, sandpapering and varnishing its columns of coconut timber, sweeping the paths which wind through the low fruit and beech trees connecting the bungalows to the main block – they were even sweeping the beach to smooth the sand for the day's single visitor.

In those days, there was just the odd journalist or aid worker while Mr Kumar patiently waited for the tourists to come back. As you made your way up the narrow, broken road to Nilaveli, past a series of rigorous army checkpoints and through the heavy iron gates set in a high wall, the place was an enigma.

The engaging Mr Kumar proclaimed himself to be a professional hotelier who enjoyed his work. He also seemed to be a bit of a philosopher which must have been something of a prerequisite in his position. Born in Jaffna, in the Tamil heartland in the north of the country, he was married to a Christian. "Same roof, different houses but the roof always safeguards you when it rains." He said he believes that men should live in peace. It was, however, clear where he was coming from although he professed that in the limited time on earth we should behave to each other as brothers.

Yes, but how did this hotel survive when all around were destroyed; in an area where the military had abandoned any attempt to control the roads after nightfall and the LTTE controlled supreme?

"Well, you see, this hotel is running in a neutral way. We are not interested in politics. We just do hotel business." The holding company - Mercantile Investments Ltd - had other interests in hotels and tourism but they could hardly be subsidising Nilaveli:

tourism was at an all time low after dramatic attacks on the centre of the capital, Colombo. Mr Kumar shrugged his shoulders, "We have a few guests. We survive." The reflection of the floodlights and fairy lights twinkled in the waters of the pool ($300 a month to maintain) and, just beyond, arc lights illuminated the entire beach frontage for hundreds of yards in both directions.

People in faraway Colombo - to whom this was an impenetrable war zone - had their own theories. As the assistant to a government minister told me, "They pay off the Tigers *and* they keep the army sweet." Mr Kumar vehemently denied this but, nevertheless, the war went on all around every night, seemingly never touching the calm of Nilaveli. "The LTTE may go to the villages but they never come here. The management at the Moonlight Hotel made a big mistake - they took sides." In fact, I am told they simply asked the local police to guard the hotel - around here that alone was quite enough to constitute taking sides.

Then, other people said the hotel's survival was linked to two radio transmitters with their towering antennas located behind the hotel. They were operated by the German Foreign Office and Deutsche Welle technicians lounged by the pool at the weekends ...

As we talked on the terrace as the sun slipped down, there was a long, deep rumbling sound. Mr Kumar looked pained. Then it was repeated. We both knew what this was. It was the sound of heavy artillery fire.

Said Sri Lank'a most resilient hotelier, "It is a very long way away, maybe 50 miles. Don't worry." Sound travels far in the still of the tropical night. And he added, "We will never give up. We will never lose hope. We will never close."

What the war could not do, the terrible tsunami achieved, rolling in across the Indian Ocean and flattening the beach front bungalows. However, I am told it is back in business. I have not returned.

You know what they say about Holiday Inn Hotels. Same furniture, same decor, same facilities - whether you're in London, New York or ... Sarajevo?

Incredibly, yes, the Sarajevo Holiday Inn was still very much open for business during the bloody siege of the city. There were still clean sheets, a functioning laundry service and, even, for guests staying on Christmas Day of 1993, there was a Christmas card and a 1994 calendar.

The Holiday Inn Hotel in Sarajevo (centre) was a miracle of survival. Right on the frontline, it was blasted in the early days of the war and then an unofficial deal was reached that it would not be shelled so that it could be safe for journalists.

Bosnia has just a few miles of coastline, interrupting that of Croatia. There is a single seaside resort called Neum which kept going all through the Bosnian war. It was a well kept secret and although the hotel in the photograph was bombed from the air early in the war, the Hotel Sunce kept going..

Not bad going for a hotel situated less than 100 yards from the frontline between warring Bosnian government troops and the Serbs. Hardly surprisingly, just about the only guests were war correspondents, for whom the hotel became something akin to an exclusive private club.

Of the 320 rooms, just about half continued in operation. Those facing the Serb positions were sensibly adjudged too dangerous for occupation and several were irreparably damaged by shellfire early on in the war. Quite a number of news operations like the agency Reuters, under its knowledgeable and shrewd boss Kurt Schork, were permanently encamped in the building. I met a woman from Radio Television Luxembourg who had been there since the beginning of the war, as had the BBC which had a suite of rooms, including one just for their own generator. "Stops the fumes from choking us," Bob Simpson observed dryly to me. It's reckoned by some the BBC paid out more than £100,000 a year for the privilege of this frontline suite.

Who exactly owned the Holiday Inn and how it continued to function was always a matter of some speculation. A splendid Christmas Day party with pink champagne and an array of cooked meats was thrown by a local trading company called Neretva as shells whizzed their not so merry way around the building.

The hotel had closed temporarily after April 5 1992: as war broke out in the city, a Serb sniper set himself up on one of the top floors and the building was the scene of fierce fighting. It reopened after the press was successively driven from other hotels in the city and, apparently, an immunity agreement was reached with the Serbs over the building: it hadn't been hit by a shell for over a year until two days after Christmas, when I happened to be there.

Most of the windows were broken by bullets or shell blasts but they were soon patched up with polythene and tape bearing the blue *imprimateur* of the UNHCR. Broken windows didn't really rate in the damage stakes in Sarajevo where shell-holes in buildings were par for the course.

There were some management problems. The first manager reportedly disappeared with several months cash takings and the next one drove off into the distance one day in an expensive armoured Mercedes owned by the Spanish newspaper *El Pais*, never to be seen again.

As my Sarajevo friend, Mirza, observed, the Holiday Inn was "like the moon to the people of this city." Three hot meals a day were served in the dining room by waiters in black tie. Where on earth the food came from in this city of the starving was always a mystery, but the best guess was that the Serbs sold it to the Muslim owners - at a price, of course. Anyway, the food was included in your daily room rate of US$82.00. Cash only, please, either in US$ or Deutschmarks.

Generally, there was little or no electricity and you took your own torch and candles. There was gas central heating, however, which sometimes worked. And as long as there was sporadic electricity there was a trickle of water in the taps.

The hotel was originally opened in 1983 in time for the Winter Olympic Games in Sarajevo. Situated in the middle of one of the most important squares in the city and ringed by the Museum, the Faculty of Philosophy and the dramatic twin Unis skyscrapers - shelled and burned out in May 1992 - it was one of the city's most important pieces of modern architecture. Built on an open site traditionally used for hundreds of years by visiting circuses, the dramatic design originally incorporated a linen cupola in the main hall.

All the glass at the front of the hotel was soon shot out and the odd stray round whistled its way through the atrium from time to time. There were various stern house rules issued to guests. You never, but never, left by the front door. There was an active sniper, appropriately enough, on the roof of the Anthropology Building across the road.

The major papers, broadcasters and agencies had armoured cars in the underground car park below and they roared in and out like joyriding schoolboys. Impecunious freelances (like me) made a heart-stopping dash across a 100 yard open space from the back door.

The whole operation was remarkably well run considering the rather adverse circumstances. And most nights there was a free firework display thrown in as tracer arced its way past the dining room.

I wrote a very complimentary article about the Sarajevo Holiday Inn at war for the Business Section of *Scotland on Sunday*. It brought an incredibly sniffy response to the editor from the Franchising Department in Brussels who denied it was any longer part of the chain. Instead of being proud of one of their most

resilient outfits, they chose to pull the rug from underneath it. Of course, they probably weren't paying their franchise fee any longer, but that could hardly be regarded as surprising.

Of course, the only way the hotel could keep going right on the frontline in the middle of the besieged city was by either paying off both sides or in alliance with organised crime. Otherwise, there simply would have been no way to get that food on the table.

Not many people know this, but blood and battle-scarred Bosnia boasted just 4 miles of coastline - including a seaside resort to rival Torremelinos. On the beach at Neum, thousands of tourists still disported themselves against a background of burned out and blackened hotels - Beirut-style. The beach is a mite shingly but the water is beautifully clean and cool. I stayed in the vast Hotel Sunce, a modern brutalist concrete structure built in 1983 housing 800 guests. It certainly rivalled the best of any Spanish hotel: bars, restaurants, casino and my own large room boasted seating area, bathroom and balcony for less than $15 a night! Of course, that was in 1996.

It used to be in all the tourist catalogues - that was before war tore apart Yugoslavia in 1991. The barman in the luxurious ground floor bar told me I was the first British 'tourist' he had seen for five years. In fact, you could come here for a week's holiday and not even know that a war was going on thirty or forty miles up the road further to the north.

In days of yore it had been given to the Turks by the merchants of Dubrovnik to protect them from the Venetians. Tito also gave it to the Bosnian people as an outlet to the seaside - and the sea. Now this coastal resort was dominated by Croats who came here both from Croatia and the Croat-populated parts of Bosnia.

Sixty-three year old Albert Luthi from Konstanz was on the beach enjoying his seaside holiday. The Germans can usually be counted on to be first on the beach but Albert was probably the ultimate in the intrepid traveller stakes.

At night, the bands played the sort of romantic Croatian music which is fashionable around these parts and couples and young children danced into the night in much the same way as Brits do on the Costa del Sol.

On the other side of the bay another vast hotel provided rather

a menacing backdrop. In 1992, Serbian fighter jets swooped on Neum and attacked the hotel with rockets. It was reduced to a shattered and burned out shell. And on the edges of Neum, Moslem-owned holiday houses had been ransacked and burned out in an exercise in ethnic cleansing.

There was the opportunity for some exciting side-trips from this Adriatic resort if you got bored with the sun, sea and the shingle. Within 90 minutes drive was the pilgrims' mecca of Medjugorje where, in 1981, three girls saw a vision of the Virgin Mary. It is still visited by tens of thousands of pilgrims every year. Just 20 miles down the road is the devastated city of Mostar - once the meeting point of east and west with its ancient high-arched bridge and unique mediaeval Turkish-style monuments.

It was firmly outside the war zones of former Yugoslavia, but there was one hotel which welcomed me within its hallowed walls on a regular basis as I made my way back to the UK to file stories and pictures. I first went there by accident. After the airport at Ljubljana was trashed by the Federal forces of Yugoslavia, it was soon discovered that they had stripped the facilities of vital radar and other navigational equipment. This tends to take any airport off the list of internationally approved arrival and departure points.

I found myself having to take a long train ride to Vienna and then having to hang around there overnight to await a flight to London. With no booking, I asked the taxi driver at the station to take me to "ein gutes Hotel". I asked for a good hotel, not the best.

We arrived at Vienna's prime resting place, the exclusive Hotel Sacher Wien, whose coffee shop is the home of the world famous cake, *sachertorte*. Quite before I realised where we were, the commissionaire and bell boys had my rucksack, flak jacket and helmet out of the back of the car and piled in a shabby heap at the front desk.

I enquired timidly as to the cost of the room. It came in somewhere around US$800. Something cheaper, I ventured? I added that I was a Scottish journalist fresh from the wars in Yugoslavia ... They took pity on me. It was also a quiet Saturday night. The receptionist said they had one small room beside the lift on the top floor and which was the only room in the hotel without an en-suite bathroom, which was conveniently located next door in

the corridor. I could have Room 84 for the equivalent of US$80.

The room was small but totally charming with beautiful framed 18th century paintings of Alpine scenes, chintz furniture and velvet drapes. I was extremely comfortable and could, of course, also enjoy the elegant public rooms of the historic hotel.

The following month I faxed the hotel to order the same room again. I received a polite fax back saying that there wasn't a single room in the Sacher which was not en-suite . . . and Room 84 did not exist.

So I turned up unannounced. The receptionist raised his eyes from the ledger. "Oh, it is the poor Scotchman, again," he observed wryly. "Give him the key for Room 84."

I became a regular at the splendid Sacher Wien.

Nine

What About the Money, Then?

Whenever I talk about my experiences in the conflict zones of the world, whether on cruise ships, at social gatherings or commercial events like conferences, the burning issue which most listeners want to know about is *the money*. Most people fondly imagine that if you put your life on the line, for whatever reason, then you will be handsomely remunerated. I agree wholeheartedly with that concept but, alas, in reality a freelance journalist was, and is, generally speaking, quite pathetically remunerated.

Of course, it is different for international megastars. The ITN correspondent and newscaster, Sandy Gall, gave his autobiography the title, *Don't Worry About The Money Now*. The title originated with a reassurance given to him back in 1955 by his desk editor at Reuters in London as he was sent off to East Africa. Reuters was doing rather well in those days.

It was rumoured whilst I was in Bosnia that CNN's top presenter Christiane Amanpour had just re-contracted with them for an amount in the region of $2m. And, of course, she didn't have to provide her own transport, flak jacket, helmet and camera out of that budget.

I wasn't particularly fond of her. I was once detained by the Serb police at the notorious Checkpoint Charlie out of Sarajevo which you had to pass through to get to the airport. I had taken a risk and it had not worked out very well for me. Some local friends in the besieged city, who were totally unable to get any mail out, had asked me I would take some letters back to the UK and post them from there. Another journalist had told me that the place to hide illicit materials you were taking out or bringing in was inside the lining of your flak jacket, which is stuffed with the supposedly bullet-proof Kevlar. This seemed a fair enough suggestion and that's what I did. When I got to the Serbian police checkpoint they searched my bag and then asked me to take off the flak jacket which they broke open ... amidst a multi-coloured shower of letters and packets.

I'd been held there a few hours when Christiane drove in with the CNN armoured convoy. "What have you done *now*, Paul?" she

asked me in what I thought was an offensive tone of voice. When I told her, she made an observation of the sort which implied I was getting my dues, and drove off merrily into the distance. No thanks to her, I did manage to extricate myself from the clutches of the Serbs, minus the letters and a few bottles.

She was probably the top earner in that war although others who flitted in and out of it, arriving when things were heating up and the war moved up the schedules, were also big earners, in six figures if not millions: people like US anchorman Dan Rather, Middle East expert Robert Fisk, veteran editor Bill Deedes (former editor of *The Daily Telegraph*) and broadcaster Michael Nicholson.

It used to be the case that if you wanted to get into Sarajevo during the height of the siege then you were obliged to queue up at Ancona airport, on the Italian Adriatic coast, and dutifully wait for a spare seat on a flight – usually a Hercules C-130 or Transall troop carrier converted into a transport aircraft for food, medicines and other vital supplies to sustain the terrified population of the Bosnian capital. Seats were strictly limited and, on the worst occasion I can remember, following the mortaring of the Sarajevo market place, there was enormous pressure on space.

I arrived at Ancona and found there were 32 UN-accredited journalists on the waiting list ahead of me. The system was that you registered with an RAF military policeman. You then pitched up at 6a.m. every morning and waited in line: some days a dozen might be taken in, on others just two or three. If you didn't turn up at six and re-register, the MP simply struck your name off the list and you had to start the process all over again. Naturally, aid workers and dignitaries got precedence over hacks so a seat you thought you imminently had could disappear in the flash of a second. On the fourth day, I finally got a seat.

On the same plane was the famous Dan Rather, US news anchorman. Intriguingly, I hadn't seen him in the line over the previous four days and I asked him how he got on. "Well, Paul, it's like this. The network needs *me* there. We paid some guy a thousand bucks to stand in line for my place."

All a rather different world from that of the humble freelance. I tended to put my paltry income together from as wide a variety of sources as possible, bearing in mind that I had to cover the

costs of my airfares, maintenance of the car (expensive), petrol (at a premium price), hotel and accommodations, food, film, maintenance and repair of camera equipment (frequent), fees for accreditations, interpreters as necessary, and so on. The list seemed endless sometimes. Just about the only thing that was free were those flights on UN aircraft into Sarajevo and the occasional chopper ride courtesy of obliging British forces.

My accounts for year three of the Bosnian war showed that I had made, from all sources of income, something over £100,000 (in US $ terms then about $160,000). That may sound a pretty fair result. The problem was that my expenses totalled £96,000. And they were all down to me. Admitted, there might have been a few bottles of champagne in there, to celebrate survival, but most of it was the necessary, everyday stuff.

So before I left for Bosnia, Croatia or wherever, I would hit the telephone and the fax (no emails in those days) and seek commissions. Infuriatingly, most editors responded with the all too familiar phrase, "Let's wait and see what you come back with." So, effectively, the freelance covered all the financial risk, as well as the physical risk. There were, however, just a few clients I could always rely upon.

From the outbreak of war in Slovenia, *Scotland on Sunday* had started commissioning pieces from me and I developed an excellent working relationship with the deputy editor there, Brian Groom. Brian was an intelligent and perceptive editor with the studious air of an academic, which sometimes seemed out of place in the bustle of a newspaper office. But he was a great detail man: very little went past him. He also understood and sympathised with the fact that I was covering vast distances and putting great physical, financial and emotional effort into the Yugoslav story.

The foreign editor was also an old friend, Trevor Royle, whom I had known at Aberdeen University. I had worked with him there on the newspaper, *Gaudie*, where he was the sports editor. Of a Saturday, he would typically send me off, when I was the paper's photographer, to picture some sporting event which was a total mystery to me: ladies' hockey or formation swimming, or something like that. I didn't have a clue what to photograph most of the time but usually seemed to come back with something printable.

A French Transall transport aircraft lands at Sarajevo Airport, 1992. The Serbs controlled all access to Sarajevo which was besieged continuously from April 1992 until August 1995. For much of the time the only access for journalists was on board UN flights.

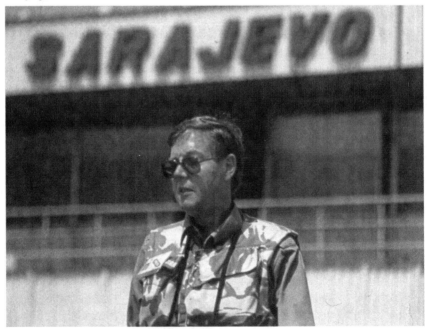

Pictured at Sarajevo Airport, summer 1992.

Trevor had developed a very successful career, after working in publishing and at the Scottish Arts Council, as a professional commentator, pundit, editor and writer. A man of unflappable urbanity, he could charm the birds out of the trees: he frequently did. He had little difficulty developing professional relationships and he would make himself a particularly successful niche in military history thanks to a remarkable capacity for research and an excellent literary agent.

The relationship with SOS meant there was hardly ever a trip when my material did not find its way into the paper. However, that might at most bring me in £500 (US$800) which would typically cover half the cost of the trip.

In the second year of the war another reward did come along. There was no money in it but there was a nice certificate as an award winner in the British Press Awards, David Blundy Award section. David Blundy had been a highly respected foreign correspondent for *The Sunday Times* and the now defunct *Sunday Correspondent* when he was shot whilst covering the war in El Salvador. His daughter, Anna Blundy, wrote one of the more unusual and revealing books about the life of a war correspondent, *Every Time We Say Goodbye: The Story of a Father and a Daughter*.

The editor, Andrew Jaspan, was delighted with the success for the paper. He asked me for the certificate after the award ceremony but I refused; I gave him a photocopy the following week for his 'trophy wall' in the office. It was probably a political error of judgement. The same week, riding on the back of the success, I asked Jaspan for a column. "No, Paul. You're not a columnist. You're a frontline man. Continue with what you're good at . . ."

Material which did not make its way into SOS would then often turn up in *The Scotsman* (I always felt my first loyalty to be to SOS). The editor in those days was Magnus Linklater and I was never able to get the full measure of him. I remember going into the office with a gruesome piece about Christmas in a Croatian mortuary. OK, it wasn't exactly festive reading.

He clearly didn't like it. "Look, Paul, read this. It's a great piece by Sir Fitzroy MacLean on Dubrovnik." Dubrovnik was, of course, under siege and in the news but, as much as I liked and admired the man who had done so much to shape Yugoslavia during the

British Press Awards 1992

COMMENDED

David Blundy Award

PAUL HARRIS

Scotland On Sunday

David Chipp
Chairman, Panel of Judges

British Press Awards 1992. The David Blundy Award certificate for my work in Croatia and Bosnia during 1992.

Second World War, I personally couldn't rate Fitz's reminiscent travelogue as a contribution to explaining the hell of Croatia which I had experienced.

To be fair to *The Scotsman*, the features editor asked me to leave it with him. The following week, on Magnus's day off, the piece made the paper together with my picture of a collapsed, grieving widow at Djakovo Mortuary.

I started getting some 'mini-exclusives' on the military and defence aspects of the war in Yugoslavia. This was the aspect of the conflict which most interested me as I had an analytical turn of mind. One day I had a call from Paul Beaver, the London-based defence consultant, who worked with the renowned Janes Publishing, the most significant defence publishers in the world. This was the beginning of a long, ten year, relationship with Janes. To analyse what was going on in the Balkans, Janes launched a special monthly news magazine called *Janes Balkan Sentinel*. Paul Beaver edited it from London and I became Contributing Editor, feeding in the stories from the cutting edge of the conflict on the ground.

From time to time, I would pitch up on early morning radio in Scotland doing a two-way (interview) on *Good Morning Scotland*. This was as a result of my giving them a very noisy tape which I made during an attack on the Croatian police station in Pakrac on my second war visit there. I found myself sheltering in the basement as the world erupted around me. It was a very dramatic tape, although, apparently, it took the engineers almost a whole day to remove the expletives. This was good exposure for me but the money was execrable: around £20-30. A mortar explosion wrecked the tape recorder as I fled from the basement, so there was no profit in the trip. However, I always agreed to do GMS, as it was known, as I felt I was building a reputation which might some day lead onwards and upwards to the stars . . .

I'd suggested to BBC Television in Scotland that I should make a documentary for them about my own work in the war and had put up a fairly detailed proposal to them early on in 1992. My proposal fell on stony ground. Then, just ten days before Christmas, the phone rang one morning. It was Allan Pender. Allan usually made sports programmes but, in the curious way wholly unexpected breaks appear in life, he told me that he'd been standing

Sarajevo under siege, 1994. More than 12,000 civilians died in Sarajevo during the war. Snipers and mortar fire claimed most victims and barricades like this one were erected to obstruct the snipers' line of fire.

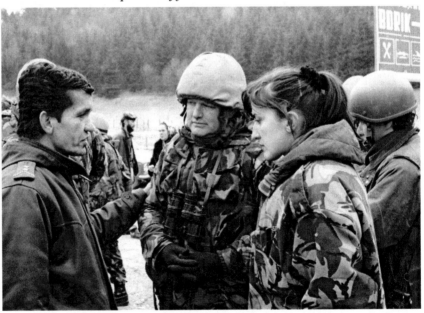

Lt Col Bob Stewart and his interpreter Dobrila Kolaba, Christmas 1992, outside Café Borik, Turbe, with the local Serb commander. Tragically, Dobrila was shot dead by a sniper at the British base in Vitez in August 1993. Bob would dedicate his book Broken Lives, on the Bosnian conflict, to Dobrila and write, 'It is beyond belief that any man could so callously line up – presumably with a telescopic sight – on to the head of a woman and then pull the trigger, but someone did.'

in the urinals at BBC Scotland when Ken Cargill, head of news and current affairs programming, had come in. They exchanged banter in the way men do in that enforced social situation and Ken confided that he had "a real problem". The planned major documentary for screening immediately after the new year, by the station's shining star, Kirsty Wark, had been 'killed' by the legal department.

Allan jumped in like a rat up a drainpipe and as a result asked me for another full proposal, but within two hours! By late afternoon, we were in business. The bad news was that this was to be a distinctly low budget affair (I seem to recall that the whole programme was made for £30,000 – that's very small budget for a 30 minutes documentary involving international travel made for national television). I would write and present the programme, and there would be one other person with me, a director-cameraman who Allan introduced to me in the Abbotsford pub in Edinburgh's Rose Street the following Saturday.

I was never quite sure what to make of Ian Hamilton. Most of the time he was moody, and had an acerbic tongue but then, quite suddenly, he would become completely charming. But I gauged he had the single mindedness which makes a good cameraman; the determination never to let an opportunity pass him by. He was then 26 or 27 years old and had been an officer in the Royal Irish Rangers, serving in Northern Ireland and the first Gulf War. This was a good background for our project. He seemed to deeply regret leaving the army and was heavily into all matters military, forever cosying up to any military characters we met in Bosnia. We had a few altercations.

At one point he deeply criticised my driving on the treacherous unsurfaced forest roads in central Bosnia so, at his demand, I handed control of the car over to him. Within minutes, it was hard aground, all wheels spinning uselessly in the air. A passing military truck pulled us out.

However, the friction in our relationship worked to produce a rather good documentary. We did the usual stuff: soldiers on the frontline in the snow on Xmas Day, a very moving scene of children singing carols on Christmas Eve, some 'bang bang' on the balcony of the hotel and the crossing of a minefield with Colonel Bob Stewart, who would become a good friend as the years went

British Prime Minister John Major arrived to cheer up the troops in December, 1992.

In December 1992 I made a documentary for the BBC entitled Somebody Else's War. *On my right is my interpreter, Anita Jakovec, and the cameraman/director Ian Hamilton (now known as Jan Hamilton after a sex change operation in Thailand). There was considerable friction in our relationship.*

by. Many of the people we filmed would, alas, soon die, like the Croatian theology student, Mario Kovac, who was the bodyguard to the Croatian commander in Vitez, and Dobrila, Colonel Bob's interpreter, mercilessly shot by a sniper just outside the British base at Vitez.

We also got to meet Prime Minister John Major, who 'parachuted' in for Christmas with the troops. We met in the mountains on a tree-lined road at a British army base known as Fort Redoubt. I asked General Sir Richard Vincent – an enormously affable man for such a senior army officer – if I could join the official party and impose a book I had written on the PM. Dick Vincent seemed to think it was a great wheeze.

My book on the wars in Slovenia and Croatia, *Somebody Else's War*, had just come out and I was able to do a bit of self-promotion on camera, presenting the PM with a copy. Ian had cleverly rigged me up with a radio microphone so everything the PM said, and more importantly some surprising observations by his Downing Street advisor, Rodric Braithwaite, on the causes of the war, were captured for the edification of BBC viewers. "We would never have had a fight here in the days of the Cold War . . . someone would have come in and nuked them." The documentary was also called *Somebody Else's War* and it must have worked out as a marketing ploy because the entire print run of some 6,000 copies was soon sold out.

Ian struck me as a deeply unhappy sort of chap but I could never work out why. He went on rather a lot about how beautiful he found our interpreter, Anita Jakovec. I assumed he fancied her but I heard later that he met up with her on another trip and they then had a disastrous fallout and he abandoned her in central Bosnia without any valid military accreditation to get her back to Split.

It was clear he felt that as well as being director-cameraman, he should also be doing my job, but I let all that go by. Then on the ferry going back into Croatia at Zadar, as we got out of the car, having had another mild altercation, he socked me on the jaw with the words, "I've been wanting to do that for the last couple of weeks." His aggression was palpable and, indeed, he became widely known in journalistic circles as 'Hambo'.

I didn't have much to do with him after that. The documentary was screened first on BBC Scotland in its documentary slot, then

BBC 2 bought it for national screening. The readers of *The Sunday Mail* (the second largest newspaper in Scotland) gave it their Red Rose Award as their favourite programme. At the pre-screening in Glasgow, one of the heads of BBC Scotland observed, "Who on earth's this Paul Harris character? He's better than most of our own people." Unfortunately, his words reached the ears of Kirsty Wark, who had not found my taking her place in the schedules very amusing.

Although Ian had seemed addicted to matters military, I was still surprised to see that he joined the Parachute Regiment in 1995 (after a brief period running a cable TV station in Edinburgh which introduced the novelty of topless female weather forecasters). He saw service in the second Gulf War and Afghanistan but the real bolt from the blue was when it was announced in March 2007 that Ian Hamilton was no more.

Ian Hamilton had been replaced by Jan Hamilton and was to undergo a sex change operation in Thailand. The *Daily Mail* said that it was 'the culmination of four decades of psychological turmoil'. Suffice to say that I was a tiny part of that psychological turmoil, albeit unwittingly.. He told the *Mail* that after returning from the hell of Bosnia he would go to his Glasgow flat and dress up in women's clothes. No more punching the unwary on the jaw, then. He also told the *Mail* he had never enjoyed men's company which did not surprise me. He was, of course, unceremoniously pitched out of the Paras, who, understandably, felt a bit misled. He/she now merits a Wikipedia entry. That's the sure sign, I suppose, of really having made it in the modern world.

I never worked again for BBC TV. It would have helped, I suppose, if I had announced I was to have a sex change operation but I think it was really because I never attempted the complexities of the social circuit and networking which you have to master to make it in TV. Similarly, I was never really much good either at networking in journalistic circles. The problem was that, most of the time, I was on the sharp end of the frontline, so to speak, rather than brandishing a cocktail glass. Anyway, I was having more fun, if not exactly making a fortune. I think I got about £500 for the BBC documentary. And another five hundred for the damages to the Bosnia rental car. Hertz said they'd never seen a car come back in such an appalling state and would never ever rent me another car.

Vedran Smailovic, the cellist, often dubbed The Soul of Sarajevo might better have been known as The Spirit of Sarajevo. He was a larger than life character, and a prodigious drinker.

There was a peculiar array of media now taking my stuff. *Combat & Survival Magazine* would run my military material and a translated copy of it often appeared in the German magazine *Barett* (who also published my book on the Slovenian and Croatian wars *Somebody Else's War* as *Der Krieg der Anderen*). For a while I worked for the German newspaper *Tageszeitung* and I was semi-retained by *The Sunday Mail* in Glasgow. The deputy editor Ken Laird was an old friend and he treated me very well, buying good material, excellent lunches and putting some payment through to help cover my expenses.

The odd commissions would turn up. When I found a burned out woollen mill working secretly at night in the town of Breza on the outskirts of Sarajevo, without a moment of hesitation the editors of *Knitting Monthly* and *Textile Horizons* commissioned story and pictures. And they paid a lot more than the newspapers were coming up with.

My best sale ever was to *The Sun* newspaper who paid around £4,000 for photographs of dancing girls *Under Wraps* strutting their stuff in the REME workshop at Vitez, all paid for by the taxpayer. I only got half of that money because the sale was made by my agents, Camera Press in London. However, they were now making regular sales of my photographs and it was crucially important to have a good agent. I then sold second rights to the British men's magazine *Mayfair*, who gave the pictures which best showed the physical attributes of the girls a good spread, so to speak.

I didn't do so well out of the photograph I took of the so-called Soul of Sarajevo, Vedran Smailovic together with Nigel Osborne, Professor of Music at Edinburgh University. I went with Nigel to Sarajevo. He posed as a journalist to get on the UN flight into Sarajevo. He was almost stonewalled over the requirement to be in possession of, and wearing, a helmet and flak jacket. But a cycling helmet and camouflage waistcoat from an army surplus store in Edinburgh got him successfully on the flight. Nigel has always been a tireless worker for what might be termed 'good causes' and I respect him for that. He felt the people of Sarajevo needed moral support from the west during the siege. In fact, his best work would be achieved in Mostar where he was instrumental in setting up a multi-cultural, multi-community music centre together with pop singer Bono.

On our second day in Sarajevo we met up with Vedran Smailovic. A bearded, very Balkan character, alternately ecstatic and morose, Vedran was drunk much of the time. But he was also a dab hand with the cello and, several hundred deutschmarks later (Nigel's money, drink was expensive in besieged Sarajevo), we were not only a bit worse for wear but hatching what could have well turned out to a disastrous ploy. Somewhere around midnight, Vedran dramatically announced, "Tomorrow at dawn we go and play for the Serb snipers." This sounded a good idea at the time. It did not seem such a good idea at five the next morning

However, we climbed up to the burned-out wreckage of the Skenderija Stadium, not far from the front lines between the Muslim defenders and the Serbs. Vedran and Nigel were perfectly attired in white tie and tails, as if there were en route for Buckingham Palace rather then the snipers. And, in the freezing morning, the cellist and supporting violinist regaled those early enough to be awake in shattered Sarajevo with Albinoni's *Adagio*. Vedran was not so stupid. He also knew that the Serb snipers would be asleep, deeply hungover. But, nevertheless, after ten minutes or so, we would scarper off back down the hill to rather safer territory.

My pictures went all over the world, unbeknown to me. I sold a picture of the event to *The Times* in London and they gave it a big spread. They missed off my byline credit in the paper and I charged them double the usual rate - £400. The next week I had a call from the German news magazine *Stern*. "Oh, hello. Wonderful picture from Sarajevo, where do we send the money?" I was momentarily baffled. "What picture?"

"Oh, the wonderful one of the musicians playing for the snipers. We're using it on the cover next week." It turned out the picture had been sent to them by *The Times* which had, indeed, sent it all over the world to magazines and newspapers. In most instances, they collected the money, and I never saw another penny. These days, I'd get very angry about that sort of thing but then I was more interested in the story and getting published, and less so in the money. Besides, I had to get back to the frontline and I regarded chasing people for money as harder work and much less pleasant than being in the heat of real battle. I shrugged my shoulders and thought what will be, will be. *Stern* was amongst

One of the successful series of pictures I took of Vedran Smailovic and Professor Niger Osborne playing Albinoni's Adagio for the Dead for the Serbian snipers at dawn in the shattered Skenderija Stadium, Sarajevo.

the few correct organisations who actually owned up to using the pictures. I know they were used extensively in Australia, home of the Murdoch organisation, without any credit or payment.

I was still doing better than most photographers in Bosnia. Professional war photographers are known as 'Snappers'. They are a mysterious law unto themselves. There were always a few freelance snappers about who went out, took incredible risks getting close to the action and then returned with their film to the chaps at the Reuters and AP offices. For every picture bought by the agencies in Bosnia they got a free replacement film and all of DM50 (£20), which they promptly spent on beer. They then hung around and waited for the next picture opportunity. They had to be mad.

All transactions were done in Deutschmarks. Germany's role in the breakup of the Balkans was controversial in the early 1990s. Early on, there was the recognition of Slovenia and then diplomatic pressure from Germany to recognize Croatia and, then, Bosnia made the paranoid suspicious about their motives, expansionistic or financial. After the war, the Germans would lead the reconstruction of Croatia, particularly the tourist industry. It was not altruistic, but it was good business.

He may not have been one of life's intellectuals, but one beery-breathed lout I picked up and put in the back of the car professed to know from whence all his problems came. At the time, I chose not to disagree with him - which was not unconnected to the fact that his AK-47 was virtually jammed in my ear as the Skoda bounced its way around the mortar holes in the road in Serb-held Bosnia.

"This is all the fault of the Germans," he declaimed. He pointed out of the window at the shattered landscape of burned houses, blown up mosques and debris-filled shell-holes. "You know they want to make the Fourth Reich - from Baltic to Adriatic!"

Conspiracy theories are, of course, universally popular as a method of ascribing one's woes to some other bunch of unfortunates. But this was a new one on me as an explanation of Europe's most devastating conflict since the demise of A Hitler. I concentrated on the driving, ignored the loony meanderings from the back and just hoped he had the safety catch firmly on.

Those travels in the more benighted parts of Europe brought a sneaking suspicion that my drunken Serbian friend wasn't quite so

far off the mark. Not that I became convinced that the jackbooted legions were about to go on the march - the Germans were then quietly and effectively taking over Europe with the mighty Deutschmark. From Estonia in the north - on the shores of the freezing Baltic - to Albania in the south, where the warm waters of the Aegean meet the Med, the Deutschmark was *the* universal currency in the early 1990s.

Throughout former Yugoslavia the Deutschmark reigned supreme, towering in strength and buying power above Belgrade's new 'Super Dinar' (nominally tied to the DM), Slovenia's Tolar or the Croatian Dinar. At one stage a year after independence, the DM threatened to undermine the Croatian Dinar to such an extent that it was actually made an offence for retailers to accept Deutschmarks at all. In both Serbia and Croatia, a policy was adopted of physically not printing enough local currency to meet demand. This radical new economic theory brought about a temporary slowdown in inflation until people realised that you can't control inflation by simply limiting the number of notes in circulation.

In Albania, where everything was in chronically short supply from a plug for the bath to a car light bulb, ready cash in Deutschmarks was just about the only way to buy anything. The local *lek* might get you a cup of goat's cheese in the back of beyond but that's about it. Even in proud little Austria, before conversion to the Euro, the motorway and tunnel tolls were priced in local Schillings and Deutschmarks. Of course, the Austrians are a rapacious lot. They robbed Richard the Lionheart blind on his way back from the Crusades and continue in much the same tradition today. In 1993, I parked in a service station just over the border from Slovenia and was almost immediately pounced upon by a crew of gun-toting *Zollwache* customs service cum special forces thugs, complete with an angry hound called Mungo, who demanded 1100 schillings to travel on the motorway. Despite the fact I'd stopped at the first place you could buy the permit to use the wretched road, it was useless to argue. When I triumphantly announced I certainly didn't have the cash and would have to go to prison as a martyr instead, they produced an American Express machine from the back of their van. Cunning lot the Austrians.

There are some things you never forget in this twilight world of nascent Harry Limes. Like the face wrinkled in disgust of the

small boy changing money in Sarajevo. He'd just been offered a fistful of English pounds . . .

There are some basic requirements for happy travelling. Negotiable instruments for a start – whether they be an American Express card or – more likely – hard cash in either local currency or the dollar or deutschmark. Some of the most lawless and dangerous parts of the world do, however, accept the magic plastic which is of course rather safer to carry around than vast wads of cash. You might think a money belt worn next to the skin is the answer. I always wore one but it could not be relied upon in all circumstances.

Nairobi was known in the trade as Nairoberry. It is a wonderful city gone bad under decades of corrupt government. An acquaintance (he borrowed money from me) in Nairobi, Keith, a pensioned-off BBC producer delayed his departure from his local bar until after dark. Although his office was only a hundred yards away, en route he was set upon by street kids who took everything off him. Yes, even his underpants. I never got my money back from him, of course.

If I'd tried to rely on the money actually earned on the war zones on a weekly basis then I would soon have sunk from sight. However, I always regarded it as bit of an experiential investment, not just a way of making an everyday living. That has proved very much to be the case. I still lecture extensively on my experiences in the world of derring-do and my photographs are now part of dozens of professional Powerpoint presentations, which I give more than a hundred times a year.

The other source of income which developed was from books. Now writing books is not to be recommended at all as a way of making any sort of a real living. However, as a contributory agent it can work nicely. As described earlier, I wrote my first book around the age of seventeen. Bizarrely, *When Pirates Ruled the Waves* would be one of my most successful and is still available worldwide from Amazon. My bestselling book has to be a modest and rather slim volume entitled *The Little Scottish Cookbook*. When I was last able to enquire about it (the publisher has gone out of business, not on account of my book I would add), it had sold 228,000 copies. I agreed to write it one year at the Frankfurt Book Fair. The publisher from Belfast, John Murphy, asked me to write it in ten days.

Pictured in 1975 at the Scottish publishers' stand together with Stephanie Wolfe Murray of Canongate Publishing and Bill Campbell (right) of Mainstream Publishing.

I did. Indeed, I polished it off over a wet weekend at my home in Scotland. He paid me £600 (around $1,000) for the job. Finish. It seemed fine to me at the time as remuneration for a weekend's work. Not so brilliant in retrospect.

However, a friend of mine in Edinburgh, Tommy Miah, is a Bangladeshi restaurateur in the city. He was riding high in the 1980s with several successful restaurants. He decided it would be a great idea to publish a book of his restaurant recipes. To be frank, I wasn't that convinced that it would sell but I was happy enough to take on the commission of writing and producing it. I spent some time in his kitchen watching him and his chefs at work and, in due course, *The Best of Bangladesh* emerged from the presses.

It was printed by my friends in the Yugoslav printing industry in what I thought was an optimistic edition of 10,000 copies. However, it showed how wrong you could be: I was used to the traditional bookshop business and it sold virtually no copies there. Instead, the enterprising Tommy used to slap it on every table together with the bill. Usually, the female member of the party would entreaty her lover or husband (maybe both) to add the book to the bill. Within a couple of years, all 10,000 had gone and it was followed by two more books, *Secrets of the Indian Master Chefs* and *A True Taste of Asia*.

When I presented my own modest four-figure bill for writing it to the energetic Tommy he said he was under financial pressure from the Inland Revenue and the VAT man. I was a bit miffed at the time. However, he offered expansively, "You eat in my restaurant any time you like." I did. For quite a long time. Me, my friends, relatives, business acquaintances, *et.al.* It wasn't such a bad deal, after all.

Several times I travelled to the Frankfurt Book Fair with the well known publisher Charles Skilton. We both shared an undiluted enthusiasm for the excitement of the annual event. I actually never missed a Frankfurt Book Fair from 1971 to 2006. (In 2007, I was offered a contract lecturing on a cruise ship sailing from Malta to Rio de Janeiro. That somehow seemed more appealing). For Charles, Frankfurt was the highlight of the publishing year, the world's great gathering of books and book people. He often recalled that he had attended the very first Book Fair after the war,

held in 1948 with a distinctly sparse post-war selection of books arrayed on trestle tables.

As the Fair developed in the 50s and 60s into the world's largest gathering of book people it became a fixed point of focus in the international publishing year. I dabbled in publishing, but I would also attend to sell my own ideas for books I might write or promote. This was frequently successful. *The Little Scots Cookbook* might not have been the most stunning financial deal but others were rather more so.

The first year I went, 1971, there was an interesting group of people seated on Charles' stand. There was Jim Haynes, founder of Edinburgh's Traverse Theatre, the first paperback bookshop in Edinburgh and a dyed in the wool rebel. He was arraigned in the Sheriff Court in Edinburgh in 1963 for wheeling a naked blonde across the stage during the drama conference at the Edinburgh Festival. He started the magazine *Suck* and edited *International Times*. For many years he was the Professor of Sexual Politics at the University of Paris. Jim probably knows more people than anybody else in the world. He was, and is, an avid people collector and has always run open houses of a Sunday night at his flat in Paris. He's one of the most remarkable men you might hope to meet.

Nick Schores was an antiquarian book dealer who hailed from Amsterdam and he was the writer of a remarkable book, written under a pseudonym, which Charles had published in 1969. *The Memoirs of an Erotic Bookseller by Armand Coppens, assisted by his tired wife Clementine and her distant lover* is, in my view, a literary *tour de force*. It is an autobiographical account by Schores derived from his own quite extraordinary experiences as a dealer in erotic books. As Charles wrote, 'He meets some very strange people, with sex tastes so crazily fanatical as to be almost unimaginable.' Some made love in their coffins, another a car dealer who commissioned an erotic novel investigating another sexual variation every fortnight, and so on.

Charles pushed Nick into writing the book, having got to know him as a vendor of erotica. In the 1970s, Charles had one of the largest collection of erotica in Britain and he bought extensively from the Dutchman. His bizarre book is wonderful and it is curious that it is long out of print. I found Nick Schores less

appealing than his book. Bespectacled and wiry, he wasn't exactly good-looking. He was a very self-important fellow who liked to dominate all proceedings he found himself in and I actually found him distinctly irritating. However, it was his ability to immediately dominate any room or gathering he found himself in which was the very key to his sexual success: maids, shop girls, secretaries, publishers all succumbed to his charms in very short order and then he had them between the sheets. Charles liked him very much, although in later years he was a trifle bitter about the price at which Nick bought books back from him as financial stringency closed in. I think that Charles envied the seemingly endless variety of his sexual success, and excess, and probably hoped that some of it might rub off.

The bespectacled and slightly corpulent Leonard Holdsworth was an entirely amiable version of Nick Schores. He had worked for Charles during the 1960s putting together the Luxor Press list of yellow-covered paperbacks. This portion of Charles' output was entirely sexual in nature, starting with *Fanny Hill* and working on to such other classics as *Beyond the Miniskirt, Black Birds* and *Pussies in Boots*. Leonard was a dab hand at venturing down to the pub in Wimbledon of an evening and returning with an assortment of dolly birds who would then strip off for photo sessions for the infamous yellow-covered paperbacks. He was extremely talented and knowledgeable in the field of erotica and, hardly surprisingly, as Charles' cash dried up in the 70s, he was poached by the highly successful Gold organisation who gave him sundry editorships, including the successful and bizarre niche magazine *Golden Rain*.

I met an outstanding publisher there, as well. John Calder had published the classic work *Last Exit to Brooklyn* by Hubert Selby Jr. and had ended up in court as an alleged pornographer. He was decidedly the copper-bottomed intellectual in the group with a list of books encompassing some of the best international literary writers. John managed to persevere in business much against the odds. He trailed endlessly around the bookshops of Europe and America personally selling his eclectic, highly literary list. He recalls the day he arrived at Thins in Edinburgh, once the leading bookshop, where he would normally make no sales at all. The proprietor, Ainslie, was a mite more welcoming in his Scottish

brogue. "I see the university is now recommending your *dirty* books so I suppose we'd better have some." He vigorously rolled the 'r' in the word 'dirty'.

Then there was a rather attractive woman on Charles' stand: tall, slim and with long dark lustrous hair. Minister's daughter Tuppy Owens was an eminent and renowned writer on matters sexual. We became firm friends, metaphorically speaking, and she encouraged me to become her roving correspondent for *The Sex Maniacs' Diary* which she published every year. This was regarded by the authorities as a subversive publication in those days. In 1970 all the materials for the diary were seized by Scotland Yard's Obscene Publications Squad. On Charles Skilton's advice, Tuppy went to the best (and most expensive) brief in London: Sir David Napley.

Napley wasted no time. He called a meeting between Tuppy and the Boys in Blue. She got her materials back and the coppers got to keep hundreds of her 'dirty' magazines for, as Napley put it, "your personal and private gratification".

I wrote pieces for the diary about romantic hotels, night clubs and acrobatic possibilities all over the world from Iceland to Bangkok. It went very well and was great fun. Tuppy's letter of introduction opened doors, so to speak, all over the world. I used her letter at the President Hotel in Bangkok, a *de luxe* five star joint. The manager was an amiable Scotsman with the unusual but distinctly Bangkokian name of Duncan Shakeshaft. I asked Duncan about the arrangements for shared occupancy of one's room of an evening. "Oh, you need a Green Card," quoth he and fished in his desk for a piece of green card the size of a business card which he duly signed. This was simply presented to door staff or security to smooth one's passage, so to speak,

We duly strongly recommended the hotel in the following year's edition of the *Sex Maniac's Diary*. 'Don't forget to ask Mr Shakeshaft for a Green Card' the 200,000 readers were advised. Soon all hell broke loose with missives of complaint from Shakeshaft , his employers and their legal advisers.

Tuppy wrote quite a good little book for an American paperback publisher aimed at men but written from a woman's point of view and giving the 'inside track' on how to pull women. It was full of pretty straightforward sound advice on things like changing your

underwear every day and the exercise of good manners. The sort of things men aren't very good at but, as a minister's daughter, she knew a bit about decorum.

These days such books are ten a penny but in the mid-1970s this was still controversial and highly original publishing. I encouraged Tuppy to rewrite it for the British market with a new title, *Take Me I'm Yours: A Guide to Feminine Psychology*. The brilliant title came to me in the bath one day as a tune with the lilting line 'take me I'm yours' came over on the radio. This was, of course, long before the days political correctness intruded upon the scene.

Tuppy did a good job with it and we went off to Frankfurt to the Book Fair and proceeded to whip up enthusiasm for the book as a provocatively dressed Tuppy graced the aisles with yours truly.

On day three, a new publisher, Mirror Books, part of the Robert Maxwell empire, offered a £10,000 advance for the UK paperback publishing rights. This was a cause for celebration. When I got back there was a contract on the desk which I signed with alacrity and sent back to Mirror. A long silence ensued . . . then came a bland proforma letter from Mirror Group saying they were closing Mirror Books, before it actually got going in business. This was very disappointing news, to put it mildly.

I then decided to try and bluff Mirror into paying. I hit the telex (this was before emails, faxes even) and sternly advised that intention to contract meant that they must still pay us the money (arguably true in law) but, furthermore, as they were an English-registered company and we were a Scottish-registered business, then our making a claim in court in Scotland meant that we would automatically get a court order under Scots Law known as 'an inhibition' preventing distribution of any English Mirror Group newspapers in Scotland. I implied that all this was automatic under Scots Law. I knew that no English lawyer knew virtually anything about Scots Law and to try and pre-empt inquiries in Scotland I put on a time limit for payment of our money of just 48 hours. It was pure bluff, but I got a telex back saying that 'in the unusual circumstances' the contract would be upheld, and a cheque for £10,000 appeared on the mat two days later. Phew!

The important thing then was to get what is known in the business as 'reversion of rights'. So I asked Mirror if they wished

to retain any rights in the book. No, they said. I then remembered that a former colleague at the university newspaper, Alasdair Riley, was on the features desk at the tabloid newspaper *The Sun* in London. Over a boozy lunch at El Vino's on Fleet Street, the UK serial rights for Tuppy's book were sold . . . for another £10,000. Ten thousand may not be a lot these days, but then it would buy a very substantial apartment or small house.

I only ever had one small bone to pick with Tuppy. She came to stay with me in my flat in Edinburgh when we were promoting her book. For some obscure reason, she left a cucumber in the bed. My cleaning lady, who obviously had a more vivid imagination than I, promptly resigned, muttering darkly, "I don't have to put up with that sort of *dirty* nonsense." I was nonplussed.

Charles Skilton loved book people, he loved books and he loved . . . the liaisons with women that the Fair so often afforded. In the early years, he would place an advert ahead of the Fair in the *Frankfurter Zeitung* seeking help on the stand. Of course, he got lots of applications from pretty, young students and often one or two graced the stand. If it was a lucky year for him, one or more would become lovers. He used to particularly like a young Egyptian girl. He enigmatically observed to me, "She has a corrugated bottom, you know," as he flicked through the pages of George Riley Scott's standard work *Flagellation*. He had got to know the eminent sexologist in 1943. Riley Scott had become a formative influence and Charles had even published some of his work.

The other ray of sunshine in my publishing firmament was a book entitled *Edinburgh Since 1900*. It was actually the brainchild of a Mancunian publisher called Henry Hochland who was awfully good at stitching up deals with newspapers. He got me access to *The Scotsman* archives and I spent a couple of weeks trawling through old glass plates, zealously guarded by an initially intimidating chap called Bill Bradley, a towering former newspaper photographer who now rejoiced in the title Picture Manager.

I soon discovered he had a heart of gold; that was a necessary quality because I had to ask him to make more than 200 black and white prints from the plates. The book took only a few weeks to put together on the cut and paste principle and over many editions (five, I think) it sold more than 75,000 copies in the then buoyant nostalgia market.

Unfortunately, poor Henry, who had stitched up one person too many, was put into liquidation by his creditors, but I managed to retrieve the printing film from the printers in Slovenia and they were happy to turn the presses back on again for cash.

These mini-success stories were exceptions to the rule. Most books sell miserably. There are far too many of them published. Publishers issue books on the premise that it's a bit like firing arrows at a target. Most may miss but a few will hit the bull's-eye. The trouble is knowing which ones . . . A Glaswegian publisher and old Harrovian called Richard Drew, who was always a better salesman than publisher, once announced at a Scottish General Publishers Association meeting in the late 1970s, "I never read any of the books I publish. But I make sure they have a bloody good cover . . .". As self-supposed literary intellectuals, we were all deeply shocked at the time. But, upon reflection, there was more than a grain of truth in his pithy observation.

The book I wrote about the wars in Slovenia and Croatia, *Somebody Else's War*, illustrated with my own photographs, was modestly successful thanks to the promotion it got from the TV documentary of the same name. I did deals with a publisher in the UK, it was published in Slovenia and a firm of solicitors in London, Dibb, Lupton, Broomhead, who were seeking to get into Slovenia as business consultants, commissioned an edition through one of their partners, David Lee Sherman: I had previously escaped from Croatia in the company of his charming, Croatian wife, Cherry, who I'd met in the lobby of the British Consul's office in Zagreb as Serb tanks closed the airport. We had a delightful and exciting escape across Croatia by train, ending up in Belgrade. It was a successful exit strategy and we were both very pleased with ourselves. So was Glasgow rare book dealer Cooper Hay because I hand carried his £100,000 elephant folio book of Charles Rennie Mackintosh prints through the war zones and restored it safely to him.

Somebody Else's War sold a respectable 6,000 copies. But there was a lot more mileage to be had out of my Bosnia material. An energetic woman spotted that. In early 1995, the Edinburgh publisher Stephanie Wolfe Murray approached me and suggested an illustrated book about my experiences in Bosnia. To her credit, Stephanie wanted a book highlighting the pain that the country

had been through. She was, and is, a sensitive person who commits herself to causes. In those days, her main cause was Canongate Publishing, which she had painstakingly built up over some 25 years, but she was soon to be replaced by an ambitious wealthy, young man called Jamie Byng, whose predecessor had famously been executed in 1759 on the quarterdeck of his flagship *pour encourager les autres* after failing to engage the enemy. I first met Byng in Canongate's Hanover Street offices in 1989. The company was just going bust, thanks to the failure of its parent, the Musterlin Group, and there was an amiable, bright young spark, sporting a mop of hair like a King Charles Spaniel, in the back office who seemed to have a plentiful stock of ideas. I did not imagine at that time that, in short order, Byng would take over Canongate and make a huge financial success of it. But, in my view, the day Stephanie left, Canongate lost its soul.

Anyway, Stephanie was still in charge when she commissioned *Cry Bosnia* which would be published in Autumn 1995 at precisely the right moment in time, as the war drew to a dramatic end with long-awaited armed NATO intervention against the Serbs. The book was generally well reviewed although one reviewer snidely observed, referring to its large format and copious illustration, 'This is probably the only coffee table book that will be published on the Bosnian war ...'. Canongate soon sold out their edition of 3,000 copies. Byng opined that the market was probably satisfied. It was published the following year in the USA by the committed Palestinian publisher Michel Moushabeck, and it would go on to be reprinted five times and sell 28,000 copies through a charity Stephanie and I set up, called Connect.

Connect was born over a pleasant lunch in Edinburgh. Stephanie wanted the book to achieve something worthwhile. Frankly, I was only interested in getting it published and, equally frankly, I didn't think it would sell *that* well. So, over the second bottle of Chardonnay, I readily agreed to her suggestion that I donate my royalties, in their entirety, to the nascent charity. Within three years, Connect had restocked libraries all over Bosnia with books which Stephanie skilfully begged from English publishers, including substantial outfits like Oxford University Press; my royalties paid the carriage costs of getting them to Bosnia.

Cry Bosnia sold like hotcakes through a body called AFES who were the US equivalent of the NAAFI, supplying serving soldiers in the field. It hit the spot with the young soldiers who could see in the pictures a clear reflection of what they were experiencing themselves: for most of them Bosnia was a stunning revelation, a catalogue of horrors. The success was also down to Stephanie's son, Rupert, who tirelessly negotiated his way around often remote Bosnian military encampments flogging the book by the carload. The car, by this time, was my own pensioned-off Skoda, which had seen more than 100,000 miles of the war zones of Yugoslavia (it failed its MOT in Haddington, Scotland, at the less than Ideal Garage having just done 35,000 miles and I drove it straight to Hull and the ferry).

Publication of the book in America brought me the opportunity for my first ever US promotion tour as an author. I'd always fancied it as a junket since reading Gordon Williams' brilliant book *Walk, Don't Walk*. Scots author Williams is probably best known as the writer of *Straw Dogs*, in turn best known as a violent 1971 movie with some rough sex involving the delectable mini-skirted Susan George, who is cinematically married to a young, effete Dustin Hoffman.

Walk Don't Walk is, in my view, a much better book which deals hilariously with the traumas and disappointments of an author on what he regards as a glamour trail which turns into a catalogue of everyday bitter disappointment.

I turned up in the States full of expectation. The first signs were inauspicious. It was raining stair-rods at Washington's Dulles Airport. Ever the seasoned traveller - hand baggage only – I directed the cab driver to the Falls Quality Inn Executive Hotel, as instructed by my publisher.

"You sure?" he enquired laconically. "It ain't exactly a quality joint." Neither it was. It's what a friend in downtown Washington mysteriously termed "a brownbagging joint". However, looking on the bright side it was better - by a margin - than the Sarajevo Holiday Inn. The only problem was there was no bar, *nothing to drink.*

Waking with a clear head on day one (it takes fully a minute for a confused brain to realise why) it seemed a fit morning to take in some Washington sightseeing. I try to call CNN where I know presenter Jim Clancy from the wars in Yugoslavia but the

telephone doesn't seem to work. Something to do with no credit. It turns out that my publisher got the room free with a new credit card and there's no account set up.

In the centre of Washington I find there's nothing approaching a cosy neighbourhood bar. Not at all like *Cheers*. In fact, no bars at all. *Nothing to drink*. Still, there's lunch coming up.

Lunch at the *Washington Times*, but *there's nothing to drink*. A strictly-no-alcohol zone. But at least I come away with a commission for a magazine feature on Sri Lanka.

In the afternoon, I decide to drop by and call on the competition, *The Washington Post*. This is not a social visit. Two years previously, they had commissioned me to do a feature for them on US Special Forces operating in northern Bosnia, and specifically the mysterious Major Guy Sands. The months had slipped into years, and a dozen unpaid statements of account, but they still had not paid me my $350. At first the chief accountant refused to emerge from his eyrie at the top of the building. On the telephone from reception, I say I'm not going. He says he'll have security 'remove me'. I say I'm being interviewed on CNN later and this is a typical case study of my fraught financial relations with the media. He comes down. Although he claims never to have heard of my invoice, he signs a declaration I have prepared promising to pay . . . They did, three months later. That's what's called a result in freelance journalism.

Evening brings my first encounter, at the American University in Washington, with the formidable Phyllis, my publisher's publicist. A female Powerhouse, I get the feeling she's used to dealing with people like me. But we have a good session with a lively panel discussing Bosnia and the media before an audience of 300 or so students, recorded for TV and radio.

Now the promised reception. Well, you see, this is university property. There's mineral water. *No, there's nothing to drink.* Is this the Land of the Free, or what? At this nadir of my existence, the wonderful and delightful Envira, Washington correspondent for Bosnian TV, enters my life. 'A click'. She knows where there is a bar and we retire together. When I return to the so-called 'reception', Phyllis looks menacing and thrusts out an armful of books for signature.

On the way back to the inappositely designated Quality Inn I observe chattily to Phyllis, as is my natural wont, "Nice girl, Envira, eh ?"

"Girl?" she barks, "If they're over 12 years old they're women around here." This is a new one on me. I suppose those were the early days of political correctness.

Washington to New York doesn't look such a long way on the map but it's five hours drive. My publisher, it seems, can't afford plane tickets. We arrive next day in time for a scheduled interview on talk radio WBAI. I am momentarily nonplussed when it becomes clear they are going to allow Phyllis, my publicist, to do the whole interview. The IBA wouldn't allow that sort of thing in the UK. Phyllis gets around ten mentions of the book title, the publisher's address and telephone number and the post paid price of the book into the 20 minute interview. I don't seem to merit a mention. I stand and watch helplessly from behind the studio glass feeling rather thirsty.

On to another public meeting on Bosnia, this time at New York University. Phyllis lives in Brooklyn in a pretty, detached wooden house which is defended like Fort Knox with locks, bolts, seals on windows and infra red beams. I'm warned not to wander around in the night lest I alert all this paraphernalia. Over coffee, discussing one of the more interesting of the evening encounters, I fall into the girl trap again. Ouch! Phyllis is very doubtful about getting onto CNN. This makes me even more determined to land them.

Thursday is a bad day. Not only are the media waking up to the fact that tomorrow is the anniversary of the Oklahoma bombing, but the Israelis shell a UN base in southern Lebanon killing more than 100 refugees. C-Span TV ring up to cancel tomorrow's live TV slot, everybody at CNN is uncontactable as they're working on the Breaking News story and my 2 p.m. press conference to launch the book with Bosnian Ambassador Muhammed Sacirbey at the UN building is off.

Back in Washington, more calls to CNN and Jim Clancy says "the interview is a goer, Paul." After half a dozen calls to Atlanta, I'm through to guest bookings and they are trying to book a studio. The studio's in New York. I'm back in Washington . . . Much of the rest of the day is spent in taxis. Radio stations, bookstores and private briefings of US 'think tanks' involved in some mysterious way in policymaking on Bosnia.

A luncheon address at the American Arab Anti-Discrimination Committee Convention (a bit of a mouthful in more than one way)

on the Saturday in Crystal City, Virginia, is not quite the cosy little gathering I had assumed. There are more than 3,000 delegates - activists, professionals and businessmen - and most of them seem to be gathered in the dining room of the Marriott Hotel. Once the clattering of knives, forks and china is stilled I'm on my feet for their Keynote Address on Bosnia.

It must have gone down OK because copies of *Cry Bosnia* are evaporating from my publisher's stand outside the dining room. After signing for an hour, recovery is called for. The organisers have thoughtfully provided a suitably luxurious suite - on the back of the door it says something about $700 a night - so the delightful Envera and I retire to quaff champagne from an ice bucket. I've thoughtfully smuggled my own into the room in a brown paper bag. All by myself, I've found out what 'brownbagging' is. Now this is what author tours are *really* about.

Michel Moushabeck, my publisher, lived in a delightful clapboard little-house-on-the-prairie just outside the university town of Amherst. It was quite different here from downtown Brooklyn. He never locks his front door, horses prance in the paddock and the frogs are spawning in the swimming pool. And New York's just three hours drive away.

Local signings, more calls to CNN, Amtrak back to New York and I arrive in plenty of time for my talk and signing in Brooklyn. I call CNN from noisy, bustling Penn Station and everything is set up for tomorrow, my last day. I then catch the underground for Brooklyn in plenty of time for the 7 p.m. talk and sign event. But I don't count on an explosion and fire ahead on the track. I'm trapped powerlessly for an hour deep underground.

I eventually arrive just after 8 p.m., an hour late. Phyllis is at the door. "Where the hell have you been? I've been searching all the bars around." She thinks she has me taped. The audience has dwindled to four hopeful stalwarts so I do my stuff, and sell two copies.

Back at Phyllis's there's a message on the answering machine from CNN cancelling. But please phone tomorrow. I duly call CNN in Atlanta from call boxes all over New York - streets, stations, bars. Just after midday I'm told, "You're on. Get into the New York studio for 1.45."

I've been keeping a log. This was the 37th telephone call to CNN.

Considering I'm about to address a worldwide TV audience in excess of 500 million, the studio is a distinct disappointment. There's an uncomfortable straight-backed high swivel chair on which the interviewee perches, in front of a fuzzy photograph of the New York skyline and it constitutes the only furniture in a dark camera and cable strewn cavern. I can't see Jim Clancy in Atlanta, so speak into a void with the questions materialising through an earpiece.

But that is it. I've knocked it off - with a full 60 minutes to go before check-in at Kennedy Airport . . .

Of course, I didn't make any money out of it. But I was rather used to that situation by now. Books have continued to pour off the presses: a book of photographs of the conflict in Sri Lanka, *Fractured Paradise*; two books of photographs of Shanghai, *Transition* and *About Face*. A book about my year in Sri Lanka, *Delightfully Imperfect: A Year in Sri Lanka at the Galle Face Hotel*, and, forty years on, *When Pirates Ruled the Waves* remains in print in its sixth edition. They make small money. However, books still carry with them a certain gravitas and they do serve to open doors to other things.

Never mind the bank manager. I am still a great believer in the ineffable power of the printed word.

Ten

Looking for Bin Laden

From Albania to the North West Frontier

I first became aware of Osama bin Laden in the spring of 1994 in the Albanian capital, Tirana. Albania had always been, at least in my own mind, romantic and remote. In reality, it was all of that, together with a considerable capacity to catch you unawares.

My interest in Albania was not entirely academic. A few months previously I had met a girl on an Adria Airways flight out of Ljubljana airport. Usually, Adria upgraded me to Business Class: not only was I a regular flyer with them, but after the June 1991 attack on the airport I had supplied their directors with a set of rather handsome photographs of the immediate aftermath of the bombing showing their shredded Airbus A-230.

However, on this occasion the aircraft was packed out and there was only one seat left in economy. Seated beside the empty place was a strikingly attractive petite, dark-haired girl with large brown eyes.

Conversation proved easy. "Hello. Me Megan. Who you?" The young lady proffered her hand. It was the beginning of a long friendship. She called me from London a couple of days later with the imprecation, "You come fetch me." I did.

She liked to come to stay at my remote country house in the East Lothian countryside for the peace and quiet. And I loved to go and stay at her home in the centre of the Albanian capital, Tirana, because there was always so much going on there: usually a revolution of some sort.

She was well connected and she used to take me to see all the top people, like Sali Berisha, the President, and government ministers by the score. Her grandfather had been the general in charge of the loyal Zogist forces during and immediately after the Second World War. Then, one day, as he left his home in Tirana, the communists executed him at the garden gate.

One morning, as we left the office of the Minister of Tourism on Tirana's main central boulevard, I noted a large poster and Megan

For most of the 1990s, Albania existed in a political and social vacuum. There was little in the way of law and order. These abandoned military weapons, pictured in 1997, had not been carried off by looters purely on account of their size, unlike AK-47s and RPGs which were easily purloined. Albania could have been a fertile breeding ground for al-Qaeda, especially with its Muslim background, but the locals were far too fond of copious amounts of alcohol. Al-Qaeda was very disappointed in them.

The war in Bosnia gave the world a new piece of terminology: ethnic cleansing. All sides in the war utilised it in a bid to create ethnically pure areas, but the Muslims fared worst in Bosnia. Pictures of Muslims driven from their homes by Serbian Orthodox militias did not play well in the Arab world and specifically influenced Al-Qaeda in its early days. I took this picture at Gunja, on the Bosnia-Croatia border, in the spring of 1992 as large scale cleansing started.

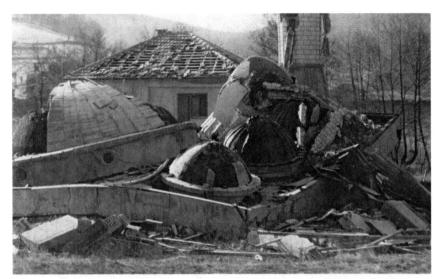

The destroyed mosque in Hadzici, in the so-called Krajina region of Croatia. Here Serbs evicted local Muslims and destroyed their place of worship. I took this picture from our moving car as it travelled between two Serbian checkpoints. Images like this were highly inflammatory in the Arab world.

Taken in a Croatian village in central Bosnia which had been ethnically cleansed by Muslims. The wording painted on the wall of this house, 'Alahu Ekbar' (God is Great) indicates that the cleansing was undertaken by foreign mujahadeen arrived in Bosnia to support local Muslims.

provided a translation. It was announcing that "some Arabs" were to undertake a programme to build 800 mosques all over Albania in an ambitious bid, I surmised, to corral the happy, bad Muslims of the country and make them into true believers. Although the country was traditionally Muslim, a hangover from the centuries of Turkish rule, religious observance had hardly been encouraged during the post-war years under communist leader Enver Hoxha. Also the harsh social conditions in the country and the traditional clan system meant that religion had slipped down the agenda: the Albanians liked to live life, which was rather fragile in many parts of the country, and drinking alcohol was one of the most popular national pastimes.

I made inquiries about the Arabs. It turned out that the funding for this ambitious programme originated in Saudi Arabia with a family called bin Laden ... but that the active links were coming out of the Sudan. The principal figure involved, a man called Osama bin Laden, was in disgrace in Saudi and had set up shop in Sudan. He occasionally visited Tirana but I was, hardly surprisingly in retrospect, unable to pin him down for a meeting.

People often ask me if I ever interviewed Osama bin Laden. Would that I could say I had! In fact, he gave very few interviews to journalists over the years. John Simpson of the BBC says he once met him briefly but the encounter was not friendly and OBL did not communicate with him apart from by issuing dire threats from on top of a white horse. Robert Fisk, one of the world's top Middle Eastern journalists and commentators secured a significant interview with him in those early days, in December 1993. The Palestinian journalist Abdel Bari Atwan was selected by OBL to interview him in Afghanistan in 1996 and entered his lair via the Pakistan border city of Peshawar. CNN correspondent Peter Bergen also secured a brief, broadcast TV interview. After 9/11, there was just one interview with him before he dropped out of sight completely. The Pakistani journalist Hamid Mir actually interviewed him three times and sports a black Casio watch he claims was a present from bin Laden.

In 1992-3 we knew very little about OBL and Al Qaeda. Operatives had, in fact, started to fan out into Europe during 1992 and Albania, Bosnia and Chechnya were the first countries to

merit their attention. All were undergoing seismic political change: Chechnya was seeking to break away from an overbearing Moscow, Bosnia from the domination of Belgrade and Albania was, quite simply, in a mess with an exploitable political vacuum evident. All three had large Muslim populations and seemed ripe for the attentions of Al Qaeda. The struggles of their peoples could easily be interpreted as the struggles of Muslim peoples against the infidel.

In the fall of 1992, Al Qaeda sent an operative named Jamal al-Fadhi to Croatia with orders to create a European base. He later turned informant and his activities are well documented in Dutch military intelligence reports.

In 1993/4 Islamic fighters from Algeria, Iran, Yemen and Lebanon arrived in Bosnia at a time when the country seemed likely to fall to the Serbs and Croats. After all, the West seemed to have forgotten that 19th century Bosnian immigrants to Algeria had built possibly the finest mosque in Algiers overlooking the Mediterranean ... but the Algerian fundamentalists had not.

Following the effective military takeover in Algeria in 1991, fundamentalist Muslim groups had intensified their struggle in the North African state. Elements from these groups also travelled to Bosnia, although they were not associated with Al Qaeda at this point. But they stiffened resolve amongst the Muslims of Bosnia and assisted in its defence.

Khalid Sheikh Mohammed, later to become the head of Al Qaeda's military committee, went to Bosnia as a 19 year-old and tried to join the *mujahaddin*. Ironically, he was rejected. Instead, he went on to plan the 9/11 attacks less than half a decade later ... not for nothing did Martin Bell describe, in his book *In Harm's Way*, the Bosnian war as 'the most consequential conflict of our time.' In his view, 'It is at least possible, if the Western democracies had reacted earlier and more effectively to the blood-letting in Bosnia, the attacks on the World Trade Centre and the Pentagon nearly ten years later, might never have occurred at all ...'

However, these disparate elements became an embarrassment: they were concentrated in late 1994 in the *El Mujaheed* unit of the Bosnian Army's 3rd Corps. It was no coincidence that the UN national group assigned to the area north of Zenica was the Turkish battalion. However, as one of their officers observed to me,

General Sir Michael Rose, commander of UN forces in Bosnia, pictured at the Turkish battalion headquarters near Zenica. Foreground, his SAS bodyguard known as 'Goose'. The Turks were critical in the process of developing UN relations with the Muslim forces and thereby undermining the foreign mujahadeen.

In general terms, the Bosnians were happy, bad Muslims who ate pig and quaffed copious amounts of alcohol. They were as much a disappointment to the agents of al-Qaeda as the Albanians had been. Here, in a farmyard near to Vitez, locals make home brew from fruit: they simply drank the raw alcohol as it came out.

President Bill Clinton sent a high level military-civilian delegation to Bosnia in September 1994. I received a tip-off about the visit and tracked them down in the destroyed town of Gjorni Vakuf. I was the only journalist present as US Air Force General Chuck Boyd (centre) met with Bosnian General Filip Alagic (on Boyd's left). On Boyd's right is US Under Secretary Robert Frasure.

USAF General Chuck Boyd marches through the shattered streets of Gjorni Vakuf. The British army officer on his right, Brigadier Andrew Ridgway, has just spotted me.

"We don't like these people because we are still the secular army created by Kemal Ataturk. These people are fundamentalists and we find them very difficult."

Turkey's involvement in Bosnia was controversial. It was opposed by the Serbs and, to a lesser but significant extent, by the Greeks. Predictably, it was welcomed by the Bosnian Muslims. Turkey's woman Prime Minister Tansu Ciller pushed hard for the incorporation of Turkish troops into the UN force. I found the Turkish approach to peacekeeping in Bosnia helpful, restrained and constructive. It maintained a distance from other powers such as Iran whose intervention was not so benign. That probably helped stem growth of fundamentalism in Bosnia. And we should not forget the good intentions of Bangladeshi troops in Bihac; the Egyptians in Sarajevo and the Jordanians in Croatia. However, in military terms the Turks were by far the most effective.

The Serbs construed Balkan Islam as being Turkish. A Serb commander once pointed out to me the government frontlines below in Sarajevo and the 'Turks' encamped there. But the Muslims of Bosnia were – and still are – very liberal Muslims. Their liberal Christian-Bogomil tradition also drew on Arab and Sufi thinkers prior to the Turkish invasion on the 16th century. The Bosnians were not forcibly converted to Islam by the Turks – instead they were given incentives. Ultimately, they became happy, bad Muslims who quaff alcohol and eat pig. Foreign Muslim fighters could not understand the unwillingness of the Bosnians to die in battle and often despaired of the people they had come to free from the infidel.

Some of these imported fighters made extravagant claims to journalists that they would attack UN and NATO forces to cleanse Bosnia of the foreign invaders but there was no significant offensive except a January 1994 attack on aid workers in which a British ODA driver was killed. Five Saudi, Jordanian and Yemeni gunmen fighting with the *mujahadeen* in Zenica kidnapped three Brits as they drove in a UN vehicle. Three of the alleged attackers died a few days later as they were 'arrested' by Bosnian police. They had become an embarrassment to the Bosniak (Muslim) government in Sarajevo.

There were two main bases in central Bosnia for the foreign fighters we called 'the muj', a contraction of mujahadeen: on the

outskirts of Travnik and in the industrial zone of Zenica. As journalists, we generally kept clear of them. They were distinctly unfriendly, their faces obscured by long flowing Arab-style scarves and they often wore intimidating jet-black uniforms. I managed to photograph a group of them for Janes *Balkan Sentinel* as they marched in Zenica but I was careful to use a new 500mm. 'long' lens, specially acquired for the job.

At the beginning of 1993 two British mercenaries working for the Bosnian Muslim forces were found dead in a stream near Novi Travnik. Ted Skinner and Derek Arlow McBride had been taken away by the muj and executed, despite the fact that they sympathised with the Bosnian Muslim cause. Apparently, the 'muj' resented their support and mistakenly suspected the two of having espionage links with the British UN forces, commanded by Colonel Bob Stewart, in nearby Vitez.

On a number of occasions, British UN troops based nearby in Vitez stumbled across 'muj' training camps. Major Vaughan Kent-Payne ran across one near Fazlici in 1993 and noted many Arabs and, even, three blacks. He reckoned that the one hundred or so men were drawn from around thirty countries. The 'muj' also had a well defended HQ at the village of Guca Gora in a former monastery, high above Travnik. Here there were not only Arabs and North Africans but, judging from their accents, Muslims emanating from the north of England: the radicalised young who would not generally be perceived as such a threat for many years.

I stumbled on a big story in central Bosnia in September 1994. A British army officer suggested to me that I should 'take a look' at something that was going on in Gornji Vakuf. He was enigmatic about it but clearly wanted me there. When I arrived there were no other journalists but I noticed Bosnian army special forces units taking up positions in the largely empty, shattered town. It was soon clear why.

First of all, their commander, General Filip Alagic, arrived. Fortuitously, I held a Bosnian 5th Army press pass. These were incredibly difficult to obtain but I had assiduously sought one for months and it gave me access virtually everywhere. Alagic, who knew I worked for Janes, said I could hang around. Apparently, I might see something interesting.

Richard Holbrooke listens intently to the briefing by Gen. Filip Alagic. He would recommend covert support, involving the Iranians, to President Clinton.

A group of senior US military officers were at the crucial meeting. Far left is Brigadier General Mike Hayden, who would become Director General of the CIA during President George W Bush's second term of office.

A late 1994 picture of Bosnian Special Forces under training by foreign mujahadeen in Zenica. The trainer dressed in black is Iranian. I took the picture with a 600mm. lens especially acquired for the job.

The famous Khyber Pass in Pakistan's NW Frontier Province.

Then the heavy brigade arrived: the US President's envoy, Richard Holbrooke, his deputy Robert Frasure, and the man he had designated to assess the military situation for him, USAF General Chuck Boyd. There were others I recognised as CIA operatives and very senior US military intelligence people like Brig. Gen. Mike Hayden (later to be President George Bush's appointee as Director-General of the CIA); Brig Gen. Edward Hanlon and Brig. Gen. Mike Mirze. I got to work recording the momentous meeting which took place. There was a minor altercation with a senior British officer, Brigadier Andrew Ridgway, who marched up to me and imperiously demanded, "Who gave you permission to be here?"

I flashed my Bosnian army accreditation and when he asked who I was working for I told him, "I'm with Jane's," he gave me a black look and went very quiet.

The meeting took place in the street in the middle of the ruined town. I stood around listening intently to their conversations, positioning myself near the interpreters. At the meeting, Boyd made the shrewd decision that the US must actively seek to bring the conflict to a close. He would recommend to President Clinton that the US should bring together the Croats and Muslims in a military alliance against the Serbs. Holbrooke and Frasure would come to the view that the Muslims should be even more actively supported with weapons supplied in contravention of the UN arms embargo in place. This was not supported by the military component in the mission and it would lead to the covert import of sophisticated weaponry and the involvement of Iran. This would, though, have a positive effect in undermining the position of the fundamentalist fighters who had flocked to Bosnia.

This was a little more than a journalistic scoop. It was one of those occasions when the worlds of journalism and intelligence gathering crossed over.

Working as a journalist in a war zone it is, of course, one's job to gather information. Early in the Croatian war, the HV (Croatian Army) realised this. Lots of young Croatian men returned to their homeland from places like Canada and Australia. Some had journalistic training. So, instead of putting them into uniform, it sent them out into the field posing as journalists to gather intelligence. Similarly, the British set up a so-called Public

Information Centre next to its base in Vitez in central Bosnia. The PIF was a cross between a social club for visiting journalists and a communications centre where they could also use telephone and fax facilities 'thoughtfully' provided by the Ministry of Defence. This was not an altruistic endeavour on the MOD's part. Journalists came in from all over Bosnia regaling each other and the military with tales of their exciting discoveries. These were duly noted and imparted to the Ministry of Defence in London who, in turn, passed the most interesting bits to the Secret Intelligence Service, MI6.

It is a very fine line between information and militarily sensitive material and that always presented me, working for a magazine like *Jane's Intelligence Review* with particular dilemmas. It was, indeed, my job to both gather information of a military nature and then to analyse it. Most journalists collected information of a more everyday nature: human interest stories, stories relevant to the national interest and dramatic tales of derring-do which would read well in the paper. On the battlefield, all information is important. Indeed, the tiniest detail can complete a confusing jigsaw. However, most journalists are not over-concerned with the military significance of their everyday filing.

For me, it was a little different. Not only was I collecting, very often, highly sensitive material but I was directly charged with assessing its import and effects. Very often, I really was *only* interested in sensitive material. What I heard and observed that day in Gornji Vakuf, I was immediately aware, was of great significance. Fortunately, as I was not working as a daily newspaper reporter, I had some time to reflect upon it. A couple of days later, I heard that the US team had been seen in Mostar by other journalists (not reported, though) and I then knew it was only a matter of time before the story got out. I then felt I was fully off the hook in writing it up.

Arms and money now entered Bosnia. The chief of US military intelligence in the region was General Michael Hayden, who was at the meeting. He headed up the day to day operation. He was Director of the US European Command Intelligence Directorate based in Stuttgart from May 1993 to October 1995. [He would run the National Security Agency from 1999 to 2005, before his appointment as chief of the CIA.]

The US would now acquire some curious bedfellows. Iran Air jumbos had flown some arms consignments in through Zagreb airport in the spring of that year, the Croats taking a cut on everything, but the really big operation was about to start; massive shipments of arms being flown into the very large military airport at Tuzla in the north of Bosnia. This was known as Operation Rescue. I went up to the airport in the spring and summer of 1995 and found the control tower, and the radar installations, being operated by men wearing the shoulder flashes of the elite US army Rangers (this provided another exclusive which went to *The Washington Post* after I had filed for Janes). One of them was a Major Guy Sands, who was subsequently promoted to Colonel of the 380th Civil Affairs Brigade (Airborne) and who popped up in Afghanistan on similar mysterious missions in 2005. Sands was a prime mover in Operation Rescue working out of Tuzla: he had previously been expelled from UN HQ in Sarajevo on the personal orders of General Sir Michael Rose, who suspected him as an agent for the Defence Intelligence Agency, or its partners the CIA and NSA. Sands was, in fact, just the highest profile person involved in Rescue. Hundreds of other intelligence operatives laboured away rather less obviously.

Some very serious materiel was being flown into Tuzla, including T4 wire-guided missiles and other anti-tank missiles which were highly prized acquisitions on the finely balanced Bosnian battlefield. Wounded fighters were then flown out to Lebanon, Iran and Saudi Arabia. The airlifts by Hercules C-130 aircraft, accompanied by US fighter jet escorts, originated in Iran but flew out of Sudan. They were cloaked in secrecy and denied at the time: for this was in direct contravention of the UN arms embargo which applied to all the warring parties in former Yugoslavia. The head of the so-called Third World Relief Agency, a Bosnian, sat in on the meetings in November 1994. This agency, it has been alleged, was funded by bin Laden: it has been definitively proved that it provided US$40,000 to the cell responsible for the first World Trade Center bombing.

I have written elsewhere in these pages about Izet Bajramovic and his textile factory outside Sarajevo. He was a brave and committed businessman who fought to keep his operation going

during the war. He had no political inclinations, apart from his support for a free Bosnia, but one day I noticed a whole shelf of Islamic books in his Breza office. He shrugged his shoulders, "The Arabs give them to me and it is polite to have them on display. After all, they come every week with cash in Deutschmarks to pay my workers ..." The Iranian Embassy in Sarajevo stayed open throughout the war and was very busy indeed.

Once the war was over, it was tricky prising the fundamentalists out of Bosnia. On February 16 1996 – three months after Dayton – NATO troops, acting on US intelligence, swooped on a so-called 'terrorist training centre' in Dusina, central Bosnia, where bomb making equipment was being prepared. They arrested several people with Iranian passports. Children's toys were found to be packed with explosives, elaborate detonators, there were documents in Farsi and pictures of Ayatollah Khomeini were found.

Shortly after 9/11, an Al Qaeda operation was busted in Sarajevo. Computers were found with the plans for 9/11, fake US IDs and other incriminating materials. Martin Bell's comments were fully vindicated.

The Iranians offered 10,000 troops to the UN to defend the 'safe havens' of Gorazde and Srebrenica. The offer was refused and thousands died ... the stalling of the West over Bosnia undoubtedly served to radicalise Muslims in other parts of the world, even if it did not the Bosnians.

If Europe and the West were criticised over failure in Bosnia as safe havens fell and Sarajevo was surrounded (would Sarajevo have been besieged for more than three years if Muslims had been surrounding Christians?), then they ultimately redeemed themselves over Kosovo. The excesses of the Serbs in the semi-autonomous province would lead to NATO military intervention in the year 2000 and, in the longer term, the self-declared independence of the 'statelet' in February 2008, after almost eight years of UN administration.

Chechnya was another theatre of war perceived in the fastnesses of the Near and Middle East not so much as a regional struggle in a far flung part of the Russian federation, but as the struggle of a Muslim people fighting for survival against soldiers of the Christian Orthodox faith. Fighters from Yemen, Jordan and Saudi

Arabia all went to Chechnya and, ultimately, the struggle would add fuel to the fire of Al Qaeda.

The 1993 attack on the World Trade Center was not an Al Qaeda operation although there was an element of long-distance financing by Osama bin Laden. In 1994 there was a hijacking of an Air France jet by Algerian GIA militants. Their aim was to fly the jet into the Eiffel Tower. It is widely believed that this provided the inspiration for 9/11. Around this time Al Qaeda *emerged* rather than was formed. Its key period as an organisation was 1996-2000. By 1996 there was a distinct 'inner circle' formulating the organisation's central strategy.

Osama bin Laden was born on June 28 1957, the only son of his father's tenth wife and the 52nd child of the prolific Mohamed Avad bin Laden. His was one of the wealthiest families in the Middle East. His father died in 1975 and he took over the family business, the Bin Laden Construction Group. At age of 16, he had joined a fundamentalist group in Saudi. In December 1979 he left to fight the Soviets in Afghanistan. In 1989, he moved back to Saudi where he was, at that time, well connected to the House of Saud. But soon relations soured as the Royals became alarmed by his extremist views and he became *persona non grata*. In 1994, the Saudi government revoked his citizenship.

OBL started to visit Khartoum from Saudi Arabia in 1989, ostensibly to start various business ventures. Now he could mix the billions made from legitimate business with his activities related to extreme Islam. He modelled AQ on an international corporation with chief executives and management.

The Sudanese had decided to attempt to challenge the Saudi pre-eminence in the Islamic world. Their opposition to Saudi Arabia attracted him, also the long land border with Egypt, and lack of restraint on his activities. He began working on the concept of 'The United Islamic State' which would be made up of 50 countries against the Infidel. Sometime around 1990-91 he started to look at terrorism as a way of promoting his ideas and AQ was born. He also started to pay attention to those conflicts in places like Chechnya, Albania and Bosnia around this time.

In 1995 the leadership of Sudan started to have second thoughts about the country's role as a centre for Islamic radicalism. The

country's image was dented, investment was going away. In 1993, the United States had nominated the country as a sponsor of terror.

In May 1996 OBL moved his operations out of Sudan to Afghanistan and his alliance with local warlords started. Tora Bora, very near to the border with Pakistan, became his base. It was a modest sixteen or seventeen hour trek over the mountains into Pakistan and then less than an hour by road into Peshawar. Peshawar was the city which became the meeting point for all sorts of dangerously likeminded people, and those who wanted to observe them. OBL worked with the cooperation of local Afghan warlords rather than the Taliban at this stage.

I had written about Osama bin Laden and his links with Albania and Bosnia but the British press had pooh-poohed my material in the early 1990s. However, in 1996 I was approached by the German magazine *Stern* who had heard about my researches from Janes. My material appeared in the magazine (albeit under a staff writer's name) and they encouraged me to go to the Pakistan NW Frontier Province around the Afghan border and do some more work for them. The area wasn't 'sexy' in those days. The British media wasn't interested although there would be markets for the material years later. It would only be in the aftermath of 9/11 that the enormous strategic importance of the wild and rugged frontier area of Pakistan would become all too apparent to the editors who polished their chairs in London.

This is a land where the writ of the Pakistan government has never run, ever since the bloody inception of the state with the independence of India. It would be one of my most memorable foreign adventures.

The 1997 general election was going on in Pakistan and there was a version of the election supposedly being conducted in the Frontier Province when I arrived. As I passed through a village high in the mountains, the mud huts and fortified enclosures were plastered with posters and paintings of a bicycle. There suddenly was the luxury home of local candidate Nur Alam Afridi. He was Mr Bicycle. The fortified 40-foot high walls of his house must have enclosed an area of around 20 acres with a veritable palace set in the middle. Kalashnikov waving tribal supporters milled around at the gate.

One of the many walled enclosures in the NW Frontier Province. In this deeply tribal society nobody knows what goes on behind these high walls. It is impossible for any intelligence agency to penetrate behind these walls and such locations represent the perfect hiding places.

A tribal elder in the NW Frontier Province.

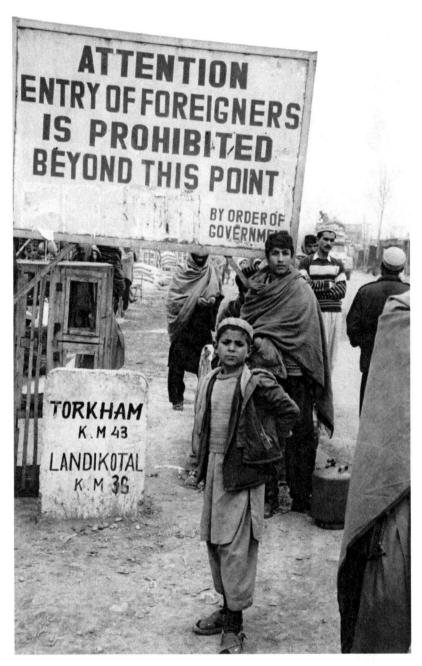

The NW Frontier Province is normally closed to foreigners. The writ of the Pakistan government does not extend beyond a hundred metres on either side of the road. I had to get a permit from Pakistan's Bureau of Narcotics and take two tribal policemen with me.

But Mr Afridi wasn't receiving visitors. Not surprising, really. He was the grandson of drug baron Ayub Afridi who was on bail in New York charged with drug trafficking. Conviction, even then, looked unlikely. "He is funded by the CIA," said my guide, "And, anyway, nobody will give evidence against him." Naturally. You couldn't, and you never will, crack family and tribal loyalties in this region. That seems to be a difficult one for Western intelligence agencies to appreciate.

Given the circumstances, his grandson's solemn election undertaking was hardly convincing. "You can break my hands if I fail to fulfill my promises after being elected." At least it was original.

There was another interesting electoral promise going the rounds. Tribal elders blithely announced that any woman voting would be fined 100,000 rupees - the locally astronomical equivalent of £15,000 pounds sterling - and her house would be burned down. There was a nil turnout of women voters.

It's strictly a man's world around there. Gun culture reigns supreme in the border badlands of northern Pakistan. It is here that the so-called tribal territories of the northwest frontier meet the terminally fractured land of Afghanistan. Thirty miles or so down the Khyber Pass from the border at Torkham is the Pakistani frontier town of Peshawar. Here prolonged exposure to gun culture has bred a certain lighthearted phlegmatism. There is a tombstone in the heavily overgrown British cemetery at Peshawar. 'Here lies Captain Ernest Bloomfield. Accidentally shot by his orderly, March 2nd 1879. "Well done, good and faithful servant".'

Peshawar is a frontier town with more than an air of the Wild West. It is in what is known as a Settled Area and lies just beyond the lawless tribal territories, the land of the Pathans. The women move silently - and shapelessly - through the bazaars in their dark *burqas*. Antique dealers and carpet salesmen eagerly tout for business anxious to offload old and beautiful items of doubtful provenance, many of which look as though they should actually be gracing the sanctuary of a museum or gallery. Some once did. And there are the impoverished refugees from Afghanistan who live outside town in vast camps still recruiting grounds for the training of international terrorists.

Tribal men newly arrived in town walk confidently in the streets with their carelessly shouldered AK-47s expansively greeting urbanised relatives: Yusufzais, Wazirs, Afridis, Ghilzai, Mohmands, Mahsuds, and representatives of a dozen other tribes. Each of these tribes enjoy historically established 'specialisations' - not least in the lucrative drug and gun trades.

The Afridis, for example, are the smugglers. Other tribes grow the opium poppies, another - the Shinwari - processes the opium into heroin in caves in the mountains. And so they live in an uneasy alliance. As the seasoned traveler Geoffrey Moorhouse observed, "The North West Frontier has been a permanent battlefield since man first settled on it, not only because of regular invasions and struggles against periodic imperialisms, but because the tribes have never ceased fighting each other on any pretext or none at all."

The agents of a myriad range of Western intelligence and drug control agencies attempt to move anonymously through the dust, the noise and colour of the narrow streets and alleyways around the bazaar area. From time to time, a mysterious Westerner without identification is found inexplicably dead in his room at nearby Green's Hotel, a somewhat faded establishment ($12 a night), but one where nobody enquires too much of your business.

I decided to stay there. I knew I was literally following in the steps of Osama bin Laden. The rooms are basic, the corridors bare but you don't need much imagination to speculate on the intrigue the hotel has seen. And, anyway, it serves the best *dhal makhani* (black lentil) curry I've ever had anywhere.

A rundown arcade of shops below the hotel sells faded and slightly crumpled postcards bearing the legend 'Greetings from Afghanistan' which are most useful for impressing the folks back home. The hotel electrician was un-phased by my problems in setting up a satellite telephone in my room. He turned out to enjoy a surprising command of modern technology as if he did that sort of thing every day. On reflection, he probably did.

Journalists on expense accounts all stayed up at the Pearl Continental Hotel, or PC as it is known, and it is all very plush up there. I only visited occasionally to get an alcoholic drink: you showed your passport and affirmed you were not a Muslim and you could imbibe in the bar on the top floor. However, for all its

lack of facilities, I much preferred the seedy ambience of Green's where the guests all seemed slightly mysterious and you could readily imagine that they were up to no good.

In Green's, in 1991, bin Laden agreed to an alliance with Saudi intelligence chief Prince Turki bin Faisal. Four years later, undercover CIA agents seized his associate in his room at Green's. He was freshly over the border from Afghanistan. Peshawar is the nearest point foreign agents can safely get to Taliban-controlled Afghanistan. It is also sufficiently lawless allow them to operate with relative impunity. At least two journalists I know of have been found dead in their rooms in Green's under suspicious circumstances. I liked the place.

In the remote and mountainous region beyond Peshawar the police have no jurisdiction at all. Foreigners are forbidden to enter. Like the British did until departure in 1947, the government of Pakistan secures the road and the area one hundred metres either side. Beyond that, it is a wild no-man's land where gun rule survives tempered, from time to time, by a system of political agents and tribal elders: a system untouched since the British entered the area, failed to control it and promptly withdrew ignominiously. The dominant tribe is the Afridi and nobody moves up or down the Khyber Pass without their assent. Drug barons, warlords and narcotics tycoons still survive largely unimpeded - as they have done for hundreds of years - closeted behind the mud and stone walls of their large defensive enclosures. Little has changed around here. Not even the towns and villages which are little more than vast gun factories. . .

The gun factories of the NW frontier are in villages like Sakhakot and Darra Adem Khel. Both are untidy, Wild West style villages of two storey wood and adobe buildings lining a dusty main street. On either side of the broad main street, local men stretched out on rope beds, or propped up on wooden chairs, eye the visiting stranger curiously taking time off to spit voluminously into the dust. You half expect to see John Wayne come lurching around the corner. Both villages are inside Pakistan but effectively beyond the law of the country. In places like these, everybody makes just one thing - guns.

On the main streets every single shop on the sidewalk is a gun shop. You can buy virtually every imaginable weapon. Most are

copies: copies of everything from the ubiquitous, modern AK 47 or the Chinese T-56, through the Pakistani Kalakov machine gun and the 8mm VIP, to the modern American M-16. The elderly Lee Enfield .303 is still a favourite in these parts and is manufactured for the tribesmen who prize its accuracy. Then there are 12 bore pump action shotguns, .22 pistols, pen guns, walking-stick guns and, even, copies of the latest laser sighted US weapons as supplied to Pakistani special forces. This last item is available for a mere 50,000 rupees - around $600.

The owner of one armoury proudly tells me, "We can copy anything you bring to us here." Even the markings are copied, the dies carefully counterfeited. But the final effect is sometimes, so to say, off the mark. There are Lee Enfield copies stamped *both* Mark III and Mark IV. Just about the only gun they could not copy is the Vector . . . the gun you can smuggle through airport security checks because it's made entirely of plastic. Plastic has not reached the tribal areas around the Pakistan border - this is a craft industry and these men are still using the traditional skills of wood and metalwork.

Behind the main streets are the gun factories. You make your way there down dingy alleys - in one, even the shoe shine boy sported a machine gun – and, in a series of buildings resembling lock-ups, men and boys earnestly fashion guns of every description. They say that if you bring them a weapon they've never seen before then, within 48 hours, they will have fashioned a copy. Once that first copy is made - and the sheet metal templates determining the size and shape of the working parts - then each additional copy just takes a day or so. Much of the work is done by hand - the rifling of the barrels, the planing of the *akhrot* stocks made from a local fruitwood, the detailed engraving of the silver inlays, and the sighting. In a yard, a man is dipping handguns into boiling liquid which colours and seals the metal, at the back of the buildings there is the constant sound of shooting as guns are tested. There are a few hand operated tools but, for the main part, this is a labour intensive operation.

These skills were, apparently, brought to the northwest frontier in the 1890s by a Punjabi gunsmith on the run for murder. The Afridi tribesmen learned from him and the knowledge has been

passed from father to son. Hereabouts, they are intensely proud of what they see as a craft industry. There is no morose reflection on the damage which the product might do. Anybody with the money is willingly sold a gun.

In Darra they estimate around 500 guns a day are made. In Sakhakot, 55 year-old Iftekhar tells me he has been making guns since he was 12 years old, starting with 12 bore shotguns. Now he employs ten men working in two shifts around the clock: they will make 100 guns in a week.

The copies of Western weaponry seem well made and on test are accurate, although those who have used them say the rifling tends to erode after several hundred shots have been fired. On the popular Lee Enfield copies, it used to be the case that the bolts failed to stand up to wear. And so, the Afridi craftsmen much preferred to steal the bolts rather than make them and many a British soldier who went to sleep with his weapon tucked between his legs woke up to find the bolt gone from his rifle - although, thankfully, with all else intact. It is said that the local skill at spiriting away the bolt of a rifle caused the British to issue the order that all bolts should be removed at night and locked in a steel chest in the custody of the sergeant-major. Some Afridis - who are not without a sense of humour - will tell you how their fathers came to steal the chest. The violence which emanates from Darra has come home to roost more recently. At the end of February 2008, the tribal elders, gathered in meeting, were massacred by persons unknown.

The British first marched up the Khyber in 1839: on the road to the First Afghan War. They lost hundreds of men to attacks from the Afridi. Effectively, the Afridi have always controlled the pass - and continue to do so to this day. Over some 20 miles it climbs from Fort Jamrud at 1500 feet to Landi Kotal at 3,375 feet. The fortified mud enclosures give little away. Gunmen lurk outside each and every one and no outsider will ever so much as hope to gain access. Behind one of these set of walls any man is safe from spying eyes and intentions. Especially someone like Osama bin Laden.

Nothing has changed around here in centuries - except the weaponry. The road is still overlooked by British-built forts like the vast Shagai Fort and watchtowers or pickets - small stone towers with firing slits, accessed by ladder hauled up by the defenders -

are located on virtually every piece of high ground. More recently, there are the tank traps put in by the British after Stalingrad - lest the German Panzers swept down and tried to force an entry into precious India. At the side of the road are the badges of the regiments who served and shed blood here - including many Scots regiments - cast in concrete and painted. Here is inscribed *Bydand* - motto of The Gordon Highlanders – there the legend *Primus in Indis*, the imprimateur of the Dorsetshire Regiment. The uncompromising landscape is not unlike some of the wilder parts of the Scottish Highlands and you wonder how the squaddies of yesteryear coped with life so far from home yet so familiar in other ways.

There, in the distance, is a camel train coming out of Afghanistan. Border controls are non-existent for an Afridi and it is a fair bet what the train will be carrying: contraband of one sort or another; most likely opium out of the fields of Afghanistan traded for guns from Darra or Sakhakot. This is where the financial base of the Taliban lies. Al Qaeda, once their clients, no longer rely on such contraband for their income but instead benefit from the instability which it creates and from the lawlessness of the region which so accommodatingly hosts them.

All the tribes in these parts live according to Pukhtunwali law: nobody else's law is accepted in the tribal territories. The British regarded the Pathans as the most noble of foes and their warlike qualities were said to be on a par with those of the Ghurkas and the Maoris. As recently as 1935, General Auchinleck found himself leading 30,000 troops against the Mohmands. For months on end they held off the Indian Army and the biplanes of the RAF with their skilled tactics of guerilla warfare.

The British finally admitted their inability to rule the Pathans and allowed them autonomy within the tribal areas - which also acted as a buffer zone between the British Empire and Russian interests which were even then expanding into Afghanistan. However, it was agreed that the British should retain control over the road links and especially the road up the Khyber Pass. But just one hundred yards off the road, tribal law took over. From time to time, the Brits would mount punitive expeditions after some tribal outrage ... This arrangement was continued by the government of Pakistan after independence in 1947.

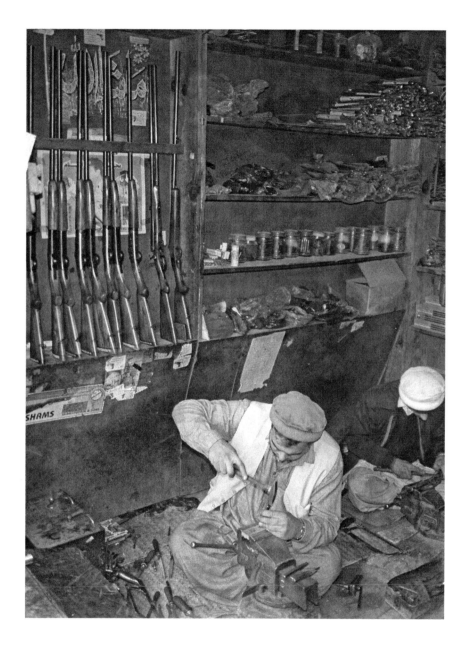

A gun workshop in Sakhakot in the NW Frontier Province. Guns and drugs are the essential currency of the Province.

Above:
Finished guns up for
sale in Sakhakot.

Below:
Fashioning a handgun.

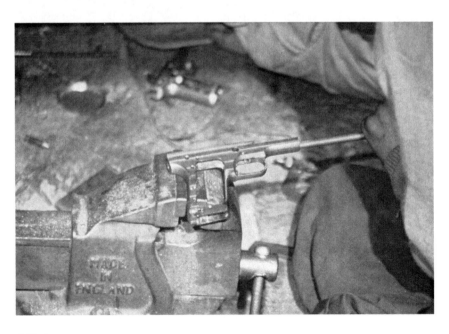

A lot of things make the Khyber singularly difficult to penetrate: the rule of tribal law, gun culture, the conflict in Afghanistan, the heroin trade. Significantly enough, you get permission to access the area from the Narcotics Office at The Home and Tribal Affairs Secretariat in Peshawar. Foreigners are most often barred from the area. But even if you do get a permit, you must pick up your *khassadar* bodyguards from the office of the political agent. The *khassadars* are his personal and private frontier force who secure the road up the pass and guarantee a degree of safety. They also protect foreigners who venture into this lawless land, levering themselves and their automatic weapons into your hired car. If you were to die whilst in their custody then their whole family, if not tribe, would be committed to a blood feud for aeons to come. This is their land for they are also tribesmen: poachers turned gamekeepers. Only the external border beyond is secured by the Pakistani army in the form of the Khyber Rifles.

As you leave Peshawar Airport, the searches of baggage and clothing are intensive; on the aircraft address system you are reminded that the carrying of drugs is a capital offence. Cannabis and opium have been around here since ancient times but, truth to tell, heroin has now replaced gun running as the most profitable form of smuggling. Only occasionally, the government cracks down - it was as far back as 1982 that 27 laboratories were closed down and destroyed by government troops.

It's a two-way traffic. A lot of goods arrive at the port of Karachi consigned to Kabul. They then proceed duty free into the tribal territories where they are 'lost' - eventually turning up again in Pakistan for sale without payment of duties.

And where do all those guns go? The war in Afghanistan swallowed up vast quantities of the weaponry for almost three decades. Now the business is, in comparative terms, in decline although there are encouraging new struggles developing in neighbouring countries like Uzbekistan.

But there are still plenty of blood feuds throughout the Northwest Frontier which require weapons to feed conflict and, daily, expensive four wheel drive vehicles roll into town with gun collectors and businessmen from Karachi and Lahore who either require playthings or weapons to keep them alive in the anarchy

that is urban Pakistan. Guns still cross the border into Afghanistan - traded for opium poppies which are then processed into heroin in the laboratories located in hillside caves above towns like Darra and Sakhakot.

None of this occasions any sort of soul searching around here. It has, quite simply, ever been thus.

Al Qaeda's Afghani bases were destroyed in the fall of 2001 following the 9/11 attack. But the attack on the Tora Bora stronghold of OBL and his leadership was not a success. There was massive bombardment from the air but all the evidence is that OBL slipped away, probably across the border into Pakistan's NW Frontier Province.

President George Bush declined to supply a requested force of 500 Rangers to cut off the retreat of OBL out of Tora Bora. One of the CIA agents running the operation to capture bin Laden, Gary Berntsen, could hear OBL on the radio and says he begged Washington for the necessary force to apprehend him. But he was refused. Similarly, a group of more than 100 British SAS men were refused necessary low level air support. Part indecision, part lack of available assets, part unwillingness to accept the possibility of casualties.

It seems likely that OBL escaped the December 2001 attack on the cave complex at Tora Bora, although around 400 of his supporters were killed. The type of indiscriminate hi-tech weaponry which was employed did not leave a great deal of examinable DNA evidence of human casualties so we cannot be sure. However, there are reports of later sightings.

Some people say he might have died on February 6 2002 when a Hellfire missile fired from a Predator drone onto a group of men on a mountaintop decimated several beyond recognition, including a tall man and his bodyguards. This attack was based on credible intelligence. But others say he has been seen since then, although there is no evidence of a positive sighting and alleged sound tapes released in recent years are unconvincing. OBL delighted in making videos to taunt the infidel and it is difficult to be convinced that he would voluntarily give up this facility.

The Pakistani authorities have failed to unearth him in the tribal areas around the Afghan border. After 9/11, Pakistan was persuaded by the United States to commit significant military

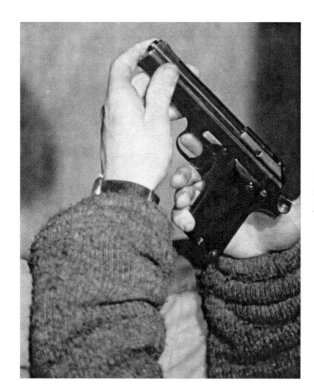

The finished product: a copy of the 9mm. Makharov pistol.

A newly finished copy weapon of local manufacture, Sakhakot, 1997

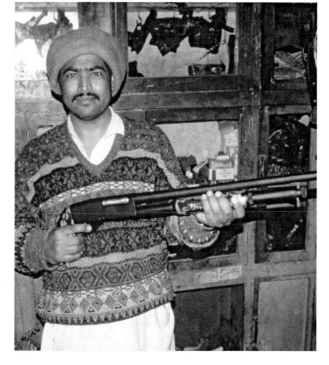

A Hunter drone pictured at Skopje Airport, Macedonia, shortly after NATO troops entered Kosovo. Such unmanned aircraft (UAVs) transmitted live pictures to NATO headquarters. General Wesley Clark, the NATO C-in-C, told journalists how he could sit in his bath in Brussels, observe the images live and call in attack aircraft to destroy targets. The Hunter has now been replaced by the larger Predator drone which can both transmit images and deliver Hellfire missiles. Such an aircraft probably killed Osama bin Laden.

Ayman al-Zawahiri effectively replaced Osama bin Laden as head of what was left of Al-Qaeda. He was now the public face seen in all TV broadcasts. He also took over the running of the show behind the scenes.

force to the tribal areas. The fighting was bitter and within a few months more than 700 Pakistani soldiers died. This was a toll the Pakistan military was unwilling to sustain. Islamabad was forced to change policy as the tribal leaders along the border allied with the rapidly strengthening remnants of the Taliban. Any Pakistani government will be reluctant to move against the tribal areas in force with the associated risks of provoking a *jihad* against the Pakistani state. In addition, elements within the Pakistan military believe that a warring and fractured Afghanistan is a rather better neighbour than a united land which might represent a territorial threat from the north. If OBL and his cohorts are lurking in the border region then nobody is telling. It would be naïve to think that in this closed society the west might ever have any chance of waylaying a popular hero and his supporters.

Some informed sources thought in 2003 that Osama bin Laden was lurking in China in that country's remote NW province of Xinjiang, a region with a similarly porous border and a major Muslim insurgency problem. I was living in China at that time and diplomatic circles were much energised by the presence of US special forces operating on Chinese territory. Indeed, the Chinese authorities were themselves sufficiently concerned to allow US Special Forces into the area to work with their own military. But not a trace was found.

If he is alive, he is most likely either in the North West Frontier Province of Pakistan or, possibly, in the Pech valley of the Nur region. This thickly wooded region of southern Afghanistan is also enormously difficult to penetrate by outsiders. Some experts doubt that OBL would bother to try and hang out in the potentially hazardous NWFP when the altogether more accommodating Nur area of southern Afghanistan is available. Here the Predator drones will never find him.

Other people think he may be holed up in one of Pakistan's vast and labyrinthine cities like Karachi or Rawalpindi. It is in cities like these that most of the arrests of AQ top men have been made. But my best guess is that they were on errands from base, not actually operating from there.

My personal inclination? Osama bin Laden is dead: dead either in Tora Bora or in the Hellfire attack, or of natural causes.

Somehow, the Hellfire attack seems most likely, and most suitable. There have been no more taunting videos from Osama. Such broadcasts as he is alleged to have made have been discredited by intelligence experts. It seems unlikely that he would, or could, have chosen to survive over the last six or seven years deprived of the oxygen of publicity.

Instead, all broadcasting has been taken over by bin Laden's deputy, Ayman al-Zawahiri, who has grown in stature and importance since 2005. Over the years, he has increasingly adopted the mantle of leader and his authority within what remains of the organisation would appear to be unchallenged. It is not just his dominance of the propaganda machine. Everywhere there are those small signs that he is the main man.

Of course, however dead he might or might not be, the legacy of Osama bin Laden lingers on to threaten and taunt the unbelievers. And that will certainly not go away for a very long time. In many ways, the legend is more powerful than the man.

Mindelo, in the remote Cape Verde Islands. A young man sports an Osama T-shirt

Eleven

Nothing Personal

Bosnia to Kosovo

War is a fairly random affair. Life is preserved or death arrives on an entirely indiscriminate basis.

It was difficult for any reflective journalist in the Bosnian war. So much to see, to do, to experience, to digest and to reconcile. For most of us I suspect that the only way to handle this and survive was, contrary to Martin Bell's thesis, rather by adopting the journalism of *detachment*. Most often we focused firmly on the story and actually tried not to be too distracted by the horror, by revulsion or, simply, by thinking too deeply about things. I know that most war photographers concentrate on looking through the viewfinder. That's not altogether a technical requirement: it does serve to suspend the reality of horror. Sometimes the strategy did not work: the very power of what was going on before your eyes took over.

There was an experience for me which stood out amongst the many. I knew a family. An ordinary family in many ways. Although, in many respects, the Bajramovics were more akin to a Western family than most in beleaguered Bosnia. Their own particular circumstances meant that they were able to survive financially, whilst all the time subject to the everyday pressures and anxieties of life in a town called Breza on the frontline of the battle for Sarajevo, just a few kilometres away from the capital.

I suppose I climbed the stairs to their first floor flat dozens of times. It was a neat, comfortable home in a modern low rise block in the centre of the town. The first thing you would notice was there was no glass in the windows at the front. That was explained by the enormous shell hole in the facade of the block less than twenty feet above their windows.

It had been eighteen months or so since I met 19 year-old Alma in a modern, noisy bar in the town when I stopped for a lunchtime drink with my traveling companion, Chris Bellamy, then defence

correspondent for *The Independent*. A self-possessed, engaging blonde in figure-hugging jeans came to our table and offered, in her excellent English, to show us her town. We willingly acceded to the offer.

The first stop was her father's office on the ground floor of the apartment block. Izet turned out to be probably the most respected member of the 18,000 strong community. Its largest employer, he had continued to run throughout the war, under the most difficult of circumstances, a textile factory within four hundred yards of the front line. The work force varied in numbers according to the intensity of the conflict, and the weaving halls and most of the equipment had been destroyed, but when I visited him later in the war he seemed quietly proud of his achievements: a workforce up to 3,000 from a low of just one hundred, and a single weaving shed back in production, the machinery reconstructed by his workforce, which now consisted entirely of women and a few old men, as the younger men had disappeared to the battle for Sarajevo. Izet worked himself hard but always had time for a joke with a visitor and for a cup of traditional thick Bosnian coffee washed down by a glass of local *slivovich*.

Above the office, the visitor was always assured of courtesy and hospitality in the Bajramovic home presided over by Alma's mother, Zelena, a strong and philosophical woman who bore the strain of raising a family in war with extraordinary equanimity. I suppose that was what I particularly valued about their welcoming home: a sort of haven of calm, sense and sanity. Outside the murder and mayhem might seem to reign unchecked but here inside the peace seemed somehow inviolable. That, of course, was an illusion. On the wall of the sitting room hung an enormous oil painting of the ancient bridge at Mostar, painted by Izet when he was an art student, but now, blown into the depths of the River Neretva, it was as much a reality as the broken windows all around.

Izet's position as one of but a handful of remaining Bosnian industrialists allowed him and his family an unusual freedom. He was able to obtain passports and tickets for his family notwithstanding the war. Alma was able to go for a few months to Italy and her 13 year-old sister, Selma, spent six months at school in Switzerland.

Izet Bajramovic and his daughters Alma and Selma. Izet kept his textile factory in Breza going throughout the war, even though it was right on the frontline.

The death notice for Adem Bajramovic. The image of Adem for the notice was taken from a photograph I had given to the family a couple of months previously.

The photograph I took of Adem Bajramovic shortly before his death from a shrapnel injury.

Bosnian fighters waiting for the offensive near to Breza in the spring of 1995.

Seventeen year-old Adem, Izet's only son, went to Libya for six months and returned speaking fluent Arabic, and, most importantly, with an offer for work and study in Malaysia. Before he went to Libya he had been slightly injured in the stomach by a small piece of shrapnel and he liked to pull up his T-shirt and show you the white scar where the molten metal had grazed his skin. Since then, though, he was frightened to go in the street and developed into a quiet, charming youth who spent most of his time in the peace and tranquillity of the family home.

In the last year of the war, Breza turned into a virtual ghost town. The Bosnian government forces' battle to free Sarajevo was launched from this town and the Serbs punished it terribly.

One grey day, as I drove in, there was no-one in the streets apart from a few soldiers. Everywhere there was evidence of recent shelling - holes in roofs and the front of buildings which I did not remember from my visit the previous month.

The square in front of the apartment block for which I was headed was ominously deserted and I parked the Skoda in as much shelter as I could find and darted up the stairs. Young Selma opened the door and smiled a youngster's familiar and uninhibited welcome. But I could already sense somehow all was not well. When the normally ebullient Izet appeared in the dark hall of the generously proportioned apartment I knew something terrible had happened here.

Kako ste ? I asked. How are you? Izet made a *comme ci, comme ca* gesture with his hands and his gaze shifted to CNN on the TV in the sitting room. I know he does not speak English but we were usually able to communicate. But usually, his restless energy does not allow him the luxury of TV.

Selma breaks the news in her *Schweizerdeutsch* learned in Switzerland. "*Adem ist getötet.*" Adem has been killed. I struggle to take this in; to make some sort of meaningful response. I have known many who have died in this war. But they have usually been soldiers or journalists. They knowingly take the risks. But Adem was an innocent. Alma and her mother enter: her mother wears a black shawl.

Alma explains. "My brother was killed by a shell just outside. A piece of shrapnel cut his neck and throat almost all around." She

gestures like in a scene from a bad film. But this is real. "We have just buried him."

It is customary in Bosnia to produce a printed death notice with a photograph in the corner. Tens of thousands of deaths had been commemorated in this way in the last three years. Adem's death notice, with its green border denoting his Muslim faith is produced: his smiling face radiating from the corner. It is uncanny. Then I realise. This is the photograph I took of him a couple of months previously with his father. "Yours was the only photograph we had." This is some sort of truly awful first; one of my photographs on a death notice.

"We took him to the hospital in Zenica." Zenica is around forty kilometres away. "He lived for five days but was never conscious. I knew from his eyes he was dead even as we took him there. I was with him when he died," Alma announces in a matter of fact way. "He died in the same hospital, in the same ward, in the same bed, as my boyfriend a few months ago. We paid the doctors DM 1,000 for his medical treatment and took him away to bury."

I find it impossible to make any sort of meaningful contribution to this litany of despair. Worse is to come. Alma takes from her bag a crumpled photograph. It shows her standing in the centre of a crowd of freshly uniformed boys. You can tell they are all proud of their new uniforms; particularly proud to be photographed with Alma. There are seven of them: all her classmates from the school in Breza. "Now they are all dead. Not one survives."

The human toll of the siege of Sarajevo was appalling by any standards. This may have been just one death but it was also the story of Bosnia in microcosm. A family shattered by a shell which, without warning, suddenly came from nowhere. *Nothing personal, of course.* Thousands fell almost every day in Bosnia during the war.

But Adem, in the end, could no longer stand being closeted inside and went out into the summer sunshine never to return alive to his cosy home on the first floor. Alas, he was not unique: half a dozen people a day who dared to venture onto the streets of Breza died on the dusty pavements in the baking sun, their bodies ripped by shrapnel.

I feebly ask Zelena how she feels after the death of her only son. Does she feel different; has the death of her son changed

Alma Bajramovic in Breza. The sign says Danger, Sniper.

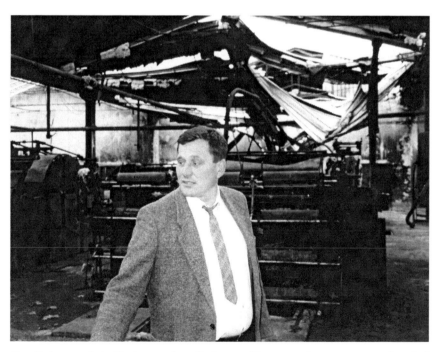

Izet Bajramaovic in his destroyed textile factory. He managed to get one weaving shed working again and the workers came in and went out by night to avoid the snipers.

her outlook? Even as I asked, I sensed that this wise and sensible woman would say something which would move me; which would amaze me, even.

"I am a mother. I have grieved for the death of every mother's son in this war. The death of Adem is no different for me than the death of any other child. He has been taken because he is the best. You know when you go into the garden you always take the most beautiful flowers."

As I leave, Alma, with all the weariness of her nineteen years tells me. "I wish it was I who had died. The death of my brother means it will never be the same." I know she is talking of her father's deep grief.

What can you say? How can you adequately convey in print what these people suffered with such incredible stoicism? I left making some feeble assertion that the war would soon end: it would do, but too late for the Bajramovics.

Zelena fixed me with her sad and wise gaze. "For me the war is already over. It ended the day my Adem died."

I got in the car and wept for two hours all the way back to Vitez. That night I got up at in the early hours at the *pansion* I was staying in, unable to sleep, and wrote these words about that terrible day. But I never, ever published the story, before now.

I travelled several times to Kosovo during 1993 and 1994 predicting, as most journalists did, that the repressed province of Serbia would, in the end, explode with dire consequences. After I had written this a couple of times, editors asked me to give Kosovo a miss until Armageddon might eventually arrive. It wasn't until 1999 that Kosovo ultimately imploded and that year I had other commitments. I crossed the Pacific at the beginning of the year, lecturing about my journalistic experiences aboard the Cunard ship *Vistafjord*, and then returned to the UK to go to Armenia and Nagorno Karabakh, a tiny Christian enclave in the Caucasus, together with a team from Christian Solidarity led by the leader of The House of Lords, Baroness Cox. She is a remarkable lady who spends what free time she has with threatened Christian communities wherever they might be in the world. I had first met her at the Trackmark Camp in Lokichokkio in northern Kenya

Lady Caroline Cox outside the Solidarity International offices in Nagorno Karabakh. She intrepidly travels wherever Christian communities are threatened.

An Eritrean train climbs through a cutting towards the capital, Asmara

LRA victim undergoing rehabilitation in Gulu, northern Uganda

During the early and mid-90s I travelled to Kosovo several times, predicting that war would break out. But it would be 1999 before full scale hostilities erupted. In 1994 I met and interviewed the poet, philosopher and inspiration for the Kosovo liberation movement, Ibrahim Rugova.

as she came out of Sudan, where she had uncovered evidence of the terrible massacres of Christians. We sat under the, admittedly, luxurious canvas of the remote campsite and she told me of her experiences. I wrote them up for *The Scotsman* which made the story their front page 'splash' the next day, courtesy of the magic of the satellite telephone, an innovation in 1998.

During 1998, I had done a lot of work in Africa. The World Food Program had ferried me around southern Sudan, where hundreds of thousands of people were starving, largely as a result of the food insecurity caused by civil war, and also Somalia, where the picture was much the same: famine had come with war and flooding had compounded the problems.

War with Ethiopia took me to Eritrea. Quite apart from the border conflicts which mar life there, Eritrea is one of the most charming, and safe, countries in the whole of Africa. A former Italian colony, it boasts a pleasant capital in the city of Asmara replete with coffee shops and ice cream parlors. Amnesty International will tell you of the country's poor human rights record. But it is, at least, completely safe to walk the streets at night. I enjoyed my time there.

I had gone to Uganda to visit Acholiland, in the very north of the country which was being ravaged by a particularly unpleasant character called Joseph Kony who headed something up called The Lord's Resistance Army. He saw himself as a religious prophet. Quite how, beats me. His speciality was kidnapping and brutalizing children: the boys were turned into fighters and the girls into sex slaves. One night he took more than 100 girls from St Mary's School, a Roman Catholic boarding school in Aboke. I went to the school and interviewed the sisters and three girls who had managed to escape the clutches of Kony. Theirs was a remarkable tale of survival.

These competing 'attractions' meant that my attention had shifted away from the Balkans, where I had effectively served my apprenticeship. I didn't 'do' the war in Kosovo on the ground. In advance of NATO involvement, however, I received an invitation to address some unspecified 'key' people and brief them on Kosovo and journalistic techniques of intelligence gathering in the Balkan war situation.

Prior to the West's involvement in Kosovo, the buzzword, in intelligence circles, was 'HUMINT': human intelligence. Previously, far too much emphasis had been placed on satellite-provided information and electronic interception. As a result of the development of 'hot' conflict in places like Bosnia and Somalia, where western interests were directly threatened, and where on the ground information was scarce, it was realized that such basic knowledge and the ability to gather information was of inestimable value. Of course, the people who are best at that are . . . journalists.

During 1998 NATO was actively planning its intervention in Kosovo and I gave a series of lectures on regional security and intelligence gathering techniques in the Balkans. The lectures were given at a secret location north of London near to Chicksands, a former USAF base located completely out of sight of the surrounding countryside in a natural hollow in the landscape. Secret and un-signposted, the facility, operated by a top secret body known as the Joint Service Intelligence Organisation (JSIO), was entered through a farmyard where battered rustics turned hay with pitchforks. It was a little bit like one of those scenes from the old TV series *The Avengers*, which starred Diana Rigg and Patrick MacNee. Further on, down the road, you came to the main event: barbed wire and minefields. There I found the NATO Defence Intelligence and Security Centre planning the war in Kosovo almost two years ahead of the war.

I was not introduced to the people I was addressing although I was usually invited to have lunch with them after my presentations. I remember one suited gent had a tie with the American flag and the initials NSA emblazoned on it.

"Doesn't that stand for the National Security Agency?" I ventured.

"Yeah, I'm the Chief," came the terse response.

At that particular seminar, there was present the head of virtually every significant European security or intelligence agency. Gradually, I made some interesting contacts.

When hostilities developed in the spring of 1999 I made several trips to the theatre of war in and around Kosovo. I spent a couple of weeks observing NATO attacks on the Serbs launched from Albania, where the US based Apache attack helicopters, and also

The bridge of the aircraft carrier USS Theodore Roosevelt. In the foreground is an F-14 Tomcat armed with a Sidewinder missile. During the spring of 1999, day-long raids were mounted against Serbian targets from the carrier, cruising in the Ionian Sea.

An F-18 Hornet prepares to take off from the deck of the USS Theodore Roosevelt

from aboard the USS *Theodore Roosevelt* in the middle of the Ionian Sea. Being on an aircraft carrier at war was a new and fascinating experience. I soon got bored by the aircraft taking off night and day to deliver their 'smart' weapons onto Serbian targets, but there are many things I remember vividly like using my Scottish bank card to withdraw cash in dollars on board, and enjoying the choice of half a dozen big name fast food outlets to 'dine' in. There were around 5,500 men and women working aboard the ship for months on end: a floating city but, for most of them, a closed-up, insulated world. Unless their work demanded it, they would never see the light of day from the beginning to the end of their 'cruise'. And yes, unlikely as it may be, they called it a 'cruise'.

After NATO forces marched into Kosovo, across the border from Macedonia, I followed them in with a colleague, Tim Ripley, a defence guru and one of the founders, and pillars, of the British Independent Defence Media Association (IDMA). It was always good to travel with Tim: he could instantly recall the most intimate private details of virtually every bit of aeronautical weaponry known to man.

I had driven down to Italy, appropriately enough, in my new red Alfa Romeo. I had moved on from Skodas. We stayed in Bari and hopped in and out of Albania by boat and on and off the US aircraft carrier by US navy air transport: a sort of short takeoff flying sardine can which achieved staggering speeds in virtually no time at all after btaking iff from the rather limited runways of an aircraft carrier.

To get to Kosovo, we took the ferry from Bari to Igomenitsa in Greece and drove across Greece and Macedonia into Kosovo. There we checked into the Grand Hotel in Pristina, the main city in Kosovo, and its nascent capital.

In any conflict there is always a principal hotel populated by the press. It's usually the most comfortable one, but the Grand was a pretty run down establishment by this time. Its entire top floor had once been populated by the paramilitary leader Arkan and his particularly unpleasant band of ethnic cleansers. He had famously posted a notice outside the lift: NO DOGS OR ALBANIANS.

Despite the catalogue of horrors perpetrated by Arkan and his men, when I had got the chance to meet him back in 1992 in

the town of Prijedor, in the Krajina, I had found him curiously intriguing. He had, of course, all the charm of the psychopath. Initially, not knowing of his perfect command of English, and half a dozen other languages, I had stumblingly addressed him in a mixture of bad Russian and Serbian, asking for an interview. He turned to me with a smile on his face and responded in perfect English. "Of course you may interview me but you have wasted too much time and now you are too late." The local Yugoslav journalists who had, up until that moment, been standing silently before him transfixed by terror, fell about in nervous laughter. He came back, though, and I got the interview. After the end of the war, he would be mysteriously shot by a retired policeman in the foyer of the Belgrade Intercontinental Hotel. That's what happens when you accumulate too many enemies.

The lobby at the Grand Hotel was buzzing with media, senior military, aid workers, fixers, translators: all the assorted types who populate war zones. Soon after check-in, a local Albanian approached me and asked for help.

He came from a small village called Cirez, high in the mountains of the Drenica Valley, about an hour's drive away. When Serbian paramilitaries came to the village, well armed and in force, the men had little choice but to disappear and fight the Serbs using guerilla tactics. They left their wives and daughters at home and the Serbs duly used and abused their womenfolk. Once they had done with them, they had executed all the women and stuffed them down the wells in the village. The men had now gone back to the village. They wished to recover the remains and start life again. But they lacked both the skills and the equipment to go about the gruesome task. They hoped that some publicity for their plight might help.

To me it seemed an interesting and, indeed, important story. It was a four-wheel drive job to get up the mountain and it was clearly not a suitable expedition for the Alfa Romeo. At this point, Ben Brown, one of the BBC's top correspondents, walked past. I knew Ben from various places, including Montserrat where we both had covered the explosion of the volcano.

I briefly told Ben the story as it had been regaled to me. "Sounds good to me, Paul. I'm fully committed tomorrow but I'll arrange for Vaughan Smith of Frontline to go up there with you. He can do some film for us and you can do some words."

Frontline TV is arguably the best freelance TV news agency in the world. The next morning Vaughan, the founder of the agency, and I made our way up the mountain in his four wheel drive. The story held up.

The village was trashed and ruined, roofs burned away, timbers exposed and doors and windows missing. There was evidence of the former Serb presence. We helped to lever open a wooden lid on one of the wells.

The sky went black with insects released from the depths and which had, presumably, been feasting for many months on the putrefying flesh. I brushed away a couple of insects from my skin and thought little more about it.

From the foul waters of the well below protruded the rotting limbs of the unfortunate women. There were, apparently, 32 dead women down there. The smell was, of course, appalling but Vaughan and I did our work; evinced the hope that it might help the village and went on our way back to Pristina. Vaughan went off to edit the tape and I wrote some words about the experience.

When I woke up the next morning, my leg ached. Ached like hell. I examined it carefully but all I could find was a tiny red mark a bit like a mosquito bite. I shrugged it off and went out and about seeing some British military types to find out what was going on. The ache got steadily worse but alcohol seemed to help.

However, things were much worse the following day. We drove out of Kosovo and into Macedonia where I dropped my colleague Tim Ripley at Skopje Airport. I didn't like the idea of seeking medical assistance in that part of the Balkans: there was virtually none available in Kosovo (NATO troops don't repair damaged journalists) and Macedonia did not appeal either. I made the decision to make the overnight drive to the Greek ferry terminal at Igomenitsa and to try and get to Italy. The Alfa eats up the winding Greek mountain roads effortlessly: at least it did on the way in. But my rally-driving skills were now at a distinctly low ebb. That night I found myself shaking uncontrollably under the sheets.

By the time I got to the ferry port, not only was I finding it difficult to walk but I couldn't eat any food. I actually left my beer at the seafront café. I now knew things were *really* bad.

Besides having rather more faith in Italian medicine, I had also met a delightful Italian girl when I was staying in Bari. We had

Zjelko Raznjatovic, aka Arkan, the notorious ethnic cleanser and Serbian paramilitary commander. Pictured here in Prijedor, Krajina, in 1992

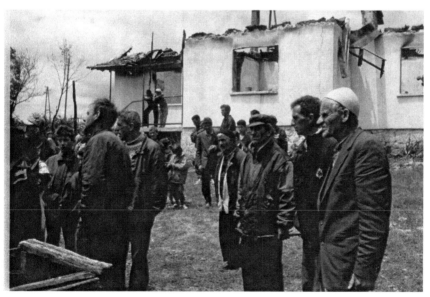

The well has just been opened in this mountain village in Kosovo. The bodies of 32 women, raped and murdered by Serbian police, lie rotting in the well. I was stung by an insect from the well with near fatal results.

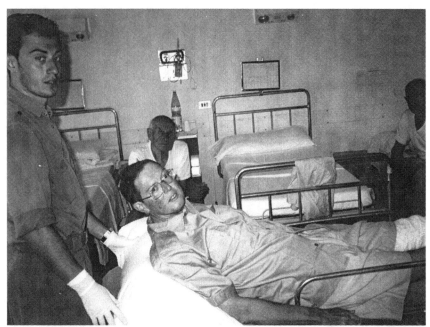

In hospital in Altamura, Italy. My bloody leg resisted treatment by seven type different types of antibiotic.

My friend Elisa. Without her support, I would probably never have survived.

become friends, exchanged books and photographs, and she had offered to show me southern Italy when I got back from the war in Kosovo. It had seemed a wonderful idea and I had been looking forward to the break with Elisa, a beautiful and bubbly girl.

However, when I eventually pitched up at Elisa's door in the pretty mediaeval town of Altamura, half an hour's drive from Bari, I was in decidedly poor condition and certainly not up to any sort of amorous tryst. In fact, that morning I had been unable to actually get out of bed on the ferry and had been carried down to the car by two crewmen who propped me up behind the wheel and sent me on my not so jolly way.

Elisa took me to the town hospital, where she knew the doctors. I didn't say anything about being in Kosovo or the circumstances of the problem. They took a blood sample and went off to the lab. They were back within 20 minutes. Through Elisa, they asked in a puzzled way, "Have you been anywhere near a dead body in the last few days?"

I had what, roughly translated, they were calling 'dead body disease'. The head doctor, Dr Perucci, said he knew it only from textbooks dealing with mediaeval diseases like the Black Death and the plagues. He opined, "You are very, very sick." The pharmacology was complex. Insects feed on dead bodies, they die and another generation of insects feeds on them. And so it goes on. The pharmacology was so complex that it was difficult to know how to treat such a disease.

Dr Perucci insisted on admitting me and I anxiously enquired as to whether they would accept American Express. No problem. Things would soon go from bad to worse. By the next day, my temperature was soaring to over 40 degrees. It would remain there for ten days, during which time I would lose my vision and almost half my total body weight. My leg would split open like a pea pod from groin to knee.

I was unconscious for much of the time. I usually woke every morning at 5 a.m. That's when they put *Ave Maria* on the hospital loudspeakers. One morning I woke up and four doctors were peering intently into the wound.

I couldn't understand what they are saying in Italian, but there was frequent mention of the word '*morte*'. By now they'd tried

several antibiotics and nothing was kicking in against the infection in my system. Elisa tells me later that they decided that morning that I would not see the day out and back in England my father was making arrangements to fly to Bari.

I decided to call on some outside assistance. The next day – I am still around despite prevailing medical opinion - I have my cellphone glued to my ear with a doctor in faraway Edinburgh at the other end as the local medicos pore over my wound.

"They seem to be using the word thrombo a lot," I report to my old friend, Dr Murrray Carmichael. Murray worked with the Red Cross during the Vietnam War in the 1970s so knows a thing or two about emergency medicine.

"Tell them you want anti-coagulants," he suggests.

"*Perfavore*. Anti-coagulants ..." I say it *veeery* slowly – *aanticoaaagulaants* – like an announcer on the BBC's World Service news in slow English for Africa.

The medicos look completely baffled. At the other end of the line a useful suggestion. "Bloody aspirin." Aspirin is indeed recognised internationally, I discover. But I need rather more than aspirin.

My leg was split open in a bloody mess exuding poison - and goodness knows what else – seemingly by the gallon. My temperature was running at fever level. I had grown drips on both arms. Most of my vision was gone. And then, on the third day - in the 38 degree non-air-conditioned hospital - my heart overheated. My last memory before lapsing into unconsciousness was of being strapped to an electric machine with bicycle clips attached to wrists and ankles. *Holby General, good evening and goodnight.*

In fairness, the Italians did a pretty thorough job: seven different types of antibiotic before there was a 'winner' found, and they actually refused to be parted from me until all trace of fever had gone. It was two weeks before my insurance company could even get permission to medevac me by air with an intensive care unit to a hospital in the UK.

The hospital was busy and noisy. There was no restriction on the use of cellphones in the hospital. They merrily trilled, warbled and rang their way through the day - and most of the night. The drug dealer who was dumped in the bed across from me after an

overdose of 'E' had a rather merry one which played the opening bars of *O Sole Mio* every few minutes from 6 a.m. Fortuitously, the *carabinieri* took him away a few hours later.

For me, though, the cellphone was my lifeline to sanity and the English-speaking world: my link to insurance companies, Italian translators, British doctors, family and friends. For a few days there were even calls from newspaper and magazine editors.

"Where are the bloody words and pictures, Paul. In hospital? Sorry to hear that old boy. Get well soon. When will we get the words and pictures?" After a few days the calls ceased. Needless to say, nobody sent a Cessna Citation to whip me off the runway at Bari Airport

It would have been difficult to survive without the help and attention of Elisa and her wonderful family. What you might like to think as an archetypal homely and caring Italian family, they brought me treats to supplement the hospital gruel, Elisa fetched me delicious cappuccino from a stall outside the hospital and provided critical translation services.

Eventually, the intensive care nurse sent from the UK whipped me away in an ambulance to the airport. I asked for the bill as we left and produced my American Express card but the kindly Dr Perucci waved it away. "Too much paperwork, don't worry about it."

Return to the UK brought two more weeks in hospital and an operation on the leg. And, after that, there was a further six weeks of dressing changes and recovery. However, I soon graduated from a zimmer to crutches and then onto a walking stick. My local pub, The Crown Hotel in East Linton, had so noticed my absence from the bar – and the drop in turnover – that the genial publican, Cliff Macarthur, was soon sending his car up to the house every lunchtime to collect me. A diet of pints washed down with mince and tatties would soon have me on my feet.

But it had been a close call. Far too close for comfort. And I found myself, for the first time, feeling uneasy about risk-taking. I suppose I'd always thought that I might sustain some injury in the course of what I was doing. As Edinburgh independent film producer Hugh Lockhart jovially put it over dinner one evening, "What you need, Harris, is a minor head wound. Then we can market you as a war hero."

In the end it was an insect that got me. Far from glorious.

I was, effectively, six months out of business as I rebuilt my health and strength. In the competitive world of freelance journalism that was too long. Some of my clients freely admitted when I re-contacted them that they had assumed I was dead. There's not much sentiment in the news business.

Shortly before the Second Iraq War in 2001, an international military exercise was held in the Omani desert, Operation Saif Sarea. I am pictured (centre) with other members of the Independent Defence Media Association (IDMA). Paul Beaver, the Janes defence guru much seen on television, is behind with arm on my shoulder.

Twelve

The Order of The Boot

Israel, N E India and Sri Lanka

Henry Boot is one of the great comic characters of English literature. The creation of Evelyn Waugh, he is a splendid pastiche of the foreign correspondent off to cover a remote war in the Horn of Africa, and a hilarious caricature of the Englishman abroad. Although it was written in the 1930's, Waugh's novel *Scoop* remains a classic yet to be superceded. I still recommend it for all visitors to Eritrea, where much of the fictitious action is set. I re-read the book rather often. Although the hero succeeds in staying with the story and resisting expulsion, the travails of Henry Boot are reminiscent of some of my own adventures: not least being 'booted' out of one country by an unreformed dictatorship.

The British passport used to be a really splendid document. Surely no self-respecting Briton could stand in that dreary arrival line in some remote airport, clutching a good old-fashioned passport with its reassuring stiff covers, and not feel a certain *frisson* of superiority? Inside the front cover there was that unequivocal, no-nonsense global command to foreign despots. *'Her Britannic Majesty's Secretary of State Requests and requires in the Name of Her Majesty all those whom it may concern to allow the bearer to pass freely without let or hindrance* Now, of course, we have the wretched, bendy Euro passport. Not quite the same thing.

Over some 25 years of travel to the remote, the exotic and the positively banal destination, my old British passport served me well and, quite often, rather better than might reasonably have been expected. Like the time a ten-year-out-of-date one secured unhindered access to Eastern Europe, or a forced landing in the Gulf necessitated a visa-less stay in Qatar with an Israeli stamp already on my passport. Nevertheless, the most seasoned and innocent of travellers can hardly fail to escape that feeling of apprehension as the line shortens and you come face to face with some inscrutable foreign immigration officer. He - or she - scans the pages, examines the likeness and the fingers tap the keys of a

computer terminal . . .

Coming home at Gatwick Airport from that trip to Yugoslavia, with the ten-years-out-of date passport, it actually proved trickier getting back into Britain than wandering about a war zone with an outdated travel document. I was required to enter into a general knowledge quiz on 'familiar aspects of British life'. The impertinent fellow at the immigration desk asked me the name of the statue in the middle of Piccadilly Circus. I knew rather better than him: it was under repair in Edinburgh.

"I think you are referring to the statue of Eros created by the renowned sculptor W.O Pilkington Jackson. It is not in Piccadilly Circus. It is in Messrs Henshaw & Co.'s workshops in Edinburgh." He thought I was a Smart Alec but he let me in.

Tel Aviv's Ben Gurion Airport is not some flea-ridden desert outpost but the modern and, to all intents and purposes, efficient entry point for international visitors to Israel. The entrance from the tarmac is more like that of a swish Hilton - up an expansive flight of steps to a marble-floored, palm-fringed arrivals hall. But then there are, like everywhere else, those inevitable lines of silent supplicants for entry.

A bank of uniformed young Israeli women perused passports. I chose the best looking on the politically incorrect basis of her probably being the most happy with life and least inclined to make difficulties for the weary traveller.

Eyes and fingers sped over the pages and tapped the keys on the terminal. The operation was repeated. I could swear the eyebrows were raised and any trace of welcome on her visage had been replaced by a glance of bemused appraisal.

"Your first time in Israel?"

"No," I admitted.

"Purpose of your visit?"

"Holiday." Generally the safest answer.

"What is your work?"

"Er, well, writer." Safer than journalist.

The computer whirred disconcertingly and a print-out started. I was nodded through and, with a certain degree of relief, headed for the baggage hall. But the gate to the hall ahead suddenly closed in my path and arms came to grab me.

"You come with us."

After getting over some initial entry problems, I visited Israel several times during 2000 and 2001. This is a shot of Palestinian girls taken in Ramallah and illustrative of the modest degree of Muslim commitment on the West Bank.

I attended the International Security Academy in Herzeliya, near to Tel Aviv. Founded by a former Mossad boss, its main activity in those days was teaching VIP protection. Pupils ranged from protection agents for Arab sheikhs to bodyguards for Russian mobsters.

The illuminated sign in English and Hebrew drew closer and more legible in our frogmarched progress: Police Post. I now became the unwilling, and disbelieving, spectator in a drama in which all the actors - excepting myself - spoke Hebrew. It was rather like stumbling into a foreign cinema and watching a film from which the sub-titles have been omitted. A uniformed officer made calls on one telephone. A large, tough-looking female officer made calls on another phone. An excited immigration official dashed in with another page of computer print out. A stream of people poured into the tiny office, stared at me with evident curiosity and then went out again. The Hebrew dialogue seemed to me excited, even triumphant. Not a word of it could I comprehend except the oft-repeated two words, "Paul Harris! Paul Harris!"

I summoned up the courage and asked the tough looking bird what was going on.

"You be quiet. You are in big trouble."

Illogical, I thought. I haven't actually been in the country long enough to be in any sort of trouble but I kept my thoughts to myself. An apparently more senior plain-clothes policeman arrived in the room. Questions, seemingly without point, came one after another. Have you written against Israel? What will you write this time? Is your father's name John? Are you positive about your date of birth? Do you always use the name Paul Anthony Harris? And then the cruncher. Are you sure you have not been deported from Israel?

Stay calm and courteous, I told myself. But then it came. "You are banned from entry into the State of Israel." This was definitely a new one on me. "You were deported on your last visit and tomorrow you will answer questions at the Ministry of the Interior in Jerusalem. They will decide what to do with you."

After an overnight stay at an agreed address I hit the telephone well in advance of the proposed visit to the Ministry. In the way things inevitably work when you are in difficulty abroad, the British Embassy had just closed - for two weeks in due reverence to Christmas and New Year - but, luckily for me, the proconsul was at home.

Many calls later, police headquarters in Jerusalem advised, without explanation, "You may stay".

That evening, at a party, I met what is euphemistically termed 'an informed source'.

"Ah, so you are the famous Paul Harris!"

I must have looked puzzled. "Paul Harris is a name a little too well known around here." And there then emerged a story of namesakes, identities and coincidences which beggared belief.

My first namesake - same full name, same father's name, same precise date of birth - had been deported from Israel after a period in jail for drug and gun smuggling. Several years later, my second namesake - same name, same year and *month* of birth - after a night of excess in a kibbutz had piled all the furniture up and set fire to it. He was also deported. My third namesake followed the same course having, like me, arrived innocently at Ben Gurion. He was instantly deported under protest without further ado.

My informant then quite seriously advised. "In time for your next visit I suggest you arrange to travel under another name."

Coincidence? Well, partially. Number two did not purport to have another identity. Number three was plain unlucky - as I would have been if there had been a return flight to London that night. But number one had - quite simply - stolen my identity. It used to be easy. Frederick Forsyth made the basic method famous in his first successful novel, *The Odessa File*.

You took yourself off to a graveyard and found the last resting place of some unfortunate infant whose age approximated with your own. A quick visit to the Registrar of Births, Deaths and Marriages at Somerset House in London would, in those days, produce a birth certificate. A child would never have been issued a passport so all you needed were a couple of phoney signatures, passport photographs and a couple of tenners in cash and, hey presto, you had a passport. Forsyth blew the gaffe on that method with his bestseller: once it was out there were reportedly queues of dodgy characters at Somerset House raising copies of Birth Certificates. Of course, the authorities clamped down. Bit it didn't take too long before the enterprising had worked out variations on a theme.

In certain circles, the name Paul Harris is not that uncommon. A Paul Harris used to edit *The Jewish Chronicle*. There's a feature writer on *The Daily Mail* with the name as well as a Reuters man, a travel photographer last heard of working in the Caucasus and

another snapper who shoots Hollywod starlets (he sounds like he has the best number). I *know* they all earn more money than me. I used to occasionally get their cheques in the post.

If you Google the name Paul Harris you will come up with a staggering number of possibilities. The Paul Harris responsible for most of these entries was one Paul Harris of Philadelphia. He was apparently a rather lonely soul short on dinner and lunch companions. So he set up a club where those of like circumstances might sup together. And thus was born Rotary International, now probably the biggest dining club in the world.

Hardly surprisingly, it's that Paul Harris who dominates Google. To get to your truly, you have to qualify the query a bit, suggesting writer, journalist or photographer.

It's inconvenient, of course, to be mistaken for somebody else. Especially when they have been established as being undesirable. It's even worse when you are deemed undesirable yourself and heaved out of wherever you might be.

Identification and documentation are vital when you're travelling as a journalist. The more you have the better - especially in war zones where paranoia tends to run riot. It's not clever to 'sneak' in posing as a tourist or aid worker, although I have done it in impossible-to-get-to Aceh in the late 1990s. You can't work properly as a journalist that way and any cursory inspection of my own kit would have revealed all sorts of unlikely appendages: three or four cameras, tape recorder, notebooks, computer, satellite telephone, short wave radio, a scanner, portable antenna/washing line, and so on. Once you're rumbled as an impostor then, quite apart from a period as the enforced guest of the local security apparatus, you can kiss goodbye to all your hi-tech gear. And you won't be getting a Loss Report signed by the local nick so you can forget an insurance claim.

Just occasionally you have no other choice but to 'wing it'. I really wanted to go to India's fractious north-east. When I said I wanted to go to Manipur - the name means 'beautiful garden' in Manipurean - the Indian High Commission in London warned me that a Restricted Area Permit would take at least five weeks. In the event, they held onto my passport for a couple of months and then expressed surprise I hadn't needed it back. I forebore from

explaining I had another couple in my desk drawer which I had been using in the interim.

Would I like to collect my passport and take tea at the High Commission? Tea with the Minister Counsellor was just what you would expect from the representative of such an enormously courteous country as India. Perhaps I would prefer to visit the tea estates of southern of India as the guest of the Indian government? No, thank you very much, I want to visit the fascinating, albeit troubled, north east of the country. *Jane's Intelligence Review* isn't particularly interested in tea estates. My passport reappears between the teacups - a large blue stamp addended. 'Access to Restricted Areas Forbidden'. All with a charming smile, of course.

When I asked at the Ministry of Information in Delhi, they quite simply said it was impossible to go there. "For your own safety, dear boy." Nearer the action, in Calcutta, people suggested that the north east was full of head-hunting savages and murderous terrorists and that I would certainly be killed. However, in Calcutta I found that I could buy a ticket to Gawahati, the main city of Assam, without permit and that from there I could go on to the state of Meghalaya.

To get to the other states of the north east - Nagaland, Manipur, Tripura, Mizoram and Arunachal Pradesh - you must obtain the Restricted Area Permit, stamped on your passport.

Waiting to board the aircraft for Gawahati at Calcutta Airport, I could not help but notice a glamorous, exquisitely dressed woman: tall slim and with long black hair, she seemed a little out of place amongst the mixed batch of passengers waiting to board.

It turned out that Jaya was married to a prominent local business-man up in Meghalaya. Well, one thing would lead to another.

At the airport at Gawahati a large desk blocked the entry channel. 'All foreigners to report here' was emblazoned on the notice. Foreigners are not allowed to enter the north east by road or rail and all entrants are registered here. A further police registration is required. I didn't get around to it immediately . . . it didn't take Special Branch long to pick me up in the street the next morning- the only white face in the area!

But Manipur was my preferred destination: home to insurrection, drugs and arms smuggling. All the sort of things I was interested in but the Indian government was coy about.

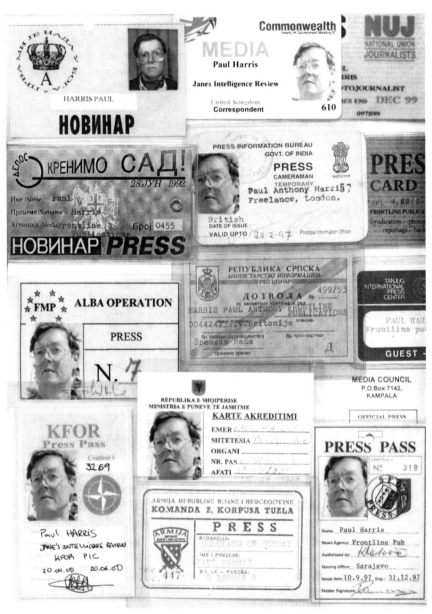

Press accreditation is vital wherever in the world a journalist might work. Occasionally, I worked without it but that usually ended in trouble, as happened in Manipur.

When I arrived in Imphal, capital of Manipur, I was met by a friend of Jaya's husband, a prominent local businessman. There was a tight security cordon and I was the only white person on the aircraft. Buying the ticket had not been a problem in Gawahati - I was simply told I would not be allowed to stay when I landed. However, Jaya's friend smoothed my passage through the airport. My New Delhi-issued government Press Pass sufficiently impressed the junior police officers on duty and after an entry was made in a vast, heavy ledger I was waved through.

I spent my first day doing the difficult bits of the story: driving up to the border, examining the smuggling routes and doing some discreet pictures of the military. When I got back to Imphal and checked into my hotel two stern-faced denizens of the local CID were waiting for me. Apparently they were at every hotel in town. My appearance was required - immediately - at the office of the Chief Superintendent. I asked for permission to don a tie and recovered from my backpack a crumpled MCC (Marylebone Cricket Club) tie with its universally recognised orange and gold stripes. Downtown things were a mite frosty. Shown into the Super's office, past phalanxes of gun-toting guards of the Sikh Light Infantry, he didn't even look up from his desk but carried on working for three or four minutes as if I simply didn't exist. He, like the Sikh guards, is evidently not from these parts. His features indicate this.

"You are in extremely serious trouble," he began as he looked up. The stern visage took in the gaudy stripes and his face suddenly wreathed in smiles. We talked about cricket for twenty minutes or so. "Now dear boy, you must understand foreigners are excluded for entirely practical reasons. There is a real danger of kidnap around here." And, he added with a wry smile, "The price for you would be very high. However, as you are a good cricket man, let's see. How long would you like to stay in Imphal?"

In most war situations, all the warring parties tend to introduce their own press accreditation. There used to be a CIA agent based in Sarajevo during the Bosnian war. If you got to know him well enough, he'd birl his computer monitor around to reveal an array of plastic laminated press passes apparently issued by all the parties to the conflict.

He would boast, "I've got seventeen pieces of ID here good for every goddamn corner of Bosnia. And they were all originated on the same Apple Mac back in Langley, Virginia!"

Most of us had to flog our way around the country either with the correct ID or en route to its collection. That was often a *Catch 22* situation. I well remember two days sitting at the Bosnian Serb border at Bosanska Gradiska on the River Sava anxious to go to State HQ in Pale to cover elections there. "No, it is forbidden to travel to Pale without the correct papers."

Fine, where are they issued? In Pale, of course. And without the papers you can't go there . . .

I think I actually got my own back on these obdurate denizens of Radovan Karadzic. In those days, policemen and border guards always liked to rake their way through the boot of your car, helping themselves to anything they fancied. So you would generally leave a couple of packs of cigarettes and a few bottles of beer lying easily to hand - with wholesale supplies hidden somewhere around the back.

Basically, I used to carry three thirty litre canisters of petrol in plastic containers - petrol was well night impossible to obtain in warring Yugoslavia – plus an awful lot of beer and plentiful stocks of food. The important thing was to wrap the food in sealed poly bags or containers. The petrol containers - a bit of a mobile bomb at the best of times - tended to 'sweat' imparting something of their fragrance and curious emetic effects to the food. On this trip I had not been careful enough to wrap up my biscuits. Consumption of just a couple the previous day had led to prolonged periods of discomfort on the pot.

Before I was allowed to cross back into Croatia there was the usual search from the Serb border guards. I was prepared. A few beers readily to hand - and a pile of tasty biscuits. I made a great show of pressing the lot onto Karadzic's men and as they waved me off into the distance they were already merrily munching their way into the laxative biscuits.

Funny, I never used that crossing point ever again. Indeed, in August 1995 it ceased to actually exist as a crossing point. As the Croatian Army swept through Serb-held territory in Croatia in its August blitzkrieg operation the border guards mined the bridge over the river at Bosanska Gradiska. They did a good job. A couple

of weeks later there was terrible thunder and . . . lightning. The whole thing was blown sky high. For me, there was some sort of symbolism in it.

Accreditation was the name of the game. In Bosnia I acquired accreditation from the government in Sarajevo, the Bosnian Croats in Mostar, the government 2nd, 3rd and 5th armies who issued their own individual accreditations, the Croatian Foreign Press Bureau, the Croatian Government Ministry of Information, the so-called Republic of Serbian Krajina (now deceased) and the Republika Srpska - the Bosnian Serb bit of Bosnia. The last one was the toughest to get your hands on. In fact, in order to get to any destination in Srpska you had to present yourself at an office in Belgrade - neighbouring Serbia - and get both a press pass and a stamped document. The press pass even specified the border crossing point you were to use and it was only valid for a maximum of 14 days. The accompanying travel document specified every town on your route and where you were to stay. Deviations from the route were not to be advised. And just in case you had it in mind to take off and go somewhere else, there were checkpoints every few miles where the travel documents and pass were perused and noted in great ledgers. The ledger keepers were not known for their sense of humour and all in all trips through 'RS' as it was known were far from jolly peregrinations.

Of course, most countries at war are far from enthusiastic at the prospect of journalists scouring the front lines. The early days of any conflict are the best time to be there - before eager beavers back at headquarters or some long forgotten Ministry get to work on control systems. In the early days of the wars in Slovenia, Croatia and Bosnia you could virtually go anywhere and do anything.

In Sri Lanka I remember sitting in military headquarters in Colombo in March or April of 1996 trying to smooth my own passage into the war torn eastern part of the island. I knew that the Tamil Tiger rebels virtually held the east in those days: indubitably, they did so at night and during the day traffic - generally massed in convoys - passed through only at their behest. The Sri Lankan military authorities tended to deal with journalists by dint of a charm offensive.

I wanted to go to Batticaloa, which was effectively well inside rebel territory. The army was not keen on such trips but in Colombo

Imphal police patrol

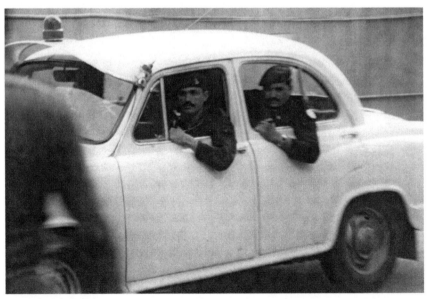

An Austin Ambassador armoured car carrying a unit of the Indian Black Cats special forces, Gawahati.

they will tell you this represents "No problem". Now whenever anybody in an official position says "No problem" you know there really is a problem.

So I spent my time acquiring names and telephone numbers of military commanders, who I assumed to be men of influence, and with the aid of Word for Windows sat myself down in the neo-colonial splendour of my suite at the Galle Face Hotel to create my own *laissez passer*. A purloined Ministry of Defence letterhead, combined with some cut and paste from some documents acquired at military headquarters, home telephone numbers of generals and brigadiers and expansive statements to the effect that I was travelling with the 'full knowledge and approval' of sundry army commanders who could be contacted at home – doubtless over their gin and tonics – was to do the trick. I was waved through every checkpoint by nervous soldiers and NCOs without so much as a hesitation of the hand over the field telephone.

The Central Bank bomb attack in Colombo happened just four days into my first visit to Sri Lanka in January of 1996. Up until that point, I had exclusively reported from the Balkans on the conflicts there. After the Dayton Peace Agreement of November 1995 virtually all the papers I worked for opined that the wars in the Balkans were over and that I should, as *Scotland on Sunday* put it, 'look for a new war'. That, of course, was easier said than done. There were plenty of wars going on all around the globe but the one that I had been ideally suited to cover – in terms of language, geography and local knowledge – now seemed to be over, at least for the moment.

I had long been intrigued by the civil war in Sri Lanka: a ferocious internecine conflict which had broken out at the beginning of the 1980s. It was, apparently, a breakaway war in which minority Tamils in the north and east were seeking self-government from a predominantly Sinhala government in Colombo. I would soon learn that it was rather more complicated than that and that the dictatorial ambitions of one very dangerous man called Velupillai Prabhakaran lay behind much of the trouble.

The climate in the Indian Ocean was rather more appealing than that of the Balkans, as was the food. Spicy food happens to

be my thing. So I decided that even if I didn't get a hot news story at least I might be able to relax in the sun and enjoy the food after five Balkan winters marked by a distinct lack of gastronomy.

When I mentioned my choice of new destination and the elements of my culinary reasoning behind it, to a nice lady I met in Tesco's supermarket in Haddington, Scotland, Jean Scott was kind enough to write a poem about it. Apparently, I had told her that I would be moving on from Bosnia to Sri Lanka. "Good war, pity about the food," was my observation, she maintains. She promptly knocked out and sent to me 'Paul's Plea'.

So to all intending rebels
May I make this earnest plea –
'Could you organise some decent grub
For journalists like me!'

I ws only joking, of course. But the food would be better in Sri Lanka.

I did do some homework. I arranged to meet the London representative of the rebels, The Liberation Tigers of Tamil Eelam. That was a decidedly cloak-and-dagger operation. I was told to stand next to a 'phone box at Euston Station. When the phone rang, I was given instructions to go to another phone box. Eventually I ended up at a vegetarian curry house in Euston Street. This was most promising, I felt.

I asked the LTTE representative in London – a man called Shanthan, who was arrested in London on terrorism charges in the summer of 2007 - if I would be safe from his organisation's depredations at the Galle Face Hotel, where I had booked in. He was reassuring. "Oh, I don't think we shall bother to blow up the Galle Face Hotel. Eventually, it will simply fall down of its own accord . . .". However, they did, in the event, lay on a most impressive show to mark my very first visit.

It was almost a quarter to eleven on the morning of Wednesday January 31 in the teeming business quarter of the Sri Lankan capital, Colombo: a warm and overcast 31 degrees. I looked at my watch just as the massive explosion rocked the Sri Lankan capital of Colombo. It was 1047. I could see, through my car window, the

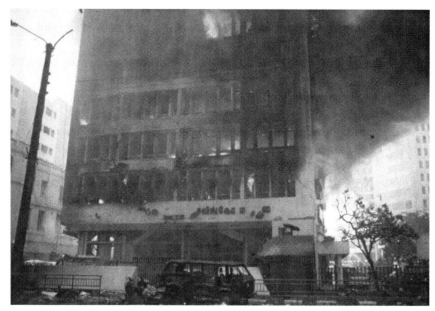

The whole of the commercial district of the Sri Lankan capital, Colombo, was destroyed by an LTTE truck bomb on January 31 1996. I was a few hundred yards away at the time. In this picture, the Ceylinco insurance building burns, half an hour or so after the blast.

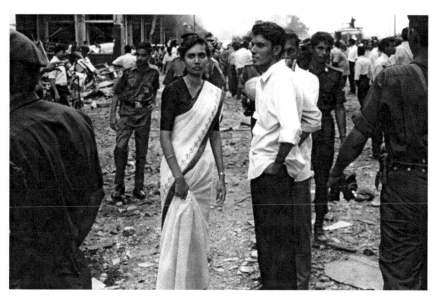

An elegant sari-clad woman stood out amongst the smoke and debris

plume of thick black smoke which was rising hundreds of feet into the air just a few hundred yards away.

Security that morning had been exceptionally tight throughout the city. Of course, that came as no great surprise: government forces had been pounding the separatist Tamil Tiger rebels in the north of the country since October 1995 and the big fear all along had been that in the wake of their defeat on their home territory in Jaffna, in the north of the country, they would bring the 13 year war, in which 50,000 had already died, to the country's capital.

Within minutes of the explosion Colombo seized up as army trucks, police, ambulances and rescue services converged on the commercial area. I abandoned my car, engaged a trishaw and then ran into a maelstrom of fire, debris and death.

In the area of the explosion in those minutes following it, visibility was reduced almost to zero. Thick black smoke billowed everywhere and through the thick, choking fog flames roared from windows, the heat searing your skin. On the edge of the commercial district, bedrooms in the ultra modern Intercontinental Hotel on the second and third floors were well alight: the service wing at the back was totally shattered and ablaze. On the forecourt of the hotel wandered a naked man - a German businessman - with just a bloody, once white bathroom towel wrapped around his waist. His face and body was shredded by shards of glass. He had just emerged from the shower when the explosion hit.

But I had seen nothing yet. The swirling blades of a circling Bell Huey 412 helicopter parted the black fog and I could see the length of the capital's main business street, buildings burning all the way along. The *de-luxe* Galidari Hotel to my right had lost every single pane of glasss in its twelve storied facade. Beyond it, the Ceylinco Insurance Company building, housing Ceylon's premier insurance company, was burning fiercely through its entire 12 stories or so. Next door, the building housing Air Lanka, the national carrier, was burning and it looked as though its floors had already collapsed. Further down the elegant colonial-style building of George Steuart's, the country's oldest trading company, was a shattered shell.

But the worst hit was the Central Bank building, its modern green and white early 60s facade collapsed over pavement and road and with flames shooting through the rubble from underneath.

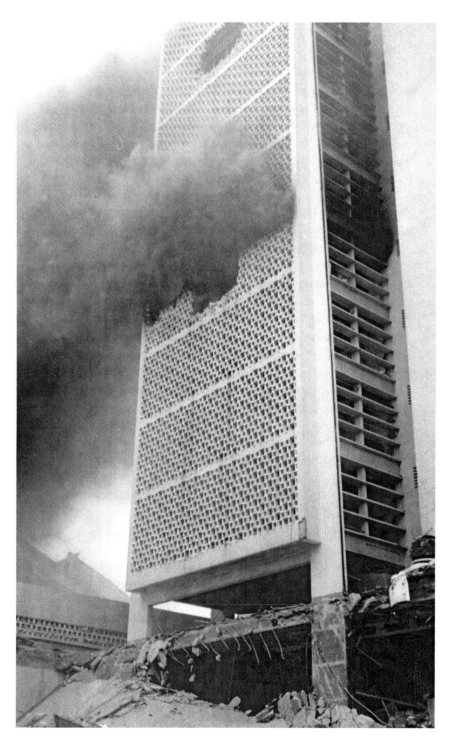

The Central Bank building burns in the centre of Colombo. The flames have spread up stairwells and lift shafts

The street was an untidy mess of the detritus of terrorism. There were the burned out cars. I counted more than thirty although, in fact, nearly 400 were wrecked, and trishaws - the small and noisy taxis you see everywhere - lay scattered all around. Curiously, the electrical effect of the explosion activated headlights and flashers and uselessly crushed and burned cars which would never run again winked and shone in seeming merry derision. And there was building rubble, glass and metal everywhere.

And the blood. In the 30 degree heat the blood was already dry on the pavements like pools of crimson sealing wax, quite hard and curiously less offensive than the blood I had seen in Bosnia, which always seemed so fresh and liquid.

All around milled the injured, the merely curious and the simply aimless. Police, army, navy and RAF personnel, Special Task Force police, sailors in crisp white uniforms from the nearby Navy HQ, bomb disposal squads, commandos from the Airborne Division. There were even a few firemen. But turntable ladders and snorkels were not to arrive for more than an hour after the explosion and by one o'clock the Sri Lankan Air Force was dropping water bombs all over the blazing centre: Bell Huey helicopters scooping up water from the Beira Lake in front of the nearby parliament buildings and then dumping it in great curling showers from the sky.

I noticed that what looked like a military-issue jacket was hanging on some spiked railings beside the Ceylinco Building. Closer examination revealed it to be a discarded suicide jacket, still with the explosives intact in the pockets! I called it to the attention of security forces personnel. One fellow blithely plucked it from the railings and started to delve into the pockets ... I made myself scarce.

Seven hours later, as night fell in Colombo, smoke rose from the terminally shattered business heart of this Asian capital. A city centre curfew was imposed, there was a city wide appeal for blood donors and hospital staff, and the Department of Information was appealing for calm. 1400 people were admitted to the overworked hospitals and by nightfall the death toll was over 90.

From my room at the front of the Galle Face Hotel, with its cracked panes, I could watch, as night fell, the smoke still rising into the sky. No time for a beer this evening. For me it would be a

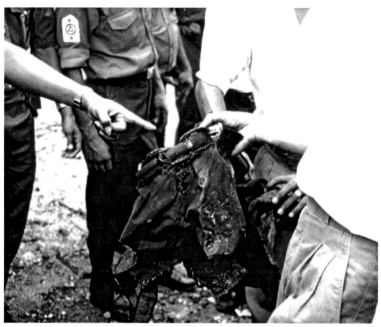

I found an abandoned suicide jacket, with the explosives still in place, hanging on the railings behind the Ceylinco building. The police started to go through the pockets. I made myself scarce..

Colombo's bloody horror

1,400 caught in Sri Lanka bombing

"A naked man wandered with just a bloody, once-white towel wrapped around his waist. His face and body were shredded by shards of glass. He had just emerged from the shower when the explosion hit. But I had seen nothing yet"

Exclusive eyewitness report from Paul Harris

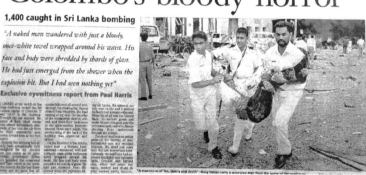

The next day, I got The Scotsman front page splash for my story of the bombing.

When I went to live in Sri Lanka at the end of 2001, working as The Daily Telegraph correspondent, I soon fell foul of the new Prime Minister, Ranil Wickremesinghe. I photographed him at a party given by Euro-MP and former Thatcher advisor Nirj Deva (rear). The PM upbraided me at the party, "I am not the man who is going to give Sri Lanka away [to the LTTE]." In my view, he tried his best

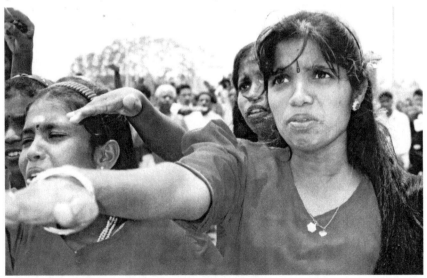

Young fanatics salute at the Trincomalee Pongu Tamil gathering organised by the LTTE terrorist organisation.

hectic evening and, indeed, right through the night I would be on the phone or at the computer. Fortuitously for journalists working in South Asia, the clock is eight hours ahead of Britain which gives plenty of time to gather news and then to file it during the evening hours. The deputy editor of *The Scotsman*, Fred Bridgland, urged me over the phone, "Give it all you've got, Paul. Bags of colour." It was next day's page one splash. Every three hours I did a live interview with the Sky News centre and they ran my voice over the powerful images which had come out of Colombo that day. In between I did interviews for BBC Radio Scotland's news programmes. This went on for three days, finishing with features for the Sunday papers. I worked hard on the writing, telephoning, visits to the hospitals, press conferences and all the other things which mark a Breaking Story: I knew it was a once in a lifetime opportunity to be on top of an international story with virtually no other competing journalists about.

A deep gloom settled over Colombo. The Tamil Tiger rebels had, in one blast, seriously undermined the commercial stability of Sri Lanka and done what they had long threatened by bringing war right into the heart of the capital. I stayed three weeks in Sri Lanka and would return five times during 1996. Bosnia may have gone from my schedule but had been instantly replaced.

I used to think it would be misleading to give the picture of Sri Lanka as a police state. Almost everyone you meet - whether in officialdom or socially – seems to exude a genuine and charming geniality. This sunny disposition survives remarkably intact despite the exigencies of civil strife.

For a country at war, there is also a surprising availability of information. If you want to speak to, say, the Head of Special Forces you could have looked Commanding officer W M J Fernando up in the telephone book. His number was there. Or, in emergency, you can call up Colonel S G Tennakoon at his home on 0372 2781. He was the head of the Military Intelligence Corps. I'm sure the home number of the head of MI5 is not listed in the London telephone directory - or, if it is, it doesn't describe the subscriber as 'Head of MI5' and give his address at 28, Acacia Gardens.

These paradoxes are at first confusing to an outsider. But, like

any society there are rules, boundaries of conduct. And most of these have been inherited from the British, and, curiously to an incomer, adapted to local circumstances. There aren't so many Brits around these days but the remarkable thing is the warmth of feeling which exists towards the former colonial power. Much more so than, say, in India or Pakistan.

That may explain why, seven days into my first stay, I found myself at the Bandaranaike Centre addressing the international relations *alumni* - an audience of generals, journalists and academics - on conflict resolution in relation to Bosnia and Sri Lanka. My *bon mots* seem to go down well enough. At lunch afterwards I must confess to being quite bowled over by a senior academic who observes, "I often wish the British had never left in 1948." It's nice to know we still have friends left somewhere.

However, I came to adjust my feelings about Sri Lanka after I went there in November 2001 with fond notions of maybe settling down in the Indian Ocean 'paradise'. Paradise is a much over-used word. British travel writers apply it to anywhere with an ambient temperature of more than twenty degrees and a couple of palm trees. I even titled my own book of photographs of Sri Lanka *Fractured Paradise*. It was published a few months before I arrived in Colombo in November 2001, full of positive feelings about the country.

After the launch of my book on Sri Lanka, *Fractured Paradise* held at the Galle Face Hotel, I was taken to dinner by the chairman of the English language crusading newspaper *The Sunday Leader*. Lal Wickremetunge asked me if I would come and edit his paper as it looked as though the editor, his brother Lasantha, would have to leave the country by the end of the year after intimidation by the then People's Alliance (PA) government. According to Lal, over a curry dinner at the Holiday Inn Hotel, a deal had been struck. To be precise, Australian intelligence had struck a deal with the government: Lasantha would leave with his family for Australia, where they would be granted residency, and, in return, the PA strongmen would be held off. In October, though, an election was called after several PA politicians crossed over to the opposition.

During November, it became increasingly clear that the electorate might opt for a change. The government changed on December 5 and the job evaporated as the United National Party

The street parade at the Trincomalee LTTE gathering. The float contains a large picture of terrorist and war criminal Velupillai Prabhakaran

The LTTE's women's leader, Banuka. In a humorous article in The Daily Mirror I commented on how attractive and sexy she was. This set off an immediate and quite unsubstantiated rumour that I was having an affair with her. She was called back to the LTTE jungle HQ for meaningful discussions with the leader, Prabhakaran.

The LTTE reads the riot act to photographers prior to an important press conference.

(UNP) took over power. At the time, I didn't see that that should affect me particularly.

I was remarkably content to be settled in the fading colonial splendour of the Galle Face Hotel, Colombo, as correspondent for *The Daily Telegraph* and *Jane's Intelligence Review*, and writing a book on the hotel. Before I went out to Colombo I went to see an acquaintance from the Bosnian war, Alec Russell, who had graduated from being a humble freelance to the exalted position of foreign editor of *The Telegraph*. He was keen to have a correspondent in Sri Lanka, observing to me, "It's a long time since we had decent material from there."

With the tourist industry then in seemingly total collapse, the management at the Galle Face Hotel did me an excellent deal for a seafront suite overlooking the blue waters of the Indian Ocean and the gently swaying palms of the gardens. The high spot of the day for me was to sit with a gin and tonic on my balcony at the hotel watching the sun sink down into the Indian Ocean. All very agreeable for US$30 a night.

Within days of taking office, the new Prime Minister, Ranil Wickremesinghe, tangibly demonstrated that peace was in the air. Virtually all of the security barriers and checkpoints in Colombo were removed from the streets. This was, or course, universally popular. People could move about without tedious security checks and the traffic flow freed up.

This was soon followed by a ceasefire. Peace moves, brokered by the Norwegian government, continued apace during January and February. A February 22 Memorandum of Agreement (thereafter referred to as the 'MOU') was, significantly, signed first by the rebel leader, Velupillai Prabhakaran, in his eerie in the jungles of the Wanni, a full day before the Prime Minister. The president had not even seen the agreement.

There were elements of the new government's peace process which were, in my judgement, flawed and I drew attention to them. In the London *Daily Telegraph* I wrote about child conscription in the east of the country, carried out under the noses of the security forces, emasculated by the MOU with the rebels.

I also wrote in *The Telegraph* of my meeting with the LTTE's eastern leader Karikalan in March He told me "it was for Tamil youth to repossess land stolen by the Muslims." This caused an uproar

in Sri Lanka as soon as it was reprinted under the arrangement *The Telegraph* had with the local paper *The Island*. Another English language daily, *The Daily Mirror*, also commissioned an article from me on the meeting.

The meeting took place during a two week long visit to the east. I had been invited to accompany an amenable and influential, if shadowy, figure who had been despatched to the east by the Prime Minister, to report on the developing situation.

Nanda Godage was an old friend who I had worked with back in 1996. A retired Ambassador in Brussels and High Commissioner in New Delhi, when I first came across him he was running the Foreign Ministry for Minister Lakshman Kadrigamar. Sri Lanka had been getting a bad image in the west for its prosecution of the war. The publicity was more related to the way visiting journalists had been treated rather than conduct of the actual war and I had suggested to a friend who turned out to be well connected that things could be turned around by the simple stratagem of simply treating the press better by making facilities available and a touch more transparency. I was duly taken on to write a report on reform of media strategy, which I completed in September 1996 after four visits that year.

I was impressed by Godage. I never actually saw him play chess but he operated like an accomplished chess player. He had an ability to see several moves ahead; to see the implications of a course of action whilst those around him were still absorbing the context of the proposal.

I visited the east with Nanda Godage and we were joined by an Indian journalist, P K Balachandran of *The Hindustan Times*. 'P.K.' was an old Sri Lanka hand who had been in the country several years. Affable and incisive as he was, I was never really sure why he was to join us. I knew why I was there – as a sounding post, with my intelligence background, for Godage.

The visit to the east convinced me more than ever that the LTTE were up to no good. In Pottuvil (March 12) the fears of the Muslim community were clearly expressed in a series of meetings at the appropriately named Hideaway Hotel. We visited a place by the sea called Kumari and I was moved by the plight of a woman whose son had been taken by the LTTE. Ordinary people clearly

feared the stranglehold the LTTE was imposing under the guise of peace. In Ampara (March 14) I was impressed by the men of the Special Task Force (STF).

In Batticaloa, the security forces seemed under no illusion as to what was going down. What they could not understand was what Colombo was up to. On March 16 we crossed into LTTE territory in the company of the local MP, Krishnapillai. The most interesting thing about the meeting was the appearance of his wife. She soon broke down into tears. The price of LTTE support for her husband's election to parliament had been their eldest son. They had handed him over to the LTTE for military training.

As Nanda spoke with the Peace Secretariat and the Prime Minister's office on a Sunday morning (March 17) from Trincomalee, the sound of cannon fire broke the still. I assumed they were practice rounds but the firing went on for a quarter of an hour or so and I could see puffs of smoke in China Bay. LTTE gunboats were probing the harbour defences.

In Muttur on March 19, the local Sinhala community revealed they had met and voted to a man, and a woman, for that matter, to leave if the security forces were to withdraw their protection.

Our trip to the east was rounded off on March 20 with an impressive briefing at military headquarters in Minneriya by Maj Gen Sunil Tennakoon, himself a former intelligence chief. In the cool of his air conditioned office, he gave us a two hour long briefing and left us in no doubt as to his own views and, indeed, those of the military establishment generally. The LTTE were gathering men and *materiel* for war.

At Nanda's request I compiled an intelligence report for the Prime Minister drawing together all the strands of our visit and culminating in a risk assessment. I was well used to this sort of exercise, now being in my tenth year of working for *Jane's Intelligence Review*.

I wrote a couple of articles for the *Mirror* and my *Telegraph* articles were re-published in *The Island*. It seemed to me that the real Achillees heel of the LTTE might be the organisation's lack of a sense of humour. In my perception it was an unreformed and anachronistic revolutionary movement spawned a quarter of a century previously in the school of Castro and Guevera. I wrote a number of wry, mickey-taking articles. It seems that these

essentially harmless, humorous article really hit home, which was, I suppose, what I wanted.

The intro to one of my *Mirror* articles raised hackles.

> These LTTE people are oh, so charming. With their cheery smiles, mild manners, warm open features and welcoming handshakes they are straight from the Saatchi & Saatchi public relations manual for Transformation of Terrorist Leaders into Genial Uncle Figures. They make the government Information Department chaps look like grumpy ogres. Who could possibly think that friendly, limping man Mr Thamil Chelvam was such a rotter? Then there's that nice man Mr Karikalan who holds court over the eastern province from his remote fastness in Kokkadicholai.
>
> He greets you with a firm handshake, beaming genially from behind a pair of designer spectacles. He reminds you of Mole, rather than Ratty, from *Wind in the Willows*. Such a nice man . . . Somewhere in the background is that rather tasty looking girl, Banuka. I first noticed her at the Batticaloa Pongu Thamil. She gave a dynamic, powerful performance haranguing the crowd. It was infinitely more effective than that of all the politicos put together. And it was oh, so sexy. A sort of beautiful version of Margaret Thatcher. I have definitely developed a crush on her (Banuka, not Margaret Thatcher). She's an absolute cracker. In more ways than one. Apparently, she sends the female cadres out into the eastern province to deal severely with male 'eve teasers'. They beckon rude boys into back streets for hoped-for hanky panky, then beat them to pulp with karate chops. On second thoughts, I think I'll leave her alone. But I'll still have fantasies about her . . .

Satire is, of course, well established in Britain as both a literary form and a political tactic. It is in its infancy in Sri Lanka and I did not then realise the truly devastating effect of humour. The day the article appeared – April 1 appropriately enough – the phone rang from early morning. Several journalist colleagues wanted to know if the rumour that I was having an affair with LTTE women's leader Banuka was true. What had been meant as wry humour became instant rumour. Nanda Godage was shocked. "I hear you've dared to call Thamil Chelvan a rotter and Karuna a bad egg." He opined that there could be "very serious consequences." At the time, I found that rather amusing in itself. But I was still on

the learning curve. . . Within days Prabhakaran had called both Karikalan and Banuka to his jungle fastness in the north for some meaningful discussions . . .

But the article which seemed to find its mark, long before it was published thanks to surreptitious emailing around the world by the magazine's staff, was one I wrote for *Lanka Monthly Digest.*

I'm getting a bit worried about this State of Tamil Eelam business. Don't get me wrong. I'm all in favour of small states. They encourage a bit of welcome diversity in a dull world. Small states are much more interesting than their larger neighbours. They tend to produce smashingly beautiful postage stamps, are notably emollient in the tax free trading department and are often good for getting your hands on a useful spare passport. All stuff I've been rather keen on in my peripatetic and dysfunctional existence.

So I'm watching with bated breath all this Tamil Eelam stuff. But it doesn't look too promising to me. I mean, these LTTE chaps are just so serious. I can never take anyone seriously who takes themselves seriously, if you see what I mean. I don't think the word fun is in the LTTE dictionary. I'm afraid there isn't going to be much joy for those living in the two thirds or so of the island of Sri Lanka who are going to have Velupillai Prabhakaran as their leader (President and Prime Minister rolled into one, we are advised by Chief Crony Mr Balasingham). Let me tell you about some unnerving incidents experienced whilst travelling in what is already *de facto* Tamil Eelam.

It's Pongu Tamil day in Trincomalee. A nice day for some snaps of all these colourful marchers with their bunting and their big placards of the Chief Genial Fatty. A funny thing happens as you lift your camera for a snap. A hand appears over the lens. I lower the camera and look around but can't see the origin of the hand which has left a large greasy smudge on the lens. A second attempt and the same thing happens. I look down. Below me is a diminutive Boy Scout of no more than 10 or 11 summers in pristine uniform. "No photographs," he fiercely instructs.

"Buzz off," I instruct his woggle. "Listen to me sonny, I'm a mate of your Uncle Karikalan and unless you clear off I'll report you to LTTE headquarters." This was, of course, before Karikalan fell from grace. My uniformed tormentor slopes off but eventually catches up with me. This time he has some rather larger boys with him and I decide that discretion is the better part of valour as I am

marched off to the Tamil Eelam press accreditation tent.

Arya Rubesinghe's Department of Information press card is of absolutely no use around here. So I get this round bit of cardboard trailing gold and red ribbons to wear. A local Boy Scout troop stand impassively by, witnesses to my humiliation.

It was a hard morning on the playing fields of Trincomalee. Three hours of patriotic songs, stirring speeches and Sieg Heils for Eelam would be enough to exhaust anybody. Now I am ready for a nice cold beer . . . Unfortunately, it soon becomes apparent that the LTTE have given strict instructions. No beer today. I am not inclined to give up easily on this personal search for nirvana and so I set off on foot on the two kilometre walk (no three wheelers today, instructions of you know who) to the Seven Islands Hotel. Here I am furnished with a long cool glass of the amber nectar. Heaven.

That is until the arrival of Mr Chandrasekeran's convoy carrying the minister, various LTTE types and fellow travellers. They eye my beer disapprovingly and my request for a second is turned down by the hapless manager. "You know how it is around here," he moans pointing at the cadres lounging by the expensive four-wheel drives.

Mallavi is the brightest light in the firmament of the Vanni. It has a couple of LTTE hotels. At our modest little guest house I ask our LTTE minders to take us to a local night club. A peculiar pained expression crosses their visages. Of course, I am winding them up. I settled for a *kasippu* store and purchased a delicious bottle of arrack. But arrack is not approved of around here and the atmosphere is distinctly frosty as the cadres observe my alcoholic indulgence on the verandah as the sun goes down. I tell them I have a terminal illness and am required under doctors' orders to drink at least one bottle of spirits a day.

Shortly after 9 p.m. things rather deteriorate socially. I am more than half way down the bottle when the screeching of tyres announces visitors without an appointment. To be truthful I have observed some chaps skulking in the bushes with T-56 assault rifles but I have studiously ignored them, although they have persistently ruined the view through the bottom of my glass.

The gates open. A squad of goons – men in civvies and birds in ominous black uniforms – stalk up the drive. All except one, that is. He's on crutches so he's not in the stalking business any longer. He's a dude called Kokulan, LTTE security chief in charge of arrangements for Prabha's press conference. They've pitched up to "search baggage and examine equipment".

The operation lasted almost three hours. Cameras stripped down, minutely examined and themselves photographed. Photographic equipment weighed using a sensitive pair of scales, as was unexposed film and even a packet of biscuits in a search for plastic explosives. Serial numbers of all equipment taken and computers photographed. The operating systems checked out by a computer whizzkid. Me and my mate Bandula [Jayasekera] are very good humoured about all this. We keep up the jolly banter although our jokes seem to be falling a trifle flat.

As we are all gathering for the Big P's Address to the World, a well known Colombo journalist approaches. "Look, Paul, the LTTE have asked me to ask you not to keep making fun of them."

I reacted without thinking. "You've got to be joking."

"No, please, no more jokes." And he scurried off back to the LTTE.

I give up. Welcome to Tamil Eelam. World Repository of Fun and Frolic. I don't think. Just pass me another beer. That reminds me. There isn't a single bottle of beer to be had *anywhere* in the uncleared areas. A good reason on its own not to be applying for citizenship papers for Tamil Eelam.

The article provoked a storm although the *Lanka Monthly Digest* took out my reference to leader Prabhakaran as The Chief Genial Fatty: probably as well, I suppose. The humour was hitting home more effectively than I ever thought. That had, in retrospect, been an ominous run-in with the LTTE's security machine in April before Prabhakaran's press conference. I was singled out for a special three hour long search which involved stripping down and examining with digital and heat-seeking equipment my cameras and computer.

The humour was hitting home but there were more serious developments taking place in the country. In May, I wrote for *Janes Intelligence Review* about the *de facto* division of the country. In another article I predicted the use of schoolchildren and other civilians in besieging and over running bases of the security forces. All of these things would come to pass and what seemed so shocking at the time became received wisdom within five or six months.

I was asked to talk to MPs in a public room in parliament on May 9. In hindsight, that was a mistake. More than 50 opposition MPs attended from the PA, the Marxist-oriented JVP and the

Muslim NUA. The panel which sat with me at the top table included respected former Foreign Minister Lakshman Kadirigamar, a former President of the Oxford Union, leader of the opposition Mahendra Rajapakse (who would become President after the fall of the UNP government) and Anura Bandaranaike, former Speaker of the House and son of the President. Not exactly a band of gangsters, I would muse bemusedly later. That afternoon a government minister, Rajitha Senaratne, dramatically announced that an M15 (sic) agent had been in parliament.

That evening I went to the European Union Birthday Party in the Hilton Hotel. After a few gins, this fellow bounded up to me and announced in the self-important way politicians do that he had "exposed me in Parliament this afternoon as an M15 agent." I said I didn't have a clue who he was and he looked decidedly put out. Then I told him, "The M15 in Britain is a motorway, not a security organisation. Anyway, it's MI6 you will be meaning."

Three days later there was the fateful encounter with PM. At a private birthday party given by Nirj Deva, MEP for the South East of England, the PM roundly reproved me. "There is only one thing I have to say to you and that is that I am not the man who is going to divide this island."

This encounter was colourfully reported in the *Sunday Leader*. The newspaper I had come to edit now became my sternest critic with an editorial, gossip column items and 'inside' political pieces about me. Then the Directorate of Internal Intelligence (NIB) started its work: surveillance started, my room was searched and hotel employees and records examined. Within two weeks the NIB investigation had cleared me, although they discovered that my work visa had wrongly been made out by the clerk at immigration inscribing my designation 'BBC'. When I had pointed out the error, he shrugged his shoulders. "We put all resident British journalists in the BBC file." As there were only two British correspondents on the island with resident visas, it didn't seem that unreasonable. Who was I, newly arrived, to question the bureaucratic procedure?

After all the press comment, a senior and respected journalist, Gamini Werrakoon, editor of *The Island*, advised me. "You have been causing waves in this country," and, rattling the ice in his whisky at the Orient Club, he chuckled and added, "Tidal waves."

When I was asked to write a weekly column in a local paper owned by the PM's uncle I construed it either as it as an attempt to rein me in, or as an arm's length conciliatory gesture. I met with Sujan Wijewardene at the Navratna Restaurant at the Taj Samudra. To be precise, we met in the closed and deserted grillroom next door, out of sight and ears of the curious. *The Daily Mirror* allowed me complete freedom. I wrote on all sorts of topics, again, often with a sense of humour. Tongue in cheek, I praised the LTTE's police force who were strictly enforcing traffic discipline on their newly opened roads, in contrast to the island's recognised police force.

I was offered a job as editor of a planned new newspaper. The problem was it was to be backed by opposition PA stalwarts and it was to be associated with former media minister Mangala Samaraweera. The project was extensively discussed at a series of dinners at Mangala's home at Kotte, at Anura Bandaranaike's plush pad in Colombo 7's Rosmead Place, and at the residences of other PA MPs. To me it would simply have been a professional assignment and I stipulated that I would brook no editorial interference from the owners or backers. But, after much consideration, I recognised the government would regard it as an inflammatory action if I took on the job, so I declined.

Nanda Godage phoned me at lunchtime on May 24 to tell me that the NIB investigation had turned up a problem. "People are saying you claimed to be a BBC correspondent in order to get your visa. The Prime Minister has been advised accordingly."

This was, of course, nonsense and I decided to deal with it immediately and wrote a letter that weekend, dated May 25, to the Foreign Ministry, addressed to Publicity Director Saj Mendis. It attempted to clarify, once and for all, my visa status. Events would prove that it had not and it is worth quoting in full:

> I understand from the efficient Colombo 'grapevine' that the NIB investigation of myself is completed and has been lodged with the Prime Minister's office. I further understand that the colourful espionage rumours are now discounted. The report, apparently, finds only one problem in relation to my residency here and that is what has been adduced as representing a misdeclaration on my part, viz. my residency visa no. A/6714 enables me to engage in business or trade as a 'writer and journalist (BBC)' [photocopy attached].

When I attended at the department of Immigration on November 21 last year I provided letter from *The Daily Telegraph* [photocopy attached] and filled in the form as representing *The Daily Telegraph*. For reasoning known only to the department of Immigration, my visa was issued in the name of the BBC, with which body I have never claimed any connection whilst working here (I did work for the BBC in Slovenia, Croatia and Bosnia 1991-4). When I complained, it was shrugged off and I was told it was not important and I should not worry. At the time, I contacted Frances Harrison, BBC correspondent, in case it affected her position, but she said, "They put all British resident journalists in the BBC file. They've only got the one file."

This problem – not of my own making – seems to have come back to haunt me. Before the NIB's deductions occasion any unfortunate consequences – it would be unfortunate if I were to be deported on the day The Hon Ranil Wickremesinghe meets Prime Minister Tony Blair! – could you please contact Controller of Immigration Mr Bambarawanage and arrange for correction of their files and my passport visa?

Monday was a Poya Day holiday and I decided to go to the Foreign Ministry first thing the following morning with the letter for hand delivery. There I met with Saj Mendis while his assistant Rizvi Hassan hovered around in the background. The Foreign Ministry, in the person of Mendis, asked me not to say anything in public again, just to write. Director Saj Mendis suggested, for the first time, on the morning of Tuesday May 28 that my conduct could be construed as being prejudicial to national security. I thought he was just being pompous. Later I would realise that the seeds were already sown. I agreed not to speak again in public and turned down a string of invitations. I naively assumed the Foreign Ministry could be taken at is word and that peace had broken out.

I adopted a suitably low profile and moved out of the airy halls of the Galle Face Hotel after a Sinhala language Sunday paper, *Nawa Pereliya*, alleged my bills there were being paid by 'a conspiracy' of 'international arms dealers'. I was flattered to see the front page and two pages inside the paper devoted to me in its undated May issue.

It was headlined ARMS DEALER PAUL HARRIS HELL BENT ON DESTROYING PEACE HERE HAVING TALKS

WITH WIMAL, DINESH WIJITHAMUNI. It was not exactly a eulogy:

> Paul Harris is an extremely dangerous person, whose job is to go to war torn countries pretending to be a war reporter, deal with terrorist organisations in his real capacity as an agent of arms dealers and turn the war in to a 'beggar's wound' to the concerned country. There are many instances where he has been involved with reactionary terrorist groups in these countries, which include Croatia, Bosnia, Sudan and Yugoslavia. It is easy for him to spark off wars in these countries and all he need for this is the cover as an international journalist.

I thought it was laughable. Others were rather more concerned. President's Council S L Gunesekera urged me to sue *Nawa Pereliya*. I didn't see the point. Indeed, I felt that litigation might lend the newspaper the credibility it did not enjoy. But, most significantly, I learned the paper was owned by the government minister who had lambasted me in Parliament: Dr Rajitha Senaratne. In the late 1980s he headed up an organisation known as the Pra Gang which was in the business of assassinating political rivals.

I took on, decorated and furnished a flat in the centre of Colombo, just across the road from the Galle Face Hotel. I started a collection of the work of young local artists, took a course and learned the basics of the Sinhala language. My office must have had one of the best views in the world, out over the blue of the Indian Ocean over a panorama of coconut trees and urban bustle.

After the altercation with the PM, surveillance and investigation had started. However, by the end of May I had the impression that the heat was off. The chap who had spent weeks underneath a coconut tree across the road from the hotel appeared to clear off.

As soon as I moved, the surveillance started again and my friend reappeared. Then he disappeared after a couple of weeks. I had started using the back entrance to the building and used three-wheelers driven by drivers unknown to me. I thought the pressure was off. Nanda urged me to live quietly and let the dust settle.

But, come October, the idyll was gradually shattered as the Foreign Ministry went silent. There was no response at all for permission sought by *The Daily Telegraph* to carry on my work. A September 30 letter, delivered by hand October 7 was simply ignored. On personal visits to the Ministry nobody was available. Nobody phoned back. Nobody wrote. A brick wall. When the surveillance restarted, I realised that some sort of decision had been made but I was in the dark. But friends and fellow journalists were being given startling information. I was "a threat to national security".

I went to the peace secretariat to see Nanda Godage who was working there in a new role. He lifted the telephone and called the acting Secretary at the Foreign Ministry. Both secretary Nihal Rodrigo and the Minister were abroad in China and Indonesia respectively. Acting Secretary Navratnarajah, Rodrigo's deputy honcho, jovially confided that my visa would not be renewed. Evidently, "a matter of national security" and, quoth he, "it's political". Nanda pointed out the implications . . .

I called upon the British High Commission with a week to go. The Deputy High Commissioner, Mr Peter Hughes, was urbane and charming. He assured me that the British government disapproved of the suppression of free speech and would energetically take up my case. "You'll find it's not that easy for them to throw out a British journalist." Splendid stuff, just what I wanted to hear, old boy. With eight days to go, pressure would be applied after the following Monday's holiday.

When information emerged from my own intelligence sources about LTTE involvement in the decision to make me leave, I conveyed this personally to the High Commissioner, Stephen Evans, lately arrived from Afghanistan. He agreed that it "seemed likely". Both the High Commissioner and his Deputy had arrived in Sri Lanka in the last few months. Both were patient and courteous. I guess they also were with the Sri Lanka authorities. The Foreign Ministry did not even return their calls.

With three days to go, on Wednesday October 6, I appealed to the President, Mrs Chandrika Bandaranaike Kumaratunga. Much maligned in the local press, I always found her a brisk, no-nonsense lady of great charm and presence. Fools are not suffered gladly and she uses her tongue scathingly on those who try to put one past

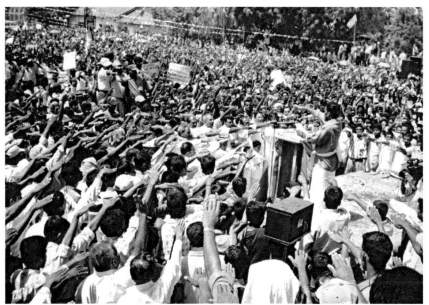

My famous picture of LTTE members giving Fascist salutes at the Batticaloa Pongu Tamil. Such pictures had never before been seen in Colombo, the capital, and many people found them disturbing. This picture was referred to in The Island editorial protesting my being thrown out of the country.

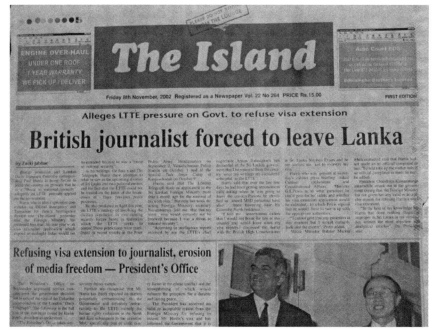

Thrown out! The front page of The Island newspaper.

her. She is the sort of woman I can deal with. She reminded me of Margaret Thatcher.

Her press spokesman Harim Pieris picked me up in his car on the edge of Galle Face Green, just across the road from my apartment. I walked over to await him and deliberately placed myself beside two characters who had been lounging underneath a palmyrah tree since shortly after 8 a.m. I greeted them cordially. "Good morning, gentlemen." One wearing a flowing white shirt and black trousers and sporting the obligatory bulge of an automatic pistol smiled wanly at me.

The president gave every appearance of genuine concern. She had previously asked to see me to discuss the security situation in the country. She told me that the commander in chief of the army had given her my article from the May issue of *Jane's Intelligence Review*. As she is constitutionally the commander of the armed forces, I could see no threat to national security in meeting with her, even though she was a stalwart of the Opposition PA party..

The President duly rattled the bars on the cages in the Foreign Ministry but even she could not extract the necessary paperwork. One of the real high points of my long sojourn in Sri Lanka must have been having the privilege of hearing President Kumaratunga lambasting Rodrigo for his duplicity in the matter of my visa. As the poor fellow wriggled and squirmed, producing one feeble reason after another for its non-renewal, Madam weighed in mercilessly like the street fighter she is, roundly admonishing the hapless fellow.

The Ministry at no stage contacted me or explained the situation. With a day to go, I publicly asked Cabinet press spokesman, Minister G L Pieris, at a televised press conference, what was happening and if he could guarantee my security. He said he knew nothing, and said he could not. "I cannot and I will not." Unsurprisingly, I was tackled by several local journalists at the end of the press conference. I went public on what was happening with just 36 hours to go.

That afternoon, the President told the nation, "The President's Office takes serious note of the government's decision not to extend the visa of journalist Mr Paul Harris . . . The President's Office recalls that Mr Harris had accurately at the start of this year predicted certain developments with regard to the LTTE in the

peace process: specifically, the use of schoolchildren and civilians to storm security forces' camps. Further, we recognise that Mr Harris has freely reported on matters potentially embarrassing to the government and definitely embarrassing to the LTTE, namely the human rights violations in the north and the east subsequent to the ceasefire MOU, specifically that of child conscription, extortion and security issues of the Muslim community in the East. Freedom of expression and the right of dissent are bedrock requirements for a democratic and free society and this insidious silencing of an often lone voice against the conventional wisdom of the government is a serious erosion of media freedom and a setback for democracy in Sri Lanka . . . The President has received no valid or acceptable reason from the Foreign ministry for refusing to extend Mr Harris's visa and has informed the Government that it is not correct to refuse a visa for a journalist from a friendly country who has done no wrong."

The next morning the telephone started to ring at 6.30. One newspaper carried the front page headline 'British journalist forced to leave Lanka'. *The Island* newspaper also headed its editorial for my last day, Friday, *Hands off Paul Harris*. I was moved by its support, "Mr Paul Harris undoubtedly is not a run-of-the-mill foreign correspondent. He has exposed LTTE violations of basic human rights in areas under LTTE control and brilliantly exposed the fascist nature of LTTE with the photograph of thousands of LTTE cadres delivering the fascist Hitlerite salute to LTTE leaders."

Nanda made one of the dozens of telephone calls which came in. "What you have never understood about this country, Paul, is that it is based around rumour, not humour."

With 24 hours to go I had to make the decision to buy the air ticket out. I discussed the situation with my girlfriend, Sulee. She shrugged her shoulders, "Where you go, I go." I poured a glass of treasured Laphroaig whisky, from faraway Islay, and surveyed my apartment: the paintings on the wall, the framed photographs, the visitors' book filled at my housewarming party.

Time to move on. I made a telephone call to the Maldives.

We left with three and a half hours to go on my visa with just one suitcase and hand baggage. The press were waiting outside and I didn't take too much notice of everybody hanging around by the door. However, the driver, himself a former policeman,

The Island

Published by Upali Newspapers Ltd. 223, Bloemendhal
Road, Colombo 13 Tel: 074-609000 & 325535
Editor: 334071; E-mail: gamini@unl.upali.lk
Branch Advertising Office:
No. 6, Sir Chittampalam A. Gardiner Mawatha
Colombo 2. Tel: 330943

Friday 8th November, 2002

Hands off Paul Harris

Much of the local and, particularly international, goodwill that has accrued to Prime Minister Mr. Ranil Wickremasinghe has been because of his liberal attitude towards the media. Whereas the People's Alliance under President Chandrika Kumaratunga became notorious for the harsh manner in which they treated the media, Mr. Wickremasinghe, even in the Opposition, was in touch with the media and pledged to liberalise media laws and dismantle certain institutions that were considered inimical to freedom of expression.

True to his promise, he did away with the archaic law of Criminal Defamation and now is considering replacement of the Press Council with a Press Complaints Commission in accordance with the wishes of the media institutions. It is, perhaps, in recognition of this liberal attitude that the Commonwealth Press Union is to hold the Commonwealth Editors' Conference as well as the Biennial meeting of the Commonwealth Press Union in Sri Lanka next February.

But the decision not to renew the visa of British journalist Paul Harris, Correspondent to the London Daily Telegraph and also a correspondent to Jane's Intelligence Review, could smear the liberal democratic image of Prime Minister Wickremasinghe.

Mr.Paul Harris undoubtedly is not a run-of-the mill foreign correspondent. He has exposed LTTE violations of basic human rights in areas under the LTTE control and brilliantly exposed the fascist nature of LTTE with the photograph of thousands of LTTE cadres delivering the fascist Hitlerite salute to LTTE leaders. Besides, he has developed a wide range of political contacts, including those of the People's Alliance. He had accurately predicted the moves of the LTTE, such as the storming of security posts using school children.

All this may not be to the liking of the ruling United National Front. But Ranil Wickremasinghe, the democrat who has ink of two of the most distinguished journalists of this country flowing in his veins, should not succumb to toadies carrying tales about journalists, who are not the cheer leaders of the UNF.

Sri Lankan journalists are well aware that Paul Harris has continued to be hounded in recent months by officials of police investigation units despite his complaints to officials of the foreign ministry .

There is nothing to be gained by not extending the visa of Mr. Harris. Mr. Wickremasinghe knows very well that he could send out the same reports from Chennai or New Delhi or write commentaries from London about Sri Lanka.

Sri Lankan journalists who have been very much concerned about the freedom of journalists should make their feelings known the Prime Minister Wickremasinghe before the stupid decision of forcing Paul Harris out of Sri Lanka is made. At a time when Colombo-based diplomats as well as visiting diplomatic dignitaries are fraternising with terrorist leaders of an internationally proscribed organisation, should there be objections if a foreign correspondent associates with leading politicians of recognised political parties?

said he recognised several characters lurking in the street as CID officers. There was no time to protect my investments, organise my property, sell furniture or extract money in local non-negotiable currency in my bank accounts. Maybe I was naïve to expect better things but I had kept saying to myself, "This is not Zimbabwe, this is Sri Lanka.".

When I left the country, there was still no response to me, or *The Telegraph*, from the Ministry. But, even as I left, the media were being given a ludicrous list of my alleged visa infractions: arriving on a tourist visa, writing articles for the local newspaper *The Daily Mirror*, making unfounded allegations of surveillance by armed men, and that it had just come to their attention, via a press release from the president, that I worked for *Jane's Intelligence Review*. "This disclosure only confirms the decision of the government not to renew Mr Harris's visa . . .".

A local businessman, who I did not know that well, had taken the trouble to telephone shortly after 6.30 that morning. He professed to be 'ashamed' of his country, and kindly sent his Mercedes to take me to the airport. "This is an appalling injustice but at least you will leave in style." Such small kindnesses are moving when you feel isolated and rejected. As I left the building where I lived, the security staff, three- wheeler drivers and local shopkeepers all lined up and shook my hand. Ordinary people, not your politicians or urban sophisticates. One simply said to me, "You told the truth."

I then knew I had done the right thing.

At Colombo's Bandaranaike Airport, a television crew was waiting. I told them that I loved Sri Lanka and hoped that I would be able to return. The immigration officer who checked us out, with four hours left on my visa, immediately recognised me. "I read all your articles," he cheerily observed as he stamped the exit visa. "You know what's really happening here."

I flew with my Chinese girlfriend, Sulee, to Male Airport in The Maldives. This 1,200 island archipelago is just over an hour's flying from Colombo but a world away in so many respects. The Maldives are organised prosperous and safe. Arrival at the airport reminds me of Venice rather than the southern Indian Ocean. Once clear of immigration and customs we are met by a representative

of my host and whisked to a motor launch tied up at the airport quayside. No broken, crowded roads to battle. No importuning touts, bagmen or taxi drivers to fight off.

It is but six or seven minutes to Kurumba Village, the very first resort developed in The Maldives in 1970. We stay there for six nights as the guest of Mr Mohamed Maniku, the Chairman of Universal. I had met him the previous July in Colombo when I spoke at – and gave away the prizes – at the annual prize-giving of the British School in Colombo. I attended the event with some trepidation: the Ministry of Foreign Affairs having told me not to speak in public again. But, I thought, what harm could there be in addressing a few hundred schoolchildren?

Afterwards, when I confessed to the Chairman of the school – Mr Maniku – that I had never visited The Maldives, he promptly invited me to visit as his guest. The constant demands on a journalist who must ever be available to cover any news that might break debarred me from immediately taking up his offer but the uncertainty over my visa and future gave me that window of opportunity to take him up on his offer.

After Kurumba, Mr Maniku moved us to Full Moon Beach, an exclusive, intimate resort island. What could be more perfect? From the private sundeck of our sea bungalow at the exclusive resort of Full Moon - just fifteen minutes or so by speedboat from Male Airport – the sea stretches before me in strips of blue and turquoise green, out to the reef beyond. I have opened the complimentary bottle *Bourgogne Grand Ordinaire* and am tucking into the bowl of delicious fresh fruit: a piece of papaya drops into the translucent water and a dozen multi-coloured fish pounce on the morsel.

Eventually, we decided to return to Sri Lanka in the early hours of a Sunday morning. Just before dawn is, as all strategists know, the optimum time for attack. The plane touched down just before 3 a.m. Most of the passengers were European tourists in transit on the way home. The lines were short and the immigration officers tired and bored. I positioned myself behind some foreigner of indeterminate origin and my Chinese girlfriend was behind me. The chap in front got a thorough check but mine was cursory; not even that. The immigration officer did not even look at the

passport. He simply opened it and stamped it with a 30 day tourist visa, pushing the landing card to one side as he stared around with studied boredom.

Sulee got the third degree. Her passport was minutely examined and the many entry and exit stamps perused; questions about her educational status; eventually, an entry stamp with no further days granted. She had three days left on her previous visa . . .

Colombo was deserted and the taxi sped in on the airport road. When we arrived at Galle Face Court, street and parking lot were deserted, even the security men were asleep. I was relieved when the door was opened by a security guard I did not know. He did not appear to recognise me, either. We left the blinds down in the deserted flat, not even raising them with daylight as dawn broke. Surveillance had clearly been lifted but we decided it was best not to be seen by anybody looking up from the street. The telephone rang a few times on Sunday but we ignored it. Sulee went out for newspapers but otherwise we remained indoors. *The Sunday Times* carried on page two the text of a statement about me by Prime Minister Wickremesinghe. 'PM says Paul Harris violated visa regulations'.

The Prime Minister's office had clearly released the text of the PM's letter written in reply to the complaints from the Editors' Guild of Sri Lanka. His response made it clear that I had been thrown out for my journalism: specifically, for writing the column for *The Daily Mirror*. The PM admitted to ambiguity in the visa regulations – and said that they would be clarified in future – but, apparently, foreign journalists were debarred from writing for local media. He declined the Editors' Guild request for an opportunity for me to present my case in my defence as this would establish a precedent. The PM's statement was, in a way, a relief. He had confirmed that I was ejected for my writing which left me with a degree of honour which would have been stripped away if some other, extraneous allegation of misconduct had been made.

On Monday morning, I decided to pay a visit to the British High Commission, just a few hundred metres down the road. The tenuous nature of my presence in the country, and the requirement to attempt to get a visa for Sulee, required such a visit. I gingerly made my way out of the building, abjuring use of the lift and

sneaking around the back of the lift shaft and out through the rubbish yard at the back.

Peter Hughes, the deputy High Commissioner, was visibly surprised to see me back. He accepted my explanation that I had to return in an attempt to clear up personal and business matters but was clearly uneasy. I expressed my disappointment at the ineffective nature of the protests lodged by the representatives of Her Majesty's government. Hughes made his excuses: the whole matter was quite irreversible. "Everything to do with your situation is being dealt with at Temple Trees across the road." He nodded out of his window to the landscaped grounds of the PM's official residence, just a hundred metres away. All approaches to the Foreign Ministry which the BHC had made had been futile. It was being dealt with at a rather higher level. And it had got personal.

The BHC was clearly uneasy about my return as a tourist with all its potential for even more drama. I assured Hughes that I would maintain a low profile, not contact the media, keep the blinds fully down – literally and metaphorically, and clear off just as soon as I had things wrapped up. Oh, and could I please have a visa for my girlfriend to come to the UK?

Oh, yes, we'll see about that. What passport? China? Peoples Republic of China? Gulp. But within three hours the visa was issued . . . and I solemnly undertook to remove myself as soon as possible from the scene.

In the waiting room, the local BHC 'information officer' Mahendra Ratnaweera greeted me. He was evidently as surprised as Hughes to see me back. Seeing him was not good news. Well connected to the Colombo grapevine, and a close friend of Bandula Jayasekera, a gossipy freelance working closely with the Lanka Academic news website and the TNL Newsroom.

The evening TNL TV News duly announced that Paul Harris was back . . . even my visa details were disclosed.

The next day the surveillance restarted . . . However, by now a number of bodies, all unknown to me, had taken up my case, from *Reporters sans Frontières* to the Editors Guild of Sri Lanka. I'd also put the word about that I was in the market for a job, please. A good friend back in Scotland, recently retired Editor of the Edinburgh *Evening News*, Ian Nimmo, emailed me as I left

The Maldives. "I've been working as a consultant to *The Shanghai Daily*, a new English language newspaper in Shanghai. How do you fancy going to Shanghai?"

Truth to tell, I'd often fantasized about going to Shanghai, a city with such a colourful past and promising future. Added to which, Sulee was, of course, from China. I thought about it for around 30 seconds and emailed Ian right back.

Shanghai beckoned ...

Leaving Colombo, with my girlfriend and wife-to-be, Sulee.

Thirteen

Shanghaied

China

At a dinner party in Colombo, soon after I first arrived in Sri Lanka in 1996, I was introduced to the assembled guests by my host and good friend, Upali, a retired Major General. "Paul Harris is here to write about the three 'Ts," he announced. "Tea, tourism and terrorism." Upali chortled cheerfully, as was his wont, and the dinner party conversation switched to discussing the peculiar paradoxes in the life of what used to be known, in better times, as Ceylon. My neighbour to my right at the table turned to me and highlighted those paradoxes with his opening conversational gambit.

"My dear boy, do you hunt to hounds?" I have to confess I was momentarily stupefied by the bizarre query across a tropical dinner table at the very end of the 20th century. Was this former army commander taking the mickey? Certainly not, as it turned out. In the decades immediately after independence it had been *de rigeur* for Ceylon army officers to take their training at Sandhurst and, in the process, learn all sorts of useful English social skills like ballroom dancing, drinking twenty pints of beer at a sitting and hunting to hounds.

It came as something of a revelation to me at the time that the normally frosty and distanced English upper classes so readily took these amusing little brown men to their bosoms. It took me a while to work this out. I suppose they represented an affectionate reminder of past national glories. And, besides, they represented no lasting threat to the local social structure as they would be returning to the erstwhile colonies in short order.

Indeed, I did write many articles on the three 'Ts' although I have to confess that most of them were on the terrorism rather than tea or tourism. Indeed, I had barely taken my seat in a tea producer's car four days into my first visit when the city's business district was blown up in front of me by the Tamil Tiger terrorists, quite overshadowing my visit to the tea auction.

When I arrived in Shanghai at the beginning of 2003, the city was in the midst
of a period of staggering, dynamic growth. Everywhere skyscrapers sprouted as old
Shanghai succumbed to the hammer.

The view from my office at The Shanghai Daily in the city's Wenxin Tower.

When Sri Lanka tired of me (not the other way round, note) I found myself in Shanghai at the beginning of 2003, working for the English language newspaper *The Shanghai Daily*. I soon discovered that there were three 'Ts" here also. Except they were ones you definitely did not write about: Tianneman, Tibet and Taiwan. Tianneman you might be asked about, privately in a noisy bar. The oft voiced query was whether or not I had any videotapes of what happened. There still seemed to be – fourteen years on – a very considerable degree of curiosity about the events in Beijing in the summer of 1989. It most certainly never found itself in print anywhere.

Taiwan did. But always somewhat euphemistically – as another province of China. Nothing which appeared in print cast any doubt on the nature of its actual status. I learned that *The Shanghai Daily* had once mistakenly implied that Taiwan was a separate state in one of its articles by referring to it as a nation. In temporary disgrace, the editor, Peter Zhang, had been required by the government to write a stern letter of self-criticism.

Tibet was quite something else. The status of this far flung land was never up for discussion in any way, at any time. In Shanghai, Tibet was known as Xizhang, a province of China, an integral part of the country despite its far flung location and, let us say, controversial status, at least in the eyes of many *laowai*, foreigners or 'barbarians', as all foreigners were historically termed.

A television show to welcome Chinese New Year at the beginning of February – a sort of cross between *The Eurovision Song Contest* and *Sunday Night at the London Palladium* (remember?) – showed film footage of furiously waving units of the Chinese People's Army doing their good works in far flung locations, from the border with Siberia to Xizhang. This was all about unity, the integrity of the state and continuity. In a country with 5,000 years of recorded history, few question that concept of homogeneity.

I made an observation to my Chinese girlfriend on the couch about the Dalai Lama. Not something I would do in public, I might add. "Dalai Lama him very bad man." End of discussion. Later, she did become No. 1 wife, though.

Of course, Shanghai is not China. Shanghai is the atypical showpiece of an already diverse and vast land about which generalisations are facile. Shanghai has always been different. I

got to a lecture given in the de-luxe surroundings of the top floor restaurant M on The Bund, with its breathtaking views over the skyscrapers of Pudong district, the relentless commercial traffic of the Huangpi River and the solid historic architecture erected by the old money on The Bund. Professor Dr Wu Jiang makes the point convincingly. "Shanghai has always been a business orientated city rather than a political city."

Shanghai has been chosen by the Chinese leadership to spearhead the economic development of China. Indeed, to symbolise it. It is breathtaking in its energy, verve and very impertinence: the most populous city in the most populous country in the world, greater Shanghai with an area of around 7,000 square kilometres is home to some 16 – maybe 18 – million people. *The Shanghai Daily* announced in a front page headline in November 2003 'Population Surpasses *(sic.)* 20 million'. The story is, of course, officially inspired; there is contradictory evidence within the story to verify this. And, of course, the headline with the extraordinary 'surpass' claim, doggedly designed to fit its space on the page, is a prize example of 'Chinglish'. But, by the time I left Shanghai, the popular comparison that was being drawn was that Shanghai was bigger than Belgium: bigger in landmass, and with more people.

It has long been unique. Many epithets have been applied to Shanghai like 'The Paris of the East' and 'The Whore of the Orient'. Some are more complimentary than others. Aldous Huxley famously observed, "Nothing more intensely living can be imagined."

Before I went to Shanghai I must have heard a varying statistic half a dozen times if I heard it once. It was the oft-quoted statistic about the world's building cranes. Some people said that more than 20% of the world's supply of cranes were located in Shanghai. Some, 50%. And some, even, ventured 80%. I'm not sure which statistic held true.

More recently, I've spent some time in Dubai which is sprouting from the desert in a similar fit of seemingly boundless energy. You now hear the same sort of claims about the world's cranes in Dubai and it seems determined to build an urban desert on even greater scale than Shanghai.

There were an awful lot of cranes in Shanghai, to be sure, although many of them seemed to be idle. When work on some

vast new building or mall started in earnest you could almost see it sprouting up in front of your eyes: it was not uncommon to start and finish a 30 or more storeyed building in less than a year. There can be little doubt that the most breakneck process of transition in any city in the world was going on in Shanghai.

But it would be mistaken to confuse relatively unrestrained economic development with the emergence of personal or political freedoms. Many constants do and will remain in China. The most enduring constant, and the bulwark of societal organisation, must be the PLA: The People's Liberation Army.

The army features prominently in many of the programmes of CCTV: Central China Television, broadcast from Beijing. If senior army officers in uniform do not dot the seemingly inevitable TV audiences, usually in the front rows, then, in and out of uniform, talented representatives of the military, male and female, grace the screen singing, dancing, juggling, conjuring and doing little *mis-en-scene* comedy routines. They seem to be a talented lot in The People's Army quite putting their English equivalents in *It Ain't Half Hot, Mum* to shame as a bunch of bumbling bum boys. There is not even the vaguest suggestion of anything sexually awry in the People's Army entertainment division.

Of course, this is not entirely about entertainment. The participation of the army in national entertainment on television is there to reinforce concepts of national unity and the determination, from the centre, that things should continue along much the same road. "The people are the mountains. The people are the seas. The people are the fountainhead of the Party's life." The *compere* waxes lyrical on a CCTV New Year extravaganza.

China, as an agglomeration of different peoples, languages, philosophies and cultures, is often perceived from outside as under threat of terminal implosion. That danger is clearly recognised where power resides. Equally, there is firmness of purpose that any such moves will be pre-empted. The TV show is a tangible demonstration of that firmness of purpose. In India, a country similarly seeking to accommodate such stresses and strains, the government tries to show its commitment by putting stickers on lamp posts declaring 'Unity through Diversity'. The TV spectacular seems by far a more effective strategy.

Literal translations from Chinese into English often have hilarious results. The job at The Shanghai Daily *was to avoid this sort of Chinglish.*

Everywhere on the streets of Shanghai the clashes of culture were evident as old and new intermingled.

Exotic dancer in Malone's Bar. Shanghai boasted a vibrant night life.

The military variety show is, however, for me at least, quite put in the shade by the next night's offering: the Public Security Bureau spectacular. The PSB – or, as it would be known in the west, the Police – also seems to be in the business of promoting itself as friend and protector of the people. The police seem every bit as talented in the entertainment department as their army counterparts. If anything, they're rather better. But this stuff is not lifted from The Laughing Policeman. Some of the pieces are of cloying sentimentality. A young daughter asks her mother where is her daddy. He is dead, cut off in his prime in defence of the people. A whole row of uniformed and be-medalled plods in the audience is reduced to sobbing, mopping their tears away with their handkerchiefs.

The 'thank you' segment of the programme features film clips of policemen helping old ladies across the road, grandpas through floodwater, and so on. Not an electrode or a rubber truncheon in sight. A white mini-skirted policewoman holds the microphone high to sing of the achievements of the PSB. More film clips of policeman cheerfully doing their duty: from Hong Kong and Macau to Mongolia and Tibet, sorry, Xizhang.

When a mother and daughter are invited to stand up in the audience, the *compere* tells the touching story of the death of the breadwinner, perished after battling 'anti-social elements'. Images of his life – and death with a picture of the grave – are flashed on screen. The little girl bursts into tears in her mother's arms, the camera zooms in, and hundreds of policemen reach again for their hankies, sobs replaced by open and unrestrained tears. The only time I can remember anyone in Britain crying at the death of a policeman was when Dixon of Dock Green bought it back in the 1950s.

Of course, in many ways this is the 1950s, albeit fifty years on, in China. There is not an ounce of cynicism to be detected in public about the work of the police or armed forces, or, indeed, any of the institutions of the state. People may talk about corruption, in hushed tones, but the bottom line is they expect their rulers to protect them, to protect the integrity of the state and provide a secure future for their children. In return full obedience is there.

Shanghai society appeared to be remarkably law abiding - at least in respect of serious crime. In the middle of February 2003,

a local police officer was reported as being killed and his buddy seriously injured in the course of a raid on a house of prostitution in the Pudong district of Shanghai. My first reaction was that surely this could not be so remarkable in a metropolis of around 20 million people. In fact, this was the first recorded incident of the murder of a policeman in almost two years which seemed to me extraordinary in a city where there must inevitably be a considerable amount of crime purely on a statistical basis.

Of course, a contributory factor to this apparently innate sense of obedience has to be that murderers of policemen are almost invariably sentenced to death and until quite recently were shot in public. A fairly effective deterrent, perhaps. Indeed, execution was a common form of punishment for a variety of crimes. The head of a bus company in northern China cut a sorry figure standing in the dock of the People's Court in a shabby raincoat. He had been sentenced to death, apparently, and you felt quite sorry for him until it transpired he had misappropriated a staggering local equivalent of US$8 million.

A lot of such executions were reported in retrospect, after the event. Here there is a strong element of didacticism: *pour encourager les autres*. It is difficult to detect much in the way of sympathy for the wrongdoer, in sharp contrast to the west where there is now, it often seems, considerably more sympathy for the criminal than for the victim.

In my first week in Shanghai, a local *laowai* businessman trenchantly observed, "Human rights are, quite simply, not an issue here in Shanghai." Nor in much of China. I would come to realise...

I am a Foreign Expert. No, this is not a Walter Mitty view based upon irrational delusions of grandeur. In China, that is the name of the job and, besides, I have a certificate to prove it: a 12-page passport-like document bound in red imitation leather and blocked in gold, issued by the state-run Bureau of Foreign Experts.

The newspaper I am working with – *The Shanghai Daily* – when I joined was a six day-a-week, 12-page mix of local news, international news, national news and features. The most glaring difference from western newspapers was the complete absence of editorials, readers' letters or opinion pieces. The actual news was

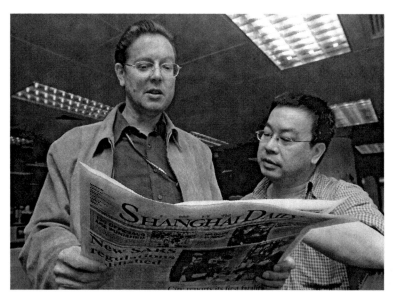

Checking the paper in The Shanghai Daily office.

The architecture of Shanghai was pure 21st century. The Grand Theatre in People's Square.

professionally presented thanks to the tender efforts of the Foreign Experts. The local copy was originally written by intelligent, young Shanghainese – then shaped and polished by the 'foreign experts'.

There were eight of us: a mixed bunch of Americans (3), Canadians (1), Indians (2), Singaporeans (1) and myself, the only Brit. Spelling and style is – irritatingly for me – based upon the American Associated Press style book. This is not the English as is spoke by my own dear Queen, rather the Ameri-English of George W Bush. I find it difficult and regressive adapting to what I see as an unsophisticated style of a language I love with all its intricacies and inconsistencies.

Some AP verbiage irritates the hell out of me: Saddam Hussein's 'ouster', the Beagle 2 rocket's 'lander' for a start. As my time went by, I detected AP-imposed changes in the language. The past tense word 'read' was popping up as 'red'. AP is crazy about attribution. The worst example towards the end of November was 'Speaking on condition of anonymity, a State Department spokesman refused to comment'. This stuff can drive you mad as an experienced journo.

Headlines were a problem at the paper. After I subbed copy, I wrote a headline. A local Chinese editor then sometimes rewrote it. On the page, I then explained, if it was wrong, why and then we changed it back again. Then a proof-reader (Chinese) looked at it and maybe changed it again. I went back to the page on the computer screen and maybe changed it again. But it's after I left the office that the real damage was all too frequently done. One of the Chief Editors goes back to the carefully prepared page and wreaks havoc.

The worst example occurred towards the end of my time with the paper. A famous Hong Kong female singer had tragically died. Everybody was upset and it was big news. I got the headline to fit neatly with the respectful phrase 'to be laid to rest today'. Al Campbell, a Canadian foreign expert on the paper, came up with the headline HONG KONG'S MADONNA DIES and I got a nice, respectful deck in underneath ANITA MUI TO BE LAID TO REST TODAY. The chief editor set about it after I left the office. When I picked up the paper the next morning, it read 'Anita Mui to be laid today'. I felt obliged to make an issue of this in editorial conference that day. That did not go down well and I was told

I had caused the chief editor to 'lose face'. I know many British newspaper editors who would have dealt with the matter rather more forcefully.

The paper was one of the worst managed I have experienced in a world full of mismanaged newspapers. It was a run by a Gang of Three and their relatives. Editor Peter Zhang was an amiable but archetypally inscrutable Chinaman. One of the foreign experts, who served on the paper for four years, Leonard Ash, described him as 'the ostrich'. Always polite and apparently amenable, it was quite impossible to get anything out of him once the pleasantries were over. The real day to day power lay with his Chief Editor, known to everyone simply as JJ. She was mercurial, to put it mildly. Her management style ranged from oily charm to towering rage: thirty minutes could see the whole range of emotions and responses. Alan Campbell, an experienced Canadian journalist who worked beside me, described her as 'the viper'. Although she was wily and a skilled player on the Chinese scene, she was, in reality, dead ignorant, for all her time spent training on *The Daily Mirror* in London. One night she shouted out imperiously in the news room, after receiving some copy on the entertainment newswire, "Who is this Mick Jagger?"

The third member of the triumvirate was Liu Hong. She 'looked after' the foreign experts . . . and molested the headlines. Most of her dirty work was done after we left the office. Then she was let loose on the headlines and our carefully crafted work started to look rather battered.

Al Campbell once got a punch in the ribs for protesting a change to his headline to the backroom minions. In an AP story revealing that America and the CIA was behind the domino fall of South American leaders in the 1960s, the Canadian journalist wrote the headline 'LBJ behind South America's Dirty War'. Satisfied that the headline fit, when Campbell came back later he noticed it had been changed. He was told by a favourite of the Gang of Three that "LBJ was not an important president, nobody knows him". When someone stepped in to separate the two, the Canadian was sucker-punched by the Chinese international expert. Al had nearly a decade of experience at the top notch *South China Morning Post* newspaper in Hong Kong. His pay was promptly frozen for the next three and a half years.

I sometimes wondered why they ever bothered employing us foreign experts at all, our headlines and rewrites were so heinously tampered with. We were never asked for our advice except in relation to specific stories we are working on. Any advice we did give on wider issues was clearly regarded as gratuitous. In the first few months I made suggestions for features, layout and additions to the paper. Polite acknowledgement was made but nothing was ever taken further. But I did manage to sneak in, from time to time, more imaginative headlines. One of my best, in my second week, dealing with legislation to curb the powers of Sweden's aristocratic upper chamber, was, I thought, 'Nobles nobbled in Nordic privilege purge'.

I suppose we were a pretty bizarre bunch and our Chinese bosses were forever terrified we were going to prejudice them with the party machine, deliberately or by accident.

Canadian Stu was the Golden Boy at the paper, despite a penchant for being whacked on drugs. The Ontario native would sit in a room by himself away from the other foreigners and nod off at his desk. He was famed for missing work without phoning in sick. After staying away for two weeks on one binge without calling in, he returned and told the gullible Liu Hong that he had enjoyed a "cough". It took six years for the paper to get fed up with his antics. He was quite possibly the laziest journalist ever but as he virtually never ever passed an opinion on anything he fitted in rather well.

Then there was a foreign sub who delighted in treading in Gary Glitter territory. He was well known for trolling the bars and his love of underage girls, who were readily available in Shanghai to 'rich' foreigners. His apartment, on the Hengshan Road bar street, was a 'sanctuary' for young bar hosts down on their luck or out of a job. Squeals could be heard in the flat at all hours as he had his way with his captives in lieu of rent. Over a beer, he once asked us, in all sincerity, "Is 15 too young?"

Our presence was purely to ensure that the paper, which seemed to print between 50,000 and 60,000 copies a day, most of which were given away in hotels and airports, looked as near a Western product as possible – without transgressing the requirements laid down by the local Shanghai government, which ultimately

owned and controlled the organ; although I did learn later that the Communist Party of China guaranteed the overdraft so it must have had some say in the show. The Party line had to be rigorously observed. As foreigners, we were not allowed to write articles for the paper. Although we put up ideas for content, many were politely accepted but usually they do not see the light of day.

All the foreign experts felt abused by the Gang of Three. We were never consulted or even told about developments at the paper. A decision was reached to increase the size of the paper from 12 to 20 pages after a visit by The Party Secretary, Chen Liang Yu (he subsequently went to jail for massive corruption). We all turned out and stood by our desks at 8 a.m. in the morning – about eight hours ahead of schedule to facilitate the visit of the Big Man.

Of course, if we felt abused, it was even worse for the local journalists employed by the paper. They got no annual holiday – just the national holidays and few of those as the paper tended to publish on many days of national holiday. They were obliged to sign five or seven year contracts and once those contracts were over they were barred from working for another newspaper for two years. The remuneration was decidedly poor for them – around the equivalent of $250 US a month (RMB 2000) - but this was considerably improved by the so-called 'red envelope' system. Attendance at press conferences was rewarded by the organisers, before proceedings even started, with a red envelope containing 300 yuan. One enterprising and energetic reporter reckoned he could fit in three on a good day and in a good month he could make five or six times his salary on the red envelopes.

Management was ruthless with its employees. Honour and integrity were scarce commodities and the journalists were poorly trained and largely inexperienced. They had to learn their skills in the field and from the foreign experts, outside any formal training structure. This sometimes had serious repercussions exemplified by lengthy printed apologies. One such apology relating to a report quoting the sales director of the The Crowne Plaza Hotel in Shanghai acknowledged that 'Wang Kairong did not make these statements and apologizes for any embarrassment the report may have caused.' Fair enough. But the last line of the apology added. 'The mistake was made by a reporter.' No corporate responsibility around here, chaps.

As the so-called 'foreign experts', we were never actually ever told about the increase in pagination. Rumours just flew around the office. When I asked tight-lipped Liu Hong if they were true, she enigmatically replied, "Maybe". The official confirmation of a 20-page paper came four days before it was to appear when a new work roster was published.

Ten days before the paper almost doubled in size sixteen young Chinese were taken on as reporters. I asked management about their qualifications. "They are all experts," avers Liu Hong, "Some of them are qualified as accountants." I say that if I wanted to get a paper written by accountants I would subscribe to *Accountancy Age*. Fortunately, she doesn't understand British humour.

The staff of foreign experts had been reduced with Lenny, the most experienced member of the team, leaving after four years. Liu Hong told him he was "too old" to work on the paper (he was, admittedly, 67 but with a barrel-load of experience of journalism from the Vietnam war to *The Shanghai Daily* through papers and agencies in the US). He left the office around 11 pm in early December. No gold watch. In fact, nobody from the Gang of Three even said goodbye to him after four years of service. Instead, we took him down the local press pub, Always Bar.

With a much reduced staff we were faced with a 20-page paper: a new boy, fresh out of Yale with no journalistic experience arrived but left for a family holiday in Hawaii just before we went to 20 pages. An old hand, Lancy, returned to India to be with his family for three weeks. And then, on the evening of December 29 I was told my services were no longer required, effective from January 19.

Enigmatically, Liu Hong told me that the paper was engaging "more experienced" people. There was no criticism of my work as such just that there were simply more proficient people coming along. This was puzzling: the paper has just engaged a boy straight from Yale with no experience whatsoever. His training and expertise was as a sculptor. My 35 years as an editor, writer and publisher were not required. I had reapplied in writing for another year's contract on October 24 – as it happened the day before my wedding to a Chinese woman in Shanghai – and three months before the expiry of my contract. After more than two months I was simply told to be on my bike in just over three weeks! I was replaced by an

American journalist who imported his wife and three children into the country as well. He will last six months on the paper.

I kept my nose fairly clean in Shanghai but I maybe stepped over the line a couple of times. Shortly before I left England, I had lunch in a pub in the East End of London with a colleague in the intelligence field. I had severed my links with Janes by this time and he asked me to write an analysis of the Chinese military and its role in Chinese society for a competing organ, *The Yearbook of the Global Defence Review*. I duly wrote three thousand words or so, eight or nine months later. In fact, it was extremely complimentary to the cohesion of the Chinese state but I guess it did not go without notice and was hardly approved of. After the SARS debacle I also wrote a piece about the role of the Chinese military in the crisis for Colonel (retired) Mike Dewar who ran *The Officer* magazine in London. Again, it was approving in tone but, probably, a tad too revelatory. Also, around this time I would become aware, through diplomatic contacts, of the activities of US Special Forces (Delta Force) in Xinjiang, northern China, in the search for Osama bin Laden. I began to notice that my emails had stopped arriving in an uninterrupted stream: the day's emails would all arrive at one time in the early hours of every morning. They were being monitored.

I had, of course, not made myself particularly popular, as usual. I had been critical of editorial policy at *The Shanghai Daily* ever since I started. Whether it has been news priorities or headlines, I have always felt the need to strive for excellence.

SARS struck within weeks of arriving in Shanghai. At the end of the first week in February the first rumours of a pneumonia-type viral infection in Guangdong province emerged at the afternoon editorial conference. Local authorities there were denying it although rumours would persist in the ensuing weeks. Most days at conference I asked if we would go with the story. But the Gang of Three kept saying "the time is not right".

One evening the news editor announced that two million SMS messages had been sent in the last 24 hours, mainly down in Guangdong, reporting deaths and hospitalisation from the disease. A few days later we published on the front page of the paper an item reporting the authorities in Beijing had made it an offence punishable by death to spread alarm and false rumour by

'No fireworks'. This was the sign that got me arrested. The police thought I was photographing the politically sensitive building over the wall.

SARS masks on Nanjing Lu, April 2003

cellphone . . . There was no attempt at explaining the report. All Chinese now had an inkling of what it was about but most of our predominantly foreign readers were totally in the dark and expats would regularly hail me in Always Bar and ask what lay behind the stories they were reading.

SARS came up every day at conference but the editor never felt it newsworthy enough to make the paper: even when people started dying by the hundred. Nothing made it into *The Shanghai Daily* until April and that was only because a senior army officer and doctor had told *Time Magazine* what was going on in China and we could no longer hold back on what had become an international story.

SARS saw the demise of one of our foreign experts, David Lore, an American known for his love of substances, most of which seemed to kick in by the time he got to the office. He was one of the more memorable characters. He was the entertainment section editor and it was always easy to tell if the Philadelphian was in residence as a plume of thick cigarette smoke was constantly hovering over his cubicle. He seemed to lead a charmed life until the SARS crisis saw him off. There was a single death in Shanghai but this set off all the local political alarm bells and journalistic interest from abroad. Without permission, Lore gave an interview to the US public radio network. He cheerfully advised on air that all the figures about SARS casualties were highly unreliable and it was all a big cover-up - which it was, of course. Lore was right but he made a fatal mistake, probably brought on by something he had taken. He identified himself as the editor of the *Shanghai Daily* to the broadcaster.

When the show was broadcast, thanks to the wonders of the internet a transcript soon appeared on the screens of our computers. The Gang of Three, and the editor, went into a frenzy and Lore was asked to clean out his desk the following day. Curiously, he continued to thrive as a journalist in Shanghai writing ad copy and columns for the free weeklies under the pseudonym of Rupert Pupkin.

I wasn't too sorry to get my own marching orders. I was relieved that there would be no more grappling with the intricacies of the 'official view' on a myriad of international stories. No more

tediously rewriting The Democratic People's Republic of Korea for blatantly undemocratic North Korea every time it popped up in a story, every day. No more keeping a sharp lookout for subversive news agency references to *Maoist* rebels in Nepal, visits by Japanese politicians to temples commemorating their war dead, or any copy a trifle critical of Iran – 'they're our friends'. But visits to Beijing or Shanghai by minor African politicians had to get big licks. The President of Togoland's visit merited front page treatment throughout China. This was all hardly my idea of a news agenda.

Foreign experts work in all fields of commercial life in China. According to a report from the Chinese Xinhua News Agency at the beginning of February 2003, there were then a staggering 440,000 Foreign Experts working within China. Xinhua said – and bearing in mind it is the official government news agency it must reflect the official view – we were playing "an important role in enhancing economic and social development of the country." You could have fooled me.

A few days after I arrived in China, Premier Zhu Rongji had made an important policy statement about the status of foreign experts. In Beijing, he told foreign experts and their families that "Chinese people cherish the friendship and cooperation of foreign experts" and that they will "never forget the contributions the experts have made to China." This seemed an encouraging enough start to my stay but it is, of course, all window dressing. Although the Chinese economic explosion requires foreign expertise, most Chinese in positions of authority do not want to accept it.

I soon realised that most of the things I liked about Shanghai were, in reality, the minor conveniences. I am amazed to find that the cellphone worked throughout the underground railway system. This seemed truly miraculous. A plastic travel card worked not only on the underground, the light railway and on the ferries, but could also be used in taxis, obviating the infuriating struggle for small change or small notes which curses travel in the west. And the taxi drivers never, ever, expected a tip. Tipping – that bourgeois act of sanctimonious expression - was not just unexpected, it was actually disapproved of. Somehow it made travel in a taxi not only cheap but totally relaxing.

There were at least half a dozen free magazines in English published at least once a month. Unlike their counterparts in the UK, they were well printed and produced and carried articles of genuine interest, as well as the usual advertorials. *That's Shanghai* was the best. The competitors – *Shanghai Weekend, Shanghai Talk, Quo, Shanghai Scene* – were simply pale imitators. *That's Shanghai* was a *laowai* presentation – the others were backed by the government – and it showed. It bulged with news, features and listings information that made London's *Time Out* look positively amateur. It was making money hand over fist. At a party someone told me 50 million RMB was about the figure: that's maybe seven million dollars a year. The government felt ambivalent about that. It's nice to have an enterprising, successful promoter of upbeat, emerging Shanghai. But it would also be nice to have its own hands on that loot. So life was not easy for *That's Shanghai*. Everything went up before the government censor in Beijing ahead of publication. Pages with text and images which did not reflect official thinking, whatever that might be, came back savaged with the offending items removed.

In the end, the owner, went into the office one morning and found a lot of strange Chinese faces sitting behind all his computers. He was advised to make himself scarce. Overnight he lost seven years investment in the Shanghai economy . . .

DVDs were another thing. At just 1US$ - 8 RMB - a throw they used to be on sale at every street corner, in bars, the markets and, even, off the back of bicycles. I used to go to an amazing DVD 'supermarket' not far from my flat in central Shanghai. The copies were usually perfect, in beautiful printed covers and wrapped in plastic. If they didn't have the movie you wanted on show, they would give you a pile of loose leaf folders to browse through and you could order your favourite movies.

Of course, there were serious copyright issues involved and during 2006 the US government started to put extreme pressure on the Chinese authorities to close the illicit copy trades down. My favourite supermarket was closed by the police, at a more senior level than the local coppers they were paying off. The result was that rip-off copies were now only available on the streets from rogues and vagabonds: the copies were terrible.

You can buy virtually anything off the back of a bicycle in Shanghai: from a bowl of plastic fruit to an eight metre length of piping. At one bus stop a crippled vendor sold CDs from the back of his self-propelled invalid carriage. I resisted purchasing one with the hard sell title 'Mozart will make your Baby Lovelier' – Mandarin does not translate faithfully into English.

Above all, Shanghai is safe: apparently safe to wander anywhere and everywhere no matter the time of day or night. I never ever felt threatened going anywhere at any time. That's a big plus in an unsafe world . . .

But I realised how far I was out of the loop on the morning of April 7. I'd gone downtown to one of the older neighbourhoods of Shanghai. I went into a building for just a few minutes to pay up my email account. By the time I came out, a considerable crowd of forty or fifty people had gathered. That's considerable anywhere in China where all gatherings not officially sanctioned are illegal. On top of an advertising bollard inviting a visit to The Shanghai Museum, was a solitary, protesting figure: a middle aged man, neatly dressed but clearly distressed. He carried two large, handwritten banners which dwarfed him. His message was clear – once I had the Chinese pictographs deciphered: the resolute march of Shanghai into the 21st century had deprived him of home, money and food. He must have been desperate. Within minutes of his climbing up and beginning this solitary protest hordes of baton-wielding police were on the scene.

I found myself disturbed by the scene. Like all foreigners, I had for the two months I had been in Shanghai taken the convenient, and conventional, view that the city was a remarkable, successful and rather admirable exposition of the undiluted virtues of human determination and achievement. Now it came home that there was a human cost to all this and, furthermore, that despite the economic bribes involved, ultimately human rights did not feature. I got one photograph off before the police descended on me and I snatched a few hasty fuzzy images as I was hustled away and men –some in uniform, some not, hauled the hapless figure from his precarious perch.

In fact, he was protesting against a notorious crook well linked into the local political hierarchy. I offered my photographs to *The*

Shanghai Daily but was told that the incident was 'not news'. Why I asked? I did not get the answer I expected. "Oh, this sort of thing happens all the time!" Liu Hong blithely opined.

A few days later I read in *That's Shanghai*, normally involved in propagating the message of the new, vibrant economy, that more than 50% of the old town of Shanghai had already been swept away in the drive for modernisation. And 2003 would sweep away another 25% . . .

Taking photographs – which is what I spent most of my time doing as I couldn't write anything – could be a tricky operation. I'd noticed not far from our apartment a place with a high wall around. There was no sign, no indication of what, if anything went on inside. There was, however, a sign on the street I found unusual and slightly amusing. It said 'No Fireworks' in Chinese and English. As I was building a file of bizarre signs, I reckoned this to be a suitable addition to 'The Chamber of Ten Thousand Flowers' (toilet) and 'Shanghai Naughty Family Pets Co.' (vets). One photograph was taken and out of the corner of my eye I noted two denizens of the Peoples' Liberation Army striding purposefully towards me. I attempted to appear nonchalant and took off in the opposite direction. Their purposeful strides soon overhauled me and I was seized, one on each arm.

We were soon joined by characters in leather jerkins I suspected were plainclothes policemen and the frogmarch terminated at a police box on the corner. More characters appeared. Men in police uniforms with batons; more plainclothes men jabbering into walkie talkies; and the simply curious intrigued to observe a *laowai* detained by the authorities. In short order, a large blue van arrived and I was deposited – politely, it has to be said – inside.

One of the better features of digital photography is that the pictures you have taken can be reviewed immediately. So, at the police station, it wasn't necessary to indulge in all that unfriendly opening of the camera and seizure of unprocessed film. The officer on duty reviewed my pictures of the day. They're mainly of local schoolchildren: all inoffensive stuff until we come to that mysterious sign.

Eventually, I am waved off from the police station, still none the wiser to what has been going on. Much later, I learned that the street where I took the offending photograph runs past the

Leadership Compound, home to the offices and homes of the city's party hierarchy.

I later learn that you can get excellent aerial photographs of it from the upper floors of the nearby Hengshan Hotel. And without any interference from anybody ... So if you want any pictures, you know where to go.

SARS had an enormous impact on the city. When appreciation of the scale and threat level of the disease reached Shanghai, it reacted: late in the day but with resolution. Public places were closed, both by order of the city government and due to financial imperatives as customers and visitors faded away. The world-famous Peace Hotel closed its doors – something it had not even had cause to do during the Sino-Japanese or Second World Wars. The infamous Great World entertainment centre, hangout of gangsters in Shanghai during the 1930s, pulled down the iron gates and stuck up a handwritten closure notice. The May holiday was cancelled and the movement of people in and out of the city savagely curtailed.

The handling of the crisis at this stage confirmed very much the latent power and organisational ability of the Chinese state. Monitoring the movements of travellers – local or foreign – was put in the hands of the existing but little-used pyramid political power structure. At the base of the pyramid are the neighbourhood committees with chairpersons in virtually every street. These became the channels of information, regulation and control – both receiving orders from above and reporting back. It proved to be singularly successful in ensuring that movement was curtailed: persons travelling into and out of Shanghai were identified by eagle eyed local denizens of the peoples' committees – often within hours of their arrival. They were served with quarantine notices, had their temperatures taken twice a day for up to fourteen days and were generally monitored. My girlfriend, recently returned from a couple of weeks in Sri Lanka, a notable SARS-free zone, was ruthlessly included in this monitoring process. Effectively, local leaders long emasculated suddenly found they had a distinct and vital role to play. It was energetically taken up at this local level, these actions endorsed and supported by calls to duty and patriotism broadcast on television, the subject of pop songs and ballads, and long articles in the press.

The foreign staff on *The Shanghai Daily* were interviewed by a journalist from a sister paper, the mass market *Xinmin Evening News*. We were asked if we were frightened of SARS in a city with public places closed and where you could, all of a sudden, get a seat on a normally crowded metro train. Of course, we said no. The statistical chances of catching SARS in a city of 16 million or so with ten confirmed cases seemed laughably minute. Our confidence, of course, got big billing in the local press.

A more interesting article in May in the state-run *Workers' Daily* raised some rather more germane issues. "Now the epidemic is challenging not only the country's public health care system but also China's mechanism against non-traditional threats to security." It acknowledged that future threats to China might come not so much from political or military developments but from new sources. The potential list was long: financial security, environmental protection, information security, internet systems, terrorism, arms proliferation, outbreaks of disease, trans-national crime, smuggling, drug trafficking, illegal immigration, piracy and money laundering.

The newspaper - almost certainly reflecting the official viewpoint emanating from the top of the pyramid – opined: "Although people have always showed concern for sustainable development, some local governments have put too much stress on economic growth while neglecting other important issues, such as protecting the environment or public health, which serve as the basis of economic development.

"This misunderstanding might push the economy forward for a short time but cannot maintain growth in the long run. It is difficult to achieve long-term growth without the support of non-economic factors, such as environmental protection, the prevention of natural disasters, social security and public health.

"To date, the development of a non-traditional security system has lagged behind the country's economic growth. The country should wake up to the fact that the absence of a sound non-traditional security mechanism might finally bring disaster to the economy and even the whole of society."

This opinion piece seemed to me to be of enormous significance and, in a way, illustrated maybe a beneficial effect of SARS on

Chinese government thinking. That having been said, China will always be an enigma to western observers. There was a poster which could be seen all over Shanghai during the period I lived there. I asked my wife what it said.

"It says Chinese civilisation flows like a great river," she explained. The implications of that poster, which would automatically be understood by any Chinese, would rarely be interpreted by a foreigner. In a city, 'invaded' by tens of thousands of foreigners, it was felt necessary to remind Chinese that their civilisation is ancient and unstoppable. The intrusion of foreigners is brief and of little consequence. The Chinese have always, and will continue to, take a long view. That is where the west fails. We have no real long term vision; our view of the world is coloured by short term political and economic imperatives.

That's why I believe the Chinese will ultimately rule the world ... I suppose I have to admit that. On August 23 2003, I married Sun Yumei, the woman who fled Sri Lanka with me, in Shenyang, northern China. We celebrated the marriage at the end of October by hiring a riverboat and cruising the Huangpu River through Shanghai.

On August 3 2004 our daughter Lucy was born in Shanghai. We left three months later.

Marriage ceremony on a Shanghai river boat, October 2003

Our daughter Lucy, age six weeks, in Tianneman Square, Beijing

Fourteen

Screwing the Widows

Cruising the Seven Seas

"You know, Paul, everybody wants to screw the widows, anyway they can," confides my neighbour over the caviar. "It may sound a little coarse but I tell you it's absolutely true." The cut crystal and the silver cutlery glistens and shines all around.

This is not the sort of dinner conversation you might expect to hear from a little old lady. But this old dear has been around the block, as you might say. She may be 94 years of age but there are no flies on Lillian. She's outlived two husbands and been making world cruises for 25 years - and, supreme optimist that she is - has already booked her passage on the *Royal Viking Sun* for next year's 14 week World Cruise, the main event in the 5-star cruise liner's schedule. She refers to her companion, Lord, a Wisconsin corn farmer, as her 'young man'. He's 84. And, she adds mischievously, "We're just good friends, you know."

The female/male ratio aboard this floating luxury palace, I learn, having personally checked the shipboard computer, is seven to one. The average age of the passengers is 68. Single men are much in demand on the dance floors and, for the less scrupulous with some cash to invest upfront, this is a gold digger's paradise. It would be comparatively easy to come away ten or twenty million dollars the richer.

Lillian is the oldest passenger. She is, let's say, a lady of considerable independent means, "at my age I don't get excited about anything except the stock market." She is not untypical of the ladies on the cruise. She leaves her farms and the winter cold of Wisconsin every January for her world cruise. "When you get to my age all your friends are dead so this is my life." An octagenerian aboard has just received a medal recognising completion of 4,000 days on Cunard cruise ships: the 'medal' is a diamond-studded pin from Tiffany's. There's a pre-dinner ceremony on every world cruise where long serving passengers are awarded these diamond playthings

for anything from 300 days up. According to Lillian, it's a deeply moving occasion. "They wear them like the *Croix de Guerre.*"

Aboard the *Royal Viking Sun* we're talking serious money, megabucks. The cost of your peregrination on the annual World Cruise, depending on your stateroom (I referred to it as a cabin for several days before I detected a general drift of disapproval from my dinner companions), will cost two people - sharing a double cabin - around $100,000 each, so to speak, give or take $20,000. This does not seem to unduly concern the punters. The talk around the dinner table is about million dollar dividend cheques, jewellery purchases on shore days and the current price of gold. Don't mistake me, this is not in any competitive, bragging way. These are not vulgar people. It's just natural. I suppose it's the sort of thing rich folks talk about as a matter of course.

Says a retired broker at our table over dinner, "I always said that when I'd made the first fifty million I'd give up trying for any more. But it just keeps on coming in . . ." The attorney promptly agrees with him and turns to me. "How have you found it, Paul?"

With a flash of Chardonnay-inspired brilliance, I opine, "I never really give money much thought." Of course, they assume I have pots of it and the subject is never referred to again.

I seem to be in the world of the effortlessly rich. All four penthouse suites on the Bridge Deck have been taken by one famous family, their maid and bodyguard. They've booked out all the accommodation for a reputed one and a quarter million dollars for the cruise. It all goes to show there's money in Dutch beer. Indeed, several people in the expensive suites seem to have brought along their own bodyguards and maids.

I'm not quite in this league. But I do enjoy a certain cachet aboard. I am a Cunard World University Programme Guest Lecturer. My brief is to "explore human experience in world cultures". So I am entertaining the ladies - and a few gentlemen - with my gripping tales of derring-do in the war zones of the world: a little frisson of excitement by proxy. My stuff is positively lightweight compared to the other lecturers. The ship's daily newspaper advises me that the morning's lecture is by the retired Inspector General of the CIA and entitled *Revisiting General 'Chinese' Gordon's Campaign Route from the Sudan to East Africa as a Backdrop for the Speaker's*

own Odyssey in East Africa. His biography tells us he is the holder of the Distinguished Intelligence Medal (DIM).

The only thing I have in common with Lillian is that we have both got this cruise for free off Cunard. There it ends. I'm working my passage, albeit First Class. Lillian - and many others - were on board the *Royal Viking Sun* last year when it struck a coral reef off the Egyptian coast, bringing their World Cruise to an abrupt end. Those who were on the ill-fated voyage talk about "the $23 million dollar reef": that's the cash Cunard had to put into *escro* to get their ship back from the Egyptians. Even less fortunate were those passengers who had just transferred to the *RVS* from the *Sagafjord* - herself disabled for days and drifting without power in the South China Sea following an engine room fire. Some Cunard customers have actually ended up with two free cruises and five figure cash sums by way of compensation from Cunard. But, amazingly, they are back in force. This lot are not easily deterred and remain fiercely loyal to Cunard.

Passengers who were regular travellers aboard the *Sagafjord* still reminisce fondly about the ship, her elegance and charm, with a tear in the eye. "She just fitted like a comfortable old shoe," a misty eyed patron from San Diego recalls. To you and me, ships may simply be floating structures of glass, wood and steel, but they have a very real capacity to induce affection and loyalty amongst the cognoscenti. Just as many world cruisers bemoan the demise of the *Sagafjord* from the Cunard fleet (she went 'mass market' with the British Saga operation), or admire the grandeur and style of the *QE2*, so there are those who are convinced cheerleaders for the *RVS,* acquired by Cunard from the Royal Viking Line in 1988 for $170 million.

For many years during the 1990s she was rated the world's number one cruise ship by the cruiser's bible, *The Berlitz Guide.* It's not difficult to see why. With her sharply raked bow, sleek flowing lines and spacious interiors she is generously proportioned and contemporary in feel, yet intimate in a way her larger cousin the *QE2* could never be. The forward observation lounge - the Stella Polaris Room - with its floor to ceiling glass was reckoned by Berlitz "to be the most elegant lounge at sea."

I have always preferred to work on small ships where the luxury lifestyle is more pronounced. In the early days, I particularly liked the Silversea and Seabourn ships. For a start, the drink was free, as was the Beluga caviar in the old days of plenty.

My first lecturing contract was aboard the Royal Viking Sun, a former Royal Norwegian Line ship acquired by Cunard. The glamour of the entertainment staff, with which I was affiliated, matched the general tone of the ship.

If, like me, you're not a natural cruiser but a trifle restless by nature, the long days at sea can, at first, seem a little aimless. The assistant cruise director tells me the captain diverts the ship around the occasional irritation of rainstorms. "If it rains they don't enjoy the food. Then if they don't enjoy the food, they don't like the entertainment . . .". As one day merges into the next in an endless expanse of blue ocean - we had five days at sea between Muscat and Mombasa - I suppose the idea is that you allow yourself to drift into a state of suspended animation, losing all track of time. Overnight, every night, they re-lay the carpets in the lifts to announce the day of the week. In an environment which never seems to change from day to day, it might possibly be helpful to know it's Monday

It is all, of course, entirely stress free on an enormous ship with just over 400 passengers and 450 crew aboard: if you *are* able to relax then this must be the ultimate therapy. Hours by the pool, patrols around the promenade deck, food 24 hours a day on demand, deck croquet or golf, lectures in the theatre, films in the cinema, ballroom dancing classes, bridge . . . The choice is so extensive as to present the only real decisions you might ever have to make whilst you're aboard.

Then there are the shore visits. By the end of the voyage, the ship will have stopped in 28 ports ranging from the prosaic to the positively exotic: from Hong Kong and Singapore to Da Nang and Mayotte. The real veteran cruise afficionadoes, however, most relish the long days at sea - and often remain on board at the ports of call.

"I can't be doing with all these shore visits," reflects a retired US attorney, seemingly resentful of the rude intrusion of the outside world on shipboard life. The range of shore visits would, you might think, suit all possible tastes. If you have the inclination, and the pocket book to match, you might opt for a two day trip to the Taj Mahal from Bombay ($2,170 per couple sharing) or a Garden Route Overland Tour from Durban (at $3,566). I opted for Durban sightseeing at $46.00, although my one day safari from Mombasa was pretty good value at $148 for 'close sightings of lions, elephants, gazelle, zebra and giraffe'.

But for all the tens of thousands being spent on the cruise, the do it yourself laundry room would be packed every day: full of the

It was February 1997 and my newly acquired satellite telephone accompanied me on board the Royal Viking Sun.

Lillian was a charming 94 year-old and an inveterate cruiser. Here she is pictured on the Royal Viking Sun with her 'young man', Lloyd. Over dinner one evening, she confided to me that her net worth was $80 million and that she was looking for another companion. She thought I was 'a nice young man' and apparently I would have been suitable. She had already outlived several husbands and I didn't fancy the appointment.

seriously rich moaning about the cost of the cabin laundry service and saving a couple of dollars washing their own shirts. Maybe, of course, that's how you get rich in the first place. I certainly wouldn't know. The bill for my drinks and laundry over a few weeks was well into four figures. That's probably why I'll never be rich.

The long days at sea determine a routine all of their own. The morning jog around the Promenade Deck, hands of duplicate bridge, dancing class, drinks at the bars. The view never changes. Perhaps, a school of dolphins might playfully accompany the ship for a while. The odd shark appears and chases them away. But for most of the time there is just the clear blue ocean . . . And then, as the evening draws on there are the cocktail parties. By now my new-found firm friend, Lillian, has been to twenty-two in the sixty or so days since this World Cruise started. All the long stay passengers give a party at some stage, with elegant invitations produced by the ship's printing department.

At my first party I meet Captain Halle Thon Gundersen, a diminutive Norwegian, who would never have got near the set of *The Vikings*. He doesn't seem to spend a lot of time clinging to the wheel on the bridge. On the first occasion I saw him he was, not unreasonably, dancing with the lissome, blonde wife of the Dutch beer magnate who's forked out more than a million dollars for his string of penthouses. Captains these days have to spend more time with CIPs (Commercially Important Passengers) than lashed to the wheel fighting the elements.

The Captain begins by asking why I did not attend his cocktail party. A strategic error on his part. I reply by informing him I didn't get the invitation. The International Hostess rapidly interjects. "He's a lecturer . . ." End of conversation. However, I shouldn't be so hard on him. He was a good enough sport to allow himself to be squirted with red and green 'goo' and tossed in the swimming pool as we passed over the Equator. This is, apparently, unheard of, aboard Cunard ships . . .

Today, the cruise industry is a boom industry. Operators are investing in new ships with the Mediterranean and the Caribbean favourite destinations. The passengers on the *RVS* were predominantly American with just around a quarter made up of Germans, Dutch, British and Brazilians. For one Scottish couple,

it was a cruise to celebrate retirement. For a Brazilian couple in a penthouse, an annual event. For most of the Americans, simply a way to see the world in the most effortless way possible, without having to pack and unpack at hotels all the time.

Of course, given the relatively high average age, not everybody completes the voyage. In the Cruise Director's office, the nerve centre of fun and frivolity, they are coy about discussing such matters. But around the bar stools it's a well known fact that an old gent has just expired in the sauna and somebody else just didn't get off his bar stool come closing time: nobody actually noticed he had moved on to a better place. The Bar Intelligence Service tells me there are eight freezer cabinets downstairs.

"There was a real panic a couple of years ago. Before the end of the cruise seven were already full. Not like the old days. Come five o'clock in the morning, officers would parade in dress uniform, the padre would say a few words and we just pitched them overboard. Then there was champagne for everyone who had attended the ceremony. One elegant young dame attended the funeral of her elderly husband and, by nine o'clock, was back on the sundeck in her yellow bikini".

Now that's cruising ...

The *Queen Elizabeth 2* – retired from service at the end of 2008 after a distinguished career – was once the undisputed Queen of the Seas, a symbol of the age of great ocean liners built for speed and luxury. I was aboard her on one of the great sail-aways. She left Sydney in grand style escorted at a respectful distance by a flotilla of hundreds of whistling and whooping small boats: tiny accolytes basking in the associated glory. Thousands of spectators lined the shore, small 'planes dived and swooped from the sky and the Channel 9 News helicopter hovered overhead.

Three thousand miles away across the Pacific, at Osaka, she entered harbour under a rainbow of coloured water from the port's fire tugs as a marching band enthusiastically played *Popeye The Sailor Man* on the quayside. Flowers and presents are exchanged, *sake* barrels smashed open, and, again, thousands cram into the ocean terminal. At a dozen other ports, schoolchildren line the quay and wave, the bands play and spectators gaze in awe on the undisputed Queen of the Seas.

Her keel may have been laid as far back as July 1965 at John Brown's Clydebank yard, and she may have been an elderly lady, but the *Queen Elizabeth 2* was a living legend wherever she sailed: an object of fascination mixed with not a little reverence. There will, of course, never be another ship like her, truly the last of the line. They don't build liners any longer; passenger ships with the speed not just to cruise the oceans of the world but to provide a scheduled transatlantic service between Southampton and New York. The fastest passenger ship afloat, her sleek lines and the nine diesel electric engines meant she could cut a swathe through the ocean at up to 35 m.p.h, in landlubbers' terminology, imparting an extraordinarily vivid sensation of speed across the seas.

There was nothing of the brash ostentation of that vulgar new breed of cruise ships they were building in Italy. The cabins here are of varnished wood with traditional portholes, the public rooms spacious and grand, if a trifle understated. With its fluted white columns, the Queen's Room is pure Sixties, the Midships Lobby *fin de siecle* shipboard architecture of polished wood and painted murals, the library and dedicated cinema with full 35mm projector monuments to a bygone age when string orchestras played for afternoon tea, people dressed for dinner and it was in the gift of restaurant managers whether or not you might be admitted. It was reassuring to some to know it was ever thus aboard the QE2.

On the World Cruise you might pay around £250,000 for your 104 day cruise, two sharing in an outside cabin. That, of course, goes a long way to determining the age and status of those aboard. Marcus Prestage was hardly your typical QE2 passenger. For a start, at 24 he's more than forty years younger than the average. He first came aboard with his parents when he was eleven years old. I ask him how often he's been on the ship. Double take: six or seven times? No, 67 times, he corrects. "I just love it. I've made lots of good buddies here." Most of his 'buddies' are amongst the staff, rather than the paying punters. He agrees he's probably one of Cunard's best customers. They probably don't know how much they're indebted to the patrons of bingo halls in Lancashire, the underpinnings of Marcus's wealth.

There's more than a little bit of Lancashire about. You can't be sure whether it's simply Blackpool style *bonhommie*, or some sort

of deeply-veiled threat. Two denizens of the entertainment staff urge the passengers from the stage of The Grand Lounge, "Have a great evening on the QE2 . . ." And, then, booming in unison, "*If you don't, we will* !"

Aboard the QE2 you *will* enjoy yourself. Cunard's entertainment staff is a determined body of men and women under ceaselessly energetic Cruise Director Scott Peterson. Forty-year old Scott is truly the King of Bonhommie: he heads up a 60-strong entertainment staff of musicians, lecturers, gentlemen hosts and entertainers. His first job back in 1979 was on the QE2. In his college days he joined the ship's decorating crew. A year ago, he landed the Cruise Director's job: the star in the shipboard firmament.

A six-foot-two Texan with swept back black hair, a constantly beaming visage and ever firm handshake, the supremely cheerful Scott sees himself as "the key communicator" aboard. He has more exposure to the passengers than any other crew member: he introduces all the acts, fronts the onboard TV channel, and grins and greets wherever he might be. Can this guy be for real?

His wife Lucinda must know. They've been married for almost 14 years and she also works on the ship's entertainment staff, putting together the daily newspaper. She was a dancer and Scott a tour manager aboard the *Cunard Princess* when they first met in 1981. "I looked at Scott and said to myself 'That man's going to marry me'."

She says he is perpetually unruffled. "He never gets depressed - he can wear you out." For Scott, the ship is his life and his life is the ship. "You can't beat the commute - from Two Deck up to this office. I travel the world. I love the work. I constantly meet different people . . . it's a way of life." Lucinda says it's never occurred to them to change it. "It suits us both - the future? - maybe Scott could be a gentleman host at the end of his career."

They're not the only happily married couple aboard. There are at least half a dozen. Bandleader Richard Anderson - from Tarbolton, Ayrshire - married Patsy, the Steiner hair salon manager last year. "This is home for us," says Richard. "We've got everything we need here and life is good." No quibbles, no gripes.

The entertainments people make sure the passengers are sated. Three movies a day; two glittering stage shows of an evening; nine

bars, each with its own harpist, piano player, trio or whatever; the QE2 showband in the Queen's Room; half a dozen lectures and demonstrations every sailing day; dancing classes, bridge, jigsaw puzzles, fitness classes, And, for 'unaccompanied ladies' there are the services of those Gentleman Hosts: surely one of the toughest jobs of all time; dancing every dance, charming the old and lonely. The greying, balding gentleman hosts must enjoy the work. "You bite your tongue from time to time," says one. "Last night, one testy old bird asked me why I didn't dance like her husband used to do. It turned out he'd been dead twenty years so I told her why . . ."

The gentleman hosts don't actually get paid for their dutiful respect and diligent attention. Indeed, they pay the agents who put them aboard $25.00 a day for the privilege. Yes, indeed, you *will* enjoy yourself whilst you're aboard the *Queen Elizabeth 2.*

Everybody dressed for dinner: black tie except for shore days. Your dining arrangements depended on how much you'd paid, or not. I am a lecturer on board and, of course, am not a paying passenger. I dine down below in the Elizabethan dining room. Despite its name, it does not share the grandeur of other dining rooms like the exclusive The Grill. I am seated next to the swing doors which give access to the kitchen and my bow tie dances gaily in the back draughts. The good news is that I have been allocated a table with the dancing girls from the chorus. The conversation is limited but the view is fabulous. The regulations require that I must sit with them every evening.

A week into the cruise and I have become friendly with the charming novelist Arthur Hailey and his delightful wife. He is also working on board as a lecturer but he enjoys a rather more elevated status on board: he dines in The Grill. They kindly invite me to dinner.

And so, I duly present myself at The Grill to join his table. The *maitre d'* gazes at me in evident disapproval. "I have been invited to dine with the Haileys," I inform him.

"This is not *your* dining room," he imperiously advises me. "Get back to The Elizabethan." And turns on his heel.

The Haileys join me for dinner down in The Elizabethan. In the world of deeply ingrained snobbery that is the QE2, my *maitre d'i* is absolutely delighted to have a couple of guests of superior quality.

Most of the time the passengers - average age 65 on this Far East sector of the annual World Cruise - complain. Cognitive dissidence. They complain that they simply can't decide what to do. Indeed, what do you do when *The Full Monty* is showing in the theatre, Petula Clark is singing in The Grand Lounge, The Irish Drovers are lyrically lamenting in The Golden Lion pub and there's a Ball on in the Yacht Club?

You have to give Cunard ten out of ten for effort. That notwithstanding, there is a curious atmosphere of restraint on the World Cruise. Neil, a barman from Glasgow, says it's very different on the Transatlantic run. "It's just five days, the ship is always packed and they party all night …" You can't party all night for three and a half months, I suppose, and, at least on this sector of the World Cruise, there are more crew aboard than passengers. Out of Sydney there were around 950 passengers and more than a thousand crew. At Manila we dropped a couple of hundred passengers. On this 963 foot long Behemoth a half empty ship seems like the *Marie Celeste*.

In The Golden Lion, The Irish Drovers, lately of Sydney, Australia where they worked the Irish bars, were entertaining four old dears in pearls and twinsets, plus a smattering of ship's officers, to a touch of the Irish. A man on a zimmer frame shuffled insouciantly through. *She's the Queen of the Seas and the oceans a-blue, the grand sailing lady they call the QE2* the Drovers drone.

Amidst all the fond reminiscence, the songs of emigrants, convicts and freedom fighters, the Drovers do a pretty full line in doom and disaster. They do two songs about the wreck of the *Titanic*, one about the sinking of the Canadian emigrant ship *Edmund Fitzgerald*, another about the wreck of train no 097 in Ohio, *The Flowers o' Manchester* about the Munich 'plane crash, a ditty about the hanging of Ned Kelly and another celebrating the execution by firing squad of union leader Joe Hill. When I a mite provocatively enquire if they do anything on public beheadings, they come up with *The Four Maries*. This tuneful, if mournful, Irish fare is met with polite acceptance. Sometimes people clap but not for anything overtly nationalist.

However, once the music fades away the passengers are conversationalists. Health - or absence of it - is the great topic.

Everybody aboard either has it, has had it or is resigned to the fact that it will get them. We may all be aboard the annual World Cruise of a living legend, but human frailty admixed with the super efficiency of modern air conditioning ensures the rapid and democratic dissemination of what is known as Cunard Flu. Whether over drinks, dinner, bridge or dancing everyone discusses the wretched affliction.

I refuse to visit the ship's doctor. One drole, elderly American gent has already shared the fashionable conspiracy theory with me. "They put it in the air conditioning just after we left Los Angeles so everybody gets it. Now they're turning over $5,000 a day down in the doctor's surgery on consultation fees."

Alcohol is the only thing that makes you feel remotely better once you've got the dreaded 'flu. At my third drinks party I mercilessly corner the ship's doctor over champagne cocktails. Like doctors the world over, he is quite happily resigned to the illnesses of fellow mortals. "Perfect breeding environment for germs. Someone sneezes at the other side of the room and everyone can get it. Nothing you can do about it. Plenty of fresh air the only answer." As I suspected, no cure known to man. But at least I've just saved myself $50.

The curious thing is that the crew seem largely immune to the shipboard plague. I'm developing a theory about this. Predominantly a young and healthy bunch, they work incredibly long hours and play hard. As a passenger, all those long hours of self indulgent relaxation are clearly dangerous for your health. At the overnight ports of call the crew are crawling up the gangplank at 5.30 of a morning after a night on the town. By six they are miraculously on duty dishing up the early breakfasts and cheerful patter. How they manage it beats me.

Of an evening, there's no doubt the liveliest part of the ship is The Pig & Whistle. Buried deep in the bowels of the QE2 in the foc'sle, The Pig is the crew bar. It's strictly off limits to passengers. As one officer puts it, "It wouldn't do for the passengers to realise what a great time the crew has on this ship."

It's Sunday night and the Irish Drovers are doing a special guest spot down in The Pig. It's packed sardine style right down to the can. The Clyde-built riveted metal walls, floor and low ceiling

- just a few inches overhead - give you the feeling it must be rather like being in a disco in a submarine. The atmosphere is hot and fetid. There is a choking fug of sweat and body heat. Everyone is having a ball.

Against a backdrop of the Irish tricolour, the Drovers are giving Irish rebel songs the full 'laldy' with vocal support from their audience. *We're off to Dublin in the Green* and *The Black Velvet Band* work rather better here than they do five decks up. There is genuine ecstasy in the air. *A Nation Once Again* sees arms linked, bodies swaying, lungs bursting. This is the best reception The Drovers have had since they came aboard.

They say a happy crew makes for a happy ship. It's difficult not to get the feeling the secret of success on the world's most famous ship lies seven decks down in the foc'sle rather than up on the bridge or in the Wardroom where the select few passengers with penthouse cabins quaff G&Ts with the officers.

And there's somebody down there who should really know. Dinner jacket and black tie discarded, Marcus is also having a ball.

A couple of months later, an article I had written about life on the *QE2* appeared in a Sunday newspaper colour supplement. As the writer I had, of course, no control over the headline which appeared: 'The Ship where the Crew have more Fun than the Passengers.' Cunard didn't invite me back ...

At the end of 1998, Cunard acquired one of the most prestigious small shipping lines in the world, Seabourn. It was rather special ...

Crisis. The champagne pours freely but there's only a single *blinis* biscuit laden with caviar left on the silver platter. I defer to the lady to my left, also apparently a fan of the sturgeon. But Susan, a Beverley Hills psychiatrist, is an experienced passenger aboard the exclusive Seabourn line, and she knows the form. She puts Oliver Twist to shame. "We have caviar every evening at five in our suite. I don't like the biscuits so they just bring it in a dish surrounded by ice. All you have to around here is ask for more ..." Indeed. The Seabourn brochure tells you, "Our policy is that any request that is not illegal or unethical – no matter how difficult or outrageous – is to be satisfied if humanly possible."

And so a bow-tied ocean lackey was now ladling Beluga caviar onto a platter from a 5lb tin with a pearl-handled spoon.

Important Note: this was way back in the year 1999. Caviar in 2008 was coming in at $100 a gram.

I happen to be inordinately fond of Beluga caviar but it is now so expensive and difficult to obtain that much of the fun has gone out of it. I was on board the luxury French small ship *Le Levant* (just 80 passengers) in the Black Sea in September 2008. Now you'd think there would be plenty of caviar around in those parts. Wrong. The Beluga was virtually impossible to obtain and after we spent $1,500 for just 15 grams we had enough for a minute speck for each passenger.

The other gourmet delight which I am now denied is a plate of truffles. I crossed parts of the Sahara with the rebel group Polisario Front, fighting for the independence of the former Spanish colony of the Western Sahara, back in the year 2000. The Sahara, which has little to commend it in my view, did produce an extraordinarily memorable meal.

One particular day, the soldiers under my affable escort, Colonel Mahmoud, put in a good eight hours work in the desert. They hunted all day for a delicacy which would have graced any gourmet restaurant in Europe. Come the evening, we were dining on camel meat and . . . truffles, recovered from hidden rocky crevices in the desert. The Colonel averred more than a hundred of his his men had covered 60 kilometres in search of our dinner. "I think that truffle hunting is excellent military training," he opined, "It is a sport. It is good exercise and it is an excellent training in reconnaissance skills." Yes, the truffles were indeed delicious; and they were available in copious quantities. A decade or so later, they are coming in around $6,000 a kilo

Any crisis on Seabourn is soon over: indeed, the temporary shortage of caviar (five minutes) was probably the closest thing to a crisis you would encounter on a Seabourn ship in those days. I probably managed to do in a good half pound of caviar before dinner then it's on to frogs' legs, lobster and the like. Susan has caviar, of course. The gent opposite – owner of the Miami Heat basketball team – has a fish specially bought for him that morning in the market. Fish, correction, more like a whale, served on an enormous platter, and decorated extravagantly. The chef boasts that any dish you like can be served up given a few hours notice. I

tried to defeat him with a request for haggis and discovered there were tins of MacSween's all the way from Edinburgh nestling in the ocean larder.

As you may gather, the *Seabourn Spirit* is no ordinary cruise ship. This is one of the Rolls Royces of the cruising industry. Vast floating skyscraper blocks carrying up to 5,000 passengers may be crossing the seas but here is a rather different seagoing market. There are three Seabourn ships with the sleek lines of a luxury yacht rather than a cruise ship. They are small in the era of the floating malls which dominate the burgeoning cruise ship business: the Seabourn vessels have 90 luxury suites with capacity for just 180 passengers – with almost the same number of crew. Schooled in the comparative drudgery of aged ships like the *QE2*, I again refer to my accommodation as my 'cabin' at dinner to the evident disapproval of fellow diners. The most basic *suite* boasts bedroom with king-size bed, sitting room with satellite TV and fully stocked bar, wine rack and refrigerator, a vast walk-in cupboard and marble bathroom. It's bigger than some flats I've lived in.

However, this is only for the seriously rich. On most cruises the cost is around £1,000 a day for this cosseted luxury. Fortunately, I am, again, travelling for free: I am The Enrichment Lecturer with the demanding task of giving three 40-minute lectures in return for my passage and all the other assorted luxuries to which I would like to become accustomed.

The drink is free. But what I find particularly remarkable about my fellow passengers is their apparent insouciance in relation to this heaven sent facility. Over two weeks I could only identify just one couple determined to liberally avail themselves of the opportunity and although they were putting it away in the Sky Bar on deck eight by ten in the morning they didn't seem to last out anyway until the afternoon. On the last night, the Captain, a rather serious, bearded Norwegian mariner of few words, told us that we had consumed 1,170 bottles of wine in twelve days between Rome and Istanbul. By my reckoning, an incredibly modest six bottles or so a head. I've been to parties in Scotland where more has been drunk in a single night.

The ice cream consumption is a different story, though. The Captain says more than 1,000 lbs of ice cream have been consumed

On the Queen Elizabeth 2 World Cruise out of Sydney I am all togged up. Black tie was the form aboard the QE2, especially when you were meeting the Captain.

The nearest thing I've ever seen to a collision. An in-ballast freighter is caught by the wind on the Mekong River in Saigon and misses Silver Shadow by just three or four metres.

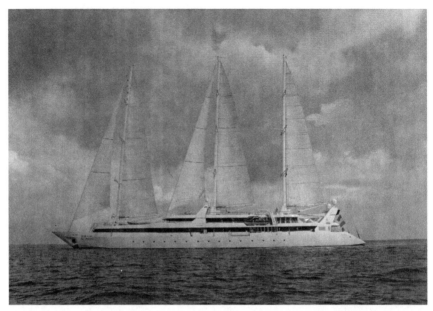

The French yacht Le Ponant carries just fifty passengers in ultimate luxury. She is definitely my favourite cruise ship to work on. In April 2008 she was captured by Somali pirates. Released after payment of a ransom, French Special Forces then killed several of the pirates and captured the others.

The Seabourn Spirit. I lectured aboard her in 1999. In 2005, she was involved in the first high profile attack on a cruise ship by Somali pirates. She beat them off with a then secret device called LRAD (long range acoustic device).

aboard, "And there aren't even any children on board. Who is eating all this ice cream?"

The passenger list gives a clue. Tastefully printed and bound in vest-pocket size, it is in your suite along with your own personalised, headed stationery. It reveals the vast majority of ones fellow travellers to be Americans. That actually turns out to be just fine. They may eat tons of ice cream but these are not your Americans of the "Brussels today, it must be Tuesday" variety. These are serious and experienced travellers who reside in places like Hollywood, Palm Springs and Hawaii. Curiously, a rather large number seem to emanate from Oregon. As a film producer from southern California observes dryly of his fellow travellers over dinner, "Where have all these people come from? I've never ever actually met anyone from Oregon before I came on this ship."

The aliens are here because they came with Christine Niskanen, a glamorous, willowy blonde of indeterminate years, who owns the exclusive Cruise Masters, a Portland-based travel agency, along with her husband Paul. She offers the total travel experience. On the shore stops she has her own tours arranged, she has her own recommended guides and translators, and refreshments are taken at restaurants already checked out personally by the duo.

Christine is having a great cruise with her sixty or so clients. I guess she's also travelling for free as Seabourn's biggest customer but there's a big difference between her and me. She's taken $42,000 out of the fruit machine since she came aboard. She seems to have an instinctive feel for the numbers game on the Keno machine. On night one she won $3,200; night three another $3,200; then came the big one of $28,000 as she picked all seven numbers and, the following night, came another $6,400. The ship pays out in one hundred dollar bills and rumour has it she's stuck them up all over the bathroom to cover the marble. Actually, on the night of the big win her husband got out of bed and made the ship put all the money back in the safe pending, let us say, rather more secure arrangements.

I reckon that the payout is her tax free commission for bringing all these good folks aboard. I tell myself not to be so cynical.

As the Seabourn ships are so small, they can anchor and moor at small, interesting ports which larger cruise ships just grandly sail past. As a result there are fewer sea days than on her larger

brethren. And so we wake up one morning below the cliffs of Taormina in Sicily, another in the very heart of Venice gratifyingly closer to St Mark's Square than the cruise ship terminal, and on another in the bay off Corfu town. The high spot, beyond a shadow of a doubt, is crossing through Greece via the Corinth Canal, with just a metre and a half to spare on either side of the ship. It is one of the great experiences of small ship cruising and I now even have a lecture on the subject.

The small size of the ship does not, however, imply any compromise in the entertainment department. Whereas large cruise ships tend to present ever so slightly faded stars of yesteryear, a small ship like *Seabourn Spirit* instead provides a platform for the energetic, thrusting stars of tomorrow: young performers trying hard to make a name. The quality is outstanding. Marsha Harris, the pert, well preserved cruise director, has a breathless style. She organises the passengers' entertainment programme, prepares the daily newspaper, meets and greets and acts as Master of Ceremonies. As if that might not be enough, she does a one woman show in which she plays Tchaikovsky, sings Edith Piaf in French and tap dances – she was British Tap Dancing Champion at an indeterminate date in the past (all she will reveal is that she was five years of age at the time). She also reveals she was in *Dad's Army, The Musical.* I can't remember when that was so I don't have a clue as to her age. She is backed up by two singers, a four piece band, a magician and his assistant and, of course, the on board lecturer.

Favourite moment? It had to be when one of my dinner companions presented himself at dinner in jacket but no tie. Our waiter pointed out his infraction but was ignored. But the *maitre d'* brooked absolutely no discussion on the matter. With an imperious sweep of the hand, he sternly sent him back to his cabin – correction, suite – to dress properly. At the end of the meal he told us he did it deliberately to test things out (he had rather a lot of shares in Carnival which had just bought the ship). The other passengers applauded the dining room staff. Seabourn is not for slobs and all the money in the world won't exempt you from the dress code.

For a passenger, cruising is really all about the suspension of disbelief. When you're on a cruise ship everyday life becomes a

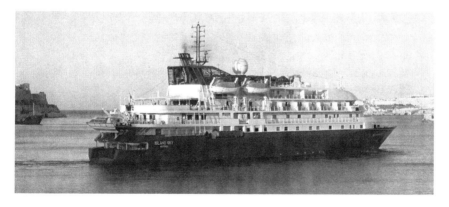

A trio of ships I regularly work aboard: the sleek, luxury 80-passenger French ship Le Levant; the elderly home-from-home, 128-passenger Clipper Adventurer; and the Italian-built 110-passenger Island Sky.

very distant reality as you are cosseted, pampered and treated to a standard of life many would like to become accustomed to but will never achieve. For some people, this involves the assumption of new and quite different personas. After all, if you are on a ship with several hundred people, none of whom know you, you are perfectly at liberty to become someone else. On the *Seabourn Spirit* there was a man who claimed he was the original inventor of the internet and bored one and all with tales of how his invention had been stolen by the US government.

Quite recently, I was travelling on the small French luxury ship *Le Levant* and met an engaging enough American who was particularly interested in world affairs. We had some pleasant discussions and then he asked to speak to me on deck. We leant on the polished wood guardrail as the blue waters of the Indian Ocean went by. The ensuing conversation was a trifle bizarre.

"I suppose you know why I am on this ship?"

I must have looked blankly at him so he went on without prompting.

"You're the reason."

I guess I looked even blanker.

"I work for an operation I can't tell you the name of but in its shortened version it is popularly known by a three letter acronym."

He paused for the full weight of this disclosure to sink in.

"We want you to work for us."

The name of a terrorist organisation which I happened to know rather a lot about was then mentioned.

"How about doing us a short monthly report? Update us with your insights."

Then, the cruncher. "We normally start people like you off at $100,000 a year."

Although this seemed highly unlikely stuff, I didn't want to pass on a gold mine through possibly misplaced personal cynicism so I agreed.

Of course, I never heard anything more.

Indeed, the only CIA man on the ship was the *sous chef.* He was a graduate of the Culinary Institute of America.

Fifteen

"A Directive Has Been issued"

From Scotland to Malta

Some houses are simply a place to hang your hat. Others are family homes full of warmth and comfort. And others are a place of refuge. For me, Whittingehame House came into that last category. Located in the depths of the East Lothian countryside half an hour's drive from the frenzy of Scotland's bustling capital, Edinburgh, it was a haven of peace and tranquillity for all the years I travelled to distant parts of the world looking at other people's troubles. It was a place to which I brought back friends, usually female, met on adventures in exotic places like Albania, Thailand, Dubai or Kenya. At a certain point, it would cease to be a haven. But that is to jump ahead.

The story of how I came to live at Whittingehame, a unique house, is unusual in itself. In the summer of 1986 I had been asked by my friend and business associate, the publisher Charles Skilton, to search out a home of substance for him in Scotland. Charles, who featured earlier in these pages, was an extraordinary character, even for the world of publishing, which was full of them in those days.

The son of a self-employed master builder in south London, as a 12 year-old he collected wooden boxes from local grocers, chopped them up and sold them on as bundles of firewood. His endeavours funded the purchase of an Adana home printing press and some movable type; a magazine was soon produced for sale in an edition of 50 copies and he was in publishing.

In 1937, he joined Stanley Gibbons, the London stamp dealers, as an office boy and then he joined the famous publishing house of Stanley Unwin, where he learned the trade thoroughly under one of the best publishers of the 20th century.

He was substantially influenced by Sir Stanley Unwin, a legendary and formidable man dedicated to excellence in publishing. There was a strong strain of pacifism in the Unwin operation, reflected both in the books – they were publishers of

Whittingehame House, East Lothian, completed in 1817, to the design of Sir Robert Smirke, architect of the British Museum. I purchased the house in 1986 together with publisher Charles Skilton.

The south front. It was a particularly grand house but was not built as a fortress. Accordingly, it was not very suitable when we returned from the Far East at the end of 2004 and enjoyed the protection of the security services.

Bertrand Russell - and in the staff. Charles was influenced by this and when his call-up papers for the war arrived in 1942 he declined to get involved.

This led to him spending a couple of months as a guest of His Majesty inside the walls of Wandsworth Prison from where he obtained an early release to become a Warden at Bexley Heath Lunatic Asylum. He said it was not an exacting job and it gave him plenty of time to go up to London and hatch his own schemes. The term 'lunatic' was still ascribed to the mentally unfortunate and the treatment of them was pretty appalling.

For years, at his Albyn Press publishing warehouse in Edinburgh's Abbeyhill district, the records of incoming deliveries were kept in an enormous, handsome leather-bound volume. Blocked in gold on the spine was 'Female Patients Punishment Book. Bexley Heath Lunatic Asylum'. Inside, the pages were divided into columns with pre-printed headings: Name, Number, Offence, Number of Strokes. The columns were neatly completed in ink in Charles' supremely neat hand.

He soon got bored with the business of the lunatic asylum and bought a small book publishing business in London in 1943 for £50. The purchase of this business got him an all important paper ration. In those days, such was the shortage of paper, anything you could print would sell. Charles would tell me that in those days the entire edition of anything you could print could be sold in half a day's stroll up London's centre of the bookselling trade, Charing Cross Road. He published several books of crossword puzzles and the entire editions were purchased by the wholesaler W H Smith.

In the years immediately after the war, he notched up a string of significant acquisitions. On his honeymoon (never a man to relax), Charles read in *Picture Post* about Frank Richards, author of the Billy Bunter stories which had appeared for many years in the comic, *The Magnet*. He immediately fired off a letter to Richards asking him to write a Bunter book. The reply promptly came back, "£90 for 60,000 words."

Charles had no money at all so he put Richards on a royalty rather than buying the rights. This would cost him in the long run. The books became an enormous popular success and the list was sold on to Cassells in a time of financial stringency. He also sold on

The publisher Charles Skilton. He was probably best known as the 1960s publisher of John Cleland's classic erotic novel Fanny Hill. It made him very rich.

successfully the Elliot Right Way Books, an early exercise in self-help books before such things became fashionable. But it was the 1960s which would bring him commercial fortune and much notoriety.

He had always had an abiding interest in matters sexual and was a fervent believer in opening up publishing to, let us say, more liberal mores. He imported initially, from India, illustrated editions of Indian 'art' books. These were large, expensive volumes which were easily passed off as academic items. He then decided to risk a paperback edition at 9s 6d of the *Kama Sutra*. Despite being staggeringly overpriced for the times, Charles was equally staggered to get an order for 10,000 copies from W H Smith, although when a copy was exposed for sale in Edinburgh the local constabulary seized the book and prosecuted the bookseller. Charles travelled to Edinburgh and testified on his behalf as to the cultural nature of the work but this was pooh-poohed by the straitlaced Edinburgh judiciary. He was found guilty in the Sheriff Court of selling pornography. He always used to aver that the *Kama Sutra* is still a banned book in Edinburgh.

But his greatest success was still to come. One Saturday morning in the autumn of 1962, Charles was making his way through Soho and a book dealer beckoned him into his emporium. "Hey, Charlie boy, why don't you reissue this?" He thrust a copy of the banned 18th century book by John Cleland, *Fanny Hill: Memoirs of a Woman of Pleasure* into Charles's hands.

"You want to get me arrested?" was the riposte.

"Not at all. Why don't you take out the really dirty bits? People will still buy it."

Charles spent the next Sunday morning in bed, bowdlerising Cleland's epic work. The blue pencil went through all the really filthy bits and it was scheduled for publication in November 1963 under the new imprint of The Luxor Press. (When things were risky, Charles would always form a new company which could be easily liquidated without bringing down the rest of his publishing empire). Charles wrote a 'learned' introduction propounding the artistic merit of the book. He took a great pride in his book design and his edition of *Fanny Hill* was to be published in large format hardback on beautiful deckle-edged paper and complete with bookmark, at the then extremely high price of 45 shillings.

After his success with Fanny Hill, Charles Skilton published an extensive series of erotic paperbacks under the Luxor Press imprint. An image of the time taken from the Luxor Press files. Inset: The Luxor Press catalogue.

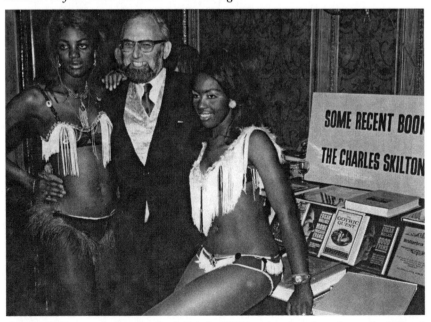

Charles Skilton at the London Book Fair in 1972 with a duo of newly acquired friends.

374

The week before publication of this carefully expurgated edition he received a surprise call from the sales director at the paperback firm, Mayflower Books. "Hello Charles, how are you? This is really just a courtesy call to let you know that next week we're going to publish an unexpurgated edition of *Fanny Hill* in paperback at 3s 6d."

Charles said that he reached for the Yellow Pages and looked up 'Waste Paper Merchants'. I'm not quite so sure about that. Something curious now happened.

By a curious twist of fate, forty-eight hours later, Scotland Yard's Obscene Publications Squad raided the Mayflower warehouse and seized the entire stock. Charles used to say he had nothing to do with it. The newspaper publicity was enormous, just as the Luxor Press expurgated edition was launched.

It was a runaway success. After reprinting several times, Charles put it into a paperback edition at 7s. 6d., still a substantial sum of money in 1964. He sold two million copies and the book was at one time disappearing off the shelves at such a rate that five printers were employed full time printing nothing but *Fanny Hill*.

Off the back of Fanny Hill, so to speak, Charles became a very rich man. Luxor Press became a most successful imprint during the 60s reprinting many long-forgotten erotic classics like *The Awful Disclosures of Maria Monk or, The Hidden Secrets of a Nun's Life in a Convent Exposed, Oh! Oh! Josephine* (the bawdy tale of a Viennese whore), and *The Perfumed Garden*. As the market matured, so to speak, the books became more daring and less academic in tone and the Luxor yellow-covered paperbacks soon became known for titles with rather more enticing titles like *Pussies in Boots, The Miniskirt and Beyond, Sexy Sue's Office Games* and *Schoolgirl Sex*.

The first month's profit from *Fanny Hill* funded the purchase of a country house in Sussex. Its official name was Oldlands Hall, but all his friends in publishing knew it as Fanny Hall, and it was the setting for many suitably bawdy social gatherings, as well as exotic photo shoots for upcoming publications.

I first met Charles in 1969 at a party given by the Independent Publishers' Guild at Strawberry Hill (the former home of Hugh Walpole) in London. In those days he sported a neatly cut beard, a smart powder blue suit and looked altogether quite dapper; he was escorting a bevy of beautiful girls of oriental hue. The Secretary

Throughout its history, Whittingehame House was home to grand parties. This party was held to welcome the new millennium, January 1 2000.

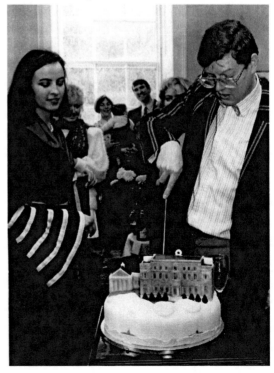

In 1988 I had written and published a book entitled Life in a Scottish Country House: The Story of A J Balfour and Whittingehame House. The launch party was enlivened by the cutting of a cake made as a facsimile of the house.

of the Guild, Joan Whitehouse, whispered to me, "That's Charles Skilton. He's *very* rich. And he's always with beautiful women." I was *very* impressed.

Charles and I clicked. We enjoyed broadly similar tastes in most things, from books to women and I would work with him or for him on various projects up until his death in January 1990.

In public life he was always completely charming, proper and correct. Many women admitted they were attracted to him because he was "such a gentleman" in the old-fashioned manner. But, like most of us, there were complex hidden depths lurking below the surface. His passions ran from windmills and watermills to divorce law reform and all aspects of sex and eroticism. He had one of the largest collections of erotic literature in Britain until he started to disperse it in the 1980s during a period of acute financial stringency. Six weeks after his death, his remaining books raised almost £100,000 in public auction at Whittingehame House.

Charles had a passion for grand country houses. After Oldlands, he would buy Banwell Castle, near Weston Super Mare: a Gothic, suitably crenellated 19th century copy of a mediaeval castle built to the order of the Bishop of Bristol. It was a sham, of course, but it enjoyed beautiful grounds and magnificent views over the rolling Wiltshire countryside. But soon he tired of it (he thought it was too small) and decided he would rather live near Edinburgh in Scotland. This is where his request to me came in.

It was one of those extraordinary coincidences of life. The week after his request, I was scanning the property pages of *The Scotsman*. There was a small, classified ad.

WHITTINGEHAME HOUSE
Mansion House and Policies. The former home of the Earl of Balfour situated in its own grounds with woodland, tennis court and fishing rights. Accommodation comprises entrance hall, reception hall, 3 lounges, dining hall, 2 drawing rooms, 2 libraries, livingroom, study, office, 33 bedrooms, 2 kitchens, 8 bathrooms, cloakrooms, storage.
Offers are invited in the region of £120,000

The advertisement was intriguing, to put it mildly. Upon investigation, it hardly even began to convey the vast scale of the house. A few days later, Charles and I investigated the property: it

took us a couple of hours just to walk through all the rooms and we counted, including the basement and cellars, 88 rooms.

We stood in the overgrown grounds and stared up at the vast sandstone edifice. "It's not a house, it's a palace," observed Charles dryly.

In fact, it had been built between 1815 and 1819 to the order of a wealthy nabob freshly back from India, James Balfour, by the architect Sir Robert Smirke, whose next commission was the British Museum in London. Smirke was given a simple brief: build a house grander than the family home in Fife. And so he built the vast neo-classical pile that was Whittingehame House. There was much of the British Museum about it. It was a plain house with vast rooms, draughty corridors and very little in the way of decoration. But it became home, in its time, to many distinguished occupants, including the grandson of the original owner, Arthur James Balfour, who would become Prime Minister of Great Britain and occupy virtually every important political office in government. A J would be born at the house and he would be buried in the grounds and during his period distinguished visitors included people like Disraeli, Winston Churchill and Sidney and Beatrice Webb. As such, it had a very particular atmosphere which only the insensitive might not be able to attune to.

Charles was always going through financial ups and downs but played his cards very close to his chest. The idea was that we should buy the house together and simply divide it into two: he would take the ground floor with vast public rooms and the cellars and basement with its storage capabilities. As he would put it, "I've a vast amount of junk." I would take the two upper floors and we would split the cost.

We agreed together to make an offer of £135,556 for the house. Although it was not the highest offer, it was the most straightforward and the vendors agreed to sell to us. In the first decade of the present century, the house would be worth around £5m. but, in those days, it appeared overpriced at what we paid for it. Charles said he was temporarily short of cash, so could I please put down the 10% deposit? I had this to hand so the property was secured until completion day three months later.

A week before completion day, Charles broke some bad news. "I've been served with a writ by American Express Bank over

unpaid bills and they've seized Banwell Castle. I don't have any cash and can't raise any on the castle."

To cut a long story short, I raised the money personally and got further bits of the house in return. It was incredibly difficult raising the £100,000 shortfall. The manager of Barclays Bank in Edinburgh's posh St Andrew's Square looked me straight in the eye and demanded, "Are you trying to tell me, Mr Harris, that people will ever commute 24 miles into Edinburgh?" Such a man of vision. In the end, I told a bank manager I already had a substantial overdraft with that unless he lent me £100,000, then he could kiss goodbye to his overdraft. As he said, "You don't really give me much choice do you?"

Essential works to make the place wind and watertight, install modern drainage, water, power and telephone connections took more than a year. Then we got planning permission to divide the house into flats, which proved to be a much more sensible course of action than trying to run such a vast enterprise on the basis of just two households.

The exercise proved extremely successful, both in terms of the results achieved in saving a rundown building, and financially. The bank got its money back in eight months.

In November 1987, Charles asked me to lunch at our London club, The Savile. "I've had some rather startling news,"he announced. "I've been told I have lung cancer." A man who despised smoking and smokers had developed lung cancer which would later spread. Alas, Charles would die in January, 1990, before he could complete work on the restoration of his own substantial part of the house.

Shortly after his death, there was a great catalogue sale by Phillips the auctioneers at the house. Charles had been a collector of anything and everything which meant he had some very bizarre collections. Phillips promptly ordered up half a dozen skips and consigned his entire collection of Ready Reckoners to the refuse. I could never work out why he ever collected them. Similarly, more than 40 years of unsorted copies of *The Daily Telegraph* went out: he thought it was a great newspaper and he never threw one away, fondly imagining that they would come in 'useful' one day. When he had left Banwell Castle his cleaning lady had actually called in council refuse trucks to dispose of them. When Charles saw them arrive at the Castle he

was livid, promptly sent them away and paid a haulier more than £1,000 to take the treasured *Telegraphs* up to Scotland.

However, he had made some rather better purchases. One day in 1972 he had been walking in one of the lanes at the back of Edinburgh's George Street. The once great publishing house of Blackwood was shutting up shop and the contents of their offices were being disposed of. Some workmen were clearing the premises and Charles spotted the large round table, which had been the fulcrum of the publishing business, being carried out. At the table had sat men like Sir Walter Scott, Thackeray and John Buchan. Charles paid them £10 for this piece of publishing history.

When it came up for auction at Whittinghame House it was estimated by the auctioneers at £400-600. They reckoned it was an undistinguished piece of furniture, fashioned in oak rather than hardwood and of no great appeal. Bidding started, however, at £2,800 and was eventually knocked down for over £17,000. Charles would have liked to see that.

There is a curious footnote to the sale. The table was bought by London fine art dealer Carlton Hobbs. They sold it on to a buyer in Kuwait. Within months Saddam Hussein marched in and the table has never been heard of again.

The 'best' of his erotic library went into a later sale but the auctioneers filled tea chests with what they regarded as 'junk'. There were thousands of pieces of ephemera: French 'dirty' postcards, photographs of SS men and women engaged in bestiality with Alsatian dogs, uniformed girls with skirts around their waists getting sound spankings on their bare bottoms, and magazines full of women in suspender belts and stockings from the fifties and sixties photographed by icons like Harrison Marks. The tea chests were estimated at £20-30 each. Most got £600-800 each amidst the most frenzied public bidding! Many people might have purported to regard Charles's tastes as arcane. They were evidently rather more popular . . .

The House was not quite the same with my old friend gone. The exotic visitors dried up. The glamour puss gold diggers drifted away. Book dealers arrived from time to time to inquire as to what had been found lurking in the basement: Phillips had refused point blank to investigate the thousands of boxes mouldering in its dark

recesses. There were, in fact, plenty of curiosities found still lurking down there.

I lived at Whittingehame happily enough through the 1990s, now divorced, and then let my part of it out in 2001 when I went to live firstly in Sri Lanka and later China.

In August 2003 I was married in Shenyang, northern China, with a formal wedding celebration afterwards on a chartered riverboat on the Huangpu River in Shanghai. The following year, my wife, Sulee, and I decided to live in Europe and we would leave at the very end of October 2004, together with our newborn daughter, Lucy.

I reclaimed Whittingehame House from the tenants and we settled in. It was still a cold and draughty pile, remote in its location in the East Lothian countryside at the foot of the Lammermuir Hills. In many ways, however, it was something of a museum of my past life and passions. I had a very large, if indiscriminate, collection of 19th and 20th century Scottish paintings, collected during the 1970s and 1980s. This collection had led to me writing a book with Julian Halsby, a London art dealer, *The Dictionary of Scottish Painters* which has remained in print for twenty years. My adventures in foreign parts had led to me feeling more than a little divorced from my previous lives and I was unsure about the future.

As so often in life, events would develop their own momentum.

Very shortly after arrival in Scotland on November 1, things took a most unexpected and quite unwelcome turn. On November 17 an email timed at 1526 hours was sent to me from the Foreign & Commonwealth Office in London. The source was unknown to me personally: the Asia & Communications Section, Counter-Terrorism Policy Department. The email said that 'urgent contact' was required. I telephoned a Mr Horsman who was a trifle vague. He simply advised "we need to speak to you". Horsman then conveyed my contact details to the security service, MI5.

Soon there was another telephone call, from Special Branch and a meeting was fixed for the afternoon of November 19 at Whittingehame House.

Two plain clothes police officer arrived promptly at 3 p.m. The meeting was convened by a smartly-suited Detective Chief

Superintendent of Special Branch and he was backed up by a Detective Sergeant (according to his business card, Counter Terrorist Security Advisor).

He opened a file from which he read frequently and consulted most of the time. It was clear he was a messenger and although he had sought to acquaint himself with its contents it was evident it did not deal with a topic with which he was intimately acquainted.

He said, "This is going to come as a shock to you." Looking at the file, he announced that MI5 had received information that my life was in imminent danger from terrorists. "I understand you know who I mean by the LTTE?" He went on to say that they were obliged to issue a warning that according to "credible" intelligence reports "the LTTE has issued a directive ordering the assassination of Paul Harris".

"Accordingly, we believe your life is in imminent danger."

I got the impression that this was all rather more of a bombshell, so to speak, to him rather than to me. I knew full well, of course, that the LTTE would love to see me as an expired person. But I was surprised to find the security services on my doorstep virtually as soon as I arrived back from the Far East and was settling in at home again. I really though that I had passed out of the LTTE's orbit of concern when I went to live in China two years previously. I really couldn't see that I was interesting or important enough to merit their continued attentions.

This information was read again from the file and, it was averred, had come directly from MI5. I then said, "Should I assume that the intelligence you have has been passed on from MI6?." For the uninitiated, MI5, sometimes referred to as the Security Service, is responsible for internal security within the UK, whilst MI6, referred to as the Secret Intelligence Service (SIS), deals with threats abroad.

The DS agreed with this supposition although I was not altogether sure whether he had been furnished with that particular piece of information. He then went on to say that my writings about the LTTE had caused them pain and embarrassment and they desired to cease my ability to comment on them any longer. Interestingly, to support the thesis which was presented to me, he then repeated a piece of information which I knew to be false: I

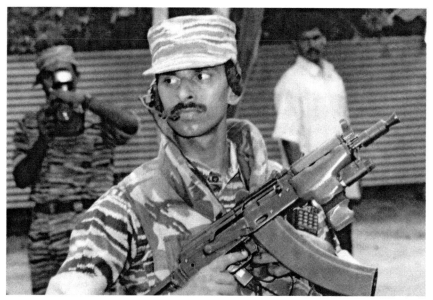

The LTTE, who had issued the directive for my assassination, had taken a distinct interest in me after articles in Jane's Intelligence Review. Here I am filmed by LTTE security before rebel leader Prabhakaran's 2002 press conference, near Kilinochchi in northern Sri Lanka. The close protection officer sports a specially adapted, snub-nosed AKS-740 5.45mm. carbine.

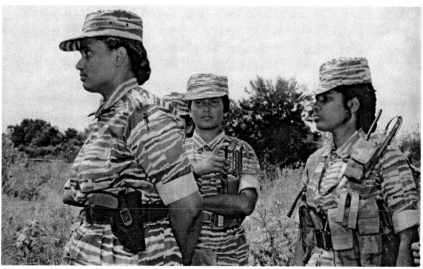

The LTTE is one of the most sophisticated terrorist organisations in the world responsible for the development of the suicide jacket and key aspects of terrorist bombing technology, which they have shared with other terror groups. They possess a highly effective women's wing which is well armed and fitted out. They own many ships and trade legitimately as well as illegally. The female cadre on the left of the picture is sporting a brand new Czech-made automatic pistol

knew it to be false because I had invented it myself as a 'false trail' in a story I had written and which was published in Sri Lanka. The source I reckoned was my story rather than coming from LTTE sources. Of course, it was entirely possible that the security services believed everything I wrote. That was doubtful, however.

I was then told that a security operation had been put in place with the codename of 'Operation Ruby'. "We understand that there are no rubies in Sri Lanka," was the enigmatic explanation from the officer in charge of counter-terrorism. In the event of any threatening situation I should telephone the police and simply quote the name of the operation and the locus for immediate attendance of an ARU (Armed Response Unit). Then I was handed a booklet. "We give this to cabinet ministers and any other people we think might be the subject of terrorist attacks." It was full of information on checking underneath your car every morning, tactics for throwing off a 'tail' on your car, eluding a pursuer and generally staying alive.

He advised me that there must be no publicity. That what we had discussed must remain top secret. At the time that seemed reasonable enough but, upon reflection, I felt that probably the best thing that might have been done to pre-empt a Tamil Tiger attack would have been to reveal the threat publicly. They would never have dared to implement the directive, surely?

Later the same day, a so-called 'panic alarm' was fitted at the house, terminating at a central control room. Activation of the alarm was said to provoke immediate police response both locally and from an ARU. Such a development would also be immediately reported to the FCO in London.

Indeed, there was an alarm the following month. Not wishing to worry my wife on the matter I did not divulge the contents of our discussion. However, I was supplied with a handheld gadget, which I generally wore around my neck. If the button in the middle was pressed, it would glow red and send a signal to a satellite which in turn would activate a security operation.

In the middle of December, I forgetfully left the gadget by the side of the bed when I went to the shower. Unbeknown to me, my wife picked it up and pressed the plunger. "It made a nice red glow, so I pressed it again a few times." When I came out of the

Velupillai Prabhakaran, the leader of the LTTE. He appears misleadingly genial in this publicity photograph. This image led to me describing him in one article as the Chief Genial Fatty. In reality, he is a ruthless killer who has ordered the murder of thousands of civilians in bomb attacks. Probably his most famous victim was Rajiv Gandhi who was blown up by a female LTTE cadre on May 21 1991. Seventeen others died on the scene.

shower I went to the telephone but there was no connection. I didn't know yet that the security operation had been activated but I did know that if ever our telephone went down I was to put defensive measures in process immediately.

So I immediately rang the Police HQ. "Operation Ruby is active."

In the next few minutes, police cars and vans full of men in ski masks and flak jackets with Heckler & Kochs were dispatched to rudely interrupt the rural peace of East Lothian. My downstairs neighbour was holding her weekly *pilates* class for the benefit of local ladies. The arrival of the forces of counter-terrorism certainly enlivened their morning.

The response to the false alarm had, however, let me know one important thing. The resources were actively in place to respond to any threat to my person. I have to confess, I had suspected that I was being wound up by the security services in a simple bid to get me to keep my mouth shut and stay away from things which, in their view, did not concern me. It seemed that they must be acting, indeed, on "credible" information as they were evidently prepared to devote substantial resources to my protection..

It was, therefore, with some trepidation that, a week later, I decided to go back to Sri Lanka. In truth, I had been offered a useful fee to make an all-expenses-paid trip for the purpose of addressing a conference on the LTTE threat. The body involved, WAPS (The World Association for Peace in Sri Lanka), which was dedicated to countering what it regarded as the pernicious influence of the LTTE, promised me comprehensive protection. I could do with the money and I also felt that it might be possible to tempt the LTTE from their lairs and dispose of the threat once and for all. The government in Sri Lanka had by now changed and the people I had fallen out with so catastrophically, Ranil Wickremesinghe and his cohorts, had now been replaced by a PA government who heartily welcomed my views.

I had addressed a similar conference for WAPS in September 2004 in the Norwegian capital of Oslo. I had talked on that occasion about the moral bankruptcy of the LTTE. If they had wished to get rid of me, Oslo would have been the perfect place for them. The Norwegians were deeply enamoured of the LTTE, were the peace brokers on their behalf in Sri Lanka and the security services there

were lax, to put it mildly. My only other involvement with WAPS had been in the spring of 2003 when I travelled to Sydney, and met some people who said they were associated with them. They talked about mounting a military coup to unseat the UNP government. As much as I find the concept of the military taking over from effete and corrupt democracies rather attractive, I declined to get involved.

The Colombo 'booking' seemed worth the risk. I told my 'minders' that I was off, just before I left. I would have been 'clocked' by Special Branch leaving Glasgow airport as my name would come up on the airline computer bound for Dubai en route to Colombo. On December 17 2004 I arrived at Colombo airport.

The comprehensive security turned out to be a single plainclothes policeman. I asked him if he was armed and he produced a 9mm. pistol which was stuck into the back of his belt. I was not too happy but we went into town and checked into my old favourite, the Galle Face Hotel. It was great to be welcomed so warmly by all the staff there, and I settled into one the suites like I had never been away.

I had lunch booked across the road at the Taj Samudra Hotel with a retired army Major General who had links into the security establishment. He was surprised to see me escorted by a 'tooled up' policeman. Over lunch we discussed what had transpired in the previous weeks. He didn't give away how much he knew – he's far too clever for that – but he made a call right away on his cellphone.

We walked across the road to the Galle Face as a mini-convoy of three police vehicles arrived. There were 19 policemen altogether, most in baggy, flowing shirts with hand guns stuck into the waistbands of their trousers.

A senior uniformed officer stuck out his hand. "Your escort, sir. We shall be with you every moment." It was, in fact, what is known as an MSD unit: a Ministerial Security Detail more usually deployed to protect government ministers.

They were unshakeable They stuck to me like glue. Half of them camped outside the door to my room, the others hung around the lobby of the hotel eyeing everybody up and frisking anybody who aroused suspicion. A telephone call came in my room. "Hello Paul. How are you?" It was another Major General, Wijeratne, now Secretary to the Minister of Defence. "Are you now happy with the security? We don't want anything to happen to you, you know," he chortled.

Although the presence of an MSD around me was reassuring, I was well aware it did not provide a cast-iron guarantee. After all, many government ministers afforded top security had been assassinated in Sri Lanka. The most dramatic instance of such an assassination was yet to come. The following year, on August 12 2005, the country's Foreign Minister Lakshman Kadirgamar would be assassinated late at night getting out of the swimming pool at his Bullers Lane residence. The weapon used was a 7.62mm. sniper rifle fitted with telescopic sights and with infra-red night vision. This was not a casual killing but a well planned execution. Kadirgamar was arguably the most accomplished politician in the Sri Lankan establishment and had previously served as Foreign Minister under the PA government between 1994 and 2001.

I had got to know him quite well during that period and, at his request, had compiled a 10,000 word report in the summer of 1997 on how the government might improve its public image and relations with the media. He was a perceptive and charming man (during his time at Balliol College he had been president of the Oxford Union) and was particularly hated by the LTTE because he was a Tamil, born in Jaffna, who totally rejected their breakaway objectives.

He had always been extremely well protected but during the period of the flawed peace process, which I had been so critical of, the government had plainly let its guard – and his guard - drop. His death was an enormous loss to Sri Lanka. Of course, the LTTE knew of my close links to him (I visited him several times at his home 2003-4) and the fact that they had the capacity to assassinate him was far from reassuring.

Close protection is kind of flattering for a while but then you get to realise how tedious it is for the rich and famous to have security around all the time. It kind of cramps your style . . . Anyway, late at night I was delivered back to Colombo's Bandaranaike Airport, fast tracked through security by my minders and into the VIP lounge.

I think my Special Branch minders were mildly surprised to see me back in Britain in one piece and the security operation was continued. I tried fruitlessly to get some more information as to the actual extent of the threat to my life. I now had not only

My wife Sulee and our daughter Lucy in the grounds of Whittingehame House in 2005.

The view from the terrace in Malta.

a wife, but a six month-old daughter and I felt I could not be cavalier about a threat to my family. Nobody would give me any information: Special Branch was, I felt, out of its depth and ill-informed; my own contacts in the security services professed to be 'out of the loop'; army contacts also were stonewalled. So I wrote to the Foreign Secretary, Jack Straw.

The Man of Straw did not bother to reply to me and apart from a formal acknowledgement my letter was not dealt with. I was frustrated in all my attempts to establish the source of the information, the level of the threat and the dangers we might be in. The man at the FCO had "left the department" according to his boss when tackled by a senior retired military officer who endeavoured to help me. Apparently, he left soon after contacting me . . .

My frustration had now turned to very real concern and I considered it a distinct possibility that behind their reasons for being seemingly obtuse, lay instructions from their political masters directed to the security services. What exactly was the involvement of the FCO's 'Counter Terrorism *Policy* Department'? I was aware that the FCO, and its local 'agents', the British High Commission in Colombo, disapproved of my intervention in the doomed peace process in Sri Lanka, which they had, in my view, foolishly supported. Of course, many of my investigations over the years had ruffled feathers and it was virtually impossible to isolate a particular cause for my current concerns.

I looked at the situation together with private security consultants who had worked in VIP close protection (in 2001 I had attended the Close Protection course at the International Security Academy in Herzeliya, Israel). We felt that Whittingehame House was extremely isolated. It was necessary to scramble ARUs from Edinburgh (minimum 30 minutes) and local police units were not up to CT (counter-terrorism) work. The first unit which had arrived during the false alarm thought it was attending a 'domestic' (violent argument between husband and wife). "What's going on ere then?" was the query. When I said it was a counter-terrorist operation and that Special Branch would brief them, they paled visibly. "Somebody might have warned us," was the bitter lament.

I told the Special Branch people that we were considering moving abroad: I had by now looked at various boltholes in the

Mediterranean area. I got the distinct impression they thought it rather a good idea.

In the last week of February 2005, my wife and I went to the island of Malta in the centre of the Mediterranean. I had previously been to spy out the territory. In security terms, I reckoned it was probably the safest place in Europe: a small island with excellent border controls, and very few of them; a very strict visa regime; a small tight community; well preserved law and order and the benefits of recent EU membership.

In a notary public's office in the capital Valletta, we signed a contract to purchase a house overlooking the famed Grand Harbour. In April, we sold our house in Scotland and we left for a new, and, hopefully, safer, home.

During the closing months of 2008, Sri Lankan security forces made spectacular progress in their long running battle with the LTTE. By the beginning of 2009, the LTTE had been forced to retreat into a relatively small, and shrinking, area in the north east of the island. In January of 2009 we took up a new home in Scotland and made plans to return.

In 1977, I edited and published a mickey-taking book about the Scottish publishers, D C Thomson of Dandy and Beano fame. Initially, there was litigation in a bid to ban it but this was abandoned and the book appeared to great publicity. The book's designer, Jim Hutchison, used a drawing of myself, winking at the reader, on the cover. Fellow Scottish publisher Gordon Wright took this photograph at the Frankfurt Book Fair soon after publication.

Bibliography

PUBLICATIONS BY PAUL HARRIS 1968 - 2007

General subjects

When Pirates Ruled the Waves, Aberdeen 1968-71, Glasgow 2007 (6 Editions, 15,000 copies)

To Be a Pirate King, Aberdeen & Amsterdam 1971 Broadcasting from the High Seas, Edinburgh 1977-78 (reprinted twice)

Oil, London 1975 (reprinted twice)

The Garvie Trial, Aberdeen 1969 / published Paris 1974 by Les Presses de la Cite as Le Quatour Infernal

A Concise Dictionary of Scottish Painters, Edinburgh 1976

Investing in Scottish Pictures, Edinburgh & London 1977

The Dictionary of Scottish Painters 1600 - 1960, Oxford & Edinburgh 1990 (with Julian Halsby) 2nd edition 1998, 3rd edition 2000, 4th edition 2002

Life in a Scottish Country House: The Story of A J Balfour & Whittingehame House, Haddington 1989

Somebody Else's War: Frontline Reports from the Balkan Wars Stevenage, England, and Kranj, Republic of Slovenia, 1992, Published as Der Krieg der Anderen, Dusseldorf 1994

T N Foulis : The Bibliography and History of an Edinburgh Publisher (with Ian Elphick) London 1998

The Whisky Drinker's Bedside Book, Ljubljana 2001

Delightfully Imperfect: A Year in Sri Lanka at the Galle Face Hotel , Glasgow 2006, Colombo 2007

Illustrated History

Glasgow at War, Manchester & Glasgow 1986

Aberdeen at War, Manchester & Aberdeen 1987, reprinted 1995

Tyneside at War, Manchester 1987 (with Clive Hardy)

Edinburgh Since 1900, Manchester & Edinburgh (4 Editions) 1987 - 88, reprinted 1994, 1998 85,000 copies

Aberdeen Since 1900, Manchester & Aberdeen 1988, reprinted 1996, 1998

Glasgow Since 1900, Manchester & Edinburgh 1989, reprinted 1994, 1995, 1998 35,000 copies

By Appointment: The Story of Royal Deeside & Balmoral, Manchester & Aberdeen 1988

Edinburgh: The Fabulous Fifties, Manchester & Edinburgh 1988, reprinted 1995 20,000 copies

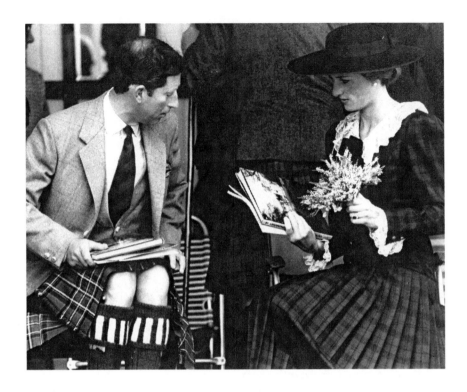

In 1988 I put together a book called By Appointment: The Story in Pictures of Royal Deeside and Balmoral. *It came out to coincide with the annual Royal visit to Balmoral and before Prince Charles and Princess Diana took their seats at the annual Braemar Gathering copies of the book were placed on their seats. They were obliged to pick them up in order to sit down and then the photographers got pictures of the duo staring intently at my slim volume. Princess Diana was clearly nonplussed.*

Disaster! One Hundred Years of Wreck, Rescue and Tragedy in Scotland,
 Manchester & Edinburgh 1989
Glasgow: The People's Story, Edinburgh 1996 25,000 *copies*
Scotland's Century 1900 – 2000: One Hundred Years of Photographs,
 Edinburgh 1999 25,000 copies

Photographic books
Cry Bosnia: Words & Photographs by Paul Harris, Edinburgh 1995, New
 York 1996 reprinted four times 1996-9 (28,000 copies sold)
Fractured Paradise: Images of Sri Lanka, Colombo 2001, Haddington 2001
Transition: Images of Shanghai in the 21ˢᵗ Century, Shanghai 2003
About Face: Photographs from the Streets of Shanghai, Shanghai 2003

Recipe Books
Cooking with Beer, London 1987
A Little Scots Cookbook, Belfast 1988; German edition Kleines Schottisches
 Kochbuch 1994; French edition Le Petit Livre de la Cuisine Ecossaise
 1994 (228,000 copies sold in English)
The Best of Bangladesh, Edinburgh 1987 (with Tommy Miah)
Secrets of the Indian Masterchefs, Edinburgh 1992 (with Tommy Miah)
A True Taste of Asia, Edinburgh 1997 (with Tommy Miah)

Anthologies
The Rhythm of the Glass: Drinking, a Celebration (Ed.),Edinburgh 1977
The D C Thomson Bumper Fun Book (Ed.), Edinburgh 1976
Scotland : An Anthology (Ed.), London 1985
The Grizedale Experience: Sculpture Arts & Theatre in a Lakeland Forest
 (Ed.), Edinburgh 1991
Contributor to In Defence of Literature: for John Calder by his friends and
 admirers Toronto 1999

Ephemera
Obituaries of Charles Skilton in The Daily Telegraph, The Independent,
 The Bookseller and feature in Scotland on Sunday February 1990
Anonymous contribution (Charles Skilton) in The Fourth Daily Telegraph
 Book Of Obituaries: Rogues ed. by Hugh Massingberd, London 1998
(As James Hartington Jones) *The German Attack on Scarborough*
 Huddersfield 1989
East Lothian Revisited Haddington 1995

In preparation
Land of Grace & Beauty: Photographs of Vietnamese Women

Other books by Paul Harris

published by Kennedy & Boyd

Delightfully Imperfect: A Year in Sri Lanka at the Galle Face Hotel

After thirteen visits to Sri Lanka, Paul Harris, an award winning international journalist and author of more than forty books, decided to make his home on the Indian Ocean sunshine island he had come to love. He would be there for a year, staying for most of the time at the renowned Galle Face Hotel, the oldest hotel in the world east of Suez, before being expelled by the government on an ultimatum from the rebel Tamil Tigers.

This is the story of a remarkable year at the Galle Face Hotel. It not only paints a fascinating inside picture of a legendary hotel, but it also provides a unique perspective on politics and conflict in a troubled tropical island.

Illustrated with line drawings

When Pirates Ruled the Waves

First published in 1968, this was Paul Harris' first book which told the story of the British offshore 'pirate' radio stations which broadcast to British listeners during the Sixties. The book was an enormous success in the 1960s and went on to sell five editions. This new, illustrated large format edition, the Sixth Edition, was republished by Kennedy & Boyd in 2007 to mark the 40th anniversary of the closure of the pop pirates by the British government.

Illustrated with photographs

Available from bookshops and Amazon.com

Index

Rettie, John 171
Reuters 11, 16, 17, 20, 130, 133,
143, 145, 150, 182, 187, 203,
279
Richards, Frank 371
Ridgway, Brig. Andrew 226, 231
Rigg, Diana 264
Rijeka 102
Riley, Alasdair 212
Ripley, Tim 266, 268
Rodrigo, Nihal 310, 312
Rogner Hotel 107, 108
Romeo, Donaldson 80, 266, 267
Rongji, Zhu 339
Ross Revenge 39
Rotary International 280
Royal Highland Fusiliers 112
Royal Viking Sun 347-50, 352
Royle, Trevor 150, 189
Rubesinghe, Arya 304
Rugova, Ibrahim 262
Russell, Alec 299, 371

S

Sacher Wien Hotel 185, 186
Sagafjord 349
Sakhakot 241, 243-6, 248
Salem 73, 76-8, 83
Samaraweera, Mangala 307
Sammon, Bill 118
Sandhurst Royal Military Academy 106
Sands, Guy 118, 119, 216, 233
Sapsted, David 72
Sarajevo, 2, 103, 120, 137, 139, 140,
143, 145, 151, 152, 155, 159, 180-
3, 187-90, 194, 199 202, 205, 215,
227, 233, 234, 253, 254, 257, 258,
283, 285
Sarande 88, 90
SARS 336-8, 343, 344
SAS 109, 110, 127, 163, 166, 225, 248
Saudi Arabia 223, 233, 234, 235
Sava, River 114, 115, 133, 284
Savile, The, club 379
Schores, Nick 208, 209
Schork, Kurt 182

Scoop! 275
Scotland on Sunday 62, 117, 142,
149, 150, 183, 189, 287, 395
Scotpix 31
Scotsman, The 47, 62, 72, 73, 191,
193, 210, 212, 263, 293, 295, 377
Scott, George Riley 212
Scott, Jean 288
Scott, Sir Walter 380
Scottish Arts Council 191
Seabourn Spirit 360-66
Searchers, The 137
Selby, Hubert Jnr. 209
Senaratne, Dr Rajitha 306, 309
Serbia 2, 51, 86, 109, 111, 114, 204,
260, 285
Shagai Fort 243
Shakeshaft, Duncan 210
Shanghai 219, 319, 320-45, 346, 381, 395
Shanghai Daily, The 319, 321, 322,
328-339
Shanthan 288
Shehu, Megan 91, 98, 103, 220
Shenyang 345, 381
Sherman Cherry and David Lee 213
Shinwari 240
Shyti, Albert 90
Sikh Light Infantry 283
Siljak, Yugoslavia 155, 157, 158
Simpson, Bob 182
Simpson, John 138, 143, 159, 223
Skanderbeg Division of SS 105
Skenderija Stadium 201, 202
Skilton, Charles, 207, 209, 210, 212,
369-80
Skinner, Ted 228
Skopje 250, 268
Sky News 72-4, 84, 295
Sliema 44
Slobodna Bosna 155
Slon Hotel 1, 9
Slovenia 1-20, 51, 61, 109, 112, 119,
153, 159, 189, 197, 203, 204, 213,
285, 308, 393
Smailovic, Vedran 199-202
Smiley, Col. David 106
Smirke, Sir Robert 370, 378

Printed in the United Kingdom by
Lightning Source UK Ltd., Milton Keynes
140184UK00001B/7/P